SURFACE
TENSION

EDITED BY KEN EHRLICH & BRANDON LaBELLE
CD SELECTION BY STEPHEN VITIELLO

SURFACE TENSION

PROBLEMATICS OF SITE

SURFACE TENSION: PROBLEMATICS OF SITE
Edited by Ken Ehrlich and Brandon LaBelle
CD selection by Stephen Vitiello

Editorial Assistance by Beth Guynn

ISBN 0-9655570-4-9

Published by:
ERRANT BODIES PRESS
www.errantbodies.org

In collaboration with:
Ground Fault Recordings
P.O. Box 4923
Downey, CA 90241 USA
www.groundfault.net

© Copyright 2003

Distributed by DAP, New York
www.artbook.com

Design by Louise Sandhaus with Penny Pehl

Assisted by Jennifer McKnight, Victoria Lam,
Emily Morishita, Randy Nakamura,
Matthew Normand, and Bruce Sachs

Typefaces: Din, Knockout, and Fairplex

Printed by Blanchette Press
Richmond, British Columbia
Canada

Cover Image by Gilson Camargo

SURFACE
TENSION

ERRANT BODIES and the editors would like to thank
the following for making this publication possible:

The LEF Foundation

Peter Norton Family Foundation

23five, Incorporated, a nonprofit organization dedicated
to the development and increased awareness of sound works in
the public arena, and to the support and education of artists
working with and discussing the medium of sound.
(www.23five.org)

The London Consortium, a unique collaboration in London
between the Architectural Association, Birkbeck College, the
Institute of Contemporary Art and The Tate Gallery, which
offers multi-disciplinary programs of study in culture and the
humanities leading to MRes and Ph.D. degrees.
(www.londonconsortium.com)

We would also like to extend our gratitude to the
following for their help in securing materials and information:

David Zwirner Gallery, New York
and the Gordon Matta-Clark Estate
Gagosian Gallery, New York and Richard Serra
Sean Kelly Gallery, New York
White Cube Gallery, London
Black Dog Press
DIA Center for the Arts, New York
Jochen and Esther Gerz
Roseanna Albertini

And special thanks to Erik Hoffman for his continued assistance.

Dedicated to the memory of Paul Hirst for his endless
knowledge, fatherly presence, and infinite humor; and to Pascale
Jeanée, for demonstrating art's ability to have real influence.

CONTENTS

 PROJECT DESCRIPTIONS

 PROJECTS

 ESSAYS

As editors addressing the issue of "site-specificity" we proceeded with the assumption that artistic practice in general is a series of negotiations between and through interior desires and exterior spaces.

These negotiations are always positioned in front of an audience, however unknown or unseen, however multiple or withdrawn, anticipated or surprising. To initiate this kind of dialectical positioning between interior desire and exterior space, however, is to reduce their conversational intermixing. Such distinctions often lead to a binary structure without flexibility, which in turn positions the individual as a free-floating agent, over and above the world. The notion that desire is inside and place is outside oversimplifies a complex terrain, for certainly desire is externalized in the very formation of place, and place itself is lived as much internally as externally.

The disruption of this dialectic is at the core of SURFACE TENSION: that is, how do we problematize the inside/outside dialectic and amplify the complicated conversations that occur within such seeming oppositions? And how does artistic practice position itself in relation to notions of public space and the complexity of audience? In this sense, "site" might function as an operative term through which to gauge practice—it is both the physical location

of presentation and the intrinsic negotiations such presentation entails. While the terminology of site appears and disappears in varying attempts to define public art, place-specific interventions, community-based projects, and artistic services over the last 30 years, "site" continues to provide a location, both real and imaginary, actualized and theoretical, for considering the physical parameters of place and the phantasmic projections of what place may signal. Site thus may continue to describe the intersection of seemingly oppositional terms, and provide a necessary space for their negotiation. In this way, the centrality of the term "site" functions more as a fulcrum across which the desire to make is countered with the desire to receive.

SURFACE TENSION features works which bring this sort of understanding into their respective content, making apparent the negotiations that occur in conceptualizing and implementing ideas within a public domain, whether that be the production of a public installation or the act of writing itself.

Our editor
was thus
the belief th
of artistic
is just as
the produ

al mission
guided by
at the "place"
production
crucial as
ction itself.

That is to say, formal problems are intimately related to social questions. We chose to chart cultural practice at its most public moment, where it is both challenged and championed as it proceeds through an idiosyncratic network of social infrastructures, personal anxiety, and faith in strategy. Intersections of private and public, conversations of hidden and sublimated meanings, confrontations between individual intention and city legislation, the meetings of the artist's body and the body-politic, etc. In this sense we might say that at the moment it comes to function as a site, artistic practice instigates a process through which subject, object, place, and, context are brought under scrutiny.

Inevitably, a contemporary "site-based" anthology relates historically to the legacy of site-specificity as a mode of art practice initiated in the late 1960s and early 1970s. As a practice and methodology, site-specificity operates with an understanding of the relational complex of subject and object, as bound to the specifics of place, whether physical or informational. It unravels and sets into relief the greater contextual situation,

whether political, social, or material. Historically, site-specificity, as a model of critical practice, functioned in some sense as "oppositional" or disruptive: it sought to antagonize the institutional space and to interrogate the museum; it formulated models for the reworking of land…spilling, rebuilding, wrapping, and defacing; it strove toward a temporal shift in structure and form, and encouraged the active participation of audiences as a challenge to the static art object. Such oppositional practices can be seen in relation to what Marshall McLuhan calls "anti-environments."[1] Theorized in an article from 1966, "anti-environments" for McLuhan set in relief the given "environment" by creating an alteration, or transformation, of the given. That is to say, anti-environments necessarily stand in opposition to environments in a way that reveals them as constructs.

SURFACE TENSION positions itself in and against this legacy with the intention of both underscoring its significance and reconsidering its operations.

[1]
Marshall McLuhan, "The Relation of Environment to Anti-Environment" in INNOVATIONS: ESSAYS ON ART AND IDEAS, ed. Bernard Bergonzi (London: Macmillan & Co., 1968), pp. 122-133.

In doing so, this anthology highlights site-based practice as a significant methodology for the production of material forms, the performativity of actions, and the continual necessity for artistic practice

to address the public. In addition, it aims to discursively tease out related problems and theories by underscoring the questions such practice inevitably raises. In this sense, it is our view that while site-based works often explore modes of rearranging spatial configurations by implementing "contextual aware-ness," and aim to promote cultural investment in artistic practices, that is, to highlight the formation of public exchange, such works often deliver more questions than answers. While recognizing the relevance of oppositional tactics,

we also sought work that might move toward a critical re-evaluation of spaces

and consider the positions of bodies as integral to the evolution of environments. Here, scrutinizing places, context, objects and subjects occurs as a means for making environments that are not necessarily positioned as "antithetical." Through such a shift in the content of this anthology, the strictly oppositional gives way to modes of diversity, transforming dialectical formulations into dispersed, contested temporal positions.

As a means of editing such a diverse anthology, we organized the publication into three categories or modes of presentation and reading: critical and creative essays, documentation of projects, and projects designed specifically to activate the space of the book. By bringing these different modes together it was our aim to bridge the disciplinary divide between theory and practice.

For example, the design and installation works of CopenhagenOffice, Eyal Weizman/Rafi Segal, and Melissa Dyne register a certain indebtedness to site-specificity while pushing beyond strictly "art-based" parameters by implementing projects within the built environment as critical architecture; DRS, Concrete Steps, and, WochenKlausur aim for a performative intervention in public space with the intention of repositioning limits, drawing out political, social, and economic constructs in the public domain through collaborative efforts with the hopes of making real change; the performing body is further highlighted in the sound works included on the accompanying audio CD. Whether it's Terry Fox's private peregrinations around New York City while bowing metal bowls, Bruce Nauman's sounding-out of his studio space, or Atau Tanaka's multi-media, networked sound ensemble orchestrated across multiple continents, these recordings sonically register the place of the body as an event; the works of Paul Panhuysen, Simon Leung, Michael Asher, and Margaret Morgan,

all reflect practices that interrogate spatial, historical, and ethical specifics of institutional, social, architectural, and cinematic situations with the aim of unraveling and making accessible information. These modes and examples of practice are complemented by analytic essays that address historical and contemporary issues, and point toward an expanded understanding of artistic practice as place-bound. Extending critical theory through diverse territories, writing is underscored as "site-specific" and performative, as in Jane Rendell's meditation on memory, writing, and the formation of history. Finally, site-based projects designed for the book aim to activate textual space, highlighting the page as a public territory.

By looking toward the broader field of site-specificity, as well as the details of individual projects, it is our view that one can witness the legacy of this practice in contemporary forms of architecture, art, performance, and design in which the divisions between each discipline become less distinguishable, and the oppositions between environments and anti-environments less static. That site-specificity has led to dynamic and often contentious productions and debates, overlapping and contributing to issues of community, city policy, urban design, and public space—just to name an obvious few—reveals the degree to which it has found general acceptance within contemporary culture, beyond the overtly artistic framework.[2]

In order to bring these concerns to the forefront of the book, we sought out instances of disjunction rather than commingling, the frayed edges over seamless surfaces, to create a constellation of related themes, projects, and histories.

2
For an informative and critical account of the developments of site-specific practice see Miwon Kwon, ONE PLACE AFTER ANOTHER: SITE SPECIFIC ART AND LOCATIONAL IDENTITY (Cambridge, MA & London: The MIT Press, 2002).

In this sense, we embraced multiplicity over singularity with the idea that each essay or work would amplify, by complementing and problematizing, the other. We thus opted for an approach that might best be described as "all over the place."

This seemed to us to be an operative mode of editing aligned with the inherent plurality of site itself, knowledge about sites, histories of site-based practice, and varying attitudes and practices in relation to place. Being "all over the place" functions as an intentional dispersal against the centrality of any book—for books as sites operate to fix our gaze, and in doing so, create meaning which may remain referential in the evolution of ideas. To adopt an "all over the place" editorial method is not to undo or unravel the integral power and sincerity of the individual works, but rather to contextualize such power within the shifting features of their effects. This intention is based on the understanding that to complicate what we understand as the limits between private and public is to arrive at a more pronounced set of variables. Can we suggest then, that the intersection of context and desire is very often the location of everyday struggle—both in terms of personal drive and cultural movement?

—Ken Ehrlich and Brandon LaBelle

COLETTE MEACHER

IMPISH
ACTS OF
SABOTAGE

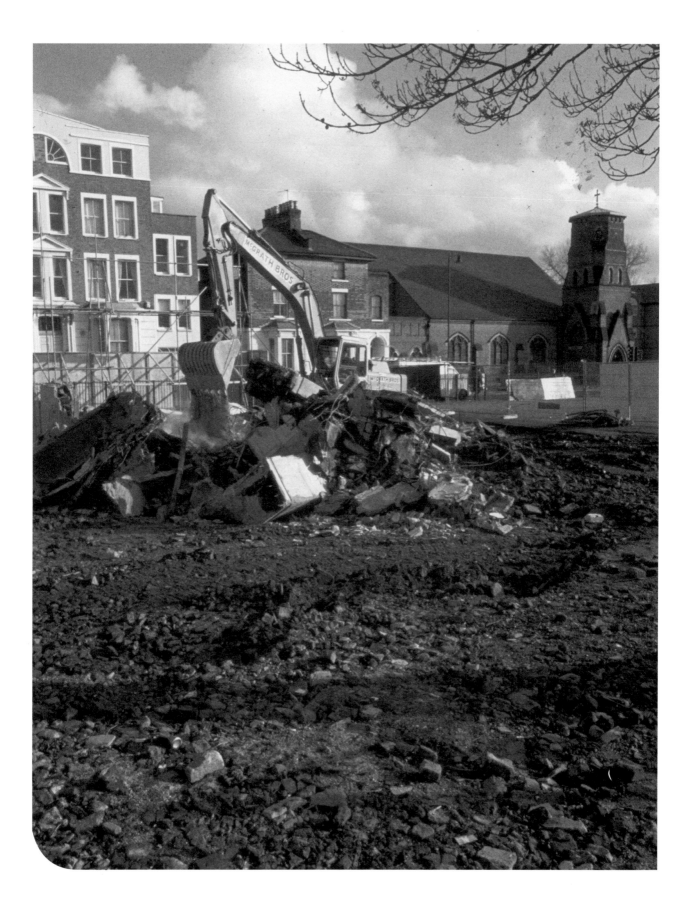

I met a traveller from an antique land

Who said: Two vast and trunkless legs of stone

Stand in the desert. Near them, on the sand,

Half sunk, a shattered visage lies, whose frown,

And wrinkled lip, and sneer of cold command,

Tell that its sculptor well those passions read

Which yet survive, stamped on these lifeless things,

The hand that mocked them, and the heart that fed;

And on the pedestal these words appear:

"My name is Ozymandias, King of Kings:

Look on my works, ye Mighty, and despair!"

Nothing beside remains. Round the decay

Of that colossal wreck, boundless and bare

The lone and level sands stretch far away.

—Percy Bysshe Shelley, OZYMANDIAS, 1817

T he Colombian painter Fernando Botero is world-famous for his pictures of happily rotund people laughing, dancing, and partying. Portrayed with such love, Botero does justice to the tenacious spirit of a people who have been caught in the eye of a civil war for the past fifty years. In a country in which academics, writers, comedians, and innumerable innocents have been customarily massacred for making public statements about the national conflict, artists have been uniquely exempt from the guerrilla's debarring of personal expression. Botero sat atop this exalted spot, and gathered renown for his generosity and optimism. In 2001, he gave more than one hundred of his paintings, drawings, and sculptures to the old Municipal Palace in an endeavor to invest a little cultural *jouissance* into the drug- and violence-dominated culture of Medellín—his city and favored home to the major drug cartels.[1] The year before, he had donated his vast private collection of international art to the Casa de la Moneda museum in Bogotá,[2] which subsequently opened the Museo Botero to house the works. Botero has also become increasingly concerned about addressing the political chaos of Colombia, most symbolically with a huge sculpture of a dove, sited in Plaza de las Esculturas, Medellín.

It was thus a shock when the dove was blown up on June 12, 1995.

Botero's response was to keep the ruined sculpture in place and position an immaculate sculpture of another, perfect dove alongside it. Botero followed this gesture with the installation of fourteen sculptures outside the Municipal Palace. These acts of figurative defiance have been greeted with awe bordering on the religious amongst the Colombian public: so much so that Botero's sculpture of a Roman warrior has acquired magic symbolism. Its penis is becoming worn with wear from the eager touches of passers-by that seek good luck from its charm.

✳

S uch acts of violence against the publicly commissioned work of art are far from new. They do, however, generate a greater sense of public horror in times of war. With the devastation of 9/11 in the United States still fresh in the global collective memory, we can all too easily visualize

1
He in fact donated 105 of his paintings and drawings, 23 of his sculptures, and 21 works of European art.

2
In addition to Botero's own works, the Museo Botero houses an impressive collection containing, among others, works by Picasso, Renoir, Matisse, Chagall, Braque, Dali, Monet, Degas, Bacon, De Chirico, De Kooning, Balthus, Bonnard, Auerbach, and Moore.

←
Rachel Whiteread, HOUSE, 1993, in the process of destruction.
PHOTO COURTESY OF ARTANGEL, LONDON

how the streets themselves became impromptu sites for memorials, shrines, and monuments, as testimonies to the atrocities publicly witnessed.

How can we come to understand acts of radical defacement, destruction, and violence against the modern image, sculpture, or edifice? Concomitantly, how do we make sense of the spontaneous and creative gestures that are born, phoenix-like, out of the displaced energy of sites of desecration and loss?

SHIFTING SANDS Art is no longer guaranteed to point us to noble, universal themes and sentiments, as it is fast fodder for a hungry market. Civic morality is no longer carved in stone and a considered walk through many nations' monuments could map out its erosion. No longer cherished, public statuary may remain a site of ritual remembrance observed by the dwindling older generations, but many memorials and public artworks have nevertheless become part of a landscape of forgotten ruins. The mass consumption of images and artifacts, and the ease with which we dispose of material goods and objects, contributes to this ceaselessly shifting urban landscape. While anthropological testaments to the continued ritual veneration of images abound, so too do substantive examples of the belief that, as Benjamin noted at the height of Modernism, it is in the "destruction of the work...[that] the external form achieves its most brilliant degree of illumination."

Within the modern British art world, works by major artists such as Rachel Whiteread's HOUSE, Vong Phaophanit's ASH AND SILK WALL, Anthony Gormley's TSWA 3D, and Henry Moore's KING AND QUEEN have all been subjected to defacement, damage, or destruction by the public. All those with an interest in art can recite a different line from this ongoing international narrative: whether it be Rauschenberg's ERASED DE KOONING, the Situationist artists who jumped on Tracey Emin's BED and peed into R. Mutt's FOUNTAIN, or of the man that sabotaged David Mach's 55-metre long POLARIS submarine sculpture on the Thames, who having set fire to the 600 tires from which it was made, was tragically asphyxiated by the poisonous fumes released.

Interestingly, these works—each of which aroused such controversy as to have been attacked, vandalized, pissed on, and painted over—have been hugely successful, largely because of the public furor and "negative" interest they have generated. It must therefore be the case that such acts are not simply the idle or wanton actions of stray philistines at a loss for entertainment on a Saturday night. Acts of destruction upon publicly commissioned work, as these sculptures were, need to be radically reassessed.

Moreover, we must examine why, each time something is threatened with destruction or actually demolished, it summons up within us as a public an *outcry* for the reinstatement of its *worth*.

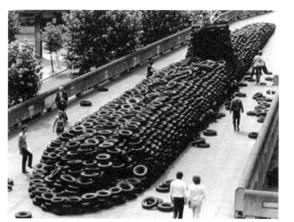

→

David Mach, POLARIS, 1983.

PHOTO COURTESY OF GOODWOOD
SCULPTURE PARK

TRACING THE FOOTPRINTS Angry words are quick to follow what are often generally perceived to be hasty and irreverent actions: indeed, it may partly be a desire for dialogue that motivates the recalcitrant mark-makers. We need only think of the universal dismay and indignation exhibited upon the destruction

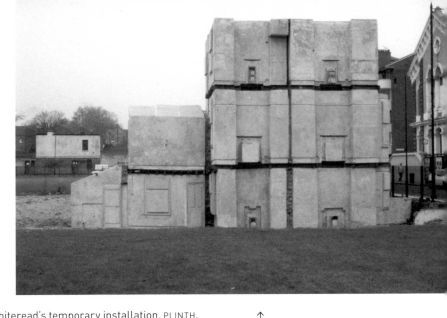

of the Buddhist sculptures in the Bamiyan district of Afghanistan by the fundamentalist Taliban regime. The United Nations Council for Cultural Affairs condemned the obliteration of the statues as "a true act of cultural barbarism," an unanimous sentiment that was echoed on a global scale. Once the Taliban had been toppled, plans were quickly afoot to "rebuild" the sculptures.

A similar protectionism is played out on a smaller scale towards the memorial and nationalist hub of Trafalgar Square in London, which is routinely scrubbed clean of the "scourge" of graffiti, as are the pigeon droppings from the resin skylight of the city, Whiteread's temporary installation, PLINTH.

Our consensual attitude displays a notable ambivalence towards what we eagerly applaud and what we righteously condemn.[3] Bow Council ordered the destruction of Whiteread's celebrated sculpture HOUSE in 1994, a controversial move that was, however, welcomed by a large sector of the general public. Yet there is more than an obvious parallel of intention between Whiteread's pieces and the Taliban's concern to rid Afghan culture of the representational image. This wish moves Judaism, Protestantism, and Islam to converge upon a point of faith, at least in theory, given that they are all mobilized by a mistrust of the graven image. The same caution was evident in modernist ideology after Adorno's statement that there could be no poetry after Auschwitz, that all endeavours to create would fall short. Postwar art did indeed retreat into the non-representational.

Defacement is more than simply a question of iconoclasm, however. When the public chooses to chisel away at a publicly sited sculpture or throw ink at a work of art (other than for reasons of wanting to take a bit home or scrawl their names upon it), something of great cultural significance is happening. Some response has been elicited which is noteworthy, whether it's a question of political argument or an expression of judgement about a work's aesthetic merit. What is being witnessed is a public engagement with art which mimics, unconsciously perhaps, the way in which artists make things with an awareness that others will follow behind them, will pick up on and embellish their work, or will want to tear it apart and make something else altogether. Such acts may thus be imitative of the regenerative industry of art, although we may simply interpret them as sabotage.

There is a case to be presented that individual acts perpetrated against esteemed sculpture thus need to be incorporated into the writing of the contemporary history of art. We are already familiar with the stories of the Puritan destruction of Christian idols, the demolition of Catholic iconography during the Reformation, and the Islamic obliteration of Hindu images in the Gujarat temple. An alternative, complementary telling of a history of art needs to be composed which places such examples within the trajectory Arthur Danto briefly traces of "incinerated art: from the destroyed icons of Byzantium to the bonfire of the vanities ignited by Savonarola to the iconoclastic flames of the Dutch reformation." For they demonstrate how both artist and audience have always been mutually engaged in the constitution of the art object. Art history is littered with examples of what Danto calls the "impish spirit of sabotage," shaping the path of art at the point at which technical features or developments become recognizable "styles."

↑
Rachel Whiteread, HOUSE, 1993.
PHOTO COURTESY OF ARTANGEL, LONDON

3
Isabel Hilton notes that although the Taliban's justification is "religious, the oldest and most common excuse for the destruction of art created by rival faiths,... it is also true that few countries are innocent of past zealotry and iconoclasm. Genghis Khan's forces destroyed Bamiyan in 1221, despite the fact that [he] himself was to become one of history's less likely Buddhists; British forces demolished most of the fifteenth century mosque in Musallah in Afghanistan in 1885 and in China, temples and monasteries were demolished during the Great Leap Forward." "From some perspectives," she claims, *"history seems like one long catalogue of destruction by one tribe of the treasures of another"* (my emphasis), in THE GUARDIAN, March 7th, 2001.

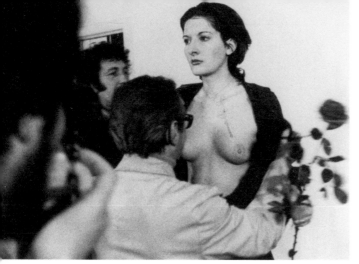

↑
Marina Abromovic, RHYTHM 0,
1974.

4
Thomas McEvilley, SCULPTURE
IN THE AGE OF DOUBT (London:
Allworth Press, 1999), p. 186.

GOING PUBLIC Performance artists in the 1960s and 1970s sought to challenge the parameters of the art world and lead it outside the confines of the gallery space. In the U.S., the term "living art" was adopted to express intent for artworks to do more than nominally or physically embody space, light, and form. Art was lived rather than made, achieved with an audience whose responses often became an integral part of the performance. The film, photographs, or subsequent text of such "happenings" served as documents of the event, rather than constituting the artwork *per se*.

The problems inherent in such attempts to democratize and open the debate about the function of art can be seen in Marina Abramovic's 1974 piece, RHYTHM 0. McEvilley sets the scene thus:

> *Abramovic appeared at her opening in Naples along with a random crowd*
> *brought in off the street, with some art world aficionados. The gallery director*
> *announced that the artist would remain completely passive for six hours...during*
> *which time the visitors could do whatever they wanted with or to her. The*
> *parameters were supposedly defined by an array of seventy-two objects laid out*
> *on a table near which [she] was standing...[and] included a pistol, an axe, a fork,*
> *a bottle of perfume, a bell, a feather, chains, nails, needles, scissors, a pen, a book,*
> *a hammer, a saw, a lamb bone, a newspaper, grapes, olive oil, a rosemary branch,*
> *a rose and other things.*[4]

Abramovic's choice of objects is interesting; they are essentially mnemonic objects with art historical associations. The book, bone, fruit, oil, and flower might be found in the still life; chains and nails summon associations of religious iconography; the scissors, pen, hammer, and saw are tools of the artist's craft.

The audience's knowledge of art history did, perhaps, resurface from memory in their endeavors to construct a living image. McEvilley, however, details the events in a less favorable way, considering the participation as feckless barbarism rather than artistic engagement:

> *The randomly selected audience, many of them not accustomed to Performance Art,*
> *grew more and more aggressive. Abramovic was stripped, painted, cut, crowned*
> *with thorns and had the muzzle of a loaded gun thrust against her head. When the*
> *art world constituency rebelled against the aggressive outsiders, the event was*
> *declared over.*

The audience had seemingly done as seemingly invited in making a tableau of their own self-appointed martyr. They wilfully employed the tools supplied to test the boundaries and the possibilities of visual representation, in a performative way traditionally not permitted in a gallery setting, albeit with a crudely venal and unexpurgated approach.

This example delineates the theoretical distinction made in the 1970s between the museum's endeavors to create and sustain a chain of associative historical memory, and the palimpsest of a loaded landscape with which public art, topographically in situ, joins and suffuses. This is a differentiation that endures, and has markedly affected both curatorial and

artistic practices. Note a dialogue generated by the recently-created Tate Modern museum in London, which replayed this familiar bandying of ambivalence. Potts observed that "one of the most spectacular effects…is to be had by stepping out of a gallery onto a balcony and getting a panoramic view over the city."[5] Stallabrass rejoined by pointing to a publicly acknowledged or designated memorial, the cathedral that mirrors the museum over the river Thames—"You can see St. Paul's, for goodness sake: the icon of London in its survival and vicissitudes."[6] Looking beyond the museum's anamnetic galleries, one rediscovers a sense of place and memory, marked with our own individual subscription of cultural and aesthetic referents. In contrast, the new museum of art features geographically and culturally for some critics as a contemporary *monument*, bearing the hallmarks of its own creative closure, its inception "mixed with ideological and cultural stagnation."[7]

It is not necessarily the case that "the gallery space has again become the unchallenged arena of discourse," as O'Doherty determines.[8] It rather seems to be the case that the monument or artwork in the public sphere is much more forgiving, and much less forbidding, of gestures of reciprocity, demands of accountability, and lapses of mass cultural and historical memory. While the curators of the contemporary museum may wish to counter retrospective historical framing of the past by banishing melancholy or nostalgia, public works must contrarily stand, quite literally, for their own historical significance. Here, prevarication about how to establish a representative version of history may more evidently be played out. Within the siting and decommissioning of such sculpture, a tussle takes place with the *prima materia* of memory itself, with the need or felt obligation to represent something which has come to pass and the inability to adequately do so given that memory inevitably fails.

5
Alex Potts, "Round Table: Tate Modern," OCTOBER 1998 (London and Cambridge, MA: The MIT Press, 2001), p. 16.

6
Ibid., p. 19.

7
Ibid., p. 11.

8
Brian O'Doherty, INSIDE THE WHITE CUBE (Los Angeles and Berkeley: University of California Press, 1999), p. 113.

9
Leslie George Katz, "The American Monument," in LEE FRIEDLANDER—THE AMERICAN MONUMENT (New York: The Eakins Press Foundation, 1996), unpaginated.

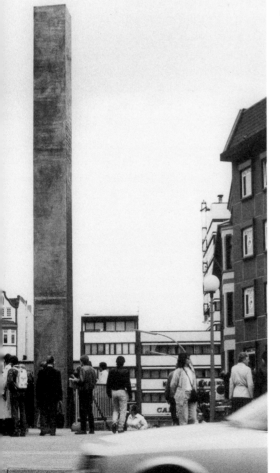

COUNTER-MONUMENTS If as Katz claims, "monuments are metaphors for human values, persistent values that survive despite notice or neglect,"[9] the tussles to represent the horrors of the Second World War, especially in Germany, are of profound human and aesthetic significance. Adorno's proclamation that it would be impossible to represent the atrocities of the world wars was applied so assiduously by makers of holocaust memorials that many of them employed mechanisms of self-effacement. Controversially, these pieces seemed not to confront the past to which they testified nor to reference historical events difficult to confront everyday. They rather nod to a tacit acknowledgement that the vagaries of the world wars marked the *memories* of those who had experienced them.

←
Jochen and Esther Gerz, MONUMENT AGAINST FASCISM, 1974.

10
Of counter-monument makers such as Jochen and Esther Gerz, Young notes "to their minds, the didactic logic of monuments, their demagogical rigidity, recalled too closely traits they associated with fascism itself. Their monument against fascism, therefore, would amount to a monument against itself: against the traditionally didactic function of monuments, against their tendency to displace the past they would have us contemplate—and finally, against the authoritarian propensity in all art that reduces viewers to passive spectators." James E. Young, THE TEXTURE OF MEMORY: HOLOCAUST MEMORIALS AND MEANING (New Haven, CT: Yale University Press, 1993), p. 28.

11
Jochen Gerz quoted by James E. Young, THE TEXTURE OF MEMORY p. 32.

12
James E. Young, THE TEXTURE OF MEMORY, p. 40.

Young has documented how a "successful" memorial to the holocaust would achieve quite the opposite to what we normatively consider the qualities of aesthetic success.[10] In counter-monumental works Musil's wry comment about the "conspicuous inconspicuousness" of most public sculpture came to be embodied. Jochen and Esther Gerz's MONUMENT AGAINST FASCISM, the so-called "disappearing monument," attested to the mercurial *quality* of memory, and thus to the need for it to be represented as alive, in a way which implicates the viewer who shares the memory by association.

The artists hoped that the work would become mnemonically internalized by those perceiving it, so that the formal properties of the piece would be surpassed, and its *intention* remembered. Gerz projects, "we will one day reach the point… when vigilance will be kept alive by the invisible pictures of remembrance."[11] While this may sound vaguely reminiscent of the self-policing Foucault identified as characteristic of the liberal utilitarian vision, it is rather the hope that memory be kept alive so that memorial debate consequentially "becomes a form of memorial activity, never resolved, forever in flux," as Young states.[12]

It is necessary to point out that such "negative" sculptures in Germany and Austria which, through disappearing, existing underground, or presenting an absence of figuration, seem to foreclose the issue of memorializing the events as do the stoic municipal cenotaphs of "victorious" Britain. They contentiously suggest that civic amnesia can be a form of collective amnesty.

LEST WE FORGET Thus, we can trace a tendency in contemporary public sculpture to aim at *mnemonic* signification rather than endeavoring to pose as a centrifugal *memorial* or monument to collective experience. This shift in representation is perhaps owing to the recognition that a singular form cannot adequately serve the panoply of individual memories. What is hereby engaged is a post-Aristotelian awareness that the prompting of memory may occur in two distinct ways. Our habitual and involuntary recourse to what our minds preserve is not clearly expressed by the English word "memory." In German, *Gedachtnis* (mneme) refers to the unwitting nature of memory and forgetting: *Erinnerung* to referential memory triggered by particular objects, for example. Proust's madeleine is a *mémoire involontaire* until the point at which he fixes the association of his memories to the cake through the act of writing about it, at which point it becomes *memoria*, capturing the ability to consciously excite what was forgotten.

When public sculptures become known and used as daily landmarks for the populace they serve, they become part of the associative or narrative map of one's imaged landscape. De Certeau's emphasis on cognitive mapping as a means by which we mnemonically traverse the city-space is given poignant and contemporary witness by accounts of people losing their way in New York since the felling of the Twin Towers.

As such metaphorical memory-anchors, their collective meaning necessarily gets washed away in the tides of time and urban regeneration. At the moment at which public sculptures fail to continue to serve as mnemonic signifiers of momentous historical events, to serve "living" memory, they are not necessarily doomed to failure. And if they are, they are rarely decommissioned to the backrooms out of the public's visual reach, as happens with museum collections. Their mere presence as aesthetic or formalized representations of individual personages, battles fought or lost or of artistic ideas, means that they may become the site of physical interventions aimed at contesting their authority, artisanship, and right to preside over the public domain.

While it may be true, as Rowlands asserts, that "counter-memorials appear... lifeless in their minimalist desire to disturb," [13] it nevertheless remains a given that public sculpture continues to be more accessible to public response than works shielded by museum or gallery patronage. And while the closed forms of many modernist-styled holocaust memorials fail as Young notes, to "gather together personal memories into a collective space," [14] they are perhaps all the more successful for it. Casting off any claim to memorialization, their substance is sequestered like the vestigial traces of memory in the mind. It is perhaps a desire to test the limits of what these silent guardians "contain," and a sign of the extent to which they may become equated with what they ideologically represent, which motivates people to physically engage with sculpture. In the case of Botero's DOVE, the guerrilla's actions were a brutal test of whether his bid for peace was an empty promise or a deeply held conviction. In reaching out to the Roman's prowess, the caresses of the admiring public reverberate with the historical echo of Ghiberti, praising a Greek statue in Padua, whose "moderate refinements the eye cannot see...only the hand touching it finds them." [15]

MONUMENTAL IMMATERIALITY In the Renaissance, the apparent fragility of exposed sculpture meant that it was deemed inferior to painting; being laid open to the vicissitudes of nature caused its hardy materials to wear and the form to corrode. Hall charts how this assumption re-emerged in the eighteenth and early nineteenth centuries; both physical touch and environmental hazards were thought to undermine the assumption that "if art was to express eternal verities, then object and its environment must be stable." [16]

There is a case for arguing that such interactions with publicly-sited work embellish the charms they proffer. The proscription that touch "was the most gross and material of the senses" and could deform sculpture has not prevented such engagement, other than in the institutional setting. Freedberg encyclopedically charts the assaults made upon sculptural works, motivated by the full range of phenomenological impulses:

> People are sexually aroused by pictures and sculptures; they break [them]...
> mutilate...kiss...[and] cry before them...are calmed...stirred...and incited
> to revolt...give thanks by means of them [and] expect to be elevated...to the
> highest levels of empathy and fear.[17]

Moreover, this compulsion to touch and physically interact with works contributes to the positioning of a piece within the annals of history. An outdated sculpture or relic can also be rescued from the ideological scrapheap or historical dustbin by such actions, be they gracious or defacing. The two following examples serve to illustrate this point.

In 2000, a public statue of Winston Churchill in Parliament Square was sabotaged by anti-capitalist demonstrators and decorated with a mohawk of green turf. Savage claims it was "a lurid green splash against the grey gun-metal sculpture." [18] Debate raged about what became "the chief press image of the day" concerning whether this constituted legitimate action or was merely defamatory vandalism. What emerged from the emotional furor was a considera-tion of Churchill's celebrated reputation accrued in the wake of the Second World War, as a "national hero." Journalists were led by graffiti to unearth his more questionable achievements:

> A simple acronymic graffiti—TIKB—placed by the Turkish Communist Party,
> protest[ed] the botched invasion of Turkey at Gallipoli in 1915 for which [he],

13
Michael Rowlands, "Remembering to Forget: Sublimation as Sacrifice in War Memorials," THE ART OF FOR-GETTING, Adrian Forty and Susanne Kuchler, eds. (London: Berg Press, 1999), pp. 129-145.

14
Rowlands, "Remembering to Forget," p. 129.

15
Lorenzo Ghiberti, from his COM-MENTARIES 1447-1448. Quoted by James Hall, "Another Time, Another Place," in ART REVIEW (July/August 2000), p. 35.

16
James Hall, "Another Time," p. 35.

17
David Freedburg, THE POWER OF IM-AGES: STUDIES IN THE HISTORY AND THEORY OF RESPONSE (Chicago: University of Chicago Press, 1989), p. 1.

18
Jon Savage, ENGLAND'S DREAM-ING: SEX PISTOLS AND PUNK ROCK (London: Faber & Faber, 2001), p. vii.

*as First Lord of the Admiralty, was responsible... For others, the sight of [him]
with Punk/anarchist insignia was delicious payback for the siege of Sydney Street
in January 1911, when Churchill...sent in the guns against armed police killers
who...had grown into an army of anarchists led by the Russian Peter the Painter.*

Here, the "scaffolding of rhetoric" which Churchill often expressed a wish to see dismantled, did indeed come tumbling down. The statue, the man as historical figure/icon and the certainty of the record of historical events were all called dramatically into question.

In a less immediate, but nonetheless theatrical way, a statue of Edward Colston, the nineteenth-century industrialist and slave-trader, was effectively challenged by a counter-memorial gesture. In Bristol, Colston is largely respected for the trade and prosperity he created for the city, remembered by "Colston Day," an annual public holiday. His less dubious political involvements have been glossed over due to his charity to the "deserving" poor and to the Anglican Church. STIRRINGS AT THE INTERNATIONAL FESTIVAL OF THE SEA in 1996, organized by a collaboration of the Guerrilla Girls and other artists, sought to challenge this ideological memorial posturing by introducing mnemonic signifiers into the city landscape. Amongst the actions was an installation piece by the Yoruban-British artist Falakeh Shoga which essentially consisted of a shrine of blood and guts placed in front of Colston's memorial. This visceral prompt sought to refuse the silence shrouding the bloody trade and to confront popular memory; to find a way of speaking history that begins to reconcile radically different notions of space—here that of colonizer and colonized.

Such acts of mnemonic obliteration or refutation transform the polemical monologue of official history invested in and represented by the memorial into dialogic objects. The monument that speaks in order to silence, thereby designating the markers of heritage, is refused its intractable authorial power. These gestures of counter-creation may be ephemeral, such as in the latter cases, or not, as with Botero's DOVE and the constantly discussed example of Rachel Whiteread's HOUSE. Their success in terms of stimulating memory or counterposing intransigent historical narratives is no more assured than the interventions that may occur in a museum or gallery space. However, their contextualization within the built environment of lived existence would seem to suggest a potentially greater audience and resonance with them. This is not, however, to presume then that a singular version of a revised history comes to stand in the stead of the previous historical rhetoric.

It is also the case that a destroyed or damaged public sculpture can, in its turn, come to gain iconic status. If this was not quite the case with the Churchill statue, it is so with Botero's deconsecrated piece, which still stands, and of HOUSE, which exists solely in the realm of memory, and in the form of photographic evidence.

A question arises: can a photograph adequately represent a memorial?

<center>⁙</center>

Ephemeral monuments, which seem to rely on the photographic memory, to seize the event and hold it in a frozen moment like the developed image on photographic paper, summon up Malraux's voice from the past: "for the last 100 years...art history has been the history of that which can be photographed." [19] Lingwood mourned the destruction of HOUSE and its memorial iconicity, considering it to be symptomatic of its erasure from public consciousness. He opined that the "badly fitted carpet of replacement turf," which now sits in place of the sculpture, feebly constitutes "a field of voluntary amnesia."[20] Yet, the massive media attention given to the controversial work both revealed a forgotten history[21] and planted its mnemonic image into

19
André Malraux, THE VOICES OF SILENCE, trans. Stuart Gilbert (New York: Doubleday & Company, Inc., 1956), p. 30.

20
James Lingwood, ed., HOUSE (London: Phaidon Press, in association with Art Angel, 1995), p. 26.

21
It became clear that the house had remained standing in an area largely destroyed during the Second World War. Temporary social housing and tower blocks came to replace the demolished Victorian terraces, of which HOUSE was the solitary domicile remaining, replete with its emotive, symbolic stature as a survivor of decades of turbulent social change. That it was felt by many members of the local community and readers of the tabloid press, who took an overwhelming interest in it, that these "memories" which HOUSE embodied had been compacted under the armor of plaster and had touched a raw nerve.

many people's minds due to the proliferation of photographs produced. The cost of the sacrifice of the sculpture itself entailed a substitutive relocation from the expanded field of the public domain to immortalized moment in the art historical archive.[22] The fact that it is remembered and frequently discussed survives the sculpture's demise, its state-sponsored desecration. Once again, the outcry which was involuntarily summoned by the public upon its demolition, has joined an art historical concurrence in its worth.

In an earlier public art project of 1987, Lingwood was coordinator of an initiative entitled TSWA 3D.[23] In the exhibition catalogue he outlines a manifesto in which a seemingly modern, or rather, Postmodern appraisal of the role of public sculpture is outlined. He posits the "possibility of a public art which is both specific and uncompromised, which understands history without historicizing." He voices concern to counter the prevailing tendency to view the modern landscape as fundamentally bereft of history or meaning, a theory of the "neutrality of space" as posited by Krauss. He conversely aimed with the instantiation of the scheme to "refute...this absolute loss of place in favor of something which is neither siteless nor homeless, and [to] criticize...neutrality in favour of the uncertain and the associative."[24]

Within his rhetoric can be heard the expressed wishes of sculptors themselves. Ever since the Renaissance criticisms of the ephemeral nature of publicly exhibited work, sculptors have been concerned with demonstrating that changes in lighting, erosion due to environmental climate, and the possibility of various perspectives *benefit* the work. Surrealists such as de Chirico considered the exposed sculpture to serve as an apt metaphor of the predicament of humanity, "isolated, abandoned, displaced, subject to fickle fate and elements," claims Hall.[25] Henry Moore similarly expressed a desire for his works to have "a continual, changing, never-ending surprise interest."[26]

As such, public sculpture is seen to remind us of the inescapable, eternal verity of change and not the immutability of our cherished human constructs: to *remind* us to observe the passage of time rather than cling to its markers.

RE-READING THE LANDSCAPE It would thus seem that although, as Potts claims, "a particular moment of mourning about the loss of a sense of the historical is over,"[27] this does not obviate the fact that at an individual, and sometimes collective level, public sculptures continue to serve as mnemonic signifiers of the fleeting historical moment. Read from the human landscape, they are elements often denied coeval visibility with the capricious field of commerce, politics, and culture. They often come to nestle alongside the fugitive life forms subsisting in obscure suburban encampments obliquely referenced by unread signs. Augé muses: "Paradoxically, it is at the city limits, in the cold, gloomy space of big housing schemes, industrial zones and supermarkets that the signs are placed inviting us to visit the ancient monuments."[28] Public sculptures are sited alongside the forgotten promises of social housing, cemeteries, abandoned institutions for the criminally insane, and crazy-paved conurbations for the prison communities.

Even within the city's limits, the monument, memorial, or meaningful path must often be wilfully carved by the walking *dériveur*, with a shrewd half-eye open to the possibilities that drift on the currents of the city's energies and peculiar magnetism. This search through the associated flotsam and jetsam of the city of London has inspired artists and writers alike for the past century, who have turned their finds into unique mneme, written and painted, carved and narrated.

Wolfrey allegorically portrayed the human limits of the imagination's capacity to perceive the city as an eclipsing of rational cognition at dusk, the crepuscular hour. He wrote of "the

22
Although, undoubtedly, the photograph as document cannot entirely replace or represent the event, it certainly does have a "mnemic" or "hypomnemic" quality. Derrida claims of the *hypomnema* that: "the archive, if this word or figure can be stabilized so as to take on a signification, will never be either memory or anamnesis as spontaneous, alive and internal experience. On the contrary, the archive takes place at the place of originary and structural breakdown of the said memory." Jacques Derrida, ARCHIVE FEVER, trans. Eric Prenowitz (Chicago: University of Chicago Press, 1998), p. II.

23
A project established with Jonathan Harvey, Arts Consultant, TSW (Television South West), and Tony Foster, Visual Arts & Crafts Officer, South West Arts.

24
James Lingwood, preface to TSWA 3D EXHIBITION CATALOGUE, Harvey, Foster & Lingwood, eds. (Bristol: TSWA 3D, 1987).

25
James Hall, "Another Time," p. 36.

26
Quoted by Hall, op. cit.

27
Potts, "Round Table," p. 24.

28
Marc Augé, NON-PLACES: INTRODUCTION TO AN ANTHROPOLOGY OF SUPERMODERNITY, trans. John Howe (London: Verso Press), pp. 73-74.

29
Julian Wolfrey's "Writing London," quoted by Peter Ackroyd in LON-DON: A BIOGRAPHY (London: Vintage Press, 2001), p. 449.

30
Ackroyd, LONDON, p. 451.

31
Richard Shone; "Walter Sickert, the Dispassionate Observer," in SICKERT PAINTINGS, Wendy Baron & Richard Shone, eds. (Catalogue produced by the Royal Academy of Arts, London & Van Gogh Museum, Amsterdam in association with Yale University Press).

32
Quoted by Ackroyd, LONDON, p. 452.

33
Michel De Certeau, THE PRACTICE OF EVERYDAY LIFE, trans. Steven Rendall (Berkeley: University of California Press, 1988), p. 108.

34
Roland Barthes, "Semiology in the Urban," in Neil Leach, ed., RETHINKING ARCHITECTURE: A READ-ER IN CULTURAL THEORY (London and New York: Routledge, 1997).

35
Michel De Certeau, p. 108.

36
Barthes, "Semiology in the Urban."

37
Barthes claims that sociological surveys in France showed that the city of Paris "was always experienced semantically by the periphery as a privileged place where the other is and where we ourselves are other, as the place where we play the other." Barthes, "Semiology in the Urban."

38
Ackroyd, LONDON, pp. 777-779.

39
Iain Sinclair, LIGHTS OUT FOR THE TERRITORY (London: Granta Books, 1997), p. I.

sinister...threatening, monstrous *inhumanity* of the limitless city;"[29] an "inhumanity" born of fear commingled with heightened delight, that became a sought-after thrill from the streets. Ackroyd reports that, "in the middle of the nineteenth century there came a vogue for 'night walks': sketches or essays in which the solitary pedestrian made his way across the dark city, marking significant moments and scenes in a journey of unknown destination."[30] One such wayfarer was the painter, Whistler, who commandeered the young Sickert to accompany him on memorizing expeditions carried out alongside the Thames at night: studies for his NOCTURNES.[31] Dickens was also on the footpath, muttering in drunken reverie: "under the pattering rain...walk and walk and walk, seeing nothing but the interminable tangle of streets."[32]

For De Certeau, there is hope in each stride; it is not merely creative and subversive, it is a "poem," it is art made in process, the living landscape felt in vivo, held by the memory alone; "memory is a[n]...anti-museum: it is not localizable."[33] Barthes, too, is lyrical about the city as a poetical landscape: "When we move about a city, we are all in the situation of the reader of the 100,000 million poems of Queneau, where one can find a different poem by changing a single line: *unawares*, we are somewhat like this avant-garde reader when we are in a city."[34] Barthes' sublime feelings for the joy of perceiving its myriad complexity and uncontainable energy in motion, is the emotional charge which, since Victor Hugo's "old intuition: the city is a writing" has continually excited those who pass through, and in so doing become possessed[35] by its sheer yet shifting magnitude. It is a possession born of difference, of disparities that cannot be reduced; the city "is the place of our meeting with the other,"[36] a place in which our own sense of identity becomes necessarily transcended in an attempt to comprehend the sheer manifold nature of humanity engaged in a semantic tussle with the built environment.[37]

This sense of otherness is furthermore compacted by layers of history; "the ancient city and the modern city literally lie beside each other...that is one of the secrets of the city's power," Ackroyd declares.[38] The psychogeographer and magician of the mapping of modern-day London Iain Sinclair stumbles upon and delights in "tiers of buried memory waiting to be unearthed by fragments, alignments, memorials, glass shards—more clues than we can gather at once, more histories than we can simultaneously read [which] emerge from the retreating townscape."[39] De Certeau uncannily reveals that "there is no place that is not haunted by many different spirits hidden there in silence, spirits one can 'invoke' or not. Haunted places are the only ones people can live in."

TINY EPIPHANIES It is not merely artists and writers, architects and historians who find meaning in the city and make this into personal monuments and memorials of their own existence. As Barthes sketches, we are all involved in this poetic unveiling of our collective, often international mythology, which lies waiting to be revealed, and perhaps contested. Moreover, some cities may prompt such lay anthropological/ archaeological mythologizing more than others.

It is no longer possible to think of the audience for public artworks in civic spaces as an undifferentiated, opaque hoard of unknowns with indiscriminate judgement, oblivious to the landscape through which they wander—as Baudrillard unequivocally asserts:

> *To want to specify the term "mass" is a mistake—it is to provide meaning for that which has none. One says: "the mass of workers," but the mass is never that of the workers, nor of any other social subject or object...the mass is without attribute, predicate, quality, reference. This is its definition, or its radical lack of definition. It has nothing to do with any* real *population, body or specific social*

aggregate. Any attempt to qualify it only seeks to transfer it back to Sociology
and rescue it from this indistinctness which is not even that of equivalence, but
that of the neutral, that is to say neither one nor other.[40]

The notion that the "mass" presents a *tabula rasa* upon which the powerful may inscript or mold according to whim has always held a particular potency. Joseph Goebbels, for instance, claimed that "the statesman is an artist too. For him the people is neither more nor less than what stone is for the sculptor."[41] The Postmodernist supposition that all human activity is becoming ever more syncopated in conformity with the movements of an agglomerated mass is one, since Fritz Lang's METROPOLIS of 1927, which is typically associated with cities.

Patrick Keiller's film LONDON of 1993 carries the trajectory of the anomic city-dweller to a poetic nullity, through the lachrymose and often laconic protagonist, a modern-day *Robinson*:

> *I am an ephemeral and not too discontented citizen, of a metropolis considered*
> *modern, because all known taste has been evaded in the…lay-out of the city.*
> *Here you would fail to detect the least trace of any monument of superstition:*
> *morals and language are reduced to their simplest expression at last. These*
> *millions of people who do not even need to know each other manage their*
> *business, education and old-age so identically that the course of their lives must*
> *be several times less long than that which mad statistics calculate for the peoples*
> *of the Continent* (my emphasis).

Indeed, it may not merely be the lives of its denizens that are foreshortened, but the lives of its civic monuments too. Compare Lefebvre's charmed account of Venice:

> *Is this city not a theatrical city not to say a theater-city—where actors and the*
> *public are the same in the multiplicity of their roles and relations?… Would it*
> *not be so because what is given free rein in this space is a privileged form of*
> *civility and freedom, founded on and in a dialectic of rhythms? This freedom*
> *does not consist in being a free citizen of the State but of being free in the city*
> *outside the State. Political power dominates or attempts to dominate space,*
> *hence the importance of monuments and squares, but if palaces and churches*
> *have a political meaning and goal, the townsmen-citizens divert them, and*
> *appropriate this space in a non-political way.*[42]

It would thus seem the case that Venetians find ways to "divert" political meanings from their public statuary "in a non-political way" because of their feeling of ideological independence from the State and its encodings of "legitimate" readings.

The quintessentially English satirical novelist Evelyn Waugh contrasted the English *ambivalence* to national pride in restoration—which he saw as an historical and anthropological given—with that of our Mediterranean counterparts:

> *The detestation of "quaintness" and "picturesque bits" which is felt by every*
> *decently constituted Englishman is, after all, a very insular prejudice. It has*
> *developed naturally in self-defence against arts and crafts, and the preservation of*
> *rural England and the preservation of ancient monument…*[43]

40
Jean Baudrillard, IN THE SHADOW OF THE SILENT MAJORITIES (New York: Semiotext(e), 1983), pp. 5-6.

41
Quoted by Michael North, "The Public as Sculpture: From Heavenly City to Mass Ornament," in W.J.T. Mitchell, ed., ART AND THE PUBLIC SPHERE (Chicago: University of Chicago Press, 1992), p. 10.

42
Henri Lefebvre, "Rhythmanalysis of Mediterranean Cities," in WRITINGS ON CITIES, Eleonore Kofman & Elizabeth Lebas, eds. (Oxford: Blackwell Publishers, 1996) pp. 236-237.

43
Evelyn Waugh, LABELS: A MEDITERRANEAN JOURNAL (London: Methuen (1991).

If London is contrarily *not* perceived as a space of "privileged...civility of freedom" by its occupants, then acts of defacement can be understood as a means by which the authorial or planning control of all those employed to shape the city and curate its public art acquisitions is necessarily politicized, in order to free up what Lefebvre calls "a dialectic of rhythms."

Richard Sennett believes that "the fruit of this conflict...is that in extricating the city from its preplanned control, [the public] will become more in control of themselves and more aware of each other. That is the promise, and the justification, of disorder."[44] The notion that strikes against cherished public landmarks are carried out under cover of darkness by an unruly mob may sometimes come close to the truth; but our anthropological awareness instinctually prompts us to accommodate the presumed resourcefulness and innovative capabilities of human beings. Buck-Morss abandons the term "the masses" which she claims "was launched in the modern era as a term of contempt." She evidences that strikes against the monumental may be triggered by hints of the ephemeral. Reaction may be involuntarily mobilized into a "physical force," even a "lethal weapon" by "the trace of physical presence: an image, a voice, clothes worn by, objects touched by, beds occupied by the person in whom the mass's psychic energy is invested."[45]

IN CONCLUSION: AN OPEN GESTURE It has yet to be claimed that marking a response upon a sculpture or monument as it sits impassively upon our path may precipitate a sense of *self-identity* for the he or she who feels summoned to express it. If it can be said that the public feel alienated by a particular sculptural piece, it may also be said that in its defacement, the same ignored, misunderstood, or unappreciated work can come to be re-appropriated—*mythologized* even—by this curious virtue. Such secret and prohibited touches are spiritually akin to what Lefebvre shares as "those tiny Epiphanies in which the absolute possibilities and temporal limits of anyone's existence [are] revealed."[46]

How does the art industry generate vast amounts of closed capital and yet at the same time apparently not take itself entirely seriously? This fact, along with an ever-increasing public consumption of art, seems to wriggle out of the net of theoretical discourse. So we turn instead to the tides of enchantment and disenchantment, as they tussle with claims and counter-claims over their found objects. It is, of course, imperative that we find a way to make sense of seemingly senseless acts of defacement, and that we fashion some kind of rod with which to discriminate between their potentially enlightening and needlessly destructive effects. We need to accept the challenge to our increasing concern to preserve cultural heritage; and understand why we inevitably feel compelled to reconfigure the worth of that work which has been challenged, the almost alchemical process by which a forgotten sculpture and its site often become re-consecrated as hallowed effigies.

What is of undoubted value, and merits our serious attention, is the reconsideration of public art we are called to address by such acts of defacement. British graffiti artist Barry McGee recently claimed that "there are beautiful acts of non-sanctioned public art happening in almost every urban city worldwide. It can be a rock soaring into a plate glass window at Starbucks or a message spray-painted across the façade of Exxon's headquarters. To me, this is public art." The horror or sublime thrill we feel when faced with such acts demands that we judge whether this statement rings true.

44
Richard Sennett, THE USES OF DISORDER: PERSONAL IDENTITY AND CITY LIFE (New York: W.W. Norton & Company Ltd., 1970), p. 198.

45
Susan Buck-Morss, DREAMWORLD AND CATASTROPHE: THE PASSING OF MASS UTOPIA IN EAST AND WEST (London and Cambridge, MA: The MIT Press, 2000).

46
Henri Lefebvre, EVERYDAY LIFE IN THE MODERN WORLD, trans. Sacha Rabinovitch (London: Penguin, 1971), pp. 158-160.

INTERVIEW BY DONALD WALL

GORDON MATTA-CLARK:
BUILDING
DISSECTIONS

Originally published in ARTS MAGAZINE, *May 1976. Re-published with permission of the Matta-Clark Estate.*

A wry paradox surrounds Gordon Matta-Clark's art: On the one hand, his building removals and dissections represent the furthest advance yet made in American behavioral architecture. On the other hand, most people, including many art/architecture critics, are not even aware that a new architecture has been among us for the last decade—an architecture which has just rendered culturally obsolete European modernist architecture as effectively as did that architecture once render obsolete the older Beaux-Arts tradition. It's time to catch up; time to begin placing the new architecture into its own genealogical framework, much like

Corbusier once did with Purism. A good place to start might be with certain comments made by Clement Greenberg in 1948. The mid-century does, undeniably, constitute a crucial germination period in American artistic thinking.

Greenberg, writing on David Smith, made the following observation: "Painting continues as the most leading and the most adventuresome as well as the most expressive of the visual arts. In point of recent achievement architecture alone seems comparable with it." The comments were well taken. American architecture, under direct insemination by the presence of such imports as Mies van der Rohe, Gropius, Moholy-Nagy, Breuer, Neutra, Chermiayeff, and others, did exhibit much the same progressive excellence characteristic of its overseas origins as had painting. But American painting under the hands of Motherwell, Still, Pollock, Newman, and De Kooning, soon broke out of the European mold. Architecture never did, then. Increasingly, architecture all but disappeared from the pages of art magazines. Its absence was easily overlooked in a decade where, as Peter Schjeldahl so aptly observed, "extreme avant-garde ideas proliferated like flies." Schjeldahl's words prompt no architecture imagery comparable to the heady list that even the most casually informed reader could compile for painting, sculpture, conceptual, linguistic, or other art forms. At no time did architecture stir intense critical debate. Nor can such a lacuna be attributed to a lack of vocabulary on the part of the art critics: given Weiner, Kosuth, Acconci, individuals like Lippard, Perreault, Burnham soon manufactured a properly responsive lexicon. Architecture was not integral to that lexicon. In contrast with their 1910-1920 prototypes, the 1960s architect did not personally participate in the various burgeoning controversies and ideological disputes. Whatever controversy there was in architecture—I am thinking particularly of the Supergraphic and Pop episodes—it looked like pale versions of harder core attitudes already firmly established by far tougher intellects. What little that did emerge remained virtually unexplored from exponent to exponent. One exception might be Louis Kahn's innovative use of structural/constructional emblematics (a type of heraldic art with strong affinities with the work of Stella and Held). But not even Kahn could legitimize the stasis of an entire discipline. Indeed, architecture so rarely qualified as serious art, it did not and could not participate in

that process of intradisciplinary auto-criticism which Greenberg and others deemed mandatory for regenerative growth. For all intents and purposes, traditional architecture became irrelevant to well over a generation of creative thinkers. Amusing, in a way, while the art and language boys were running around trying to talk painting and sculpture to death, functionalist architecture assumed the culturally mortuistic without sponsorship, and without fanfare.

But not architecture itself. By the mid-1960s, radically new precepts of architecture were in the process of formation in America, almost all of it of non-European derivation. Most of the activity took place among artists, not the professional, practicing architect. And for good reason: ambitious art exists only by breaking with fixed notions concerning what is possible and what is not. So when the artists did focus attention on the built environment, two mainstays of conventional architectural thinking (functionalism and patronage) were quickly rejected. Rather than depending on use specified by others, the artist substituted himself as locus of development—and all that this implies in terms of years of enriched autocriticism.

The following interview with Gordon Matta-Clark illustrates the new origins. Matta-Clark traces his genealogy not to the Bauhaus, nor to Corbusier, but to the Greene Street establishment. Predominate are influences from his childhood, especially that of voyeurism, dollhouses, and silent comedy. An irreverence for today's architecture is notably apparent. And always there exists concern over what constitutes allowable limits.

Matta-Clark's work should not however, be understood as that of an outsider. Similar to others who have begun to redefine our posture toward architecture (Insley and Saret), Matta-Clark received a formal architectural education. Typically, he also abandoned customary architectural notions in favor of the strictly ideational. Therefore, whether referring to his early diggings under 112 Greene Street, or to the compost heaps under stairways, or in his use of dumpster containers as "found" architecture, Matta-Clark's work accepts architecture first as information before all else: to be specific, information that is itself undergoing a feedback process (metamorphic),

from other sources, whether ecological (his garbage works), or man made (the removals and dissections). Due to this decidedly process and performance base, Matta-Clark's architecture is absolutely antithetical to the "object"-oriented architecture characteristic of European sources. If one has to classify Matta-Clark's work, it obviously does not belong to the conventionalists like Moore, Venturi, Roche, Meier. Rather, his art belongs to that ever-growing body of work stemming from people like Acconci, Morris, Nauman, Smithson, Levine, Asher, Bochner, and others who have explored the behavioral and definitional aspects of place. These individuals originate from a potpourri of influences—art-as-idea-as idea, developmental psychology, happenings—or whichever factors one wishes to cite for the emergence of "performance constancy" as a concept distinct from "object constancy."

The impact of all this was the pulverization of architecture into discrete pieces of subject matter, with each artist usually addressing a specific circumstance. For Vito Acconci, this meant behavioral-spatial topology derived, perhaps, from Lewis' psychology. For Matta-Clark, this meant a metamorphic cutting into a building's specific semiology.

Such a pulverization was guaranteed, for within the auto-critical attitude (which most artists, even now, subconsciously carry around) lay the reductivist mentality. "The growing specialization in the arts is due," augeristically wrote Greenberg again in 1948, "to our increasing faith in and taste for the immediate, the concrete, the irreducible and in principle, to avoid dependence upon any order of experience not given in the most essentially construed nature of the medium." The impact of reductivism cannot be sufficiently underscored where hybrid art is concerned. All hybrid art, to which architecture certainly belongs, faces instant disintegration as soon as the components are differentiated into the autonomous. In its geometric abstractness, for instance, decorative Greek pottery was replaced by architecture; in its depicted imagery, the pot succumbed to the invention of the easel painting. A similar case can be seen in architecture. Prior to 1900, architecture held virtual sway over geometric abstraction in the fine arts. If geometry existed in painting, it existed either covertly as underlying compositional structure, or overtly in the renderings of interiors or exteriors of buildings, in fabric patterns, on the sleeves of garments, etc. where it predominately served as a foil for biomorphic human form. With the rise of non-objective painting and sculpture, architecture slowly lost dominion over the geometrically abstract, not only in terms of flexibility of enterprise, but also in purity of results. No longer

need a spectator depend on the gothic cathedral in order to experience horizontal/vertical equilibration: there were now the Mondrians. (Granted, the comparison is overly simplistic.)

Similar comments could be made about other so-called "prerogatives" of architecture. Scale, geophysicality, projective viewpoint, location, etc., eventually became subject matter in themselves. This seems to suggest that the irrelevance of modernist architecture cannot be attributed to architecture as architecture, but to the means traditionally employed to sustain architectural thought. It is too early, however, for an accounting of what precisely are these newer means. Today's behavioral architecture is still at a yeasty stage of development, and should be left that way.

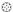

GORDON MATTA-CLARK: By undoing a building there are many aspects of the social conditions against which I am gesturing: first, to open a state of enclosure which had been preconditioned, not only by physical necessity, but by the industry that profligates suburban and urban boxes as a context for insuring a passive, isolated consumer—a virtually captive audience. The fact that some of the buildings I have dealt with are in black ghettos reinforces some of this thinking, although I would not make a total distinction between the imprisonment of the poor and the remarkably subtle self-containerization of higher socio-economic neighborhoods. The question is a reaction to an ever less viable state of privacy, private property, and isolation.

I see in the formal aspect of past building works a constant concern with the center of each structure. Even before the SPLITTING, BIN.GO.NE, and PIER 52 projects, which were direct exercises in centering and recentering, I would usually go to what I saw as the heart of the spatial-structural constant that could be called the hermetic aspect of my work, because it relates to an inner-personal gesture, by which the microcosmic self is related to the whole. In fact, one of my earlier works dramatized this when I hung myself upside down at the center of one of my openings. More recently I have enjoyed a term in reference to Walter Benjamin, "Marxist hermeneutics." This phrase helps me think about my activities which combine the inwardly removed sphere of hermetics and interpretation with the material dialectics of a real environment. The activity takes the form of a theatrical gesture that cleaves structural space.

The dialectics involve my dualistic habit of centering and removal (cutting away at the core of a structure); another socially relevant aspect of the activity then becomes clearer. Here I am directing my attention to the central void, to the

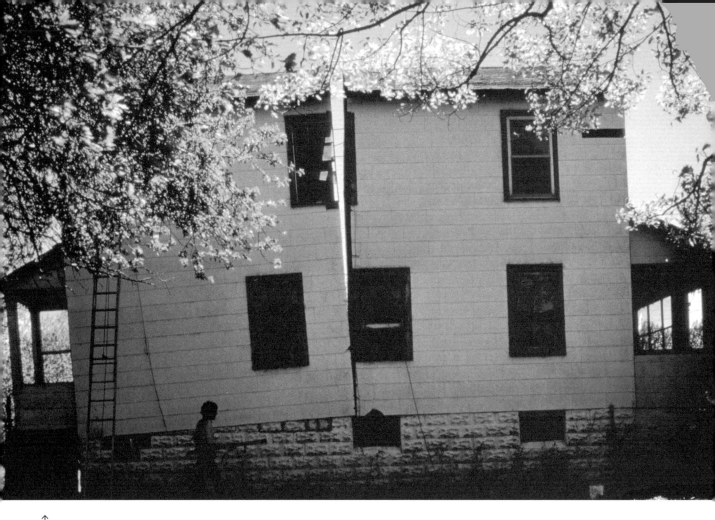

Gordon Matta-Clark, SPLITTING, 1974.

gap, which, among other things, could be between the self and the American capitalist system. What I am talking about is a very real, carefully sustained, mass schizophrenia in which our individual perceptions are constantly being subverted by industrially controlled media, markets, and corporate interests. The average individual is exposed to this barrage of half truths and monstrous untruths which all revolve around "who runs his life" and how it is accomplished. This conspiracy goes on every day, everywhere, while the citizen commutes to and from his shoebox home with its air of peace and calm, while he is being precisely maintained in a state of mass insanity.

DONALD WALL: *Would the following be a fair description of how you proceed? First, you find an abandoned building, one that has outlived its usefulness, go in with chain-saws, sheet-metal cutters, and what have you, then section, out various portions of the building; when it's all done, the building is re-abandoned. For the layman as well as for the practicing architect, wouldn't this be regarded as not only useless but almost inane behavior? And don't you find something perverse in this form of expression?*

GMC: No, that would be an oversimplification. One of my favorite definitions of the difference between architecture and sculpture is whether there is plumbing or not. So, although it is an incomplete definition, it puts the functionalist aspect of Machine Age Moralists where it belongs—down some well-executed drain. Without getting too carried away, what I mean is that the very nature of my work with buildings takes issue with a functionalist attitude to the extent that this kind of self-righteous vocational responsibility has failed to question, or reexamine, the quality of life being serviced. I know that this may sound like artistic rationalization (and to some extent it is), but it is exactly here that I defend Art against Architecture—or at least that aspect of architecture that is a janitor to civilization. I don't mean to belittle the janitor's role as people, only as policy. My best (wo)man-in-the-street reaction to the Paris work came from a 70-year-old concierge who said, "Oh, I see the purpose for that hole—it is an experiment in bringing light and air into spaces that never had enough of either." As far as being perverse, I am sure of it. Especially to the extent that anyone is, who enjoys breaking the rules while being convinced that he is right some of the time.

DW: *In view of this, how does your life as a professional artist function in the gallery system? Especially since your work deals with specific sites?*

GMC: The whole question of gallery space and the exhibition convention is a profound dilemma for me. I don't like the way most art needs to be looked at in galleries any more than the way empty halls make people look or high-rise city plazas create life-less environments. And even though my work has always stressed an involvement with spaces outside the studio/ gallery context, I have put objects and documentation on display in gallery spaces. All too often there is a price to pay due to exhibition conditions; my kind of work pays more than most just because the installation materials end up making a confusing reference to what was not there. But for me, what was outside the display became more and more the essential experience.

DW: *Yet the Humphrey House residue might end up in the Hirshhorn sculpture court.*

GMC: There is always that danger. I am more interested in making the Hirshhorn a piece. I mean, if someone in the museum was truly interested in my work they would let me cut open the building. The desire for exhibiting the leftover pieces will hopefully diminish as time goes by. This may be useful for people whose mentality is oriented toward possession. Amazing, the way people steal stone from the Acropolis. Even if they are good stones, they are not the Acropolis.

DW: *What criteria do you use in selecting a building?*
GMC: The best building I can find.

DW: *Best in what sense: Picturesque? Structural? Compositional?*
GMC: I seek typical structures which have certain kinds of historical and cultural identities. But the kind of identity for which I am looking has to have a recognizable social form. One of my concerns here is with the Non.u.mental, that is, an expression of the commonplace that might counter the grandeur and pomp of architectural structures and their self-glorifying clients. In Paris, I was incredibly lucky in finding just such a situation. The work [CONICAL INTERSECT] was done on two seventeenth century town houses. Typical, but with remarkable identities, almost to the point of having anthropomorphic qualities. This old couple, as I called them, were literally the last of a vast neighborhood of buildings destroyed to "improve" the Les Halles-Plateaux-Beauborg areas. And they were surviving in the web of an immense modern structure which—in the traditionally monumental French approach—is to house all the Fine Art Agencies of Parisian Culture. *[The buildings Matta-Clark worked with were being demolished to make way for the new Georges Pompidou Centre.]*

The determining factor is the degree to which my

intervention can transform the structure into an act of communication. It is undesirable to have a situation where the fabric of the space is too run down for it to be identified as ever having been changed, or a situation where I would be competing with factual disintegration.

DW: *This brings up the placement of your work historically. Does it lie more within Dadaist or Land Art concerns?*

GMC: I'll answer the last part first because Land Art is more recent and my break with it is clearer. First, the choice of dealing with either the urban environment in general, and building structures specifically, alters my whole realm of reference and shifts it away from the grand theme of vast natural emptiness which, for the earth artists, was literally like drawing on a blank canvas. But more important, I have chosen not isolation from the social conditions, but to deal directly with social conditions whether by physical implication, as in most of my building works, or through more direct community involvement, which is how I want to see the work develop in the future. I think that differences in context is my primary concern—and a major separation from Earth Art. In fact, it is the attention paid to specific occupied areas of the community.

At this point I should mention my feelings about Dada since its influence has been a great source of energy. Its challenge to the rigidity of language both formal and popular, as well as our perception of things, is now a basic part of art. Dada's devotion to the imaginative disruption of convention is an essential liberating force. I can't imagine how Dada relates stylistically to my work, but in spirit it is fundamental.

DW: *Are you solely interested in the social implications of the "cuttings?"*

GMC: The act of cutting through from one space to another produces a certain complexity involving depth perception. Aspects of stratification probably interest me more than the unexpected views which are generated by the removals—not the surface, but the thin edge, the severed surface that reveals the autobiographical process of its making. There is a kind of complexity which comes from taking an otherwise completely normal, conventional, albeit anonymous situation and redefining it, retranslating it into overlapping and multiple readings of conditions past and present. Each building generates its own unique situation.

The DATUM CUTS, for example, took place in an engineers' drafting rooms and offices. I couldn't deal with the outside because there wasn't enough exterior enclosure to really penetrate anything. What fascinated me was the interior central plan. The engineers took a small, square, primitive hut shape and divided it in half to make one big drafting room. They divided the other half into a quarter which became the

→
Gordon Matta-Clark, CONICAL
INTERSECT, 1975.

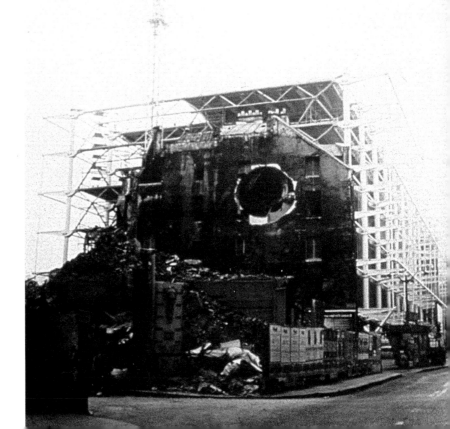

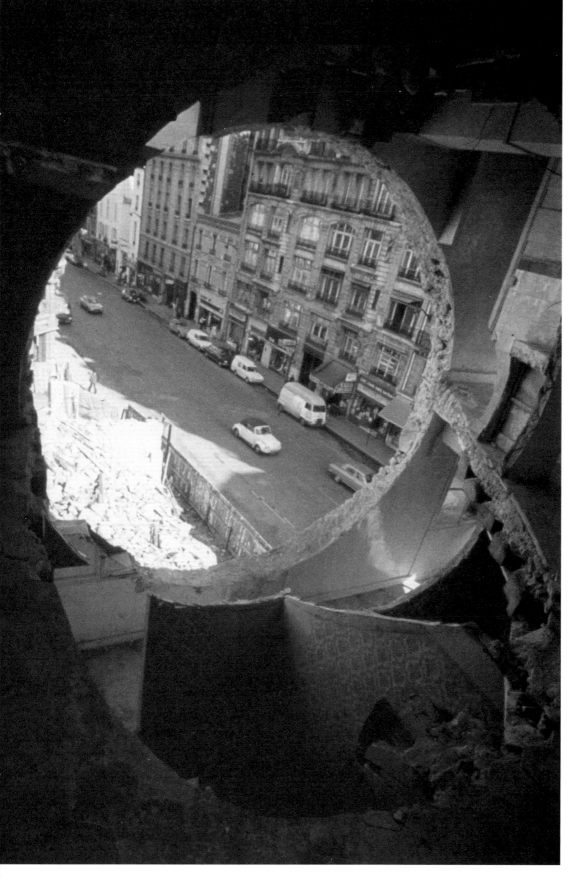

←
Gordon Matta-Clark,
CONICAL INTERSECT,
1975.

office, and divided the remaining quarter in half again for the coatroom and bathroom. And then divided that again to make a shower or something. Everything was so progressively divided so that the remaining piece was 1/32 of the whole. I used the idea of division around the center. Therefore, I removed a square section out of the roof apex, then projected that cut from the roof down into the building and spread it out laterally through the walls and doors. The walls in Italy are fascinating because they hold a good fine chisel line without falling apart.

The NIAGARA FALLS was quite different. It involved a subtraction game. Each of the removed pieces is 1/9 of the total façade, randomly taken out. I would have preferred a sequential removal. As it turns out, the problem of just getting it done physically was so great that it couldn't be ideally choreographed. I crated all the removed pieces and debated for a while to reconstruct the crated façade in immediate proximity to the house. In the crates the removed sections had this incredible anonymity which was also an identity—a masked identity. If you looked really hard you could detect differences. For a while I thought of showing them in their crates in New York, at John Gibson's. Instead, I left 6/9 extractions, still in their crates, out in the countryside. They were dumped—thrown off the back of my truck and left pretty much as they fell.

DW: *Are they still there?*
GMC: I have no idea.

DW: *Do you feel any apprehension in occupying an ideological position diametrically opposed to the practicing architect, and to all that the profession implicates regarding solving humanity's problems?*
GMC: I don't think most practitioners are solving anything except how to make a living. Architecture is big business. It's an enormously costly undertaking and, therefore, like government, comes equipped with its entire panoply of propaganda.

I must clarify several issues. First, I think it is a mistake to place what I have done, which its very specific and, especially, local emphasis into so grand a historical context, as the whole issue of modernity, proliferated by the International Style, must be seen in the development of postwar American imperialism. The state of that architecture reflects the iconography of the western corporate axis. It is first the abuse of Bauhaus and early Purist ideals that I take issue with. Then I must clarify how monolithic idealist problem-solving has not only failed to solve the problems but created a dehumanized condition at both a domestic and institutional level. So what I am reacting to is the deformation of values (ethics) in the disguise of modernity, renewal, urban planning, call it what you will.

DW: *Are there other artists or architects who interest you?*
GMC: Yes, anyone who challenges the preconceptions of limits.

DW: *The limits of what? Perception? Or just limits?*
GMC: Artistic, ethical, and moral limits. I don't know too many artists who are concerned solely with perception. It's more a mixture. There's Sonnier's transmission piece which pushes our conceptions about local space to an extreme: it's very hard to grasp locality at the speed of light, in motion, from the one side of the continent to the other. Then there is Vito Acconci; he deals in an entirely different spatial context, which is a type of space we all, all of us, have stored in memory: spaces that are detailed and precise, fragments generally, at all levels of reminiscence. And of course, once you get into reminiscence, an infinite number of associations emerge. Memory seems to create a unique kind of space setting up an about-to-be-disintegrated level.

DW: *How sympathetic are you to performance art?*
GMC: I feel my work intimately linked with the process as a form of theater in which both the working activity and the structural changes to and within the building are the performance. I also include a free interpretation of movement as gesture, both metaphoric, sculptural, and social into my sense of theater, with only the most incidental audience—an on-going act for the passer-by just as the construction site provides a stage for busy pedestrians in transit. So my working has a similar effect. People are fascinated by space-giving activity. I am sure that it is a fascination with the underground that captures the imagination of the random audience; people can't resist contemplating the foundations of a new construction site. So in a reverse manner, the openings I have made stop the viewer with their careful revealings.

Moreover, I see the work as a special stage in perpetual metamorphosis, a model for peoples' constant action on space as much as in the space that surrounds them. Buildings are fixed entities in the minds of most—the notion of mutable space is virtually taboo—even in one's own house. People live in their space with a temerity that is frightening. Homeowners generally do little more than maintain their property. It's baffling how rarely the people get involved in fundamentally changing their place by simply undoing it.

DW: *To interject for a moment. Duchamp once said that a major artist makes maybe one or two major statements in his lifetime, and the rest is infill, something to be done merely to occupy time; in effect, garbage. How close are you to those statements?*

GMC: Duchamp was a master strategist. Being a perfectly tutored rational being, he could define his problem in terms of a few discrete, well-maneuvered gestures. I see the process of my own work as being much more diffuse. Generally, I don't know what the next piece will be. I work similarly to the way gourmets hunt for truffles. I mean, a truffle is a fantastic thing buried somewhere in the ground. Very fleshy, esteemed as a prized food. So what I try to find is the subterranean kernel. Sometimes I find it. Sometimes I don't.

In fact, the next area that interests me is an expedition underground: a search for the forgotten spaces left buried under the city either as historical reserve or as surviving reminders of lost projects and fantasies, such as the famed Phantom Railroad. This activity would include mapping and breaking or digging into these lost foundations; working back into society from beneath. Although the original idea involved possible subversive acts, I am now more interested in the act of search and discovery. This activity should bring art out of the gallery and into the sewers.

DW: *What were your first works like?*

GMC: I believe that was the pipe piece at the Boston Museum of Art in 1971. I extended one of the gas lines from behind a wall out into the exhibition space and then returned it back into the wall, accompanied by a photographic documentation of the pipe's journey from the street into and through the building. The pipe led two lives: it had both physical as well as photographic extension, and dealt with the building as a mechanical system rather than as a series of discrete spaces. Well, no, I guess that wasn't the first. A year previously I dug a deep hole in the basement of 112 Greene Street. What I wanted to do I didn't accomplish at all, which was digging deep enough so that a person could see the actual foundations, the "removed" space under the foundation, and liberate the building's enormous compressive, confining forces simply by making a hole. To be able to pass freely under an area once so dominated by gravitational constraint—that would have been something!

Another installation I had for Greene Street, which I was a bit reluctant about since it might have jeopardized the people in the building, was to have cut each column at midpoint and insert a small steel cube. Where digging a hole liberated compression, this one would have done the opposite:

concentrated the entire building's forces onto those little cubes. The cubes then would have balanced the building: an identity transference. The sheer compressive energy being involved would have made, I think, the physical reality of confronting those cubes a fairly threatening experience.

DW: *Hadn't other artists become deeply involved with the environment by 1970, either using the environment as explicit subject matter of using the environment tangentially on their way to other concerns? Where do you fit into all this? Obviously a proving into place, whether through information interdiction or perceptual modifications, had been firmly established by the end of the 60s. Yet your reliance on the existing architecture's infra-system points to unique, somewhat divergent sources.*

GMC: One of the prevailing tendencies was—and I think Greene Street was typical of widespread sensibilities—the idea of working with a very specific, particular space. The generalized was downplayed. So most everyone's work at that time involved doing art in a space as well as for a space. I wanted to alter the whole space to its very roots, which meant a recognition of the building's total (semiotic) system, not in any idealized form, but using the actual ingredients of a place. So physically penetrating the surface seemed the logical next step.

Let me qualify this. While my preoccupations involve creating deep metaphoric incisions into space/place, I do not want to create a totally new supportive field of vision, of cognition. I want to reuse the old one, the existing framework of thought and sight. So, on the one hand, I am altering the existing units of perception normally employed to discern the wholeness of a thing. On the other hand, much of my life's energies are simply about being denied. There's so much in our society that purposely intends denial: deny entry, deny passage, deny participation, etc. We could all still be living in towers and castles, if we hadn't broken down some of the economic barriers, inhibitions, and restraints. My work directly reflects this.

I would like to end with an idea of the direction in which I can see my work evolving. One of the greatest influences on me in terms of new attitudes was a recent experience in Milan. When searching for a factory to "cut-up," I found an expansive long-abandoned factory complex that was being exuberantly occupied by a large group of radical Communist youths. They had been taking turns holding down a section of the plant for over a month. Their program was to resist the intervention of "laissez-faire" real estate developers from exploiting the property. Their proposal was that the area be used for a

much needed community services center. My exposure to this confrontation was my first awakening to doing my work, not in artistic isolation, but through an active exchange with peoples' concern for their own neighborhood. My goal is to extend the Milan experience to the U.S., especially to neglected areas of New York such as the South Bronx where the city is just waiting for the social and physical condition to deteriorate to such a point that the borough can redevelop the whole area into the industrial park they really want. A specific project might be to work with an existing neighborhood youth group and to involve them in converting the all-too-plentiful abandoned buildings into a social space. In this way, the young could get both practical information about how buildings are made and, more essentially, some first-hand experience with one aspect of the very real possibility of transforming their space. In this way, I could adapt my work to still another level of the given situation. It would no longer be concerned with just personal or metaphoric treatment of the site, but finally responsive to the express will of its occupants.

Certain ideas put forth in this interview evolved out of discussions with such friends as Joseph Kosuth, Marlis Grueterich, and Betty Sussler.

WORKS

PARASITE (1999) CAMBRIDGE, MA

*P*arasitism is described as a relationship in which a parasite temporarily or permanently exploits the energy of a host.[1] ❇ PARASITE proposes the appropriation of the exterior ventilation systems on existing architecture as a means for providing temporary shelter for homeless people. ❇ *Parasites live on the outer surface of a host or inside its body in respiratory organs, digestive organs, venous systems, as well as other organs and tissues.*[2] ❇ The PARASITE units in their idle state exist as small, collapsible packages with handles for transport by hand or on one's back. In employing this device, the user must locate the outtake ducts of a building's HVAC (Heating, Ventila-

tion, Air Conditioning) system. ✵ *Frequently a host provides a parasite not only with food, but also with enzymes and oxygen, and offers favourable temperature conditions.*[3] ✵ The intake tube of the collapsed structure is then attached to the vent. The warm air leaving the building simultaneously inflates and heats the double membrane structure. ✵ *But a host is certainly not inactive against a parasite, and it hinders the development and population growth of parasites with different defense mechanisms, such as the cleaning of skin, peristaltic contraction of the digestive apparatus, and the development of antibodies.*[4]

In April of 1997, I proposed my concept and first prototype to a homeless man named Bill Stone, who regarded the project as a tactical response. At the time, the city of Cambridge had made a series of vents in Harvard Square "homeless-proof" by tilting the metal grates, making them virtually impossible to sleep on.

In his book, CITY OF QUARTZ, Mike Davis describes a similar war on homelessness in Los Angeles. He lists a series of these hindrances throughout the city:

> *One of the most common, but mind-numbing, of these deterrents is the Rapid Transit District's new barrel-shaped bus bench that offers a minimal surface for uncomfortable sitting, while making sleeping utterly impossible. Such bum-proof benches are being widely introduced on the periphery of Skid Row. Another invention, worthy of the Grand Guignol, is the aggressive deployment of outdoor sprinklers. Several years ago the city opened a "Skid Row Park" along lower Fifth Street, on a corner of Hell. To ensure that the park was not used for sleeping—that is to say, to guarantee that it was mainly utilized for drug dealing and prostitution—the city installed an elaborate overhead sprinkler system programmed to drench unsuspecting sleepers at random during the night. The system was immediately copied by some local businessmen in order to drive the homeless away from adjacent public sidewalks. Meanwhile restaurants and markets have responded to the homeless by building ornate enclosures to protect their refuse. Although no one in Los Angeles has yet proposed adding cyanide to the garbage, as happened in Phoenix a few years back, one popular seafood restaurant has spent $12,000 to build the ultimate bag-lady-proof trash cage: made of three-quarter inch steel rod with alloy locks and vicious outturned spikes to safeguard priceless moldering fish heads and stale french fries."*[5]

> *Parasites respond to this defense by anchoring themselves with hooks and suckers onto skin, or digestive mucous membrane, and by developing protective devices and substances which lessen defensive capabilities of their host.*[6]

The system by which the device attaches or is anchored to the building is designed to allow the structure to be adaptable. The intake tube can be expanded or tightened to fit the aperture of the vent through an adjustable lip made possible by elastic

1
Dr. Kazimir Tarmon, OSMOVE EKOLOGIJE, Text distributed by P.A.R.A.S.I.T.E Museum of Contemporary Art, Ljublana, 1990.

2
Ibid.

3
Ibid.

4
Ibid.

5
Mike Davis, CITY OF QUARTZ (New York: Vintage Press, 1992), p. 233.

MICHAEL RAKOWITZ

drawstrings. Hooks are attached to the metal louvers for reinforcement.

There is "tension" between a host and its parasite, since the host endeavours to get rid of the foreign body, while the parasite employs new ways to maintain the connection with the host.[7]

The connection of the inflatable structure to the building becomes the critical moment of this project.

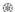

From February 1998 until April 1998, I built seven prototypes of the PARASITE shelter and distributed them to several homeless people in Cambridge, among them Bill Stone, George Livingston, and Freddie Flynn, who worked closely with me on the design and production of these units. Most were built using temporary materials that were readily available on the streets (plastic bags, tape).

While these shelters were being used, they functioned not only as a temporary place of retreat, but also as a station of dissent and empowerment; many of the homeless users regarded their shelters as a protest device, and would even shout slogans like "We beat you Uncle Sam!" The shelters communicated a refusal to surrender, and made more visible the unacceptable circumstances of homeless life within the city.

For the pedestrian, PARASITE functioned as an agitational device. The visibly parasitic relationship of these devices to the buildings, appropriating a readily available situation with readily available materials elicited immediate speculation as to the future of the city: would these things completely take over, given the enormous number of homeless in our society? Could we wake up one morning to find these encampments engulfing buildings like ivy?

This project does not present itself as a solution. It is not a proposal for affordable housing. Its point of departure is to present a symbolic strategy of survival for homeless existence within the city, amplifying the problematic relationship between those who have homes and those who do not have homes.

The issue of homelessness is of global proportions and it is foolish to think that any one proposition will address all the issues associated with this problem. There are many different types of homeless people. The mentally ill, the chemically dependent, those who are unable to afford housing, men, women, families, even those who prefer this way of life are included among the vast cross-section of homeless people in every urban instance. Each group of homeless has subjective needs based on circumstance and location. My project does not make reference to handbooks of statistics. Nor should this intervention be associated with the various municipal attempts at solving the homeless issue. This is a project that was shaped by my interaction as a citizen and artist with those who live on the streets.

6
Dr. Kazimir Tarmon, OSMOVE EKOLOGIJE.

7
Ibid.

CLIMATE CONTROL (2000)
P.S.1 CONTEMPORARY ART CENTER, LONG ISLAND CITY, NY

P.S.1 Contemporary Art Center is housed inside a former primary school building. Most museums and exhibition institutions are required to have a central climate control system maintaining and regulating ideal temperature and relative humidity readings to preserve artworks on exhibit. P.S.1 lacks such a mechanism and during the winter months turns the radiators up to 90°F, clearly ignoring these institutional standards.

CLIMATE CONTROL is an apparatus of ductwork and fans that engulfs the existing radiator in the Special Project room to which the project is confined.

Standard temperatures for institutions exhibiting works of art exist within a range of 68°-72°F. In order to lower the temperature of the exhibition space, the mechanism incorporates the existing radiator system on the interior of the building with the cold winter temperature.

The maze of ductwork, normally integrated into a central HVAC system in buildings and hidden underneath floors and drop ceilings, is exposed in this piece due to building code regulations, and completely engulfs the room.

The system starts in the center of the room, where three intake fans introduce the museum air into the network. Air travels towards the windows, passing through a tower of three dampers, adjusting airflow based on variables (outdoor temperature, shifting radiator temperatures). The air then travels to the cubic duct enclosing the radiator, operating above 90°F. An inline duct fan then moves the air up into an extension of ductwork that pierces the North window of the gallery. It rests here for approximately five seconds. In this time, the air is cooled to the ideal standard reading of 68°-72°F through conduction between the galvanized steel duct and the exterior cold temperature, thus never leaving this hermetic system. The climatized air then reenters the room through the South window.

The central absurd element of this piece was visible from the street, where pedestrians and local contractors would sometimes ask the museum to explain the reasoning for a continuous piece of ductwork to exit and enter the same space with no exhaust or intake purposes.

Upon reentering the space, the air travels to three different points of discharge around the room. At one point the viewer can stand just beneath the register, coming into direct contact with the altered air, while at another point, the ductwork is forced to jog around a fixed bench used in the museum for film screenings, discharging the air near one's feet.

An internal humidifier emits small clouds of warm mist, regulating the relative humidity in the room to acceptable levels. Typically, because of the dry heat of the radiators, the relative humidity reading at P.S.1 is around 11%, dangerously low and potentially damaging to objects like paintings or prints, which usually require stabilized environments not less than 40% r.h. and not exceeding 50% r.h. (Each material has its own standard.) The relative humidity standard for exhibiting works of art made out of galvanized steel is 15%-20% r.h. While the system is adjustable and can maintain a stabilized environment for the exhibition of delicate works on paper, there is no room to exhibit other works of art. The relative humidity setting is thus regulated to remain at 20%, resulting in an absurd machine built to maintain itself.

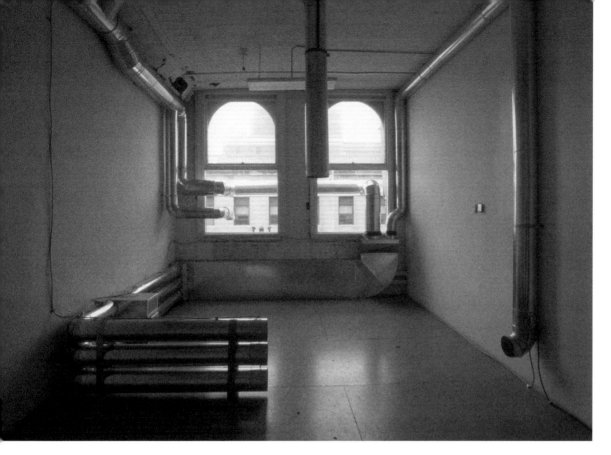

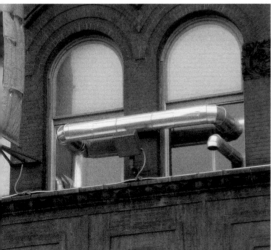

MICHAEL RAKOWITZ

←←
View of ductwork climbing
125 feet from Fei Dar Bakery
into the 9th floor window of
129 Lafayette Street.

←
View of ductwork extending out
into the main gallery space.

RISE (2001)
129 LAFAYETTE STREET, NEW YORK CITY

In August 2001, TriBeach Holdings LLC Real Estate opened floors 6 through 11 of 129 Lafayette Street in Manhattan as the site for a temporary exhibition. Curators from different galleries and institutions in New York City were each given a floor of the building with which to work. The exhibition, titled "GZ:01" was staged to raise visibility of this vacant building for real estate purposes. Formerly functioning as a large, multi-story community center and business network for the local Chinese community, 129 Lafayette Street was regarded as a prime location to extend SoHo's gallery scene into a new area.

I was invited by Erin Donelly and Susanna Cole of the Whitney Museum of American Art's Curatorial Studies Program to produce a site-specific artwork for the 9th floor of the building. Researching the space, I walked around the four city blocks the building occupies. I wanted to bridge the gallery space with the local community, as most residents I encountered had not heard of the planned exhibition and questioned why newer community or business centers were not being introduced to this site.

Fei Dar Bakery is located on the ground floor of an adjacent building at 191 Centre Street. The bakery is one of the most popular Chinese pastry shops and also functions as a meeting place for many young Chinese residents in the neighborhood.

In RISE, the central oven duct of Fei Dar Bakery is extended up 125 feet into the 9th floor gallery space at 129 Lafayette Street, filling the gallery with the aroma of Chinese pastries as they are baked. The duct is attached to the main oven's hood, then enters the back room of the 9th floor gallery space, and extends into the main gallery space.

For the opening reception of the exhibition, Fei Dar Bakery provided pastries so that gallery goers could taste what they were smelling. Throughout the duration of the show, Fei Dar received a steady flow of customers from those who had visited the gallery.

LUCY LIPPARD

LAND ART IN THE
IN
THE
REARVIEW
MIRROR

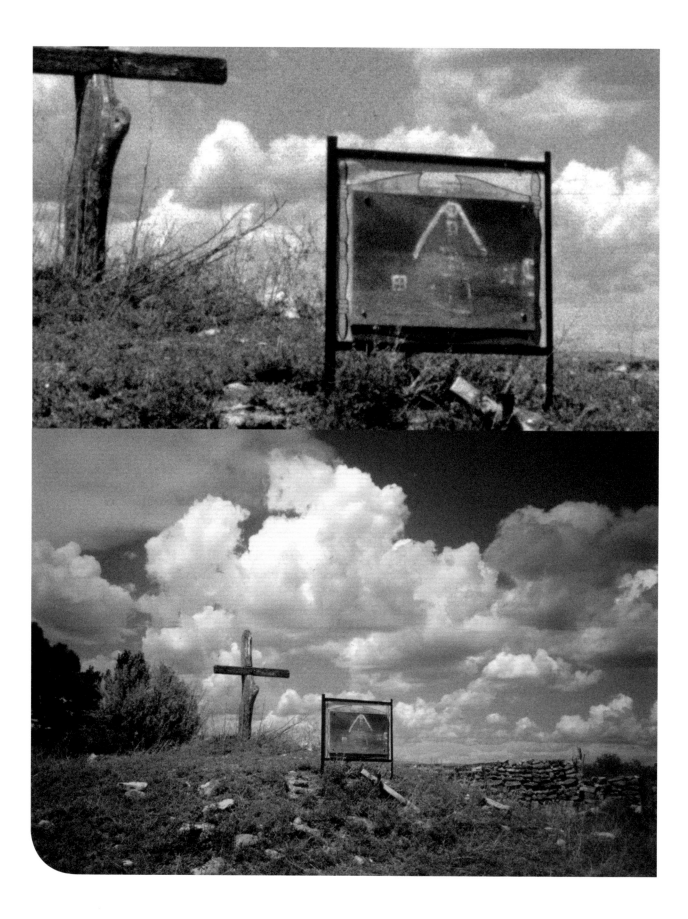

I've titled this essay "Land Art in the Rearview Mirror" for two reasons. First, because as you'll see my own interests have gone on down the road since I was first entranced by Earth Art in the 1960s and since I published a book called OVERLAY: CONTEMPORARY ART AND THE ART OF PREHISTORY in 1983. Second, because the monumental Land Art that epitomizes the term takes much of its power from distance—distance from people, from places, and from issues—while my own interests over the last few years focus almost entirely on the nearby, and on the content of specific places as they reflect the interactions between people and what we call "nature," which includes people.

I'm arguing for a micro-view of land and art, grassroots connections, rather than macro-pronouncements about paradigms; though these have their place, too. I want to bring together some ideas about site-specific art and place-specific art and focus on a framework for a Land Art that's not distant, that's not necessarily an object, and that constitutes an empathetic exchange between the artist and the land, with its inhabitants as a medium. (In the 1970s, I proposed a show that nobody wanted called The Grass on the Other Side of the Fence about useful art outdoors, urban and rural, because use is an important component here— understanding the use of the land and the possibilities of utilitarian goals for art.)

To begin with, I want to distinguish between land, *landscape*, and place, because I know I've often confused them, and because I think the land in so-called Land Art is usually landscape. Land, on the other hand, is neither place, property, nor landscape. Living in the West for the last decade, I've become increasingly conscious of "land" as a distinct spatial and spiritual element, as well as the raw material for habitation and use. For non-land-based people, land is an idea, an abstraction. We talk about physical land, a neutral term measurable in acres; or metaphorical land, often abused in imitation Indian practices but too strong a notion to be weakened by its burdens; or ideological land, a loaded term, as in Motherland or Fatherland. Often in the context of Land Art, land is a raw material for art, or it's the space around the art, a kind of mat within the frame around the photograph. In conventional Land Art, the landforms are secondary to the art and are rarely allowed histories and identities of their own.

For land-based people—those fortunate enough to maintain their places over generations, or unfortunate enough not to be able to leave them—the word "land" means a great deal more. It's an amalgam of history, culture, agriculture, community, and religion, incorporating macro- and micro-cosm – the surroundings further than the eye can see and the living force of each rock, blade of grass, small animal, or weather change. In many indigenous belief systems, all of these parts are linked. Land is the epitome of experienced reality and an idea worth dying for: *Tierra o Muerte.*

In the case of a restless, multicentered, and multitraditional people (us, that is), even as power of place is diminished and often lost in modern life, it continues as an absence to define culture and identity. Raymond Williams wrote in 1980 that "We have mixed our labor with the earth, our forces with its forces too deeply to be able to draw back and separate either out. Except that if we mentally draw back, if we go on with the singular abstractions, *we are spared the effort of looking*, in any active way, at the whole complex of social and natural relationships which is at once our product and our activity."

If place is land that is known, inhabited, worked, and layered with memories, landscape is place at a distance, or everything you see when you go outdoors, if you're looking. It's a set of surfaces as far as the eye can see without the aid of microscope or telescope. Unlike place, landscape can only be seen from the outside, as a backdrop for the experience of viewing.

←
Antonio Anaya, a painting of an early nineteenth-century church (on an old real estate sign), mounted on a mound of rubble where the church once stood, in Galisteo, New Mexico, date unknown.

↑
Rebecca Beemore
(Ojibway), AYUM-EE-AAWACH
OOMAMAMOWAN, 1991, a
gathering with 13 Native
speakers addressing the land
through a huge megaphone at
the Banff Center for the Arts.

The word "landscape" is used interchangeably for a scene framed *through* viewing (a narrative) and a scene framed for viewing (a picture). Landscape and the concept of "the view" are such Western concepts, and we're so used to receiving the world ideologically framed, either in art or in language or by the media, that we have a lot of trouble understanding how land-based cultures approach place, even when we envy them their legendary connection to nature.

Another word that has to be considered is "space"—a neutralized art word that also implies an artist's manipulation of material and frame. It's more widely used as a sociological, psychological, and economic term, as in public and private space. Sometimes space even implies "devoid of nature" to the point where geographer Margaret Fitzsimmons pleads for a "new integrated geography of Nature and Space" in both city and countryside. It's been said that space is male, while place is female. I use the word "space" as a physical, sometimes experiential component. Space is where culture takes place, is lived. Place is the result of their union.

In the last twenty years or so, the word "environment" has replaced and demythologized a large part of what was once considered "nature"—a word that we can, alas, only use now in the preferred post-modern mode of distancing, in quotation marks. "The concept of country, homeland, dwelling place becomes simplified as 'the environment'—that is, what surrounds us," writes Wendell Berry. "Once we see our place, our part of the world, as surrounding us, we have already made a profound division between it and ourselves." Art in the modern world has always cultivated this division, because art is supposed to be set apart from life—above it all or below it all—something different and by implication better than the products of ordinary mortals. Art is always understood from the outside, as a view, a picture, a spectacle. Art on the land has not escaped this definition. Most of us envision rather than see the classic Land Art works. If we do manage to get to the site, we already have in mind the glamorous aerial views we've seen in magazines. The real thing can be a letdown, like what we used to call the "Skira Book Syndrome," those juicy color illustrations that made subtler reality disappointing.

Ecology—shallow ecology, deep ecology, and social ecology—is another kind of overview. Its importance as a science is its emphasis on the interconnections, the ecosystems, the whole as well as the parts. Obviously, any self-defined environmental artist worth her salt looks at the ecology of her site before she digs in, so to speak. But too often the ecological becomes a cover-up for disregard or displacement of the social. The environmental justice movement is a compelling synthesis of the green and the red.

The issues of land and water rights in this country are mired in contradictions artists can't ignore. The site of one person's deep pride in labor may be the site of another's miserable drudgery and of another's pleasure to drive past. Beautiful sunsets may be created by hidden pollution. A loved place like the deserts of the Western Shoshone homeland, now cratered by atom bomb tests, can be described by outsiders as "a good place to throw used razor blades," as one military man put it. The good people of Maine and Vermont, who love their places, contracted to send their hazardous waste to the good people of Sierra Blanca, Texas, who are mostly Hispanic and poor and love their places too. (The deal was eventually canceled.) The Mescalero

Apache voted to welcome a national nuclear-waste dump onto their southern New Mexico reservation, disillusioning those who think that Native people are less willing than the rest of us to trade in their principles to escape poverty. (This deal too was canceled.)

Some photographers and some "environmental artists," as well as some painters and sculptors, have ventured into the landscapes of hidden, human-made catastrophe and brought us their contagious rage at the wanton, shortsighted destruction of North American places. I wish there were more models, more of these artists who are interested in the narrative landscape, whose concepts of place and history include people, and form the grassroots of an interactive and public art. Actually, I hesitate to use the word public art in this context, because the classic earthwork art is private art and proud of it. Yet if Land Art is more than artists indulging their desire for scale and monumental presence on the land and documenting their individual passages through it, that old populist question has to be asked: who is it for? When an artist says it's not for anybody or it's for himself (I use that gender advisedly), I'm not so sure it's art.

Gender has also been a matter of contention in this field. Gilles Thiberghien's book on the history of Land Art includes only one woman, Nancy Holt. She was not the only woman to be working with these ideas early on. (Pat Johanson, Harriet Feigenbaum, Alice Aycock, Agnes Denes, Mary Miss, and later Lynn Hull, among others, have made important if neglected contributions.) But Holt was perhaps the only woman able to work on the scale that had become expected of conventional "Land Art" by the late 1970s. I've written elsewhere about gender and landscape art, and I won't repeat it here except to say that I have found women's work in both public art and photography to be characterized by a preference for what I've called an "acculturated landscape," a landscape that at least evokes the close-up and the close-by, a sensuous interaction between land and landscape, people, and place.

The notion of the sacred place has come down to us from indigenous cultures, because we have usually lost sight of our own ancient belief systems. But rather than understanding that all places are sacred in one way or another, we've set the idea of a sacred place apart from life; it's usually somewhere else, distant, desired but out of reach, to be visited but not lived with, like church on Sundays. If it's art, way out there somewhere, we may even have to pay a lot to have the experience. For land-based and indigenous people, on the other hand, the sacred space—the "right place"—is home.

I always like the idea of starting at home, from the center, from lived experience, and then working outward, because if we don't understand ourselves and where and how we live, we're in no position to tell other people what they should look at. The politics of place is layered

Jerry Burchfield and Mark Chamberlain, THE TELL, 1989, (under construction) a 600-foot-long sculpted photo-mural to protest a highway through Orange County, California's last un-spoiled coastal canyon. The 80,000 photographs were donated by local families.
↙

Hachivi Edgar, HEAP OF BIRDS (Cheyenne), from NATIVE HOSTS, Vancouver, c. 1988.
↓

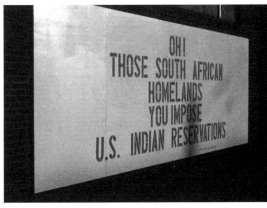

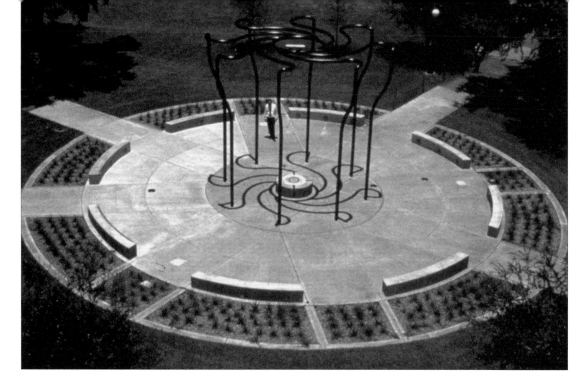

↑→

Nancy Holt, SOLAR ROTARY, 1995, University of South Florida, Tampa. Height: 20 feet. Width: 125 feet. Length: 135 feet. Aluminum, concrete, bronze, meteorite, plants. A bronze ring in the circular seat is inscribed as follows: "A circle of sunlight is cast around the circular seat at solar noon between 1:31 and 1:32 pm on the summer solstice." Circles of sunlight also surround each of five round bronze plates in the plaza pavement at certain times on certain historical dates, which are inscribed on the plaques. In the central circular seat is a meteorite. An inscribed bronze ring around it indicates that it is a "4.5 billion year old meteorite said to have fallen to Earth in Dade County, Florida." As the dedication plaque states, "Sand from the four corners of the University (NE, SW, NW, SE) was used in making the circular seat."

with emotional and aesthetic resonance that is hard to analyze. Its reciprocal nature is better expressed within a circle (Around Here) than on a line (Out There).

I'm concerned with the connection between land and people and what people do on their particular turfs, as well as what they are forced to do on and for others' domains. In a rural landscape, the best place to begin might be where gardens and plants and yards and gates and fields and corrals and outbuildings are built and why. Then, from the inside, how separate the house is, how many windows there are, what they look out on, whether the pictures on the walls reflect or counter what lies outside. What can these models teach artists, who tend to come in and impose their own ideas on the land without understanding how it's been used and abused?

Land-based people are a minority in the United States today and are often fighting no-holds-barred for their lifestyles on the land. They're not inherently concerned with ecology, and I don't want to idealize them, since they tend to be framed as a nostalgic ideal within North American mythology, which specializes in vanishing races. What interests me is that rural people rarely have a say in how they are represented or how their places are represented. Their relationships to place differ from those of people living in cities and towns who usually represent

them, or, in the case of some Land Art, work among them or walk among them. Land-based artists (in the Southwest this would be Native peoples and Hispanics), rarely paint or photograph what we call landscapes, apparently because it is irrelevant to separate land and life, place and self. And land-based people are less likely to think in terms of art other than communal events oriented to another kind of product—a firehouse, for instance, or a playground, which are the two ongoing projects in the village where I live—or an occasional mural and celebration. Little attention is paid by anyone to the vernacular artists, the so-called folk or naive and outsider artists who've burst out of the usual, and sometimes even out of acceptable, decorative conventions. What are they saying about their attitudes toward landscape? Isn't this an area acculturated land artists should be curious about?

J.B. Jackson holds up the possibility of a landscape that would "provide us with some symbols of permanent values...landmarks to reassure us that we are not rootless individuals without identity or place, but are part of a larger scheme." This seems a role made-to-order for artists. Yet the vernacular landscape and its ongoing formation, from farms to subdivisions, homes to malls, has not often been the subject of innovative on-site art forms, although human creativity is an integral part of the web formed by land, history, culture, and place.

Art on the land then has a certain responsibility to the place. Land artists aren't exempt from a place ethic, a respect for place that is rooted more deeply than an aesthetic version of "the tourist gaze." Any place is diminished when it becomes a backdrop for mainstream art. Artists working on major earthworks have more of a chance to become intimate with a place than those parachuted in from elsewhere for a commission or because they like the view.

Nature is always mediated by culture. But land artists don't seem to get involved, for instance, in the very public concept of "the view" as it's reflected in the roadside scenic overlook, which is removed from actual experience even as it may move us deeply for a moment. Scenic overlooks are places provided by the highway bureaucracy to pull over and look at a view that has been chosen for us. They are also controlled views of landscape, like art. The overlook represents our environment the way the mass media represents us and social events. Usually these views are far less interesting than those we've just driven past too fast to take in, so they are always a kind of letdown, paralleling the way history is handed down to us.

Travel and tourism are, like art, experimental approaches to change. Dean MacCannell points out that tourists or pilgrims used to come from the peripheries to the centers, whereas today we go from the centers to the margins to find what is missing, what we miss, or what we have missed, which is often the illusion or remnants of so-called primitivism. As tourists, or pilgrims, to the great Land Art sites in the United States, our expectations determine to a large extent what we see out there in the great unfamiliar and what we overlook. In the 1960s and 1970s, Land Art tended to be made and admired by city dwellers—often based in the East, though they may have been born elsewhere—people who loved the outdoors, who spent time in open spaces. Land Art is still identified with the American West, which offers vast spaces, inexpensive real estate, and the illusion of wilderness. Deserts, in particular, offer an uninterrupted space, unprecedented silence, and an apparent motionlessness that help artists simplify and abstract. Caves, mountaintops, and the ocean can have similar effects, but deserts are considered "empty." They have become the sites not only of revelation but also of desecration, of modern apocalypse, as in the Nevada test site, or White Sands, New Mexico; "national sacrifice areas," they're called, in a parody of religious language.

Historically, no area has better exemplified the history of innocence, optimism, violent imperialism, and second thoughts than the American West, as Patricia Nelson Limerick has

pointed out. Even if we live in the East or in cities (and most of the western population lives in cities, too), the West has been a formative image. A mile away from where I live is a western movie set, a perfect post-modern illustration, a vignette within the view. Right there on the cusp of the next hill, the myths that formed the landscape around me are being recreated in microcosm; this very landscape is framed, distanced, and laid over the one in which I live my everyday life. A case could be made for much Land Art replicating these conditions and these myths. Richard Long, I think, once said Land Art was a kind of megalomaniac American invention involving bulldozers and the control of nature, which was literally foreign to him. Scale and distance, which add up to monumentality, are still perceived as necessary components of Land Art, which is why the western landscape is so often written into the contract. A rural art would be very different, involving local people for whom desert or rangeland is not exotic, rather than art tourists.

Cultural reciprocity is crucial to understanding the vernacular meaning of the land in any place. For artists who respect context, it's no accident that decontextualization is often the focus. Displacement is often as significant as placement, defining a colonized or expropriated place. For instance, the writer Melvin Dixon has explored the dilemmas of African-American writers facing their sense of homelessness and an often puzzling relation between land and family: the legacy of slavery. In narratives of journeys, havens, refuges, and freedom, African-American artists have created alternative landscapes, which Dixon identifies as Wilderness, Underground, and Mountain Top—"broad geographical metaphors for the search, discovery, and achievement of self."

So far, the greatest appeal of art on the land, and its greatest success, is its limited function as a spiritual medium where the art is considered not only as part of the view but as a participant in the cosmos. The endangered unity that is land and ourselves is an emptiness that fills, under the right circumstances, the space between breaths where what we call nature comes to consciousness. The words "spirit" and "spiritual" are thrown around a lot in contemporary criticism, but contemporary visual evocations of the divine in nature are so difficult to transmit that they have rarely been successful. The contemporary inability to talk about the spiritual in unsappy, un-self-conscious images is a major obstacle in a culture whose sacred spaces tend to be battlefields. The spiritual component is situated between nature and culture and ideally merges with or transcends both. Artists have at least to acknowledge its existence since art is still considered by many a spiritual pursuit. No amount of minimalist rhetoric has managed to dampen this particular enthusiasm, though some artists won't admit to it in public in this climate of post-modern prejudice against the subjective.

Visionary artists of all kinds, from tribal Americans to Shakers to vernacular (or "outsider"), artists to the avant-garde, depend on some connection with the spiritual side of "nature," but specific places play minor roles in vision quests, transcended by the experiences produced there. For those who have "seen the light," no human-made artifact comes close to the power of the experience itself.

Land Art has an advantage here. The viewer is as affected by the space as by the object, often more so. The artwork is endowed with the emotional power of the space or place. It's often aggrandized by the scale of its surroundings, although it goes both ways; the landscape can dwarf or flatten uncongenial art. Works like Robert Smithson's SPIRAL JETTY, James Turrell's RODEN CRATER, and Charles Ross's STAR AXIS avoid this to some extent by being literally built into the land forms. Nancy Holt's SUN TUNNELS, which sits isolated on the flatland, could be said to be built into the skies, an instrument for seeing rather than an object to be seen, as are the Turrell and the Ross.

For our culture, spiritual experience is often fused or confused with sensuous experience.

That's where walking comes in. Walking cross-country is a form of meditation (especially for those of us with an excess of nervous energy). It's my favorite way to open myself to the "spirit of place" and to its buried history. When I was walking among the Stone- and Bronze-Age megaliths of Britain in 1977-78, I wrote that I was "avoiding art by seeking sensuous and aesthetic pleasure in the natural environment, only to be seduced back into art by artifacts that had almost returned to nature... I began to perceive places as spatial metaphors for temporal distance."

Motion permits a certain freedom of mind that translates a place to a person kinesthetically. "Walking is the only way to measure the rhythm of the body against the rhythm of the land," writes Rebecca Solnit. We walk in both places and landscapes, in a medium that's both visual and sensual. Richard Long's work, which I knew first of the walking artists, seemed a stroke of genius—to be able to walk and make art, even perhaps to make a living. Wow! I've always been terribly envious of the walking artists, none of whom are women (although, some women have done occasional and usually very different kinds of walking pieces). When I was a tomboy kid and wanted to "ship out on a tramp steamer" or become a cowboy—which I saw as the epitomes of glamorous adventure—I already knew that girls didn't do that kind of thing. Some girls do, of course, but I didn't have the guts or know the models, like Isabella Bird and the other extraordinary nineteenth century British women travelers. For women, walking and traveling alone is about desire, the desire for freedom rather than freedom itself, because it includes an extra dose of risk; for women, there's an additional predator out there. But walking through places where others live, as an art form, decontextualizes or aesthetically transcends, just like other forms of Land Art. Personal experience replaces any communal connections, and collective history is relegated to the background.

My problem with the macroview is that artists tend to wander in with a preconceived idea, often a pretty grandiose one, rather than giving the land itself time to speak. The story is told by traces on the land of geological, biological, and anthropological use—the vast spaces and the detail found underfoot. These should be and sometimes are of a great interest to visual artists, not merely as forms and colors constantly changing when light and shadow sweep over them, and not only as raw materials, but also because of what they have to say about who we are, what cultures and ecosystems have lived and merged and disappeared in this place. So far only a few photographers and some land artists involved in reclamation have really begun to look at land use, the history of production buried in the land. And only rarely is their goal to involve the people who are making the land look the way it looks.

As you may have noticed, I'm trying to turn the dialogue on Land Art to the land rather than the art. Because I'm convinced that when too much focus is on the art, we lose something in the way of depth, meaning, content, context, whatever, which necessarily relates out to more people rather than into the art world or the artist's private problems (and insights). Place-specific art illuminates its location rather than just occupying it. It usually takes place outside of conventional venues, which entice audiences by publicity and fashion. It is not closeted in white cubes, visible only when admission is paid or boundaries are breached. It is not accessible only to those in the know;

Nancy O'Connor, LEWIS' BEND: THIS IS WHERE I BEGAN TO THINK OF HOW MY LIFE WOULD COME TO BE, 1980, mixed media, 35 by 58 inches. From a series of photographs and handwritten interviews with elderly inhabitants of an African-American town near the artist's hometown in Texas.
↓

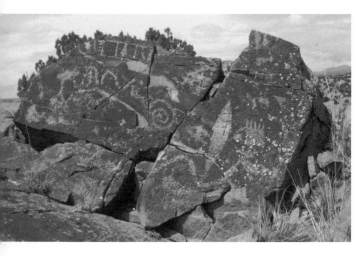

↑
Rock art on volcanic dike,
north-central New Mexico.

it becomes, at least temporarily, part of, or a criticism of, the built or daily environments. It makes places mean more to those who live there or spend time there.

I have to admit my favorite art in the land is not contemporary. It makes no attempt to dominate through scale or to impress through borrowed scale. American Indian geomorphs and rock art (petroglyphs and pictographs) are found by roadsides, on golf courses, and in the most remote deserts and canyons. Although individual images stand out, they're most compelling in relation to each other and to the place and to the clues they offer about the cultures that created them. Contemporary Land Art demands all the attention, like a spoiled child, where rock art quietly absorbs us into its place, even when we understand very little about the messages we are getting. And, of course, it's easier to identify with the long-dead people who were once stewards of that particular landscape than with today's property owner, who's likely to appear with a rifle and get you arrested for trespassing.

I keep wondering how artists might bring rural history to the surface again without attracting the wrong kind of attention—eyesores of commerce and tourism. Do we manipulate places because art is always supposedly better than no art? Can the land speak for itself? What would a rural public art consist of as opposed to imported art on the landscape? Is it necessary? Would it destroy what it sets out to reclaim? Could it help fight rural gentrification and dependence of service economies? Militarization, toxic dumps, and habitat destruction? Would such work involve new land forms in homage to the old? Photo-text? Signage? Or would it be purely conceptual, expanding the work of Hamish Fulton and Long, creating a new frame for what is there, visualizing and envisioning with village and county planners, highway commissions, local traditional landowners, community-development corporations, and grassroots groups?

There are few courses, much less full-scale programs, in this country that train artists to work in social contexts. Most tend to come to a piece of land with an idea in their head, with their approach already formed. Few artists are working in park systems or allying themselves with farmers, ranchers, cultural geographers, archaeologists, national park bureaucrats, and wilderness advocates, or even know about the new field called "environmental interpretation," which should be made-to-order for artists.

Is there grass on the other side of the fence? And is it greener? (Is it greener than it should be? Is it a golf course?) How can art help connect varied communities, make the connections visible, stimulate people's own ideas about what they would like to see in their environments, and empower them to make changes? Artists are good at slipping between the institutional stools (I use the word advisedly) to expose the layers of emotional and aesthetic resonance in our relationships to place. The reconstructive potential of an art practice that raises consciousness on the land, about land, history, culture, and place can't be underestimated.

An earlier version of this essay was given as a slide talk at "Art in the Landscape," a symposium hosted by the Chinati foundation, Marfa, Texas, Sept. 30-Oct. 1, 1995, and subsequently published in a catalogue by the same name. Some passages are taken directly from the book, THE LURE OF THE LOCAL, *published in 1997, by the New Press, New York.*

LAURIE PALMER

3 ACRES

3 ACRES ON THE LAKE: DUSABLE PARK PROPOSAL PROJECT developed in response to the claustrophobic climate of increasingly privatized urban space, and the dwindling of habitats and haunts for opportunistic plants and curious persons. It was also a response to the discriminatory and devastating effects of city policies favoring high-income development. Initially, the project invited, without sanction or authority, speculative proposals for how a small plot of public land in Chicago might be used. There was no jury, no winner, and no prize. It was an invitation to irony, fantasy, and utopian imaginings, but also an attempt to pry open city planning processes for public scrutiny and participation. Parallel to

developing the proposal project, I joined a loose coalition working to influence the actual future of the park. These separate but linked activities, the speculative/imaginary, and the actual/political, exerted inextricable influence on each other and created the larger project concerning the park. While 3 ACRES began out of curiosity about a specific place, it continues to unfold in an intricate ongoing story punctuated by conflicts and contradictions relevant to many urban spaces, involving private interests, toxic residues, repressed histories, racial conflict, and public art.

IMAGINARY PROJECTION In the context of feverish downtown development, vacant land on the lake—overgrown with sweet-smelling grasses and meadow flowers, and colonized by redwing blackbirds and gangs of monarch butterflies—jumps out as strange and thankful. I biked over and looked down on this land for many years without knowing anything about it, or how to get there. Its position at the dead end of a peninsula between the Chicago River and an engineered inlet, underneath an eight-lane highway, and fronting the lake, makes access difficult. The meadow is shaped as a half-hill, its high side backed up to the highway and its slope rolling down towards the water. I know of only one other hill in Chicago, and its closely mowed turf is trampled bald by runners and dogs. Cars, boats, bikes, skaters, and streams of pedestrians thread through arched underpasses, exits and on-ramps, linked walk- and waterways, circulating in a lubricated network of multi-leveled recreational opportunities all along the north lakefront. This meadow, however, is a dead-end, virtually an island; unmowed, unpaved, unpatrolled, and not selling anything. Pastoral, slow, and sensuous, I saw it as an excerpt from elsewhere, unplugged from the flows all around it. Because it is mostly viewed from above, because access is hidden or locked, and because it doesn't appear to have a purpose, it was ripe for imaginary projection.

Seemingly abandoned lots in a city undergoing rapid re-development are, of course, riddled with complicated histories and bulging with intricately mapped future plans. As I began to investigate the site, three salient features emerged: no one wanted to claim ownership, at least initially;[1] the ground is allegedly contaminated with radioactive thorium (half-life 14 billion years); and the site was dedicated in 1988 by the Harold Washington administration to become a commemorative park honoring Jean Baptiste Point DuSable. DuSable, a black explorer, was Chicago's first non-native settler but he has never been adequately recognized by the city,[2] and the promised park has never been developed.

[1]
The land was given, by a quit claim deed, to the Chicago Park District from the development company that owned it after the Lakefront Protection Act rendered it unde-velopable. But the Park District continues to seem confused over how much it can do without explicit permission from/collabo-ration with the same development company that owns the adjacent land (on which it is building two new high-rise condo complexes). When pressed about why DuSable Park had not yet been developed 13 years after its dedication, the Park District initially said that it didn't own the land, then it said that it didn't own the right-of-way; now it says that the expense of rebuilding the seawall and of the thorium clean-up are holding up the park.

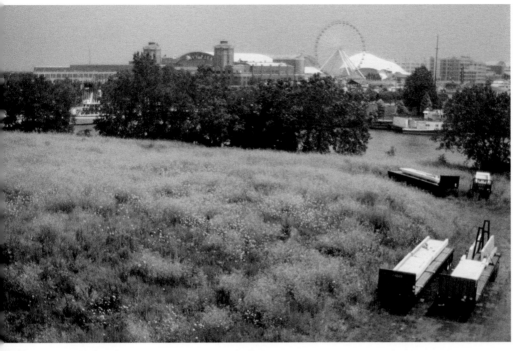

← DuSable from bike trail, with
Navy Pier in background.
PHOTO COURTESY OF LAURIE PALMER

Aerial view of DuSable Park.
PHOTO COURTESY OF DOUG FOGELSON
↓

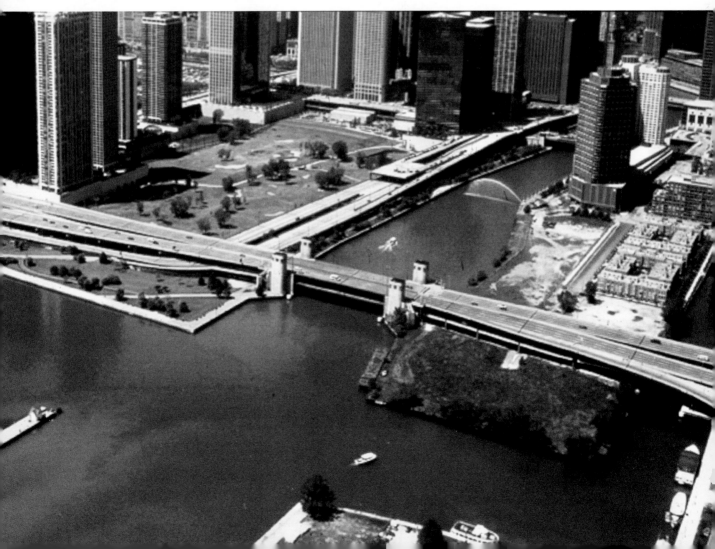

SPELLING DUSABLE In the summer of 2000, the park district announced a plan to turn the promised park into a parking lot. A coalition formed that quickly trounced that plan, on legal and environmental grounds, as well as bad public relations ("they paved paradise..."). Although I wasn't involved in that scuffle, I joined in the subsequent and continuing project to hold the park district accountable to its commitments. None of us in the coalition want exactly the same thing, but we share suspicion of what will happen without our input. Organized by Friends of the Parks, a well-established non-profit advocacy group that is smoothly integrated into city systems, the coalition includes: two groups representing wealthy white condo owners who live near the park (an area which hosts the most expensive real estate in the city); The Haitian Physicians of America (DuSable was part Haitian); Friends of the Chicago River, a non-profit environmental organization; Friends of DuSable Park, a white brother and sister team who live near the park and decided to create their own organization; a few individuals like myself, not representing any group; and the Chicago DuSable League, whose membership includes older black women from the Southside who are continuing a 73-year long campaign dedicated to securing appropriate civic recognition of DuSable.

The Chicago DuSable League was founded in 1928 and at its height had about 40 active members, down now to 4, most of whom are in their 80s. Artist Esther Parada's 1992 project WHO DIS/COVERS, WHO DIS/COLORS documenting the League's history highlights their campaign to erect a replica of DuSable's cabin during the 1938 Chicago World's Fair. Parada's installation showed letters documenting the League's polite, but insistent demands, met with faintly-veiled racist rebuffs by the fair committee. Behind these exchanges Parada displayed the fair publicity images which showed bare-chested black men carrying loads on their shoulders while white men wearing fancy waistcoats stand about in pointed shoes. The cabin replica was finally erected for the fair, due to the persistence of the League women. Though this was an important victory, a permanent public monument to DuSable— their primary goal—has yet to be constructed.

When DuSable Park was dedicated 50 years later, in 1988, a monument was promised and a proposal commissioned— without public input or an open call—from the well-respected African-American sculptor, Martin Puryear. The League's ongoing demand (carried on by the daughters and grand-daughters of the original founders), is for a figurative bronze statue that is recognizably "black." Puryear's first maquette was apparently abstract, like most of his work. When Puryear's gallerist presented his most recent maquette to our coalition this summer (a decade after the initial commission; Puryear was not present), we saw a figurative stone relief of a man carrying an ax, at a scale approximately one inch to one foot, intended to stand about 9 feet tall. The League objected vehemently to the primitivizing ax, to the small size (they would prefer 20 feet, or higher), and to the fact that, since it was a relief, he was only "half a man" (language reminiscent of the "3/5 of a man" proviso originally written into the U.S. Constitution regarding the fraction of a franchise allowed for black slaves).

The specifics of these criticisms point to the agonizingly familiar dilemma of representation in public art, where constituents' projected investment in a traditionally conceived public work is often bet against an artist's power to persuade with the finished, previously unimaginable, monument. In the famous case of Maya Lin's VIETNAM WAR MEMORIAL, the experience of the completed project won over the majority of those who had criticized the piece as it was proposed. But Lin's proposal was selected from many in a juried competition. There was neither an open call, nor an invitation to open discussion for the DuSable monument—in spite of what we have to assume was an intention, at the time of dedication, that this monument, and the park itself, might symbolically address, and even somehow, possibly, minutely assuage the histories of racial division that continue to split Chicago. But if a monument (or park), is going to effectively gather and symbolize some version of a plural public's emotional reservoir, it has to come from some version of a plural public process, in which multiple voices at least get to feel that they've been heard. Perhaps the lack of an invitation was due to fear of a public that would reveal itself as conflicted; that such an invitation would open, instead

2

John Kinzie, a white man who bought DuSable's house, and turned it into a store, has long been celebrated as the city's founder (and father of "the first white child"). Both "founding" stories—DuSable's and Kinzie's— obscure, of course, the presence of the indigenous Potowatomis on the same territory. However, DuSable's story contradicts that of the prototypical settler: not only did he marry a Potowotami woman named Catherine but he also apparently lived in unprece-dented accord with the local Indian population.

of cap, controversy. But in the end the city did not actually put up funds for the monument; a long-established private trust volunteered to pay and financial responsibility apparently empowered the trust to choose their candidate "behind closed doors." The issue is not about whom they chose, but how. My argument is for an open process, to negotiate (hard-won) aesthetic credentials with Chicago's long-term memories of racial division and exclusion, and also with the city's existing context of enduring public monuments. These include a large number of recognizably white men on plinths, and even a bronze plaque marking the spot where Chicago's first white child was born. (Which turns out to be the same spot where DuSable built his house.)

History hangs around. Until all of the lingering statues of white men are replaced with "abstractions," there will remain a need for a figurative representation of DuSable that is recognizably black. However, no one knows what DuSable looked like; there are no photographic records or oil portraits, only imaginary renderings. So what does "black" look like? Partly in response to this question, the African Scientific League has started a campaign to disinter DuSable's bones and use hi-tech forensic technologies to re-create his facial features (THE DuSABLE ARCHAEOLOGICAL GRAVE SITE PROJECT). This endeavor is one of many projects nationwide that are using archaeological and forensic techniques, including DNA testing, to produce physical evidence regarding African-American history and diasporic lineages. Some histories hang around above ground—others have to be excavated. The elusiveness of DuSable's physical identity might be something he has to offer, in terms of unseating reliance on factual evidence in favor of acknowledging the present as history's final filter. At the same time, research contributes new information to that filter. Esther Parada's 1992 installation (WHO DIS/COVERS, WHO DIS/COLORS) included a long list of different spellings of DuSable's name since it was first marked in historical records, including a relatively recent version, J.B. Pointe DeSaible, which was deliberately changed a couple of decades ago because it sounded like "disable".

The debate over the DuSable monument is not one that has caught the interest of a representative portion of African-American communities in Chicago. There is something obscure and irrelevant about a monument—whether figurative or abstract—commemorating a long-dead settler, when current experiences of racial discrimination take immediate form in criminalization, police brutality, and displacement due to gentrification (which the city could slow and alter if it had the will). But the League's long-term battle testifies to the continuation and ongoing effects of the city's history of racial division. The issue of "non-recognition" is evident also in the historical lack of attention to the south lakefront, and lack of parkland in poor communities of color, for which practices the park district was sued by the federal government in 1983 (charging "benign neglect") and forced, by consent decree, to "spend more of its money in minority neighborhoods."[3] The dedication of this park in 1988 was clearly an attempt to reach out to the African-American community, but also fraught with contradictions since it is located in an extremely wealthy, and increasingly white, neighborhood.[4] But the continuing lack of even a *symbolic* affirmation of DuSable's significance within the city, and on the downtown lakefront which is the city's public face, is a *symbolically significant* historical omission that this tiny 3 acres—located at the city's symbolic gateway, the mouth of the river—might address. If the city wanted to.

The coalition work, proceeding down its own errant and surprising paths separate from the proposal project, has generated unexpected pleasures and connective moments. One morning a coalition member contacted all of us to crash a meeting that afternoon to which we hadn't been invited. When I arrived at the outdoor fountain where the meeting was supposed to start, there was no meeting, only other crashers present. It was furiously windy and I was on my bike, under an obviously gathering storm. As we waited, drops from the fountain flew at us and the loud water made it necessary to shout. The historian of the DuSable League, who is hard of hearing anyway, pulled images out of her purse to show me, including an example of a "public" monument—somewhere— that looked like a squashed car: evidence of the imbecilities pawned off as commemoration. She began to tell me a detailed

3
Blair Kamin, "The Great Divide", CHICAGO TRIBUNE, October 27, 1998.

4
Detailed data from the 2000 census is not yet available, but even 1990 census data for the Near North area shows a striking decline in numbers of African-American residents, and increase in median rents and numbers of owner-occupied homes. The summary page for the 1990 census for this tract concludes: "the most significant issue, however, will be how the disparity between the very rich and the very poor of the community will be resolved."

LAURIE PALMER

↑
Neighborhood Writing Alliance
workshop on DuSable Park.

DuSable Park bike trail
under Lake Shore Drive,
heading north.

↓

story about DuSable's political affiliation with the French. Meanwhile two older white men conspired to meet with the private trust paying for the monument; apparently they had an objection to "modern art" per se. While we waited for the meeting to arrive, other individuals who had come for the missing meeting, including a curator and a reporter, sat down with us, mistakenly thinking we were it. The reporter became more interested in the DuSable League than the meeting he had been assigned to cover, and ran an article the following week about their history and campaign. When I got up to bike home, worried about imminent rain, the historian stood in front of my bike, straddle-legged, hat cocked forward, still talking about the French. She ran ahead about ten feet and stood there, on the bike path, barring the way, still talking, and raising her hand defiantly in the air. She did this for several increments of path, then said a few disarmingly sweet endearments about taking care of myself, stepped aside and waved me on. Where do I fit into all this? With the white guy who hates "modern" art, and an obsessive, demanding, and charming, octogenarian? Many people keep asking me what I want to see on the park, and I keep saying I don't want a specific thing. The unlikely awkwardness of this coalition is close to what I am looking for; a version of public that includes multiple and conflicting claims.

THE PROPOSAL PROCESS After initial research, I rendered a selective description of these 3 acres and distributed it for imaginary use by direct mail, e-mail, and the web. Mailing lists included local housing activists, gardeners, and neighborhood planning groups, as well as artists and architects. I also took out an ad in STREETWISE, a publication sold by homeless vendors. An exhibition at Temporary Services in October 2000 introduced the project to the tiny art crowd that attended, and the website went up in February 2001.

Over 150 inquiries came in over the Internet from international architects, not all of which resulted in proposals as many misunderstood the project's speculative nature. Local participation from residents who were neither architects nor artists was more difficult to solicit. I held two design workshops in June to encourage this, involving group discussion and hands-on drawing and proposal production. Between 20 and 30 participants came to each workshop, and divided into groups to create collaborative proposals. By the deadline, (beginning of August), 65 proposals had come in, approximately 60% from the Chicago area, the rest

from cities across the U.S. and abroad, including Lima, Guadalajara, London, Victoria (Australia), Paris, and Berlin. The exhibition opened in September in Chicago, with two public events, including a site visit and an open forum for discussing responses to the proposals.

The proposals take many forms, including hi-tech digital images, an oil painting, a hand-built sculptural ship, an interactive website, text spelled in trash, notes written in longhand on a legal pad, a paper cut-out model, watercolor drawings, audio-taped bird sounds, an audio/visual interview. Contributions range in attitude from earnest to ironic to critical; some are historical, or playful, and a few supremely egomaniacal. A few participants hadn't read the prospectus, and others hadn't read what I thought I had carefully inserted between the lines. Several proposals attempt to reconcile or even dampen conflict—to create spaces for "everyone"— although unseating the assumption of an "everyone" was a fundamental reason to do the project, as someone is always excluded by that term. I hoped the unofficial nature of the project might invite impractical, outrageous, and seemingly private desires into a discussion of public, defined as plural and presuming conflicting needs and ideas. Not many defiantly radical desires were articulated (except for a communal lesbian bathtub), though the proposals have not in the least been disappointing.

Examples of group proposals might give a sense of some of the local participants' ideas: The Stockyard Institute, an art program for youth in the Back of the Yards neighborhood on the South Side, led by Jim Duignan, created an artist's book of plans developed over several months, including a hospice program (DuSable LifeHouse) administered by youth on specially-engineered bikes. The Journal of Ordinary Thought, a neighborhood writing group, held writing workshops on the site, focusing on memory and memorial, then worked with an architect to represent their ideas in visual form. The Chicago Rowing and Paddling Club drew up a detailed plan for a launching spot for small craft. Esther Parada proposes to commemorate all the women, past and present, of the DuSable League, in lieu of commemorating DuSable, and engaged the exhibition audience in the project of identifying past members from an archival photograph. Architects Kevin Hong and Eigo Komai propose an inaccessible "speakers park" planted with loudspeakers broadcasting the voices of "those who want to be heard."

GROUNDLESSNESS Among the virtual projects, a predominant theme was groundlessness. It is as if the actuality of the site (in terms of substance) was irrelevant, or multiply undermined, and what mattered instead was the artificial construction of a new ground, or a second surface, above the contaminated hill. In the 1920s and 1930s the Lindsay Light company's production of gas mantles contaminated many acres of the Streeterville neighborhood with radioactive thorium, which decays into radon gas. The hill is a pile of excavated dirt from nearby high-rise construction projects, dumped over a period of years. Its contamination is assumed, though just how hot has not yet been determined. Creating artificial ground relates not only to the alleged toxicity of the dirt, but also to the curious fact that the land is not an old geological formation, but a recent artifact of human engineering. It built itself 150 years ago by the accumulation of silt and debris when a jetty was constructed downstream that rerouted lake currents. When I went to the Bureau of Deeds initially to find out who owned the land they couldn't find it on the map, and concluded therefore that it must be landfill as opposed to land. It is explicitly a constructed, as opposed to a discovered site and these facts made it peculiarly ripe for virtual imagining.

Making something out of nothing is a basic tenet of capital and speculative development; we've seen it enacted via dotcoms recently, it is the story of private property historically—put a fence around space and call it yours, then rent or sell it. The same development company that had been given the newly created land by the State of Illinois in 1857 sold it in 1972 for a lot of money to a developer who planned to build two 40-story high-rise towers on the park's skimpy silt-built 3 acres. The passage of the Lakefront Protection Ordinance the following year interrupted these plans and the city had to pay the buyer back, since the act that rendered the land valueless was a city ordinance. That act transformed the land from prime real estate to a parcel of weed, hosting mallow, bouncing bet, grandma's lace, goldenrod, loosestrife, thistle...

Gordon Matta-Clark's purchase and imaginary use of oddly-shaped remnants of "land" in his 1973 FAKE ESTATE referenced an economy of space in New York that countered the idealism of the earth men working simultaneously in the wide-open West. In 2001, in Chicago, Michael Piazza riffed on Matta-Clark's parsing of space: putting up flags on the thicknesses of the boundaries between properties, he

made visible these infinitesimally small slices of "space" still unclaimed; single stripes of a differential calculus, boundary (in its paradoxical dimensions) as space. (BOUNDARY OF 0, Department of Space and Land Reclamation, April 2001, the Butcher Shop, Chicago.)

A related conceptual approach to expanding the literal dimensions of space through imaginary activity—multiple possibilities blooming simultaneously out of a single tiny plot—informs 3 ACRES. However, my own experience, and understanding, of the city is specifically limited by my spatial orientation within it. Living on the North Side and working downtown, I am surrounded by claustrophobic development against which this tiny parcel of unused space assumed enormous proportions. But visiting a DuSable League member's house on the South Side, I am reminded of a different experience of urban space. There are plenty of vacant lots, scattered between stately graystones. The lots are often overgrown. Mostly these lots are not looked upon as desirable, but deliberately neglected. Word is that none of these lots are actually "abandoned" but each one is bulging with a carefully designed future waiting for the right moment to unfold.

The desire to create loop/worm holes in a tightly constricted fabric of urban space doesn't find resolution in this story but only the endless digressions and contradictions it deserves. Further research into Freedom of Information Act documents regarding DuSable Park turned up a provision of the deed allowing the land's former owner to buy back the park from the park district if it is not developed after 20 years, and an easement for his company to build a restaurant, bar, and boat launch. It is hard to know what role the DuSable monument and park will play in this lucrative scenario, with only 7 years left out of 20.

After a year of being open to the public (thanks to the coalition's efforts), the park is once again definitively closed, with a new fence up that precisely marks the eastern edge of Lake Shore Drive's shadow. Although the extent of thorium contamination has never been definitively measured, the park district puts this issue forward as the primary reason the park has been delayed, and why it needs to be closed off—to protect the public. The fact of the new fence brings my involvement full circle—returning to the idea of the land as inaccessible, and although visible, resonantly virtual—a groundless space for imaginary projection.

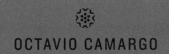

OCTAVIO CAMARGO

PÉ COM CABEÇA

PÉ COM CABEÇA took place on the February 14, 1995, a Saturday morning, from 9:00a.m. to 11:00a.m. on Rua XV de Novembro in Curitiba, Brazil. It consisted of the simple action of lying down in silence or two hours and then evading. There were 25 participants. It was an unexpected event (intervention). In front of the first person in the line there was a music stand with the words "Pé com Cabeça" written on a sheet of paper. ✹ **METAPHORIC ACTION** "Pé com cabeça" is an idiomatic expression in Portuguese for something with a beginning and an end, something that makes sense. Maybe it could be translated as "head to toe" or "head and tail." First, the performance is a metaphorical event. It expresses literally the

phrase in its ambiguity. The people lying on the street were building a multiple reproduction of the metaphor. The opposite side of the metaphor is the nonsense of the activity presented in a public space (street), in an unexpected manner (unannounced in the media, and not marked as an artistic event). In this way, passers-by would wonder about the meaning (reasons) of the action. When the performance ended the participants "evaded" (they left the place in silence without any interaction with the public, so that a question remained about the action.)

THE CHOICE OF THE SITE The Rua XV de Novembro is a pedestrian street right in the center of the city, also known as "Rua das flores" (Flower Street), and stands as a symbol of the city of Curitiba. This street was once for cars, but in the last 40 years it has been blocked off and made an important commercial center for pedestrians. In 1995 I read statistics that showed the number of passers-by was up to 20,000 per hour. So, I recognized the potential of that street as a "publishing space" for art. Nowadays this performance would not be possible in the same place because the mayor of the city has installed a fountain there.

ABOUT THE RECEPTION OF THE PERFORMANCE Some 20 minutes after the beginning of the performance a crowd surrounded it and remained growing until its completion. A parallel consequence of this was the spontaneous presence of the media (news-

papers and TV). Journalists asked watchers about what they were seeing, and attempted to interpret the action.

SOME TECHNICAL ASPECTS The performers engaged in this action were unpaid. I mean, they did it because they wanted to do it. They were given simple instructions, such as "lying down in silence and after two hours evading."

SOME CLUES Open signifier, conjunct action, resignifying space, free action (the attitude of non-response), presentation, non-action, music, soundscape, time frame, poetry, suspension.

JULI CARSON

TWO WALLS: 1989

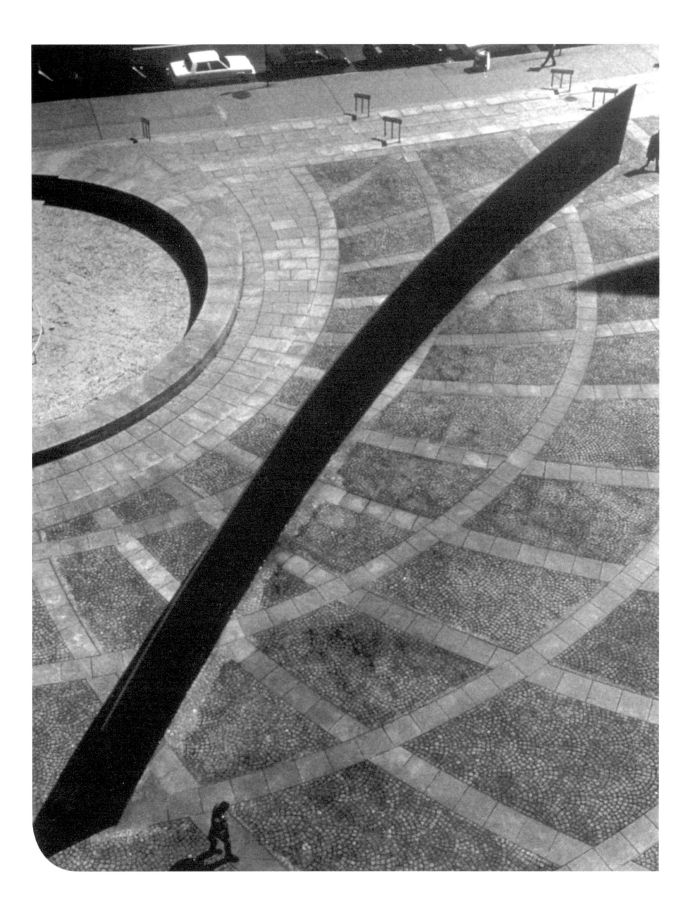

I don't make portable objects; I don't make works that can be relocated or site adjusted. I make works that deal with the environmental components of given place... as [the] phrase implies, site-specific sculpture is one conceived and created in relation to the particular conditions of a specific site, and only to those conditions. To remove TITLED ARC, therefore, is to destroy it.

—Richard Serra, statement at the hearings to remove TITLED ARC

PART I: ON SITE TILTED ARC, a wall about which we have read so much, one that most of us in fact know only through such readings, is the referential "site" for the following story. In 1985, William Diamond, the New York Regional Administrator for the General Services Administration (GSA), recommended that Richard Serra's TILTED ARC be removed from the Federal Plaza in downtown New York City. Four years and several failed appeals later, TILTED ARC was removed, or in Serra's own words, "destroyed." Shortly thereafter, in 1991, THE DESTRUCTION OF TILTED ARC: DOCUMENTS was published by The MIT Press, officially entering the controversy surrounding the hearings into art historical discourse. Indeed, the hearings from 1985 were a ready-made for such a book, as scholars, artists, and critics, ranging from Claes Oldenburg, Douglas Crimp, Abigail Solomon-Godeau, Rosalind Krauss, Benjamin Buchloh, Annette Michelson, Frank Stella, and Roberta Smith all spoke in defense of Serra's project.[1]

Since then, the plethora of critical writings engendered by the controversy has underscored the nature in which TILTED ARC, in fact, is merely a site for "a story that *acts* as if the site pre-ceeded it," as Mark Wigley has said in relation to other self-proclaimed "site-specific" projects.[2] For it was a book produced under Serra's supervision—one that ironically sought to document the manner in which his project was destroyed upon its *physical* removal from its site—that illustrated the manner in which TILTED ARC's "site-specificity" was always *already* discursive. The most important contribution of THE DESTRUCTION OF TILTED ARC, therefore, was not the historical record of the work's physical whereabouts that it purported to preserve. What is more striking is the manner in which the book performatively demonstrates how TILTED ARC's "presence" is inextricably bound up with the rhetoric from which it was conceived (Late-modernist, phenomenological notions of site-specificity), and to which it contributed (Post-modernist notions of the discursive site). Indeed, there was a destruction of Serra's TILTED ARC in the works here; however, it wasn't merely the physical object destroyed at the hands of those policemen who removed it in the middle of the night. For the "object" destroyed was the very one borne within the modernist dialectic over a work's *physical* site-specificity, bound up, as it were, in the logic of transcendence—a dialectic between a work seen to transcend any physical union with its site and a work seen to transcend any physical *contradiction* with its site. Born as such, TILTED ARC's "death" occurred at the instance that it was *discursively* bound (and for many, first received), off-site, first in the hearings, then concretized in the pages of THE DESTRUCTION OF TILTED ARC. Which is to say, quite simply, TILTED ARC's *raison d'etre* ended the *moment* that it was written.

At the core of Serra's dilemma is thus the contradiction of presence that Jacques Derrida writes about in his critique of logocentrism. What Derrida refers to as that "*logos* of being" relies upon the difference between a signifier and a signified such that a transcendental signified—pure presence, pure voice—could primordially pre-exist all subsequent signification. And yet, in the very instance of *logos* being *known*, it first had to be reiterated, which is to say, it had to be presented as that *thing-not-itself*. This, of course, is what bothered Greek philosophers about writing in the first place, that one would "repeat without knowing" the truth of that very presence they sought to document, such that the "truth" of writing would in fact be *non*-truth. This is the

1
Clara Weyergraf-Serra and Martha Buskirk, eds., THE DESTRUCTION OF TILTED ARC: DOCUMENTS (Cambridge: The MIT Press, 1991). The book includes an introduction by Richard Serra.

2
Mark Wigley, ON SITE, unpublished manuscript (at time of this writing).

3

Jacques Derrida, "Plato's Pharmacy,"
collected in DISSEMINATION,
trans. Barbara Johnson (Chicago:
University of Chicago Press, 1981).

4

Jonathan Culler synopsizes
Nietzsche's notion of CHRONO-
LOGISCHE UMDREHUNG this way:
"Suppose one feels a pain. This
causes one to look for a cause and
spying, perhaps, a pin, one posits
a link and reverses the perceptual
or phenomenal order, pain…pin,
to produce a causal sequence,
pin…pain." In WERKE Nietzsche
thus derives the following temporal
dilemma: "The fragment of the
outside world of which we become
conscious comes after the effect
that has been produced on us and is
projected *a posteriori* as its 'cause.'
In the phenomenalism of the 'inner
world' we invert the chronology of
cause and effect. The basic fact of
'inner experience' is that the cause
gets imagined after the effect has
occurred." Friedrich Nietzsche,
WERKE, vol. 3, Karl Schlecter, ed.,
(Munich 1986.) Cited in Culler, ON
DECONSTRUCTION: THEORY AND
CRITICISM AFTER STRUCTURALISM
(Ithaca: Cornell University Press,
1982), p. 86.

same contradiction in writing that Derrida called the "*pharmakon*," following Socrates' fable about the invention of writing as recounted by Plato in the PHAEDRUS.[3] To recount the fable again: Thamus, the King of Egypt, the representative of Ammon, God of all Gods, is offered a *pharmakon* (recipe), for memory and wisdom: writing itself. The king or God can thus be seen as the origin of writing's value, a practice that comes to him from elsewhere, for the God as speaker-of-the-word, of course, doesn't write. And as such, the "God who speaks," according to Derrida, acts as the Father who treats the *pharmakon* (given as a gift or remedy), with great suspicion because it simultaneously threatens the *value* of his presence in the very instance of dutifully *recording* it.

The God's derision of writing can thus be seen as a paternal act, one which accords with the Platonic notion of logos that assigns the power of speech to the paternal position. As such, the Father is not logos itself; rather, the origin of the power of speech (as *logos*), is always the Father. He thus gives birth to living logos in the form of the Son who wants dutifully to record his spoken word. But in the very attempt to record the Father's spoken word, to make *good* on it, there is the threat of producing what Derrida calls the "orphaned" text: that piece of writing separated at birth from its Father, whereupon the orphan forever forth becomes "his own man." Derrida analogizes the Father/Son/Orphan relationship to the positions of presence, speech, and writing this way:

Father	Son	Orphan
The Origin	Speech	Writing
The Good	Living Logos	Supplement
The Source	Mneme	Anamnesis

We can see that the graphic mark is none other than writing separated at birth from the father at the very moment of inscription. As such, writing stands opposed to living *logos*, the latter of which is the dutiful purveyor of active speech, maintaining a closer proximity to the Father in order to make a good "return" on his "source of capital." *Logos* thus relies on the binaristic tension between speech (operating upon the prohibition of perversion), and writing (the everlasting threat of patricide). For speech purports to *remember* accurately the word of the father, while writing inevitably threatens to *forget* it.

THE SON BEGETS THE FATHER Who then begets whom, Derrida asks, following the Nietzschian principle of chronological reversal[4]—the Father or the Son? For the Father, as that metaphor for pure presence, can only be conceived *after* the fact in the form of what he has made to represent him—the Son—even if that Son is the one who unwittingly becomes orphaned in the space of dutifully recording the Father's word. For simply, how can there be a Father if at *first* there is already not a Son? In the case of Serra, THE DESTRUCTION OF TILTED ARC ironically registered the split of a (Postmodern), discursive practice from Minimalism, one that would put under erasure the very notion of presence (in the form of site-specificity), that the book was meant to record and preserve. But isn't this split, this accidental "birth by negation" consistent with the very terms of Serra's own project to begin with? Which is to say, isn't Greenberg-the-Father still lurking somewhere in Serra's (residually), modernist project, albeit it in oppositional terms? For Serra's project rhetorically begets Greenberg's Modernism in the act of negating him in the first place, inasmuch as the (Postmodern) record of TILTED ARC begets and reveals Serra's (modernist), project. As such, is Serra's defense of TILTED ARC, in the late year of 1989, not a pivotal instance of Modernism's last living logos?

I look to Rosalind Krauss's well-known essay on site-specificity, "Sculpture in the Expanded Field," which lays the structuralist foundation for my assertion here (a foundation that is too readily dismissed or willfully forgotten in current discourse). modernist sculpture, the brand with which Serra's work dialectically engaged, asserted an inherent *sitelessness*, one that in the hands of Brancusi, for example, made claims to being functionally placeless and self-referential, as base and sculpture were subsumed into a single transportable form. But, as Krauss argues, it was a limited practice, exhausting itself mid-century as the belief in the "positive" self-referentiality of form began to be experienced as pure negativity. "At this point," Krauss argues, "modernist sculpture appeared as a kind of black hole in the space of consciousness, something whose positive content was increasingly difficult to define, something that was possible to locate only in terms of what it was not."[5] What it "was not," of course, was the site itself in which sculpture was posited. As such, sculpture—in positive terms—could only be defined as *neither* architecture *nor* landscape.

The nature of modernist thought about form, the idea that something would be defined as that which it is not, involved more than just sculpture. Greenberg made this explicit in his essay "Modernist Painting," when he definitively associated Modernism with "the intensification, almost exacerbation of a self-critical tendency...[whereby] the characteristic methods of a discipline... [would be used] to entrench it more firmly in its area of competence." Each art form, then, "had to determine, through operations peculiar to itself, the effects peculiar and exclusive to itself." The cost, Greenberg admits, may have been that a given art form would limit its area of competence, but the ends justified the means here, for at the same time "it would make its *possession of this area* all the more secure."[6] [my emphasis]

As we know, the discrete instance of an aesthetic form's coming into being lent itself to a certain belief in the transcendence of experience, for the artwork was not just distinct from other forms in the world, it was distinct from the body of the viewer himself. Such was the backbone of Greenberg's theorization of the visual field in the guise of a disembodied eye, which Krauss lyrically recalls in her book THE OPTICAL UNCONSCIOUS. Here is her anecdote of what a work must disavow in that moment of presumed transcendence that pivots off the "look":

> And were we to ask Clement Greenberg about his own description of "the look," the look that art solicits, the look that is the medium of the transactions between viewer and work? The time of that look is important, he claims, because it must be time annihilated. "With many paintings and pieces of sculpture," he has insisted, "it is as if you had to catch them by surprise in order to grasp them as wholes—their maximum being packed into the instantaneous shock of sight. Whereas if you plant yourself too firmly before looking at a picture and then gaze at it too long you are likely to end by having it merely gaze back at you.

She continues, explaining the body's intervention in the field of vision, when time is not properly annihilated:

> And when time has not been thus suspended...then the trajectory of the gaze that runs between viewer and painting begins to track the dimensions of real time and real space. The viewer discovers that he or she has a body...and that the picture, also embodied, is poorly lit so that its frame casts a distracting shadow over its surface now perceived as glassy with too much varnish. What Clem refers to as "the full

5
Rosalind Krauss, "Sculpture in the Expanded Field," collected in THE ANTI-AESTHETIC, Hal Foster, ed. (Port Townsend, WA: Bay Press, 1983), p. 36.

6
Clement Greenberg, "Modernist Painting," in THE COLLECTED ESSAYS AND CRITICISM, vol. 4, John O'Brian, ed. (Chicago: University of Chicago Press, 1993), pp. 85-93.

7

Rosalind Krauss, THE OPTICAL
UNCONSCIOUS (Cambridge: The MIT
Press, 1993), p. 98.

8

This claim for what Krauss would later
call sculpture's embodied "expanded
field," wasn't limited to proponents
of Minimalism. In fact, Michael
Fried, Greenberg's main spokesman,
based his critique of minimalist form
precisely on the work's characteristic
phenomenological occupation of the
viewer's entire field of vision. In his
classic essay, "Art and Objecthood,"
he clearly demonstrates his
understanding of Morris's brand of
Minimalism, thus positioning himself
dialectically against it: "[In minimalist
work] the object, not the beholder,
must remain the center or focus of
the situation; but the situation itself
belongs to the beholder—it is his
situation. Or as Morris has remarked,
'I wish to emphasize that things are
in a space with oneself, rather than
...[that] one is in a space surrounded
by things.'... It is, I think, worth
remarking that 'the entire situation'
means exactly that: all of it—including,
it seems, the beholder's body.
There is nothing within his field of
vision—nothing that he takes note of
in any way—that, as it were, declares
its irrelevance to the situation, and
therefore to the experience, in
question." Michael Fried, "Art and
Objecthood," collected in Gregory
Battcock, ed., MINIMAL ART: A
CRITICAL ANTHOLOGY (New York:
E. P. Dutton, 1968), p. 127. See also,
Robert Morris's "Notes on Sculpture,"
collected in the same anthology.

9

As for those works occupying
the "permanent' site, Heizer and
Smithson have conventionally
been lumped together within the
category "earthworks." However, it
should be noted that Smithson's
entire project as read through
SPIRAL JETTY, may be said to have
challenged the very notion of site
(as a transcendental signified)
through which earthworks were,
and still are, commonly understood.
For a discussion of Smithson's
interrogation of a transcendental
notion of site-specificity, in tandem

meaning of a picture, i.e., "its aesthetic fact" drains out of this situation, relocated
as it is in the all too real. And the result is that instead of generating an aesthetic
fact, the picture, now reified, simply returns the look, merely gazing "blankly" back
at you.[7]

It was precisely against this disembodied eye—the eye of the viewer as much as the eye of
the work—that an "expanded field" would challenge not only the definition of form but the space
of its experiential limitations. Which is to say, should we shift the space of viewing to an *embodied*
perspective, sculpture would no longer be defined *itself* as that which it is *not* (that which "you
back up into when you look at a painting," as Krauss cites Barnett Newman as saying). Rather,
sculpture (as a negation of Greenberg's negation), would *possess* that which modernist form had
adamantly disavowed: the mundane materialist aspects of its physical site. And in doing so, it
would only ever be *itself in its site*.

And here, then, we have a dialectical reversal within the logic of modernist form, one best
demonstrated by Robert Morris's CORNER PIECE of 1964. If for Greenberg modernist painting
discretely possessed its disciplinary area of competence, dialectically, minimalist sculpture
presumed to completely possess the physical site common to the object and beholder with the
intention of provoking a subversive *intrusion* within Greenberg's transcendent, disembodied field
of vision. For the corner of the corner piece, being at once the corner of the gallery, subtracts
from us a space in which we stand. Space, wall, floor, and the beholder's body are now each, in
this "expanded field," one term among others that *stand* to define the object, an object that we
willfully and necessarily recognize as "staring back at us." It is an effect made even more directly
by Morris's four mirrored cubes of the same period, in which the work literally constitutes itself
vis-à-vis the reflection of surrounding space, wall, floor, and beholder. [8]

The reader, here, may protest my assertion that there is a convergence between a site-
specific artwork permanently located in the world—be it in the form of an earthwork like Michael
Heizer's DOUBLE NEGATIVE, Robert Smithson's SPIRAL JETTY (both of 1970), or Serra's urban
projects, and site-specific artworks like Morris's four mirrored cubes that are mobile by nature.
What these projects nevertheless have in common is the focus of this essay: the assertion
of "site" as a transcendental signified, be it permanent or mobile, based upon an essentialist,
positivistic notion of "experience."[9] It is a concept that will implicate even more intellectually
discordant practices in architecture, to which I will now turn.

Within the "internal logic" of sculpture in the expanded field, operating as it did upon a closed
structure of oppositional terms, the notion of "site" is still a physical, materialist one (an
operation maintained precisely through Minimalism's dialectical challenge of the modernist
assertion of a Cartesian mind/body split). It shouldn't surprise us, then, that a residual
effect of this materialist "anti-modernist" sculpture—a negation of a negation—positively
continued the rhetoric of modernist architecture. This rhetoric (to the chagrin of the minimalist
intellectualism), echoed Frank Lloyd Wright's more romantic notion of site-specificity as
providing a heavenly bond between a given structure and its physical environment, about which
he swooned to his students at Taliesin West:

> ...now you are released by way of glass and the cantilever and the sense of
> space which becomes operative. Now you are related to the landscape... You
> are as much part of it as the trees, the flowers, the ground... You are now free

to become a natural feature of your environment and that, I believe, was intended by our maker.[10]

On the level of intentionality, the citation of Wright's project in the context of Minimalism constitutes a form of heresy to the proponents of either practice. For, of course, the minimalists' intention of fusing sculpture with landscape and architecture was one of critical (or even political), subversion, against the romantic, idyllic intentions of Wright's conservative site-specificity. Nevertheless, the philosophic terms of such a work's fusion within its environment are remarkably similar, particularly when we consider the late instances of Minimalism's project in the hands of artists like Serra, engaged as they were in the ideal of "public works of art" constituting a social expansion of an already "expanded field."

Within the time frame of TILTED ARC'S controversy, the philosophic convergence of these two models—High Modernist architecture and late minimalist sculpture—is demonstrated by arguments for and against the project, both of which state their claims in terms of a fusion between project and site. As for those against the project, high-modernist architectural paradigms of site were evoked. I am thinking specifically of testimony given by Margo Jacobs, the wife of Robert Allen Jacobs, the latter of whom was one of the architects for the Federal Office Building and International Court of Trade. For what Jacobs argued at the hearings concerned who best *occupied* the site, the sculpture or the plaza, which is to say, who occupied the site *first*. She stated:"...the sculpture does not belong in the Federal Plaza because it is hostile both to its environment and hostile to the public, since it acts as a barrier to their free movements. The plaza is both an *integral part* of the design of the Federal Office Building and Courthouse and, at the same time, an *extension* of Foley Square Park" [my emphasis]. She continues to assess the damage that TILTED ARC enacts on the plaza's harmonious placement within the site of an idyllic public sphere: "This plaza was not designed to be an empty space, but it was designed as a place for people and for their public assembly. The plaza is a site-specific work of art incorporating a geometric pavement design, now destroyed."[11]

In tandem with Jacobs's testimony, compare here again Serra's defense of TILTED ARC positioned against the modernists in minimalist terms, all the while dialectically maintaining Modernism's basic suppositions about site:

> *The specificity of site-oriented works means that they are conceived for, dependent upon, and inseparable from their locations. The scale, the size, and the placement of sculptural elements result from an analysis of the particular environmental components of a given context... Based on the interdependence of work and site, site-specific works address their context, entering into dialogue with their surroundings. Unlike modernist works [i.e. those made by Brancusi and others] that give the illusion of being autonomous from their surroundings, and which function critically only in relation to the language of their own medium, site-specific works emphasize the comparison between two separate languages and can therefore use the language of one to criticize the language of the other.*[12]

This belief in a closed dialogue between two things—a work and its site—is consistent in both Serra's and Wright's defense of their respective projects, regardless of the intellectual divergences of their claims. Which is to say, each claim hegemonically privileges one side of this dialogue—the position of the speaking subject in the space of the work, who (which), *first*

with a deconstruction of dialectical temporality, see my "On Critics, Sublimation, and the Drive: The Photographic Paradoxes of the Subject," in ART: SUBLIMATION OR SYMPTOM Parveen Adams, ed. (New York: The Other Press, 2003).

10
Cited in William J.R. Curtis, MODERN ARCHITECTURE SINCE 1900 (Oxford: Phaidon Press, 1982), p. 200.

11
THE DESTRUCTION OF TILTED ARC, Clara Weyergraf-Serra and Martha Buskirk, eds., p. 124.

12
Ibid., p. 12.

JULI CARSON

identifies a site and *then* enters it. A harmoniously transcendent dialogue is then presumed to take place between artist and site, one unhindered by any possibility of the cacophony of other voices that might contradict the artist's projection that a site ontologically exists *a priori* to his engagement with it. A projection, in fact, that represses the manner in which one's engagement with a site retroactively constitutes that site, stemming from what one subjectively invests as *being* "there." What this repression maintains of Modernism's initial belief in transcendence, albeit by negation, is not the artwork's anti-materialist (or site-less), condition but the belief in an artwork's unadulterated experience in the form of a dialogic, *non*-contradictory existence *in-situ*. This belief, of course, maintains (as much as it is maintained by), classic tautological form, founded here upon the logic that a one-to-one dialogue exists *solely* between two languages because two languages are put into dialogue with each other. But, as we know, the logic of tautologies is that they exist because they say nothing of the world, and since all signification takes place within the world (i.e., all *utterances* are *spoken* in the world), tautologies—be they Serra's or not—can never really *show* themselves.

We must ask, then, if Serra is the speaking subject in this context, of whom does he *really* speak? Ostensibly he attempts to speak *for* himself and the work, but as we see he unwittingly contradicts himself, breaking ranks with his own tautological assertions by speaking instead of Greenberg by negation and Wright by discursive association. He thus begets, again, the Father in the space of Modernism *through* his very attempt to denounce him/it. For he is still within the snares of his/its logic about site. Serra here is the good Son he does not want to be, which we see even more when the "other" speaks back. Not because the other is right, but because the "other" inevitably will speak, even and *especially* when that other is spoken unwittingly by the author himself, the one who thus revenges himself upon his own closed definition of site-specificity.

THAT DANGEROUS SUPPLEMENT What happens when the "other" is something in the space of the expanded field that speaks *back*? This "other" may be the government in the form of power lines that were installed in the vista of Taliesin West, prompting Wright's letter campaign to the president in an attempt to have them removed. The attempt, of course, failed, prompting Wright defiantly to reconfigure Taliesin's living quarters to face its opposite vista: the blank side of the hill from which it was *intended* to spring forth. Or, the "other" may be the performative instance of a *disharmonious* public.[13]

For TILTED ARC, as we know, it was the GSA that first spoke back in 1984 when William Diamond pressed for a public hearing to relocate the work. One year later, from March 6-8, a hearing was held, at which time 122 people spoke in favor of retaining TILTED ARC and 58 spoke against it. Through this litigation, TILTED ARC became a wall that heterogeneously signified contradictory political and aesthetic ideologies. According to the GSA's security specialist, Vickie O'Dougherty, who conjured up the specter of a criminal public indexed by the sculpture's graffiti, combined with its encouragement of loitering and its obstruction of the government's visual surveillance of the plaza, TILTED ARC was a security hazard.[14] For Harry Watson, an employee of the Bureau of Investigations of the State of New York, TILTED ARC was an index of the government's wasteful insanity, a "rusted metal wall" for which the government paid $175,000, but which could be sold "to a scrap metal farm for maybe fifty dollars."[15] And for Shirley Paris, a private citizen, TILTED ARC was, simply, "the Berlin Wall of Foley Square."[16] A claim of violence being inflicted upon "the public" (in tandem with the public's fantasy that the sculpture would further encourage more violence), thus supplanted Krauss's assertion at the hearings that TILTED ARC "invest[ed] a major portion of its site with a use we must call aesthetic."[17] Indeed, this

13
For a specific discussion of how the controversy surrounding TILTED ARC served as an index of a disharmonious public sphere, one that is repressed by the notion of an utopian public born of Enlightenment thought, see Rosalyn Deutsche's "Tilted Arc and the Uses of Democracy," in her EVICTIONS: ART AND SPATIAL POLITICS (Cambridge: The MIT Press, 1996).

14
THE DESTRUCTION OF TILTED ARC, Clara Weyergraf-Serra and Martha Buskirk, eds., p. 117.

15
Ibid., p. 120.

16
Ibid., p. 126.

17
Ibid., p. 81.

was the modernist signified of which the arc (turned mere wall) contingently "spoke," but for which it was not a suitable "representation."

As appeals failed, TILTED ARC met its final demise in 1989. It is a moment Serra recalls in terms that phantasmatically evoke the trauma of a public execution:

> *Once my own say in the fate of the sculpture had been finally denied by the federal courts, William Diamond, the regional administrator of the GSA and the man most responsible for the campaign against* TILTED ARC, *acted immediately to have the sculpture removed. In a sinister all-night session on March 15, overtime work crews labored to dismantle tilted arc, brutally sawing and torching the piece. Finally around 4:30 a.m.,* TILTED ARC *was reduced to raw materials, to be carted off and stored in Brooklyn, reportedly pending relocation. "This is a day for the people to rejoice," said Diamond, "because now the plaza returns rightfully to the people.*[18]

18
Ibid., p. 3.

The discursive evocation here of the body's violation in the metaphoric space of the arc's "public execution" is unequivocally present in Serra's account: the denied attempt to stay the inevitable sentence, the subsequent midnight action, the "brutal sawing and torching" of the piece, the reduction to raw material parts, and finally the (phantasmatic), cheering mob. It was, of course, the very terms of Minimalism's *embodied* essence of production and reception that in part afforded, if not secured, the inevitably *personal* violation felt by Serra; for what was reduced to fragmented and discarded parts, shipped off-site and locked away, was not just the presence of a work of art, but, by metonymic association, the logic of Serra's authorship itself. But what of the *other* destruction that metonymically took place here, that of the author's presence/authority behind his own word? For Serra, it was the very moment at which *his own say in the fate of the sculpture had been finally denied* that the execution began. And in written defense of the integrity of this physical body, and in protest against its wronged execution, there emerged another body, the *corpus* of writing as both the executor and progeny of Serra's *own* word in (and on), the space of "site-specificity."

Let's return again to Plato, intertextually through our reading of Derrida's "Pharmacy" essay, whereupon we encounter another, even more familiar, wall. Of *logos*, as *the* Father or Source, it is impossible to speak directly, no more than it is possible to look directly into the sun. And it is here that Derrida directs us to re-visit Plato's famous passage from the REPUBLIC, in which the following scenario is played out:

> *Picture men dwelling in a sort of subterranean cavern with a long entrance open to the light on its entire width. Conceive of them as having their legs and necks fettered from childhood, so that they remain in the same spot, able to look forward only, and prevented by the fetters from turning their heads. Picture further the light from a fire burning higher up and at a distance behind them, and between the fire and the prisoners and above them a road along which a low wall has been built, as the exhibitors of puppet shows have partitions before the men themselves, above which they show the puppets... See also, then, men carrying past the wall implements of all kinds that rise above the wall, and human images and shapes of animals as well, wrought in stone and wood and every material, some of these bearers presumably speaking and others silent. What the men see,*

therefore, is not each other nor the men behind them, but only the shadow cast from the fire onto the wall of the cave that is in front of them.

That is what constitutes reality for them—the shadows on the wall. The scenario continues:

Consider, then, what [would happen when] one was freed from his fetters and compelled to stand up suddenly and turn his head around and walk and to lift up his eyes to the light?...And if he were compelled to look at the light itself, would not that pain his eyes, and would he not turn away and flee to those things which he is able to discern and regard them as in very deed more clear and exact than the objects pointed out?[19]

19
Edith Hamilton and Huntington Carins, eds., THE COLLECTED DIALOGUES OF PLATO (Princeton: Princeton University Press, 1989), pp. 747-748.

For Derrida, the mythic Father-as-Source of *logos* is located here in the place of that blinding light, the visible-invisible figure of the Sun as the origin of all "onta" (or Being). The shadows on the wall function as the *logos*, which represents him by proxy along the logic of a penumbra: *that partial shadow, as in an eclipse, which allows something to be partially seen by blocking it out.* But in doing so, the penumbra, as a type of *pharmakon* or supplement is a toxin in the very space of presence it means to relay.

Herein lies the paradox of signification in general, and writing in specific: the necessity of a representation to signify pure presence through *blocking* that which such representation means to preserve (the very definition of writing). This paradox was, of course, a basic post-structuralist lesson in linguistics that intrigued a branch of Postmodern artists (Sherrie Levine, Silvia Kolbowski, Cindy Sherman), in the very decade that Serra sought to defend the *presence* of his project through the *truthfulness* of his written record. And it was the same paradox that produced the aporic site of TILTED ARC, a site in which the controversy that logically succeeded it could, in fact, be understood as simultaneously producing it. For, without the controversy, transcribed into writing, TILTED ARC, the last living artifact of Modernism's *logos* of site-specificity, could never have been directly seen. Unwittingly, however, through the very act of being written, TILTED ARC became that wall within Plato's cave upon which reflections of Modernism's belief in the transcendence of site—in the form of a minimalist dialectical reversal—were projected and thus enacted. Of course, without the written supplement, such an "Arc" would never have existed. It would have remained sited in another signifying order, and as such it would have stood as that anachronistic rusted, steel wall, merely punctuating the end of an "embodied" sculpture's transgressive expansion.

What we have, then, is Derrida's legacy of *logos* enacted by Serra in the following manner:

Father	Son	Orphan
Minimalism	Expanded Field	Supplement
Embodied Presence	Site-Specificity	Discursive Site
Serra	Tilted Arc	The Destruction of Tilted Arc

First, we have what Serra intends, his word to mean something in the living *logos* of his minimalist form, against which a dangerous (Postmodern), subject is born in the form of the discursive site that undercuts the authority of his own word (on site). This is the instance in which Serra enacts the Platonic fear of speaking without knowing. But in the same gesture we have a dialectical reversal, a negation of a negation, which puts Serra's word in the mimetic space of

Greenberg's. Serra, as a man of his word in the late moment of Minimalism's last gasp, thus exists as a pivot between High Modernism and Post-Modernism, and against all *intentions* he at once begets one inasmuch as he is begotten by the other:

Father	Son	Orphan
Transcendence	Expanded Field	Supplement
Disembodied Sitelessness	Site-Specificity	Discursive Site
Greenberg	Serra	Tilted Arc

A boomerang effect is thus in play here, one in which the minimalist claim against authorial intentionality is undercut by the inherent intentionality of such a claim. For the work never simply *is*. Rather it begets as much as it is begot by the other that it is not, something TILTED ARC demonstrated through the legal, social, and philosophic fields in which it was inextricably entangled. And in the course of all this we experience the strange turn of events, a chronological reversal, whereby TILTED ARC gets away from Serra insofar as he moves uncomfortably closer to Greenberg's Modernism, as the prodigal son.

My use of the term "boomerang," is knowingly ironic, as it is the title of a video made by Serra himself that demonstrated the operation I am describing here; simply, that a subject is never located *only* in the place from which he/she speaks. BOOMERANG (1974), records Nancy Holt speaking with a slightly delayed audio feedback delivered to her through the headphones she wears. The video is called "boomerang" because it aptly demonstrates the state in which the subject experiences the temporal and psychic effect of chronological reversal. For Holt's own words come *to* her as much as they come *from* her. Increasingly, as the tape records ten minutes of this operation, we are confronted with the fact that there is no speaking subject *behind* the word, only a subject spoken retroactively *by* one's own word. Likewise, if TILTED ARC is therefore a model of the last living logos of Greenberg, as I've been arguing, it isn't due to Serra's authorial intention. Rather, it is due to a certain time-delayed feedback of its own. Moreover, the point should be made even more clearly that the author's intention for a given project's criticality does nothing to secure its function as such. For as regressive as I am arguing TILTED ARC to be, Serra's own BOOMERANG video just as clearly makes the case for an orphaned model of time that undermines the branch of Modernism to which Greenberg has been attached and for which (in the end) Serra's TILTED ARC unwittingly speaks.

PART II: ON TIME Now, to begin again. In Plato's REPUBLIC, the cave put into operation the dynamic of two walls: one behind the men over which objects are held as in a puppet show and another onto which these objects' shadows are projected. Should the men have turned around, they would have been blinded by the source of light that afforded the objects' presence via their projection; which is to say, the men would have been scotomatized by the very source that afforded the objects' *inscription* onto the world of representation. However, what we know of writing's paradox is that the subject may not, in fact, be blinded by the instance of an *actual* "sun"—itself a classic metaphor of pure auratic presence—but an *effect* that the subject may *experience* as being blinded.

What then blinds the subject if we are speaking not of a referent but of an effect? If we rethink this scenario in psychoanalytic terms, what would blind the subject, should he turn and look beyond representation towards what he believes to be the site of a primordial *source* of inscription, would be a dazzling encounter with something undifferentiated, which is to say, an

20

I am delineating these registers and heavily reducing their characteristics for brevity's sake. However, their interlocking complexity, like Charles Peirce's NOTION OF THE SIGN, is of great importance to note. Which is to say, one should not make the same erroneous presumption of the real, symbolic, and imaginary registers as have been made of the indexical, symbolic and iconic facets of the sign. For just as there is no pure index, Peirce was quite clear on this point, there is no "real" apart from the symbolic or imaginary registers, bound together as they are in a borromean knot.

21

The installation is documented in EAST International, Norwich Gallery (Norfolk: Norwich School of Art and Design, 2001).

encounter with pure *nothingness*. It would, in short, be a brushing up against what Lacan calls the "real," that third register of the subject's psyche that can't be represented in itself, but which instead drives the subject's position within the two other registers that do stand within representation.[20] These two registers are characterized for the subject in the following way. On the one hand, there is the acquisition of convention based upon semiotic difference (constituting the register of the symbolic), and on the other, the specular identification within the symbolic's visual terms (constituting the register of the imaginary). The concept of a "source" in the space of the real, then, unlike Plato's light, is something that quite simply exists by *not* existing at all, designating the real as a psychic *function* between the two other registers rather than a hidden *thing* beyond them. The subject, however, consistent with Platonic thought, needs to believe, against all evidence to the contrary, that the real exists in the place of something lost vis-à-vis its representation. Which is to say, when the subject looks at a representation, he staves off— though he is at once driven by—the threatening recognition that there may, in fact, be *nothing at all lacking* in what he sees.

What if we were to rethink the Platonic penumbra, therefore, not as a thing that obstructs something else, allowing us to glean that thing's glow through its partial obstruction, but rather as a state in which something hides the *fact* of nothing. Should we do so, a Lacanian penumbra would present itself, illustrating the manner in which the subject retroactively posits, albeit phantasmatically, something (some *thing-in-itself*), that pre-exists penumbral obstruction. And what if we were to apply this Lacanian principle, not to a deconstruction of the residual classicism of late modernist thought in the moment of Postmodernism's challenge of presence, but as a working condition of more recent deconstructions of site, one in which a temporal and spatial paradox is *courted* rather than disavowed? What would such an artwork look like? More importantly, what would it *do*?

Recourse to an anecdote is appropriate here. At the Otis College of Art and Design Fall 2000 artist lecture series, one of the participating lecturers, Kenny Berger, presented a talk on his installation project entitled WALL MEMORIES.[21] The project was provoked by the artist's simultaneous realization of two facts in the course of his graduate studies at UCLA. The first realization was "meta-historical." In the year 1989 a series of extraordinary events took place: the fall of the Berlin Wall, the Soviet withdrawal from Afghanistan, the student uprisings at Tiananmen Square in Beijing, the imprisonment and release of Vaclav Havel in Prague, OPERATION JUST CAUSE in Panama, The Exxon Valdese oil spill, the passage of the Helms Amendment barring any government funding of "homosexual" art, and amidst all this, the destruction of TILTED ARC. The second realization was autobiographic, a type of reaction-formation to the weight of this historical convergence. "The thing that struck me, in particular," Berger explained, "was how entirely inaccessible an intelligible recollection of that history was to me." The project thus took as its point of departure the temporal contiguity (in psychoanalytic terms), of the larger issue of historical memory (1989), with the specific problematic of the subject's incapacity to remember such history (1998).

Cutting across this dialectic was a peculiar "screen memory," a "little catastrophe," as it were, mediating the "big catastrophe." The one thing Berger could recollect of this historical moment, with sudden but great clarity, was the following event: In 1989, on the eve of his annual high school's charity basketball game, a flaming car was sent speeding across the field, destroying the school's cafeteria. The result of this event—the "catastrophe" for the subject here—was that the game was cancelled. Berger's talk went on to discuss how he chose to visualize the interaction of these three "moments," reduced to three discursive-temporal "sites"

(the historic fall of the Berlin Wall, the teenage basketball anecdote, and contemporary meta-historical consciousness), in order to address, as he put it, the "representational modalities for the effective address of history."

And then came the outburst. A German exchange student, excited and exasperated, demanded to know why Berger refused to do the appropriate thing; that is to say, why he refused to *memorialize* the fall of the Berlin Wall in the form of a proper public monument. For a monument, the student argued, was precisely what we needed in order to mourn and move on, something we could do only by locating the historical moment *there (then)* and our memorial *here (now)*. Of course, such an historicist notion of time is constituted by/from a discrete point of (meta)retrospective. And on this note, the student's challenge to Berger's "atemporal" relation to the Berlin Wall is not limited to twentieth-century discourse on the problems of memorialization, a topic to which I will return. Rather, this *logos* has its roots once again in Greek philosophy.

ARISTOTLE: FATHER TIME Of time Aristotle asserts "while it is resoluble into parts, some parts have been, some are to be, and none is."[22] Which is to say, time marks change on the level of our discerning a "before" and an "after" in relation to a given event. In this formulation the "now" necessarily stands outside of time because when we feel we are in time, we feel ourselves separated from the temporal positions of "before" and "after." Put another way, in the "now," no time seems to have passed, but when we do perceive a "before" and an "after" we are then speaking of time.

This notion of time should sound linear, even numerical in its progressive nature. On the analogy of time to numbers, Aristotle was in fact quite clear.

> *For that is what time is: number of change in respect of the before and after. So time is not change but is that in respect of which change has a number. And indication: we discern the greater and the less by number, and greater and less change by time; hence time is a kind of number. Thus, the thing that we are counting when we count time is "befores" and "afters."*[23]

If the "now," on the other hand, is quantitative at all, it has a value of zero because its value is not based upon a *period of time*, but of an *instantaneity* that transcends time. Unlike time, "now" is thus an indivisible and durationless point, a *point* that can be counted only once it has turned into that which has "ceased to be." Moreover, the "now," if it is not a period, is the *limit* of a period; for it determines time by marking itself off from the future and the past without taking up any time itself. In this way, time is not an adjoining of one "now" to another, because that would create a situation in which there were a simultaneity of "nows" in between which we would find infinitely more "nows." To the contrary, Aristotle argues, this is *temporally* impossible because if "both previous and subsequent nows are in this present now, then events of a thousand years ago will be simultaneous with those of today and none will be either previous or subsequent to any other."[24] So the "now," which is to say the *present* (and by extension *presence*), is outside of time because it is singular, incapable as it is of being redoubled. Simply, for what stands as present, there is only *the* here and now.

History, conceived of in a scientific, positivist light—a classic model based upon the successivity of events as first articulated by Thucydides—is related to this model of time. Aristotle's notion of time is thus the edifice for the historicist practice of teleological narration, one that works from (and through), a transcendental position of "now," wherein a calculation of

22
Aristotle, PHYSICS Book IV, Chapter 10, 218a, 5, collected in A NEW ARISTOTLE READER, J.L. Ackrill, ed., (Princeton: Princeton University Press, 1987), p. 123.

23
PHYSICS, IV, 11 219b 5, Ackrill, p. 125.

24
PHYSICS, IV, 10 218a 25, Ackrill, p. 123.

the succession of clearly delineated "befores" and "afters," in relation to a given event, ensues. Such historical successivity is afforded by the indivisiblity of the "now," for if "now" *were* divisible, "part of the past [would] be in the future and part of the future in the past," Aristotle argues. "For the point at which [now] is divided [would] be the boundary of past and future time." While the endless divisibility of the present wasn't conceivable for Aristotle or Thucydides, it is, of course, the fundamental principle underlying a psychoanalytic model of time. Freud's notion of time is one in which past and present loop infinitely around each other, *precisely* enacting the simultaneity of "now" and the "events of a thousand years ago."

Herein lies the classic problematic of temporality that *still* fosters debate: the assertion of an Aristotelian "moment-in-itself" against a post-structuralist "moment-not-itself," a debate reiterated in the polemic in which materialist historians (or dialecticians), and Freudian-Lacanians engage.[25] Lest one think that this post-structuralist question of temporality has been asked and answered in contemporary art practice, it is here that the German student's demand for a proper memorial circles back to us. For it is the Aristotelian, dialectical model of time that the logos of public memorials speak.

MEMORIALS AND MONUMENTS: THE SON'S RETURN Memorials stem from the mindset that one needs "to come to terms with the past," as they say. But as Adorno argues, specifically in relation to Holocaust memorials, coming to terms with the past "doesn't imply a serious working through the past, the breaking of its spell through an act of clear consciousness." Rather, "it suggests...wishing to turn the page and if possible, wiping it from memory," because to memorialize is to leave behind; moreover, it is to "forgive and forget."[26] The paradoxical act of remembering something in order to leave it behind should point us to the impossibility of locating a time that is clearly past, as Aristotle would have liked. This is because the past is always already located/ constituted in/by a given desire to remember it in the "present." However, we consciously deny this paradox in the instance of reflection or historicization, as we need a "before this" in order to free ourselves from the past. But this "before" is actually *conceived* in the phantasmatic space *from which* we believe ourselves to be perceiving it; which is to say, the "before" is instituted *in* the very space it *is not*—in the discrete, timeless, "now."

Recognizing this is not a relativist, historicist gesture. For there is, of course, an ideological impulse at work when we manipulate history vis-à-vis the disavowal of our continual presence in it, such that there is critical import to addressing memorials that posit historicity as unmediated meaning afforded by a classical concept of time. To deny the manner in which meaning is mediated by paradoxes of temporality is to cut ourselves out of history and consequently to remain unaccountable for what we ideologically and unconsciously *place* in the site of our so-called "discoveries." However, this is not to say that we are only ever and solely *there* in the past either. So, it is time's paradoxical *looping* effect that is important to maintain because the conflation of a given "then" simply as "now" amounts to the same move as positing a "then" *versus* "now." Which is to say, either move alone feigns an authentic *return* to a "now" that has "ceased to be" in the space of time conceived like a tapestry composed of discrete present and future moments delineated by an ephemeral present. But this is merely a phantasmatic tapestry through which the subject, unmediated by the unconscious intellectual constraints of his own condition, feels himself free to weave in and out.

Here I am specifically thinking of the problematic James Young attaches to the most cathected of war monuments: the reconstruction of German death camps, such as Auschwitz, which he calls "memorial camps."[27] The trouble with memorial camps, directly related to the

25

See: Slavoj Žižek, THE FRAGILE ABSOLUTE (New York: Verso, 2000); Joan Copjec READ MY DESIRE: LACAN AGAINST THE HISTORICISTS (Cambridge: The MIT Press, 1994); and Joel Fineman's THE SUBJECTIVITY EFFECT IN WESTERN LITERARY TRADITION: ESSAYS TOWARDS THE RELEASE OF SHAKESPEARE'S WILL (Cambridge: The MIT Press, 1991).

26

Theodor Adorno, "What Does Coming to Terms with the Past Mean?," in BITBURG IN MORAL AND POLITICAL PERSPECTIVE, Geoffrey Hartman, ed. (Bloomington: Indiana University Press, 1986), p. 115.

27

James Young, "Memory and Monument," collected in BITBURG IN MORAL AND POLITICAL PERSPECTIVE.

ideological use of Aristotelian time, is the way in which they collapse the difference between themselves and what they evoke, afforded by the viewing subject's phantasy of time travel.

> *In these "memorial camps" (as I will call them), the icons of destruction seem to appropriate the very authority of the original events themselves. Operating upon the same rhetorical principle as the photograph, in which representation and object appear to be one, the memorial camps at Majdanek and Auschwitz are devastating in their impact—not just for what they remember, but because they compel the visitor to accept the horrible fact that what they show is "real."... [T]he camps have been have been preserved almost exactly as the Russians found them forty years ago... Nothing but airy time seems to mediate between the visitor and past realities, which are not merely represented by these artifacts but present in them... Claiming the authority of unreconstructed realities, the memorial camps invite us not only to mistake their reality for the actual death camps' reality but also confuse an implicit, monumentalized vision with unmediated history. Though they contrive to preserve for memory the suffering of the victim and the past crime of the Nazis (a sort of dutiful writing of the victims' suffering word as pure presence), these camps, of course, are anything but unmediated.[28]*

To the contrary, memorial camps are, in fact, constituted by the same paradox Roland Barthes used to described the photograph's essence: the coexistence of its "there-then" (the event), with its "here-now" (the image). For memorial camps are paradoxically as much about those who maintain them now, as they are about those who maintained them then. In both instances the camp's maintenance relies upon national myths, religious archetypes, and ideological paradigms, the first time as tragedy, the second time as farce, as Marx said of the 18th Brumaire of Louis Bonaparte.

As such, memorial camps remember the victims to the extent that they continue to (re)write the victimizers' ideology—one unconsciously brewed in the present *through* the very belief that one is authentically returning to something irretrievably past. On this point, Young states:

> *In fact, the Holocaust memorials throughout the Eastern Bloc are often as Judenrein as the countries in which they stand. Jewish themes in these monuments are usually found only in the languages used to inscribe a memorial message. So in the center of a symbolic graveyard at Treblinka, enclosed by hundreds of protruding, jagged rocks set in concrete slabs, a stone plaque reads from top to bottom in Yiddish, Russian, English, French, German and Polish: "Never again." What it is that must not happen again is left to the visitor's imagination. In memorial camps like Treblinka and Auschwitz-Birkenau, the "remembering icons" continue to elide the religious identity of the victims and why they suffered, an elision based upon the residual intolerance for those who no longer remain but who, nevertheless, are historically "memorialized."[29]*

Memorialization, as a kind of screen memory taken for a real event, thus covers up a contemporary intolerance in the same gesture that it symptomatically and supplementally acts it out. Camp memorials, in particular, let us forget one thing (a present, unconscious anti-semitism), in the place of remembering another (a past, conscious anti-semitism).

28
Ibid., p. 106.

29
Ibid.

30

The arguments I am making here about the historical event and the ethics of a non-positivist approach are taken up in a different context, that of the "face of the other," by Emmanuel Levinas. Specifically relevant is his discussion of what lies beyond the face for the subject, a concept that allows identity to coalesce. It isn't within the scope of this essay to weave his theory of the other overtly into this discussion. I cite him, however, in order to signal a loose inter-textual reading here. See: "La Trace de L'Autre," translated by A. Lingis, TIJDSCHRIFT VOOR PHILOSOPHIE (Sept. 1963).

31

Jacques Lacan, THE FOUR FUNDAMENTAL CONCEPTS OF PSYCHOANALYSIS, trans. Alan Sheridan (New York: W.W. Norton & Co., 1981), p. 103.

32

Fredric Jameson wages what may sound like a similar complaint about the image-permeation of everyday life in "Transformations of the Image in Postmodernity," in THE CULTURAL TURN: SELECTED WRITINGS ON THE POSTMODERN 1983-1998 (London: Verso, 1998). However, an unconscious residual effect of Jameson's analysis is a latent melancholia over the loss of authentically autonomous aesthetic experience. It is the philosophic basis of such melancholia that I mean to unpack here by truncating the very dialectic of authentic vs. inauthentic, regardless of whether we are speaking of modernist or post-modernist production.

THE MOMENT-NOT-ITSELF: ORPHANED MEMORIES There is an ethical dimension, then, to avowing the moment-not-itself, something that Berger's WALL MEMORIES plays upon.[30] Operating from the position of "orphaned" time, that is, operating from the psychoanalytic model of time against the more ubiquitous one of Aristotle, he makes us ask who looks from where and for what? This atemporal representation of the Berlin Wall's destruction ("atemporal" in the sense of metalypsis not transcendence), positions the viewer squarely within the Lacanian dilemma of the scopic drive. As Lacan said in Seminar XI: "When, in love, I solicit a look, what is profoundly unsatisfying and always missing is that—*You never look at me from the place from which I see you. Conversely, what I look at is never what I wish to see.*"[31] In love, there is thus the problem of an untraversable divide, initiated by the primordial instance of the mirror stage, which the historian analogously faces vis-à-vis his object cause of desire in the form of a "lost" past event. As Lacan said, on the matter of the subject's never being able to complete himself by way of coalescing with the other, *there is no sexual relation.* The same may be extended, allegorically, to the historian and his event when we say: *there is no historical relation.*

This is not to say that there is no history, but that it is impossible to attain the highly cathected object that we approach, be it in love or in research, because it is the very impossibility that makes an object cathected in the first place. Now, the nature of this impossibility can be described by Zeno's paradox of Achilles and the tortoise at race. Simply, the slower runner, the tortoise, will never be overtaken by Achilles, for the pursuant runner must first reach the point from which the slower runner started, such that the slower must always be some distance ahead. What this implies is the paradox of an infinite regress at work in the very instance of each step forward a runner takes. Say I want to move a certain distance, 100 feet, in a certain amount of time. I'll never actually get there from here because to reach the 100 feet mark, I must first reach the 50 feet mark, and to reach that I must first reach the 25 feet mark, but to do that I must first reach the 12.5 feet mark, and so on and so forth, until I have not moved at all. Of course, a person in the world can actually walk forward 100 feet. So what we have here is a paradox of mathematical logic that posits at once the indivisibility of space and its divisibility, a paradox that can psychoanalytically be extended to interrogate positivist historical logic. What the subject, then, consciously does in the actual approach of his (historical) object is undercut unconsciously by an unavoidable recursivity. This is the crux of WALL MEMORIES' investigation: the manner in which the historian's approach is necessarily (but unconsciously), all aim and no goal.

On this level, the issue of recollection is central to Berger, as it is the point at which his own positionality is interrogated. The problem of memory that attends all historical investigation is especially acute for those of Berger's generation, raised in a post-Baudriallardian moment of critical recuperation aided by academia's consumerist proliferation of cultural theory departments. Simply and literally, for many there is nothing beyond representation because the nebulous category "representation" problematically is the meta-object of analysis. No relational paradox at work here, only the flip side of the Platonic ideal, as the memorial camps demonstrated: the Aristotelian "it just is." In filmic terms, the historical event that the documentary HOLOCAUST humanistically tried to represent, just is the movie SCHINDLER'S LIST for a subsequent generation raised on the simulacrum.[32]

However, either move (humanist Marxist or post-modern simulationist), turns a blind eye to the manner in which "nothing" functions as a driving *thing* in representation. This "nothing" is quite different from a nothing that is nothing at all, the latter of which dialectically maintains the positivist belief in something being "nothing but *this.*" Such a positivist, simulationist impulse is an instance of the subject aligning himself with the image. Because, of course, such a move is

a type of reaction-formation devised to tame the image. This it does by laying down the threat attached to knowing that beyond the image there *is* nothing to see or to be in, a threat produced by the subject's desire to believe, in fact, that there is something beyond the image to see—the desire to *see what* the image represents. But, as I previously said, in the context of a Lacanian penumbra, the subject is chasing something he can't have because this "thing" necessarily and paradoxically is only ever there in the form of that-which-it-is-not. The scopic drive, nevertheless, provides a consistent pressure that produces in the subject his aim of peeling away one layer of representation after another in order to find or experience something essential. In so doing, the subject enacts an attempt to regress infinitely to a state of pure presence of form, some *thing* in some *place*, of course, that he can't and won't ever encounter. Hence: *What I look at is never what I wish to see.*

How, then, does the subject approach the historical event as it comes to be represented vis-à-vis this problematic of "nothing?" It's a pertinent question because to ask this cuts across the dialectic of an authentic moment *behind* representation, versus a tautological conflation of an event *with* its representation *as* the event. But how to get there, to the event, when there's no *there* there? As Berger's work demonstrates, putting the concept of a screen memory into play with one's narrativization impulse (a constant pressure in our conceiving of time), visualizes (as oppose to solves), the problem of nothingness vis-à-vis historical memory and representation.

For Berger, what is looked for in the space of the screen memory is neither the humanist, ontological event (epistemologically barred from him), nor the semiotic certitude of the image alone (an uncritical move towards coalescence). Instead he looks for the operation of what Lacan calls the "vel," that paradoxical imbrication of the "neither/nor" of two different sets. For Lacan, the vel is the source of the subject's primordial alienation not because he exists *only* in the field of the other but rather because he finds himself in the *division* between "meaning" and "aphanisis." Conventionally we know of two vels. The first one posits an *either* here or there (I can't have both, I must choose). The second posits a relativist either here or there (it doesn't matter which, I'm ambivalent). Lacan, however, is interested in a third vel. "The vel of alienation," he explains in Seminar 11," is defined by a choice whose properties depend on this, that there is, in the joining [of two sets] one element that, whatever the choice operating may be, has as its consequence a neither one, nor the other."[33] The example he gives is the impossibility of choosing between the threat "Your money or your life." To pick money means giving up one's life, but to pick life with no money is to have no life at all. One can exist in neither one state nor the other.

Lacan thus argues that the subject is defined in a state of alienation afforded by a primordial impossibility of separating being and meaning. For instance, in conceiving of a subject, if I choose to place him solely in the position of "being," the subject disappears because he falls into non-meaning (i.e., we fall outside language). If I choose meaning, the meaning survives only deprived of that part of non-meaning that constitutes in the realization of the subject the unconscious (i.e., we fall into positivism). Extended to the historical event in Berger's work: I am neither here (on the side of meaning in representation), *nor* there (on the side of being in the space of the event). As such, subjectivity—constituted *as* a temporal crisis—is located in the division between the two. Historically speaking, if we choose the pure presence of the event (being), the event falls outside of meaning; if we chose the mere representation of an event (meaning), the image/text falls outside of any recognition of the subject/analyst's unconscious affect. Thus said, what is the "here/there" of Berger's investigation? Moreover, what is the division in WALL MEMORIES, through which the subject is constituted vis-à-vis his object cause of desire, one that phantasmatically promises to resolve the subject's paradoxical temporal position?

33
Ibid., p. 211.

First, a description of the installation's physical layout, which enacts a certain spatial "vel." Berger calls the structural center of this enclosed installation a spatial "no-man's-land," a space as much defined by its two "exterior" borders—two 8 x 4 x 23 foot walls adjoining two permanent structural walls—as these borders are defined by the space between them. The "exterior" of these borders, moreover, is not secure because their porousness simultaneously directs our attention to the installation's interior. On the outside of one border, a small "window" allows us to physically glimpse the interior. On the outside of the opposite border, a built-in video monitor shows a looped segment from the movie CRASH, in which the protagonist's car crashes through a highway divider. This allows us to "preview" intellectually the interior montage of video projection and audio narrative, directly related to the Berlin Wall.

Such spatial paradoxes as these were fundamental to minimalist practices like Morris's, exemplified by his four mirrored cubes whereby "interior" and "exterior" hang in the balance of infinite chiasmus—the exterior of the cubes simultaneously reflecting the interior of the house in which it sits, for example. What is different in Berger's case is that this spatial paradox, or vel, intersects with something the minimalists overtly kept out of their work in the 1960s: narrativity. In Berger's hands, however, the narrative isn't overlaid onto the work as with Haacke's 1980s ISOLATION BOX, wherein we see the conventional vel: *here*, a cube, *there*, a narrative covering it like a skin—an approach that informed Felix Gonzalez-Torres' work of the same period. In WALL MEMORIES, phenomenological experience can't be separated from (nor conjoined with), narrativity, as the latter can only be gleaned vis-à-vis the space that it is not. If the two are bound up, they connect such that something of (or between), these two sets of ideas, derived from the meta-idea of being and meaning, is never there as either one or the other. Rather, something paradoxically exists at the interstice of *neither* phenomenology *nor* narrativity. Which is to say, the event's meaning is neither physically here in the installation nor conceptually there in its historic, referential site. Rather the event's meaning performatively drops out of (but is simultaneously produced within), the tension between the two. And by imaginary extension, the subject's meaning drops out/exists in this vel because the subject is never solely *there* in the field of historic other, nor is he *here* in the space of perception.

The question of narrativity brings us to a temporal vel, which, of course, deconstructs the conventions of narrativity. In the installation's "interior" a video projection is culled from three sources: ODE TO JOY and FREEDOM, a documentary on the fall of the Berlin Wall; videotaped material recorded during Berger's visit to Berlin on the tenth anniversary of the fall; and WINGS OF DESIRE, Wim Wenders' 1987 film. Projected eight feet high onto one of the permanent walls, the looped images alternate and pulsate at varying rapid speeds, ranging from 1/15th to 17/30th

of a second. The audio narrative, delivered in a monotoned voice over, is also culled from three sources: the novel CRASH, in which the protagonist gives a first person account of imaginary car crashes; a first person account of Berger's own recollection of his high school car crash; and a series of newspaper excerpts discussing the high school accident. The audio narrative, delivered in a single voice, alternates from source to source such that the subject position "I" continually displaces itself from one temporal, discursive site to another. Exactly *who* is speaking, in relation to *what* event/image, slips and slides in an atemporal pulse evoking the undifferentiated, free flowing character of unconscious drives.

It is precisely in relation to this temporal "vel" that the screen memory enters the picture. 1989 is ostensibly the "there"—but only *there* insofar as the adult recollection of a childhood dream by the Wolfman, Freud's famous analysand, was the belated "there" of an even earlier primordial event. Analogously, the adult recollection in 1998 of a childhood event from the year

1989 retroactively points to an even earlier moment in which the subject phantasmatically understands (or projects), what it is like *not* to be able to be a Communist in a post-cold war episteme after the fall of the Berlin Wall or, associatively, a modernist (after the destruction of TILTED ARC). What is "here" in the space of the subject's "now" are representations of or near the year 1989, both documentary (ODE TO FREEDOM), and literary (WINGS OF DESIRE). Between the temporal site (there/here), and discursive site (fact/fiction), the screen memory intervenes quite literally in the guise of a car crash, represented associatively through the newspaper accounts (documentary), and the movie/novel CRASH (literary).

Through the screen memory's temporal intervention, Berger thus presents us with an endlessly divisible "now." However it is not a divisible "now" located at one point in time that infinitely regresses to its interior—a sort of Chinese box effect. Rather, the "now" is divisible in its endless temporal *displacement*. In this way, instead of an instantaneous "now" at the limits of before and after, we have what Aristotle dismissed as a simultaneity of "nows." Which is to say, in WALL MEMORIES the "before" (communism and Modernism), is not delimited from the "after" (contemporary recollection), by way of a transcendent and therefore forever lost "now" that in "ceasing-to-be" becomes a monumental event (the fall of the Berlin Wall and the destruction of TILTED ARC). Rather, the screen memory, characterized as it is by making meaning for the subject through the deferred action of "recognition," affords the temporal confusion Aristotle warned against: part of the future is in the past and part of the past, in the future.

So, what falls out of the temporal division here? What is the subject's object-cause of desire, or that "thing" algebraically standing in for a phantasmatically lost object produced in the vel between being and meaning?[34] This may very well be our *idea* of the event in question. In the last two decades of the twentieth century, "returns" to the events of World War II and subsequent Cold War typically oscillate between spectacular consumption (narcissistic indulgence and commodification), or political passivity (let's wipe the slate clean and move on).[35] Between these two cynical variations of Postmodernism I have posited a psychoanalytic model as a critical imperative. For this allows us to visualize the space of the drive itself, that is, the subject's *aim* of getting to the (lost) event, which in fact circles around our *idea* of that event, presented to us in the guise of its multifarious visual representations. In so doing, perhaps WALL MEMORIES' most ethical achievement is the manner in which, unlike conventional memorials, it makes no attempt to (re)present the pain (or the pleasure), of a highly cathected past political moment. Rather, it *effects* the subject's contemporary pain of *never* being able to get at that moment, though he endlessly takes aim at it.

Leaving the event altogether (being without meaning), or simply coalescing around its image (meaning without being), are normative goal-oriented approaches to history and memorialization. Again, Berger is working across either trajectory. For many, the fall of the Berlin Wall specifically meant the end of communism as a failed experiment, but more generally it also meant the death of a certain *conviction* of presence. Rather than taking either a cynical or a melancholic approach to the impossibility of re-presenting the event, WALL MEMORIES takes the problematic of never being able to attain the (lost) moment *as a means of* asserting conviction itself. For it is *there* that the subject *wants to be*. Such that it is there, in the space of wanting, in neither the space *before*, nor the event *after*, that we find the subject's closest proximity to his object, in the space of the simultaneous (non-self-same), *now.*

CODA: THE INTERNATIONAL STYLE The supplanting of the subject's phantasy of historical plenitude, afforded by performatively positioning him within the eye of historicity's problematic,

34
Berger's visualization of this moment is meant, allegorically, to constitute a critique of historicity rather than a clinical analysis of culture's general desire. The latter approach would be to align oneself with Jung who, unlike Freud, believed in a collective unconscious.

35
Again, Adorno addresses the problematic involved in "wiping the slate clean" in COMING TO TERMS. For questions associated with the spectacular account of historical atrocities, see: Stephen Greenblatt's introduction to his LEARNING TO CURSE (New York: Routledge, 1990). Also see Fineman's THE SUBJECTIVITY EFFECT for a non-dialectical challenge to Greenblatt's theories.

36
See Rosalind Krauss's "A Voyage on the North Sea" in ART IN THE AGE OF THE POST-MEDIUM CONDITION (New York: Thames and Hudson, 1999).

allegorically supplants his phantasy of visual plenitude as well. This is why WALL MEMORIES purposefully takes up the formal tactics of what Rosalind Krauss calls the new international style: video projection, as third generation Greenbergian painting, founded upon the positivist notion of the "self-same."[36]

From mega events like the "2001 Venice Biennale" to more ubiquitous group shows like "Making Time: Considering Time As A Material In Contemporary Video & Film" mounted at UCLA's Armand Hammer Museum (2001), contemporary video installations, regardless of the artists' intentions, have increasingly left behind the paradoxes of subjectivity and presence that dominated the medium in the 1970s. I am thinking of such important work as Serra's BOOMERANG or Vito Acconci's CENTERS (1971), in the face of recent work following Douglas Gordon's lead. While Gordon and others (debatably), make video projections purporting to disrupt the conventions of narrativity and temporality, cultural institutions nevertheless consume and "frame" the work as if they were color field painting. In this way, recent video in the form of large scale, discrete projections, are now as common as modernist painting was in the 1960s (Jules Olitski, et al), or "trans-avant-garde" painting was in the 1980s (Julian Schnabel, et. al.). Increasingly, video art is installed so monumentally that the fundamental qualities Greenberg alternately attached to the medium of painting (flatness of image and disembodied opticality), are similarly emphasized. Indeed, in both "Making Time" and the "2001 Biennale," recent video work was projected in individual darkened rooms such that their interactivity with anything other than one's singular, transcendent point of vision could phantasmatically be negated. Significantly, in "Making Time" all videos from the 1970s were shown in one room on different monitors, not only affording a certain seriality but a definite interactivity. The 1990s videos, on the other hand, were all located, and segregated, elsewhere.

WALL MEMORIES borrows two key traits from this "international style": projection and isolation. But it does so with the intention of putting what Krauss calls the "self-differential condition of mediums" to work against the phantasy of transcendent, self-same visual plenitude that usually attends these traits in recent video. Berger's work thus proposes that sculpture's expanded field be extended beyond (while still incorporating), the materialist conditions of the work's exhibition (Minimalism's project in the 1960s), the non-narrative capacity of film (structuralism's project in the 1970s), or the discursive function of the work's "allegorical impulse" (appropriation's project in the 1980s). Berger factors into this "expanded" field the temporal problematic of historical site, a move that necessarily entails the employment of psychoanalytic paradoxes as both a methodological and a critical tool. Such a move puts the operation of the drive to work as a conceptual device capable of visualizing what video artists explored in the 1970s: the self-differential condition of time. It does so, however, beyond the formalist, narcissistic concerns of video's first generation artists. In Berger's hands, the "field" thus expands from the medium-not-itself to the (historical) moment-not-itself, a critical reconfiguration of "site-specificity" at a time when the impasse between relativism and humanism has ushered in a disengaged, site-less model of video as the new formalist painting.

LIZE MOGEL

PUBLIC
GREEN

In 2001, I initiated the PUBLIC GREEN project in Los Angeles. This mapping of publicly, accessible green space in the city and environs is posted throughout the public transit system, inside city buses and in transit shelters. Cartographic and textual information shows the distribution of green space across Los Angeles, illustrating the complex and symbiotic relationship between the development of parkland and the growth of the city. The map locates public parks and frames an understanding of historical and current practices of acquisition, creation and maintenance of public green space in regards to Los Angeles economics, real estate practices, and history.

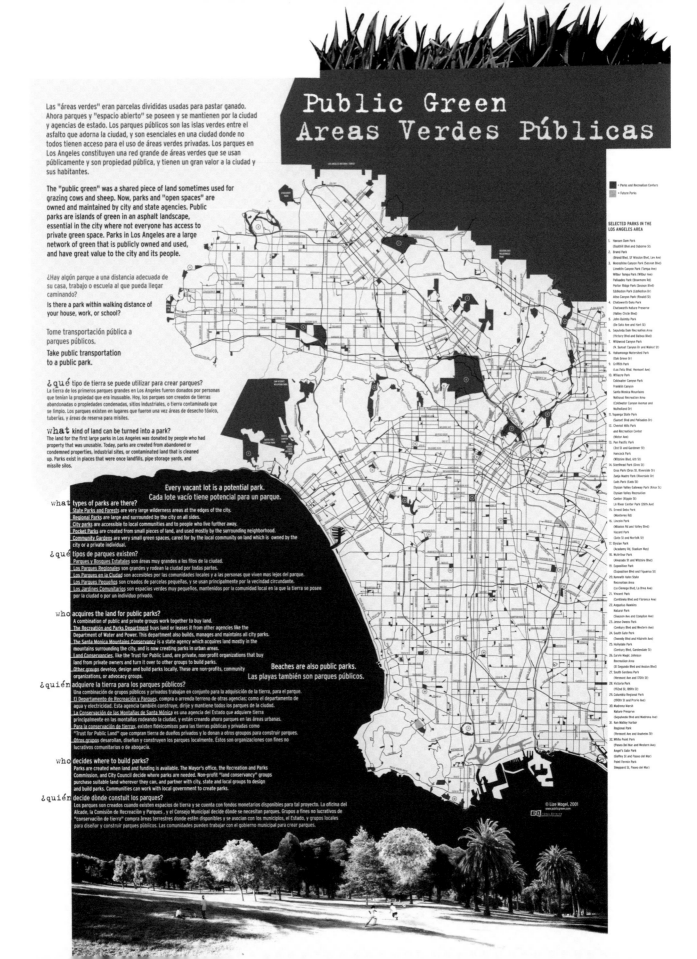

PUBLIC GREEN is displayed inside city transit shelters donated by four communities who use local shelters for community postings, as well as through Viacom Outdoor, which owns and operates the advertising "real estate" of all city transit shelters. PUBLIC GREEN suggests the use of the public transit system as a vehicle for tourism of parks—a fragmented greenscape connected by transportation networks.

PUBLIC GREEN poses questions about ownership of land, and suggests the transfer of property from private to public

LIZE MOGEL

use. Viewers are asked to rethink their local landscape, and to physically transform their environment. Through tactics of information distribution along existing transportation networks, the viewer becomes an agent of mobility and change. The information in the posters can be used geographically, to find parks locally or near daily commutes; or as a basis for community advocacy. PUBLIC GREEN proposes a dual function of maps: as wayfinding devices which locate the self and possible destinations, and as means for activating political agency.

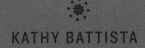

KATHY BATTISTA

DOMESTIC CRISIS: WOMEN ARTISTS AND DERELICT HOUSES IN SOUTH LONDON 1974-1998

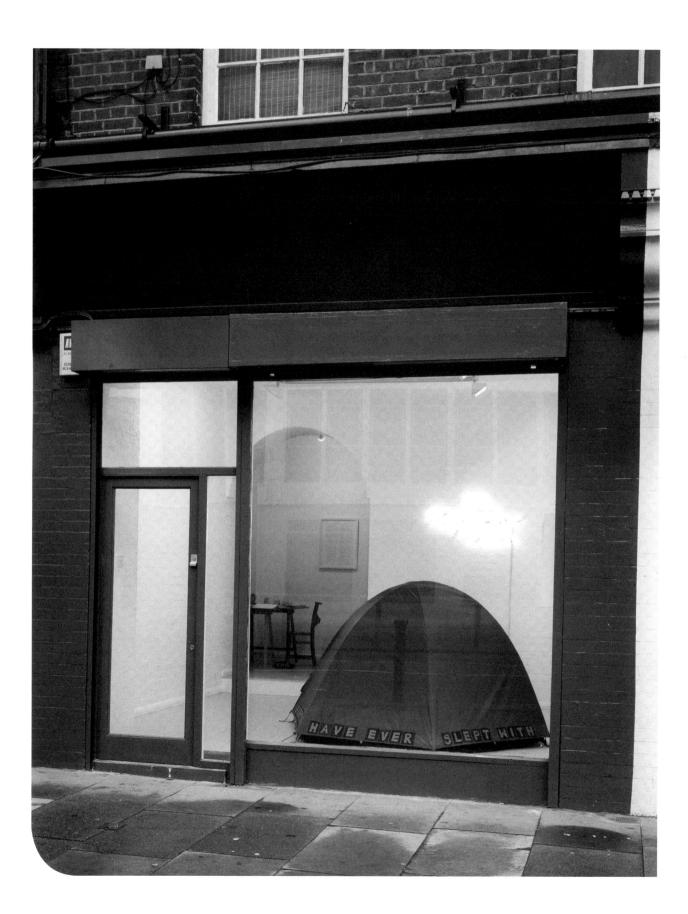

n North America and Europe, women artists in the 1970s gathered forces and attempted to create and organize spaces to show their work through short-term occupations of women's centers and in alternative institutions created for the sole purpose of showing women's art. London was a hive of this type of activity in the middle to late 1970s, and at times took its inspiration from American projects earlier in the decade. Exhibiting in spaces allocated for women's art solved the dilemma of going public: women could mobilize their work and present it to sympathetic audiences. However, the question of the ability to transcend the ghetto they themselves created remains.[1] While artists such as Mary Kelly occupied both ends of the spectrum, having devoted time to women's projects, but also received wider recognition, many others suffered in their isolation from the "mainstream" system. For example, many of the women making art at that time did not continue with their practice because of lack of funds or familial demands. Looking back at the phenomenon of women showing in their own spaces it is necessary to ask the following questions: What was the investment made in this type of "alternative" strategy? Did these exhibitions lead to further isolation from what was considered the mainstream art world, or help to encourage a burgeoning practice? Which kinds of sites in London were amenable to their projects? How did the marginalization of women's art in London during the 1970s both reinforce and resist conventional notions of gender? How have contemporary female British artists reckoned with the so-called "essentialism" of 1970s feminism? What were some of the spatial politics of the domestic sphere as seen by particular women artists in the 1970s? And finally, is it possible to draw conclusions about specific changes in these perspectives since that time? These are some of the questions examined in this essay through specific examples of women's artistic production since the 1970s.

✴

LONDON In London many women artists were open about their animosity toward the mainstream gallery system, and chose to work outside of it. In 1976 Rose English and Sally Potter created a four-part performance called BERLIN, which took place in an ice rink, a squat in Mornington Crescent, and a swimming pool at Swiss Cottage. In the early 1970s Rose Finn-Kelcey placed her flag pieces in highly visible public locations, including controversially, on top of Battersea Power Station. Bobby Baker created an entire edible family and then invited guests to consume it in her Acme[2] pre-fab mobile home, which doubled as a studio and living space. Anne Bean gave a performance in the Thames River, while Silvia Ziranek performed on its bank. This was not a phenomenon limited to women; similarly, male artists were working outside of the system. For example, Stuart Brisley did ritualized walks in the English countryside and at one time had a residency in a factory.[3] Gustav Metzger and John Latham were producing auto-destructive art events[4] on the South Bank, and David Medalla enacted impromptu performances, often undocumented and unseen by anyone.

Rose Finn-Kelcey described the sentiment of some artists in the early 1970s in London:

We thought, 'We don't want to show in white cube spaces. We don't want to have anything to do with a commercial gallery—they are death.'...And so a lot of us looked outside the galleries for alternative sites to do work, and made work for those sites.[5]

←
The Tracey Emin Museum, 1995-96
PHOTO COURTESY OF WHITE CUBE GALLERY, LONDON

1
Take for example, the Women's Free Arts Alliance in London, whose name was eventually shortened to the Women's Arts Alliance. Men were only allowed to visit at certain times, for example during private views. This necessarily excluded a large percentage of the art-going public.

2
The Acme Housing Association Limited was (and still is), a non-profit charitable organization that provided artists with inexpensive studios and living spaces in London. This was developed by Jonathan Harvey and David Panton from a small, self-help group into an institution that dealt with various problems facing artists in London. They also ran a gallery—also called Acme—from 1974–1980.

3
Brisley spent eighteen months in a new town in North England and became interested in the plight of the miners as part of his involve-ment with the Artists' Placement Group, run by John Latham and Barbara Steveni. For more infor-mation see andrea tarsia and tamsin dillon, A SHORT HISTORY OF PERFORMANCE: PART ONE (London: Whitechapel Gallery, 2002), unpagi-nated; or John A. Walker, "APG: The Individual and the Organization, A Decade of Conceptual Engineering," in STUDIO INTERNATIONAL (London: March/April 1976, vol. 191, No. 980), pp. 162–172.

4
For more information on the Destruction in Art group in Eng-land and their 1966 conference in London, see Kristine Stiles, "Thoughts on Destruction Art," IMPAKT (Utrecht: Impakt Festival 1997), pp. 2–5; and Kristine Stiles, "Thresholds of Control: Destruction Art and Terminal Culture," in OUT OF CONTROL (Linz, Austria: Ars Electronica & Landesverlag), pp. 29–50 reprinted in Timothy Druckrey, ed., FACING THE FUTURE: A SURVEY OF TWO DECADES (Cambridge, MA: The MIT Press, 2000).

5
Rose Finn-Kelcey in discussion with the author, June 15, 2000.

6
To this day, none of the female art-
ists working in the 1970s in London
have gallery representation, except
for Mary Kelly, who now lives in
Los Angeles and has representation
in New York and Los Angeles.

7
Lisa Tickner in discussion with the
author, 26 June 2000.

8
Thanks to Jack Wendler for a
discussion with the author about
his gallery and the general climate
of the art world in London during
the 1970s.

9
"Feministo" became the name of a
women's postal exchange, in which
small and mostly ephemeral works
of art were sent between women
artists. Meant to be an alternative
to the isolation of working within
the domestic space for women
confined to their homes, "Feministo"
eventually became a major tour-
ing exhibition: "A Portrait of the
artist as a Housewife" was at the
Institute of Contemporary Arts in
London, June 10–July 20, 1977.
"Feministo" was also presented
at The Readers Lounge, Central
Library, Birmingham, August 4-27,
1977, and at the Academy Gallery
in Liverpool, October 4-18, 1977.
Sadly, but perhaps indicative of the
spirit of the project, much of the
work has been lost or destroyed.

10
This was located in a house at 14
Radnor Terrace, in the Brixton
district of southwest London, which
falls within the Lambeth council.

11
Telephone interview with Kate
Walker, August 8, 2001, by Kate
the author.

For artists in the early 1970s, when Finn-Kelcey was emerging from art school, the commercial stakes were much lower than in today's market. It was not a feasible option to become an overnight success and sell works for vast amounts of money. Instead artists strove for freedom to experiment as their paramount goal. Today's markets appear to welcome such seemingly radical gestures, but quickly commodify and institutionalize such work. For example, the "Freeze" exhibition organized by Damien Hirst and his colleagues in a warehouse in the Docklands in 1988 is now the stuff of legend; garnering an almost mythic reputation as a radical intervention by a cast of irreverent youngsters. Almost every artist in that exhibition has gone on to considerable financial success. Most importantly for the discussion here, female artists such as Tracey Emin (who did not show in "Freeze"), and Sarah Lucas (who did), were welcomed into the commercial market with representation by major London galleries.

This was not the case for women artists in the 1970s.[6] But, indeed it is important to remember that part of the ideology of many practitioners at the time—female or male—was to actively refuse the commodification of their work. Art historian Lisa Tickner recently looked back on the feminist aversion to the blue-chip gallery system:

> *I think there was a feeling in the 1970s, in certain quarters, and this is just a memory of the flavor and temperature of the times, that there was something called selling out,…and to do this was absolutely unacceptable. And certain things would be considered without reflection as ipso facto selling out. So having a show, working other than in a group…or being an individual but having an exhibition in a commercial gallery…*[7]

While Tickner's remarks are poignant, it is difficult today to imagine the intensity of reaction against the mainstream system. However, even in some of the more mainstream galleries, there was little expectation of making money. For example the Jack Wendler Gallery in London showed many of the main proponents of early Conceptualism and Minimalism including Carl Andre, Lawrence Weiner and Sol Lewitt. Wendler has noted that most of the works remained unsold, although the gallery was located centrally in Covent Garden, nearby other important spaces such as Garage.[8] Thus the motivation behind avant-garde artists and dealers in the 1960s and 1970s in London seems to have been focused more on a cultural belief than on a business mentality. For feminists, the added dimension of questioning and challenging accepted societal codes would have provided even further incentive to function within an alternative system.

SOUTHWEST LONDON: "A WOMAN'S PLACE" Kate Walker, one of the founders of "Feministo,"[9] was instrumental in creating a center for women in southwest London.[10] The local council gave the use of the house to Walker's group at a low rent to enable a women's advice center. Walker recounted her impressions of the house: "We got hold of this tiny house, three stories high, unreclaimed, unrestored, fairly scruffy, and we did it up and it was an office."[11] Walker's group was one of the more radical and under-documented factions of the women's liberation movement in London; however, it is an important British example of women occupying domestic spaces as an alternative to gallery practice.

An advertisement described the center as "a Women's Liberation information service":

> *Apart from the collating of information about feminist and related groups and activities, we also have information on other relevant services offering practical*

help and advice... We currently have three meeting rooms available for women's groups to book, and duplicating and scanning facilities, which are used weekly by The London Women's Liberation Newsletter Collective, amongst other groups.[12]

As a local center, women could drop in and have a drink, and pick up relevant information relating to the movement. It was self-sufficient, funding itself by selling books while members worked diligently to keep the center running.[13]

Walker was a friend of the artist Sue Madden, who was part of the Peckham Group.[14] It was through Madden that she learned about WOMANHOUSE,[15] a project from 1972 by American artists Judy Chicago and Miriam Schapiro, and their students at The Feminist Art Program at CalArts.[16] In this project the students, under the tutelage of Chicago and Schapiro, reconstructed a derelict house in Los Angeles, making installations in each of the rooms. Thus, they were able to utilize spaces that were loaded with feminist associations, such as the bathroom, bedroom, kitchen and even the dollhouse. Schapiro wrote about the examination of domestic spaces:

> *We asked ourselves what it would be like to work out of our closest associative memories—the home. Our home, which we as a culture of women have been identified with for centuries, has always been the area where we nourished and were nourished. It has been the base of operations out of which we fought and struggled with ourselves to please others. What would happen, we asked, if we created a home in which we pleased no one but ourselves? What if each woman were to develop her own dreams and fantasies in one room of that home?*[17]

For example, the kitchen was transformed into an installation featuring breasts protruding from the walls, and Sandy Orgel's LINEN CLOSET was a tongue-in-cheek comment on the role of women in the domestic division of labor. In this installation a female mannequin is seen attempting to step out of a linen closet, her neck and torso bisected by shelves. Works such as this one, made by a young feminist student, helped to instill confidence in participants, and gave them the space to experiment and express themselves in a manner that would've been impossible in a traditional art program.[18]

L.A.'s WOMANHOUSE became the inspiration for Walker and her British colleagues, who in 1974 took over the Radnor Terrace women's center for a similar exhibition entitled A WOMAN'S PLACE. Phil Goodall, Patricia Hull, Catherine Nicholson, Sue Madden, Sue Richardson, Monica Ross and Suzy Varty, along with Walker, transformed the house into various exhibition spaces, in

12
Unattributed advertisement for "A Woman's Place," FAN: FEMINIST ARTS NEWS, No. 7, p. 29.

13
Walker said regarding funding: "In those days there was no point in applying for funding either from private or state sources. People would just laugh in your face. I took a degree when both of my children were very young—a certificate of education—and just glued myself to that as a way of earning a living. And anything I did was for pleasure and education and entertainment, self-funded." From a telephone interview with the author, op. cit.

14
The Peckham Group was one of the myriad women's "consciousness-raising-style" groups in 1970s London. Almost every neighborhood had a women's group of this kind.

15
WOMANHOUSE was also presented at a meeting of the Women's Workshop at the Artists Union. Notes from a meeting held in June 1973 include a blurb about PROJECT WOMANHOUSE, which speaks of the possibility of creating a London version: "We still haven't located a suitable short life house for the project as we originally (sic) intended it, but are in touch with South London Women's Centre who think they may be able to help." Members present at the meeting were Judith Adams, Alexis Hunter, Tina Keane, Jane Low, Roberta Hunter Henderson, and Alene Strausberg. On the agenda for the next meeting was a viewing of slides of WOMANHOUSE. Although information was processed and traveled slower at that time, the project nevertheless interested many London artists. See unattributed, "Notes from Artist's Union—Women's Workshop," Monday, June 4, 1973, found at the Women's Art Library (Make): Women's Art Alliance/WWAU file.

16
This was the first program dedicated to feminist art practice. Their teaching methodology included consciousness-raising techniques, such as discussing personal experiences, sexuality, and emotional and physical trauma, as well as the use of this personal exploration in the making of feminist art. For more information on WOMANHOUSE see: Amelia Jones, SEXUAL POLITICS: JUDY CHICAGO'S DINNER PARTY IN FEMINIST ART HISTORY (Los Angeles: UCLA at the Armand Hammer Museum of Art and Cul-tural Center in association with the University of California Press, 1996); and Peggy Phelan, "Survey", in ART AND FEMINISM. Helena Reckitt, ed. (London: Phaidon Press, 2001), pp. 21–22.

17
Miriam Schapiro, "The Education of Women As Artists: Project Womanhouse," ART JOURNAL, 32, reprinted in ART AND FEMINISM (London: Phaidon Press, 2001), Helena Reckitt, ed., pp. 208–209.

18
Clearly female students in London were not as fortunate, as many of the British artists I've interviewed—including Bobby Baker, Kate Walker, Silvia Ziranek, and Cate Elwes—spoke of the isolation and misunderstanding they confronted during their art training.

19
Telephone interview with Kate
Walker, op. cit.

much the same way as the WOMANHOUSE artists did. The advertisement for their exhibition billed it as, "rooms of images of mental states, from unconscious basements to HOT TIN ROOFTOPS." Walker's installation occupied several rooms on the ground floor and centered on the figure of the bride. In her nightmarish kitchen footsteps on the floor marked an endless traversing from sink to stove and refrigerator. A wedding cake was on the gas oven, and beneath this a woman in full bridal gear half submerged in a heap of garbage. Strewn around the figure were traces of adolescent female identity: old dolls, colored pages from a Cinderella book, and in general dirty and sordid ephemera such as milk and cider bottles. Walker's version of the home is far from an idealized image of feminine domesticity.

A candlelit performance by Walker accompanied the installation during the evening hours on certain nights of the exhibition, including the opening. During this event the artist performed a reverse strip-tease. Beginning naked, she would dress in more and more clothes, including housewife pinafores, and other loaded guises. Finally she dressed as a man and left the house. She notes, "Of course the fire authorities would have had a heart attack. It was all completely alternative and underground and all kinds of mad things were going on."[19]

Like their American colleagues, the women who created the Radnor Terrace exhibition appropriated the loaded site of the domestic house in order to articulate issues that were central to their work. The site in South London, conceptually a million miles away from an established gallery, enabled the work to be read in a powerfully direct and unmediated way. The domestic setting offered the artists the opportunity to rethink the role of women in the home, the artists' relationship to their bodies, and their place within what was considered a patriarchal society. Thus, the space of the house is inseparable from the work, which certainly would not have carried the same impact if enacted in a traditional white cube space.

The house was on view for two months, during which time many people made the journey to see the installations, including Nick Serota, who would later become Director of the Tate Gallery. Despite significant interest at the time, it has largely been ignored in British art history, most likely because of its underground status, and equally because of the ephemeral nature

←
Radnor Terrace.
PHOTO BY NIGEL TALAMO. 2002

of the work shown there. A review of the exhibition by Roszika Parker serves as an important recollection. In this piece, she quotes Walker's colleague Sue Madden—whose work was installed on the first floor of the house—speaking about the shortcomings of the project: "I think for women to build up any significant working situation they must first commit themselves to developing close contact and communication between themselves."[20] Clearly, Madden felt that the artistic project was premature because the women participating were lacking sufficient emotional commitment and contact. As Parker notes, however, the project was a test case and was bound to have its pitfalls:

> As an exhibition it was light years away from the art market and conventional shows. It was initiated by the artists themselves not for profit but as an experiment in working together. In fact it was the way they got the show together as much as the content of the house which overturned the accepted idea of a women's relationship to the home. They worked on the home as a group instead of in isolation, creating a public instead of private environment.[21]

RADNOR TERRACE and WOMANHOUSE were important steps in the movement of an art practice concerned with the transformation of gender politics. Like the FEMINISTO postal project, A WOMAN'S PLACE literally re-positions questions of gender and domesticity and initiates a movement from thinking of female identity as an essential category towards an investigation of socially constructed gender differences. It can be seen retrospectively as part of the general trend—in male as well as female practitioners—within conceptual practices of the 1960s and 1970s to work collectively and outside of conventional art spaces. If collectivity was perhaps seen as an antidote to the heroic, macho individuality associated with artistic success, then Radnor Terrace provided an example of an experimental rethinking of the functioning of gender and space. The domestic setting provided an ideal site for such rethinking as it connotes the very notion of womanhood that the artists were trying to undermine.

20
Rozsika Parker, "Housework," SPARE RIB, No. 26, 1975, p. 38, reprinted in Parker and Griselda Pollock, eds., FRAMING FEMINISM: ART AND THE WOMEN'S MOVEMENT, 1970–1985 (London: Pandora, 1987), p. 200.

21
Ibid.

22
See Kate Bernard, "The Women who won't win the Turner Prize," EVENING STANDARD (London, October 30, 1996), p. 28.

23
Emin related to a journalist how one person sent a check for 50 pounds with a note that said, "Never contact me again." See Richard Gott, "Sexual in-tent," THE GUARDIAN (London, April 5, 1997), p. 29.

24
Emin met Lucas at the latter's show at City Racing, an artist-run gallery in South London. Emin said of Lucas' work, "The feminist angle to it was quite subverted, kind of twisted." See Richard Gott, op. cit. p. 29.

25
The shop was at 103 Bethnal Green Road from January to July 1993. They were originally looking for a studio space and then came up with the idea of having a shop. For an account of the shop see Gregor Muir, "Like a Hole in the Head," PARKETT, No. 63, pp. 36–38.

26
Richard Gott, "Sexual in-tent," op. cit., p. 30.

27
The Tracey Emin Museum was located at 221 Waterloo Road in South East London.

28
Jon Ronson, "Who wants their own museum?," THE INDEPENDENT, section two (London, February 9, 1996), p. 8.

29
Esther Pierini, "Tracey Emin," FLASH ART (November/December 1997), p. 102.

→
221 Waterloo Road, site of The Tracey Emin Museum. The shop still exists but is presently unoccupied.
PHOTO BY NIGEL TALAMO, 2002

SOUTHEAST LONDON: THE TRACEY EMIN MUSEUM

Twenty years after the RADNOR TERRACE project another generation of women artists in London were working outside of the gallery system. Interestingly, the context had changed so completely from the 1970s, when a project such as A WOMAN'S PLACE might have aroused some curiosity, but no commercial gain. Tracey Emin, a young artist who created a museum dedicated to herself, would become one of Britain's most commercially successful artists. Emin early on showed a knack for business, when she funded her work by 'friends of Tracey' contributions. These took the form of Tracey Emin bonds that could be swapped for works of art.[22] For a small fee, it was also possible to regularly receive letters written by the artist. In return for the donation the supporter would be guaranteed to receive four letters from Emin.[23] The artist ironically called this the EMINWAY SCHOOL OF ART. Then Emin met fellow artist Sarah Lucas[24] and together they decided to open a shop in a dilapidated Victorian House in the East End of London where they sold various bits of ephemeral art including ashtrays with Damien Hirst's face printed on the bottom, Rothko blankets, and other hand-crafted merchandise.[25] Sarah Lucas said, "A lot of the merchandise was crap, but the seeds of subsequent ideas were sewn—both in my work and in Tracey's."[26] Their shop was patronized by some of the most successful art world players such as Hirst, and his dealer Jay Jopling, who would eventually become Emin's dealer at White Cube gallery.

In 1995 Emin rather immodestly opened her own space called the Tracey Emin Museum. Located in South London,[27] the self-dedicated museum was actually a rented flat in a converted minicab office squeezed between a hairdresser and a dentist.[28] While the museum is now closed, it lives on in some quasi-mythic performance that has become Emin's career. Some visitors to the museum described it in terms of a performance in which the visitor participates. Art critic Esther Pierini wrote about her experience at the museum, where she viewed HOW IT FEELS, a documentary-style video about Emin's abortion and miscarriage. (Emin had become pregnant after being told she was infertile, had a botched abortion, and suffered a horrific miscarriage a few days later.) Pierini writes:

> While the details are harrowing, Emin manages to relate her rage and anguish in a candid manner which falls between sordid public confession and art-styled ironical autobiography... The performance begins as soon as you arrive at the "museum", and the overwhelming sensation for an audience member is that no matter how much Emin exposes of herself, her process of creativity and dissection is incessant; audience response in the Emin Museum is taken for cataloguing and filing for future reference like any other subject under the microscope[29]

Pierini's account of her visit brings two ideas to the surface. First, the experience of confession, and second, the very different experience of being an audience member in the museum. To take the first point, The Tracey Emin Museum cannot be separated from the entire body of

Emin's work. Like her videos, poems, performances, drawings and installations, the museum is a hyperbolic form of self-confession and self-obsession, as well as a coping mechanism. Adrian Searle wrote of Emin's

solipsism,[30] while Richard Dorment has observed, "In a performance of monstrous audacity, she expects her audience to be interested in virtually everything that has ever happened to her."[31]

Arguably Emin's most sexually charged work, EVERYONE I EVER SLEPT WITH, 1963 TO 1995, also centers around the theme of self-confession. Emin's embroidered sculpture contains almost one-hundred names, including her nan, her twin and her teddy bear. Visitors to the Tracey Emin Museum would take off their shoes, climb inside, and have a look around. It was originally made for the "Minky Manky" show at South London Gallery in 1995, which was curated by Emin's then boyfriend, Carl Freedman.[32] Indeed his name is stitched on to the tent flap. Provocative as it may be, her use of textiles and stitching again seems to refer to generations of traditional "women's work." Emin herself sewed each name on to patches of fabric and then applied the fabric to the canvas of the tent. Janis Jefferies writes of the piece, "While quilting and embroidery techniques are employed, Emin's gigantic patchwork adorned tent refuses the first wave of a woman's celebratory experience, cited earlier through the example of Judy Chicago's THE DINNER PARTY."[33] This rejection of a celebratory "women's" experience is an important one. Certainly Emin's talk of abortions, suicide attempts, and loneliness contrasts with the almost naïve collaborative spirit of Chicago's project. However, Emin's use of sewing and stitchwork was not consciously derivative of an earlier feminist project. When questioned about the relationship between the domestic and her textile pieces she said, "I sew simply because I sew and I am actually quite good at it. It's not like I'm trying to come up with some kind of grand female statement. And I like the humbleness of sewing."[34] However, it is important to acknowledge that she does return to a traditionally feminine medium. Her patchworked pieces have many historical antecedents, more recently the AIDS quilts projects and those made by Kate Walker in the early 1970s. All of this handstitched work—from the tent to the quilts—is doubly significant when seen in Emin's own domestic space.

EVERYONE I EVER SLEPT WITH, 1963 TO 1995 is reminiscent of feminist 1970s practice, which exploited the tactics of confession and personal revelation. Take for example, the rape plays performed by the women on the feminist art program that staged WOMANHOUSE. Similarly in England, projects such as FEMINISTO encouraged women to express themselves through work based on their domestic situations. Likewise, in A WOMAN'S PLACE, Kate Walker's performance managed to convey the horrific aspects of being a bride and wife. At the time when these works were made, women artists ideologically avoided the mainstream art world, which had never opened its arms to them in the first place. In ostracizing themselves, however, they inadvertently succeeded in creating a ghetto. Such ostracization provided a necessary space apart where women artists could explore and undermine the societal structures of gender on their own terms. These tactics are witnessed again in the 1990s, in the work of women artists such as Emin and Lucas. But the latter work, and its subsequent acceptance, reflects a shift in radical politics and the counter-cultural movement, whereby marginal activities, instead of positioning themselves on the outside, now insert themselves into the center. Indeed, the very lines between the notions of periphery and center have been so altered that marginality is quickly commodified and further, the re-appropriation of stereotypically feminine attitudes have taken on the appearance of radicality. It's almost as if, having moved through a series of radicalized stances regarding the position of women artists, younger artists feel entitled to pick and choose among an array of so-called feminine identities.

How does the contemporary commercial art world's interest in women artists with aggressive stances affect women's artistic production in general? Is it still useful to articulate a distinctly female mode of artistic production? Are young women artists who are no longer wary of working with galleries actively promoting or denying particular brands of feminism? American

30
Adrian Searle, "Me, me, me, me," THE GUARDIAN (London: 22 April 1997) p. 13.

31
Richard Dorment, "All about Tracey Emin," THE DAILY TELEGRAPH (London: 30 April 1997).

32
Minky Manky was at South London Gallery from April 12 to May 14, 1995.

33
Janis Jefferies, "Autobiographical Patterns," N. PARADOXA, No. 4 (London: KT press, 1997).

34
Quoted in Mark Gisbourne, "Life Into Art," CONTEMPORARY VISUAL ARTS, No. 20 (London: Gordon & Breach, Autumn 1998).

artist Carolee Schneemann suggests that galleries are interested and capitalize on one controversial female artist, the most likely reason being economic. She writes:

> *In the 1960s and 1970s, there was no gallery willing to exhibit my works with explicit erotic imagery, nor that of other feminist artists. But by the 1990s, any significant hot gallery had to have one bad cunt to really be a part of the art game.*[35]

Her sentiments have a particular relevance when seen in the light of an artist such as Tracey Emin. She is, after all, a sexually-charged young woman[36] who is open about her abortions, love affairs, masturbation and suicide attempts. It is precisely this candor that is so unsettling for some and yet simultaneously so attractive.[37] Her antics on television during the Turner prize debate on channel 4 in December 1997 have made her a kind of anti-hero.[38] This has led to her modeling for Tanguery gin and top British fashion designer Vivienne Westwood as well as writing a column for a men's lifestyle magazine. Indeed, Emin is a celebrity based on her acerbic personality as much as her work. Opening her private life helped her gain the public's attention; more importantly it provided a way into exorcising her own personal memories and traumas, as well as an accepted art practice, which relates back to confessional tactics of 1970s feminist artists such as Kate Walker and her colleagues in South London.

CONCLUSION Emin's self-dedicated museum and Walker's domestic project chart in multiple ways the spatial shifts that are articulated in and around women's art. In terms of architecture they represent a move from the gallery to the home, and in Emin's case, back to the gallery. Culturally, both projects represent a shift from the mainstream art world to more marginal sites. Such shifts can be measured between distinctions of what occured between the early 1970s to the mid-1990s, revealing the larger differences of the economics of the art world, as well as the smaller individual notions of how an individual can navigate her way through such a world. This then leads one to consider the changing role of the artist, as well as the role of the spaces that artists occupy. What was once a radical statement in the 1970s is now wholly integrated into the commercial, and public, London art world.[39]

RADNOR TERRACE, as well as its precedent WOMANHOUSE, reveal the politics of the places they inhabited. In both examples, by repositioning themselves—their bodies as well as their work—the artists were able to function in a way that may uncannily resemble the way the art world functions today. Instead of relying on a gallery for support, they formed a social network that provided the necessary backup. Thus, they were able to retain their sense of self-determination, and produce the kind of work they were interested in, rather than as was determined by a commercial or external force. This is similar to Emin and Lucas' early attempts at independence with The Shop and Emin's museum.

A WOMAN'S PLACE and RADNOR TERRACE itself are largely forgotten, having never found their way into the annals of art and cultural history. RADNOR TERRACE no longer even exists as a street; the whole neighborhood was torn down to make way for a high-rise council estate. Hidden underneath the layers of the city lies a memory of a place that opened up possibilities to young women artists in the 1970s. One has to question whether we understand the RADNOR TERRACE project as opening up domestic spaces in spatial and sexual terms, paving the way for artists such as Emin and Lucas. Or do we understand the Tracey Emin Museum as a product of the art world's own success in capitalizing on marginal practices of yesterday, which are at times largely erased from history?

35
Carolee Schneemann, e-mail to the author, September 2, 2002.

36
One reporter wrote of her "quite impressive cleavage." Would a male artist tolerate this kind of depiction in the press? Critics would say that she opens herself up to such accusations because of her sexual promiscuity, which is reminiscent of earlier attitudes towards Schneemann. Alastair McKay, "Art is an Eminist issue," THE SCOTSMAN (Edinburgh: August 4, 1998), p. 10.

37
An interesting point of comparison with Emin is another artist who notoriously uses sexuality in her work. Austrian Elke Krystufek, b. 1970, has made performances where the public watches her masturbate and has used photographs of her own vagina juxtaposed with various objects. See, Elke Krystufek, IN THE ARMS OF LUCK (Geneva: Centre Genevois de Gravure Contemporaine, 1999) and Angelika Nollert, Elke Krystufek, NOBODY HAS TO KNOW (Frankfurt am Main: Portikus, 2000). Clearly there is room, as Schneemann purports, for one 'bad girl' in every country as well as every gallery.

38
In December 1997 during the post-prize-giving debate led by Waldemar Januszczak, Emin stormed out of the taping, saying "I'm leaving now. I want to be with my mum. I don't give a fuck. You people aren't relating to me now." At the time she was so drunk that she was convinced that she was in someone's house. Waldemar Januszczak, "Eminism," THE SUNDAY TIMES MAGAZINE (London: July 12, 1998), p. 30–31.

39
For example, Emin's MY BED was shown at Tate Britain during the Turner Prize exhibition in 1999 and currently Sarah Lucas has an entire gallery at Tate Modern dedicated to her work.

KIM ABELES

REMAPPING THE URBAN STRUCTURE

I walk a 60-block radius to carefully chart the sky-line, and pirouette on rooftops to capture round horizons. I draw a mile a minute through the window of a moving train. I walk through people's houses to direct my pilgrimage to the San Gabriels on a day so smoggy that the mountain disappears the closer I reach. I trap the footsteps of the sky in haunted messages made of smog. I paint the sky each day like a single patch upon a quilt. I rechart the city's borders to reveal her sister sites. I tape her sounds and show her smoky breath, transforming autos into swarms of cicada. I build in somber puns: "too raz bil' ding iz too târ it doun." ✺ Historically, at its core,

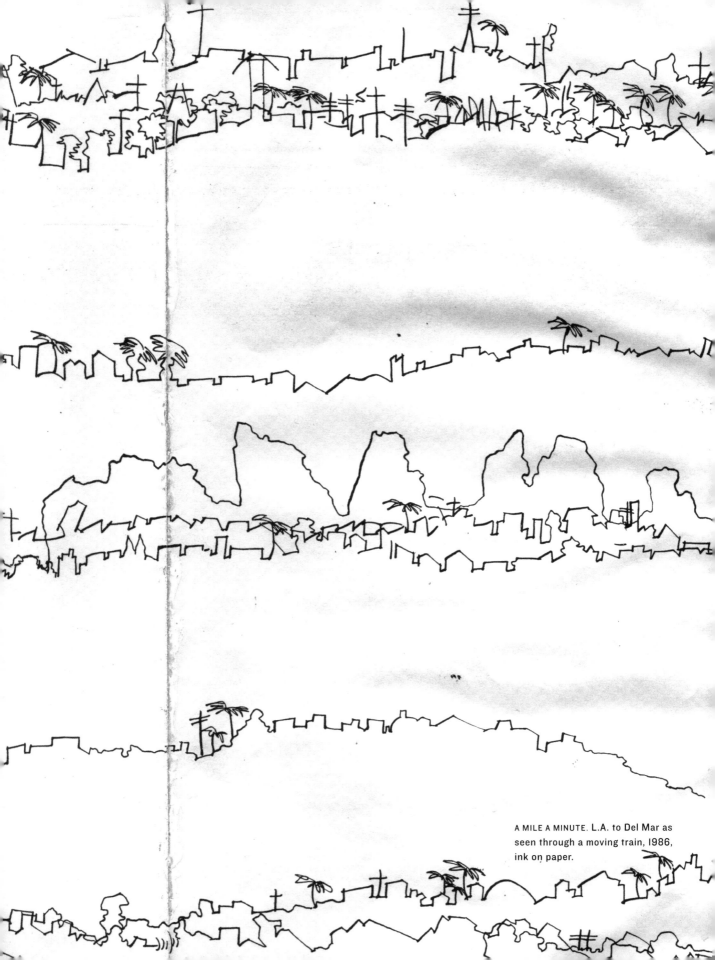

A MILE A MINUTE. L.A. to Del Mar as
seen through a moving train, 1986,
ink on paper.

art has served as a guide to the vistas that we see from our own observation decks. Art functions in the framework between the viewer and the viewed, pulling banal and beautiful to places usually reserved for direct experience. Through manipulations of structure, strategy, and system, we awaken to this existential world. My work from the past two decades results from the urban experience, chronicling historical and contemporary issues housed in sculpture and installation. In the cases of the pieces I present here, my physical engagement with the environment is the urgent aspect of the art. These are lick-the-ground performative systems to ingest sensory and conceptual data like stray notes on a music sheet, pulling them back into a lyrical logic of a new form. The pieces are performative, highly rigorous in their procedures, and result in a poetic look at the urban structure and infrastructure that is typically limited to a city's planning department. My projects and artworks are portraits of Los Angeles, though I view this city and these concepts as symbols of the urban. L.A. has all the components, problems, and achievements of the typical urban schema.

PILGRIMAGE TO THE WEDGE

The Mountain Wedge From February 26, 1985 to March 17, 1986, I took 274 photographs looking north on Broadway in Los Angeles as seen from my fire escape. My ultimate purpose was to photograph a "wedge" of the San Gabriel Mountains.

On a clear day, the Mountain Wedge miraculously interacts with the buildings at the horizon. Though it may seem to be a simple, decisive task, it was not. The mountain was not clearly visible for over a year. I have had my studio in downtown Los Angeles for 20 years and have only seen the Mountain Wedge a few times. When it appears, it is breathtaking.

The Pilgrimage On September 10, 1987, I walked from my Broadway studio to the Mountain Wedge to try to capture a clear image of the mountain. I selected a day with a first stage episode for air quality: air unhealthful for everyone.

 Departure time: 7:49a.m. (2nd and Broadway)
 Arrival time: 5:37p.m. (Mountain Wedge)
 Distance: 16½ miles

I wanted to see how close I'd have to be to get a clear photo of the Mountian Wedge. As it turned out, I had to be at the foot of the mountain. I walked as the crow flies, 16½ miles in a direct northeasterly route. And so, if I had to cut through

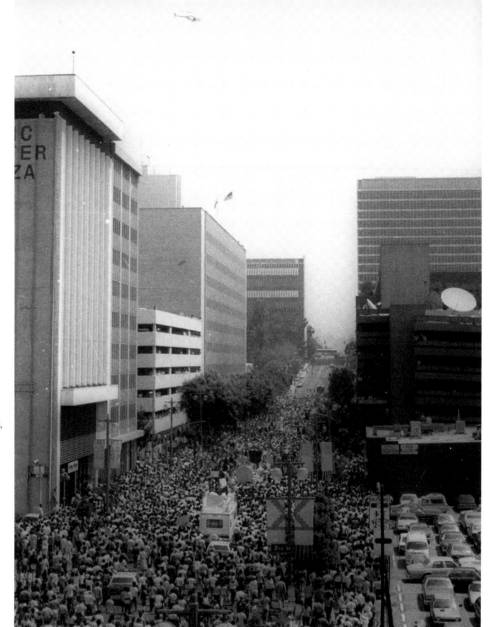

PILGRIMAGE TO THE WEDGE
View looking north toward
a wedge of the San Gabriel
Mountains (obscured by smog),
as seen from 2nd and Broadway,
Los Angeles. This example of
the 274 photographic attempts
to get a clear view of the
Mountain Wedge was taken the
morning of a parade for the Los
Angeles Lakers.

The northeasterly route
of Abeles' pilgrimage from
downtown Los Angeles to the
San Gabriel Mountains.

PHOTO BY ABELES' ENCYCLOPEDIA PERSONA
↓

yards and houses, I sometimes knocked on the door to ask permission. I climbed barbwire fences, fell down dusty cliffs, under freeways, and past dogs barking and grabbing my pants. Kids followed after me as if I was the Pied Piper, and in other neighborhoods they told me I wasn't safe walking alone. I saw a couple having sex reflected in a mirror, and a friend's painting hanging on a wall. By the time I was finished, I had walked for about ten hours. I wasn't in good shape. I didn't do this after an athletic fitness program, plus I was a chain smoker at the time. By the time I got to the mountain, I looked like I'd been trashed. My glasses were broken, my hair was full of brambles and thistles. I had been bitten up by red ants at one point when I sat on an ant hill. I was literally a mess, pants torn and dirty, cuts and blood everywhere. I never took a photo of myself in that condition. That wasn't the point, though the tale is worth telling.

The Mountain Wedge was not clearly visible until I stood at its base.

EQUIDISTANT I envisioned concentric circles drawn upon the Los Angeles city map with the La Brea Tar Pits as the center point. (The Tar Pits as a beginning, a center of time and space, a place where the elephants sink and the surface bubbles.) Each point on each circle has its counterpoint that is equidistant to the center, and each time I photographed both sites. Though I could select the original site by choice or seduction, its mate was always dictated by the location of the first.

Each photograph noted on the map has its twin, like sister sites and psychic pairs, they are linked by distance divined by the system, as if waiting for the other all this time.

I selected sites like the Watts Towers and Mann's Chinese Theater for their fame and importance. Other sites called to me as they came into my view as if I were traveling by air like a housefly waiting to land. (My daughter and I snuck into a wedding and the couple's video will later reveal my 7-year-old in a neon colored jacket darting in and out as the bride begins her walk down the aisle.) The partner site was always the calling of the first.

Inhabitants of Los Angeles typically remain within the confines of their villages, some complete with freeway walls or tall ornate gates protecting their keepsakes. We feel safe among ourselves within these villages and to venture outside their boundaries is to feel singular in a strange land.

Each site had a pronounced aspect that acted as its signature, an obvious spot of composition or content. I attempted to attend to the matched sites, leaving my preconceptions behind; while some clichés held fast, others fell to the curb.

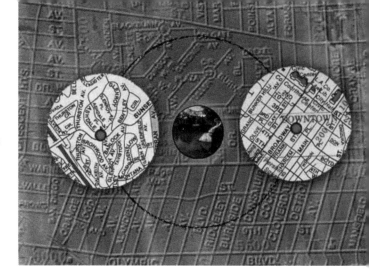

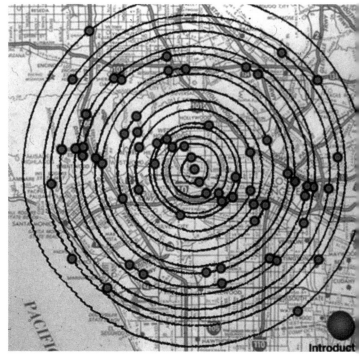

↑
EQUIDISTANT re-plots the Los Angeles map, placing the La Brea Tar Pits as the center of several concentric circles. Using photography, video, and audio, each paired site is documented; each point has its counterpoint that is across the diameter. Both sites are photographed each time. The site downtown on Broadway and its equidistant point in Bel-Air were recorded on videotape during a 24-hour period of time. The computer version of EQUIDISTANT was created in 1996 in collaboration with the web magazine, ARTCOMMOTION. A sculptural and a quilted, hippy version were also made.

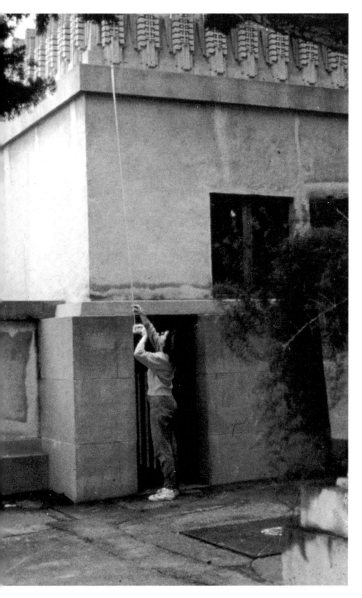

↑
Hand-measured buildings with the help of a sonic device and an ordinary tape measure. The seven buildings and structures were measured and rendered to the same scale, fitting inside one another to express their proportional relationships.

→
LEGEND FOR A MAPPING (LOS ANGELES ARCHITECTURE) Installation view at the Los Angeles Municipal Art Gallery, 1997. Each "legend" item is numbered to correspond with the building it represents. Installation includes welded metal structure, mixed media objects, and photographs.

Indeed, the keen eye sees beauty even in decay, and spiritual decay may sparkle. Well-kept homes, both spacious and modest, appeared in all directions of the circles. I stayed suspicious of my viewpoint understanding the choices of my viewfinder.

I know where beauty is and you can buy it as a necklace in Beverly Hills. I know the beauty of rust against wood against crumbling paint and great artworks have frames around their surfaces. (People stand, sit, speak, and sleep behind each doorway and urban cave.) Nature can be bought and it's tucked away behind security signs, but nature also flexes her strength as the lush, green grassy knolls undulate in the once-concrete front of the gas station at Main and 59th.

The site downtown on Broadway and its equidistant point in BelAir were recorded on videotape during a 24-hour period of time. You will see each minute of change, and you are able to pull up specific moments. The notion of surveillance revealed itself more apparently with our ability to rewind and repeat and observe more closely the occasional human interaction on the street. Otherwise, people move past one another quickly.

I visited over 120 locations in the Los Angeles region, gathering site and sound for EQUIDISTANT. The concept provides a method for viewing the urbanscape disregarding conventional city divisions, ignoring the layout of the streets. Nature offered the balance for my observations, since she consistently insists on pushing wildly through each sidewalk, park and cemetery. In Los Angeles, Nature can be found groomed, polished, and shaped into friendly shrubs.

LEGEND FOR A MAPPING (LOS ANGELES ARCHITECTURE)

I have this romance with Los Angeles. I wear the stillness of its empty nightgown. I drink it up in the morning light. I find my quiet self amid the noisy movement of lunch trays and wiggling jello.

Los Angeles hides her magnificent buildings behind a windshield. The architecture ranges from the exquisite lacy interior of the Bradbury Building (born from a séance of psychic dimensions), to housing complexes that are homes for the strong hands that provide for society's comforts. Each building holds a story revealed through books and guided tours. The story I love best about Hollyhock House is not really about the architect Frank Lloyd Wright, but rather, about Aline Barnsdall: the cultural visionary, adventuress, self-determined single mother. Simon Rodia created the Watts Towers from an unusually pure creative force, the momentum of the spirit, in a world where motives most often drive the tool. And by contrast, the destruction of extraordinary feats of architecture, like the demolition of the Richfield Building, leaves a ghost-like silhouette upon the skyline. L.A. holds the genius of Julia Morgan in the Mission-style home of the previous HERALD EXAMINER, and architect Claude Beelman's turquoise and gold Deco wonder of 1930, the Eastern Columbia Building. The Los Angeles Public Library is a monument to Bertram Goodhue's philosophical understanding of art integrated with architecture as a truly inspired space.

The primary structure of LEGEND FOR A MAPPING compares the proportional scale of some of the notable buildings of Los Angeles expressed as a welded, steel-rod outline. The outlines of each building fit one inside the other to express their proportional relationships. Each building represented on this metal grillwork is assigned a number attached to its silhouette. Individual artworks in the form of drawings and sculpture become the legend for this mapping of Los Angeles architecture. These respond to the beauty, tales, and human-touched moments of the architecture.

FROM YOUR SEAT As a public artwork for Metro Art, the art program for the Los Angeles County Metropolitan Transportation Authority, LEGEND FOR A MAPPING transformed into a concept using the same system: comparative measurement

→
FROM YOUR SEAT, 2001.
Porcelain enamel on steel inset into concrete seating located at the Grand Central Market, Downtown Los Angeles. Commissioned by Los Angeles County Metropolitan Transportation Authority.

of architectural structures, and the "legend" as a format for organizing fact and fiction about them. In this case, however, the artwork is also intended to relocate the viewer to another site in the city by conceptually defining architecture somewhere else in the city and physically explaining to the pedestrian how to get there. It's a play on the "You are Here" maps, and in this case, "You are There."

The images and text are created as panels made of porcelain enamel on steel (a durable process combining offset printing and baked enamel, like the surface of a cooking stove), inset into concrete seating. The seating is located in the plaza area adjacent to Grand Central Market in downtown Los Angeles. Some of the seven sites, like the City Hall, are accessible on foot, while others, like Watts Towers or Hollyhock House, are explained through the use of the metro, starting from the very spot where the person is seated.

SIDEWALK MEDALLIONS The Metro project includes a second art component, SIDEWALK MEDALLIONS (manhole covers), placed in the sidewalk between 3rd and 4th street on Hill. The medallions visually develop themes pertaining to the infrastructure of the city with facts about miles of electrical and communication cable under Hill Street, the tally of Los Angeles streets, and storm drain system.

HILL STREET TIMEKEEPER The third component of the HILL STREET AVENIDA projects commissioned by Metro Art is a sound piece that announces the time every 15 minutes followed by 35 seconds of sound from the downtown core, including ambient sounds and residents speaking. The piece transplants local sounds like chopping at Grand Central Market, a bank robbery,

the lounge singer at the Biltmore, and the shopkeepers in the jewelry district to the site of the 4th Street exit of the Pershing Square Metro. Workers on their regular, week-day pattern to and from the subway hear the same 15-minute sound clip, while the tourist receives, Dada-style, a surprise sound fragment of tortilla-making or an elderly gentleman talking about his broken hip. Like a haunting, the sound comes and goes before the passerby can understand the ghost they encountered. Space is created then vaporized to the ether of memory.

PUBLIC SITINGS (ALL SPACE IN LOS ANGELES COUNTY)
PUBLIC SITINGS defines all the public space in Los Angeles County. My definition of *public* encompasses a psychological approach rather than that of legal ownership. A mall, for example, is privately owned, but most people consider it to be public as they stroll or loiter among fountains, artificial plants, and shops of every specialty. I use a magnifying glass to pinpoint each public siting, paint its color code, and connect it with telephone wire of the same color; the wire in turn is connected to the matching disk color. I work from the determination that regardless of the actual size of a site, a person's experience is based on a psychological connection and a physical idea of one body, one place. Therefore, all sitings received one disk, like a poker chip, regardless of the actual area of the space.

The terms of *public* remain limited to rules of entry. Parks may be visited during daylight hours, and freeways require a vehicle. People wearing metal spikes cannot walk onto Alhambra Golf Course. Huntington Memorial Hospital is public if you require emergency care, and anyone can visit from 11a.m.-8p.m., unless a person is in intensive care, in which case only the immediate family is allowed. Norton Simon Museum, like most

→

WALKING WHEEL, UNDER YOUR SOULS, Los Angeles County, 38,753 streets
POWER AND COMMUNICATION, 42,803 miles of power and communication cables under Hill Street Avenida. Enough cable to circle Mars 10 times.
UNDER YOUR SOULS, 5,000 miles of storm drain channels. The distance from L.A. to N.Y. & back again. Shoveled in the 1920s and 1930s by workers paid a dollar a day.

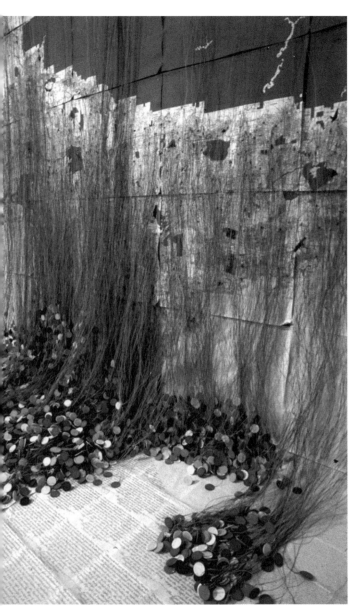

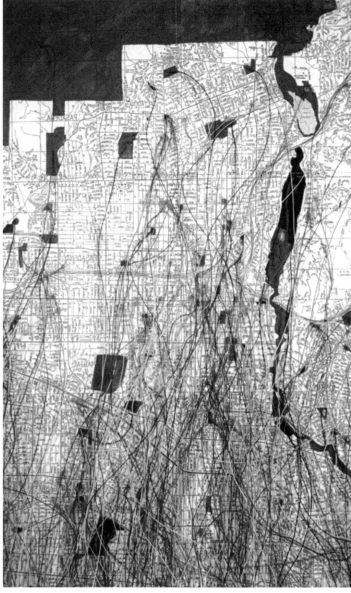

↑
PUBLIC SITINGS (section: southwest Los Angeles), 1998-99. Inkjet printing and acrylics on treated canvas; color-coded wire and poker chips defining public space.

museums, is public to children under the age of 12, or if you pay ($4 for Adults, $2 for Seniors 62 years and over, and $2 for Students).

I dismantle and orchestrate chaos to a system in order to locate a new observation deck. I took a perfectly good THOMAS GUIDE and other maps of worthy direction, and hand-painted my public considerations. Like scalp implants, I plugged each site with its color-coded wire. Wild hairs sprouting like electricity from the orderly circuit board. I try to begin without predetermination of the results by stitching a massive quilt of Los Angeles County, hung upon the wall, floating onto the floor with piles of coded poker chips or coins tallying the cultural view.

Sections of this text were first reproduced in ARTCOMMOTION, *catalogs published by Armory Center for the Arts and Pomona College Museum of Art, and* KIM ABELES: ENCYCLOPEDIA PERSONA, A 15-YEAR SURVEY *published by the Fellows of Contemporary Art.*

MELISSA DYNE & JEN HOFER

A PIGEON ON THE BRONZE HEAD OF HISTORY

SPUN TIME: A DEVICE FOR SEEING: SELECTIVELY: IN SEQUENCE: DETERMINEDLY: INDETERMINATE

What there is to see is what is seen. ✺ In sights are time's tremendous alleyways, non-sequential transport. ✺ Green more tremulous than cement. ✺ The gaze cannot be equaled, challenge out of step or place shifted, told to be by tone or nailed down. ✺ In the other other world, the traffic, undulating, gives no impression of slacking its rhythm. Will suddenly thin. Then swell. Uniforms more often than not. Necessitate signal cooperation. ✺ Parameters multiply, overlap, announce themselves coyly. Embodied, no standard will stand still. ✺ History made layered, visible unmade (bitter beauties) in brick, ribbed, barred, wrought, homeless, buried, man-made, shielded and sunglassed, impositions tripped over time or asked questions not potentially partial, and partially unpainted due to matronly distaste.

People making out (making do), people wearing neck braces (traffics), people inhaling thinner (sockets, unofficial statistics, blankly clouded), people wearing blue paper hospital masks (memory's rubble wafts shakily with soaring diesel engines as backdrop), people walking the goose-step (children equalized through plaid), people in plaid skirts (little-girl nubility at discount prices), people sporting billy clubs (in and out of holsters), people reading (paper airplanes made of dirty comic books), people staring (devout, devouring), people scratching themselves (politesse and public display ricochet), people spitting (not finding anywhere to sit), people gossiping (eliciting response or revenge), people waiting for the bus (public possibilities, quickness, dented efficiency), people directing traffic (organized bottleneck), people selling hot dogs 3 for 10 pesos (tropical umbrella in not tropical weather), people selling spiral vegetable cutters (a trick of the eye, a flick of the wrist), people sitting too close (people sitting too close), people explaining too much, people walking quickly with an odd forward lean (inexplicable), people crossing themselves (a blown kiss or blown chance), people asking what time it is (flimsy excuses, daftness, bent purpose), people pushing dollies (little devils, in inaccurate exactness), people infringing (the mist or tone off a day), people arguing (public displays), people whistling (under the guise of), people doing homework (pigeon-toed), people driving taxis (syndicalized aggression), people sneezing (rubbing up against), people avoiding the cops (double-chinned pack on the flatbed), people in line to park their cars (rusty chain of command), people with glorious mustaches (displaced mobility or better luck elsewhere), people with glorious cardigans (time beneath time arm in arm), people with inappropriate dress shoes (laborious deprecation depreciates precipitously), people in trolleys (on ice until further notice), people in love (a telescoping kaleidoscope to be set in the wall), people tolerating advances (progress or corralled into cramped safety), people intransigent (a gaze trained on something else), people mobile (roulette tread), people singing products cheaply (ways to converse or salute), people with canes (people with cigarettes), people with broken glasses (people with soda pop), people yawning (ad campaigns designed with you in mind), people muttering to themselves (externalized racial markers or they is what they is), people in red aprons (daily tasks), people with plastic bags (a double bass with multi-colored strings), people with babies (modes of transport or transfer), people with no sense of privacy (border towns: the worst of both worlds), people shining shoes (unionized), people feeding pigeons (a tributary system), people selling christmas lights (a mafia system), people selling polyester sweaters (a false system), people squinting (a pigeon with its legs tied), people hobbling (bright metallic polluted sky), people on their way to work (Lucky Lady manufacturers of pants and

MELISSA DYNE & JEN HOFER

outfits), people sweeping (a system of sticks without carrots), people praying (imperceptibly), people moving objects (the mobile real), people moving papers (the mobile ideological), people snoozing (the endless urban), people looking around (dramatized overendowed government knockers), people drinking juice out of plastic bags with pink straws (stubborn commercial generosity), people in high heels (voracious normative interest rates over the long haul), people in wraparound sunglasses (three very bright lights shining into nothing), people wearing helmets of hair gel (slick obedience or radio plays), people in lavender sweat suit sets (coordinated efforts throughout the neighborhood), people with nothing better to do (coarse hands clasped), people with taps on their shoes (people asking people to marry them), people wearing skirt suits (people asking people to work for them), people wearing swathes of beige fabric tied around their waists (a monument to corn in front of city government offices), people living out of plastic bags (nominally a judicial system), people selling blue corn tostadas out of cardboard boxes (confrontative confiscation fiscally lucrative, the path indicated or lubricated, emergency exit), people in panama hats (tipsy unprotected imitative migration), people in straw fedoras (instigations of an honest sort), people in curlers (the inside brought outside or ousted), people repairing phone lines (what is beautiful externally), people avoiding car accidents (internally terms damned or ridiculed), people soliciting bicycle taxi passengers (singing tra-la-la), people on cell phones (very important importance), people on benches (wrought dirt of the whispered sort through the grate), people with lollipops in their mouths (the thieves had been beaten almost to death by the innocent mob), people missing teeth (prevalent indications), people missing shoes (indicative sediment), people wearing fake hello kitty t-shirts ("hello kityy"), people wearing cornet-yellow eeyore sweatshirts (missing direct article), people entranced (safety hatch), people distracted (hatched), people attentive (public), people idle (security forces keeping the pace), people occupied (public spaces paced in a stretch or suspended view).

As if standing in the center of a space and spinning, wide-eyed, a flinging of the gaze which boomerangs back in centrifuge, collects towards you a momentary alighting focus, a break or brittleness in the whirl, where most of what we see is periphery and we have to choose to pause. ✺ Movement (bird-like), passage of time (mobile-like), context and moment (sphere-like, with tendrils): the camera obscura is an eye, an idea, a window (affording a view), a perspective (determining a view), a wide-open impulse towards specificity. Sight manifests through time, gap, pause, pixel, and pixels (as a crowded metro train or street packed thick with

jostles, merchandise, mafiosos) measure through moments—so much is possible in a second—and saturations.

The camera obscura is bound to time (constructed pieces of its context, to catch or tempt the eye through familiar artifice), as in a day light's movement chases time and is chased (a light trap or capturing of spun attention), slanting finally into an other where. It is at sunset, sunrise, moonrise, that the vertiginous tilt, the pull and spin of the earth become palpably available. The moment when the eye of

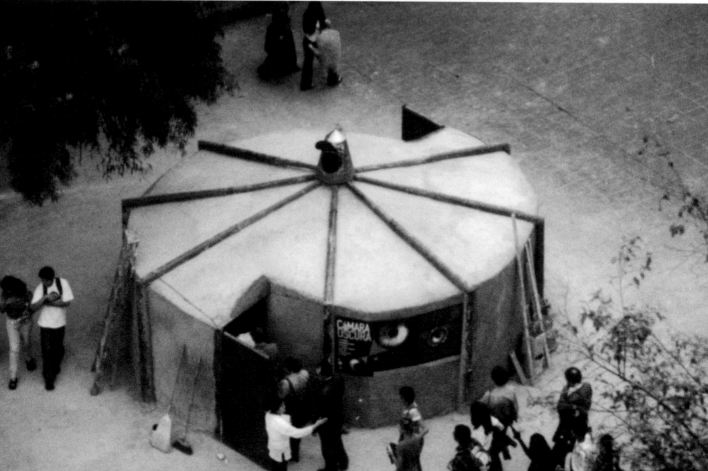

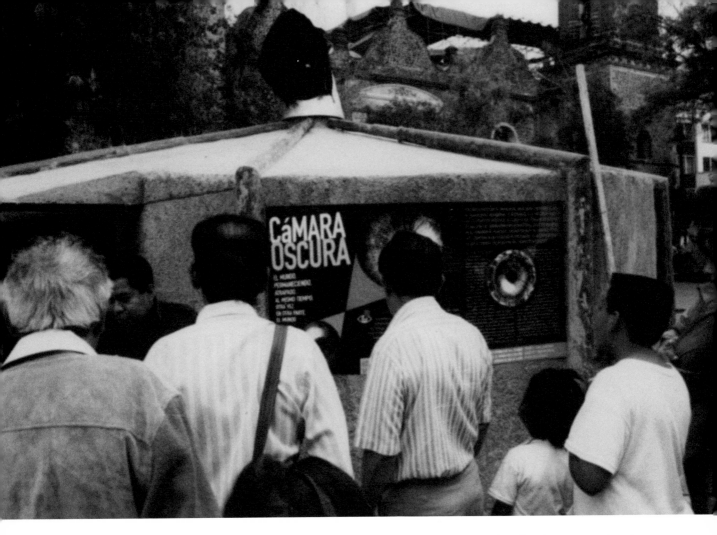

the camera—utterly dependent on light to effect sight—slowly shuts, as slowly or as quickly (questions of perspective) as the turning of a world. ✹ Spun, as a color wheel meant to trip differentiation or capture the eye in the moment of between: the camera obscura is a device for seeing what is already there, and for seeing seeing.

The building itself (the eye's sheath or skin or housing or immediate context) (context within context), a series of ideas and attempts in sequence, unsequenced, overlapping (allowing the effects of busy streets, traffics, tempered encounters, accidental and purposeful). To be built of debris, used urban ligaments stacked (after being counted, catalogued, left to rust) in precise disuse in formerly vacant areas: familiar elements de-familiarized by the presence of a common eye. Context out of context. Material elements of "la mancha urbana" (the urban stain) or "la ciudad sin fin" (the endless city)—metal, cement, labor—on the corner of Pino Suárez and República del Salvador, reflected in real time in intimate decontextualization, recontextualized beside itself, where the outside shimmers in interior view, optically shifted to reflect whimsy, will or mere reality.

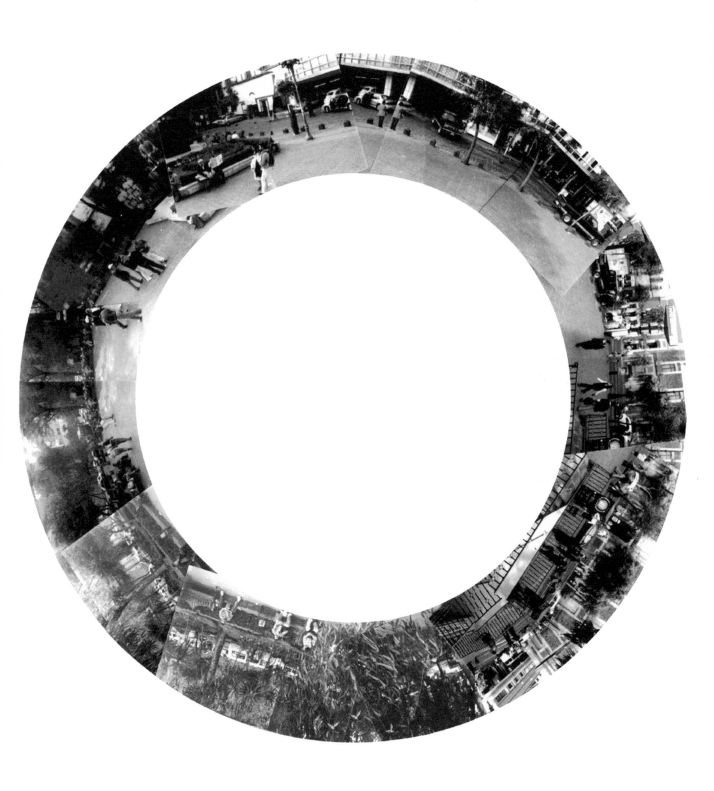

CIRCULAR PHOTO DESIGNS AND DIGITIZATION
BY EZEQUIEL CISNEROS

MELISSA DYNE & JEN HOFER

The mechanisms stutter: space on space super-imposed: so the eye wants not to rest: they eye difference cagily: an exploration bent by bad manners or chemical fumes. ❀ Filters which act as magnifiers rather than membranes. ❀ Students wait in a restless line. Certain facts indicated as relevant. ❀ Convergence teased into shifty congruence by strangeness made explicit? ❀ The camera obscura offers an uncommon commonality. ❀ Over time routinization smooths unavoidable. So we don't see, or see past. An edifice (not a monument, an instrument) can interrupt, and interrupting engage attention or elicit curiosity, disrupting the routine to make the familiar strange. ❀ That is to see. To incite sight.

Being a form (not in formation) of perspective, innately human (constructed on history and in history in broken or corroded layers). Neither the people nor the mechanism (eye: human) stands still. So what reflects is merely reality ("merely").

Across the street one way the Hospital de Jesús, just a few blocks around the corner from the Farmacia de Dios: the Orozco mural in the Catedral de Jesús (communal confirmations and communal marriage ceremonies held at intervals throughout the year; inquiries taken in the parish office)—at the far end from where the remains of Hernán Cortés are set into the wall to one side of the altar—unfinished, due to the scandalous nature of its depiction of political and economic violences: also unremoved: a blemish or the evidence of a blemish.

As a spiked light flung off-axis history layers and tumbles, patterned and unpatt-erned, post facto precision and de facto rewritten. So the plaza, Primo de Verdad, is named after an enlightened figure (1760-1808) murdered for his public views on equal access to education and the democratic process. (All statues, and here there are many, have something of Stalin in them.) There are tunnels under the plaza, under the museum, under the street, under the cathedral. Bones, weapons, passageways, accesses. It was on this site (unsighted, unmeasured, hierarchized idealizations distributed falteringly over and above the stone and asphalt foundation, so that what is glimpsed in intervaled moments—indeterminate versions in repeated momentary stacks—is (de verdad) truly) that Moctezuma first met Cortés. An auspicious beginning, which came after. ❀ Blemished, pocked, rough, troubled: it is in relief that the seen is made seen: dimensionally yours, truly, materially: history stands out upon its constructed foundations: there for the taking: taken in: a haze of pollution dims the rhetoric brightly: the things of the world wear no halo, no mantle of mystery, the eye's route framed not determined, no dramatic glow of accuracy: it is the pigeon that throws both sky and statue

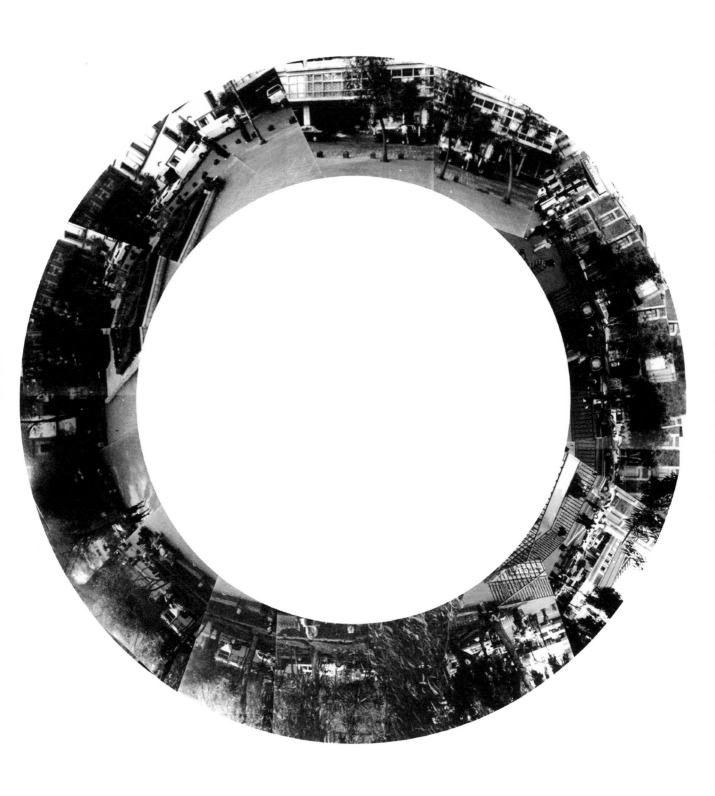

MELISSA DYNE & JEN HOFER

into view: a winged and pestilent edifice: unable to show the proper respect so improperly: a bird's eye exploration (humanized) not just of what but of how, with plenty to look at.

Built primarily out of debris from Mexico City's Department of Maintenance and Public Works, the camera obscura documented here was designed by Melissa Dyne as part of the HYSTERESIS project. "Hysteresis" refers to the magnetic tendency of a metal to revert to its past state or previous form, and describes the impulse to create works using old-style, or lagging, technologies and simple mechanics. The camera obscura, one of the first cameras ever in existence, projects a live image of what is happening outside on an inside surface—a constantly moving picture in real time which has no grain, needs no development and has no permanence. The windowless elliptical building is completely dark, save for an opening in the top, on which a mechanical hood is fitted. Light enters the hood through a round aperture, hits an angled mirror, and falls through a three-lens optical system onto a curved screen, on which the image seen by the camera's "eye" is projected.

This first incarnation of the camera obscura was sponsored by the Museo de la Ciudad de México and realized by José Castro Villicaña, Melissa Dyne, Sergio González Rodríguez, Jen Hofer, Juan Jurado, Carlos Marín, Juan Mendoza, Rodolfo Padilla Martínez, Rodolfo Padilla Souza, Carlos Tejada de Vargas and Luis Velasco Jiménez. It was open to the public on the corner of Avenida Pino Suárez and Calle República del Salvador in Mexico City's Centro Histórico from April 2002 to February 2003.

MARGARET MORGAN

THE PLUMBING OF MODERN LIFE

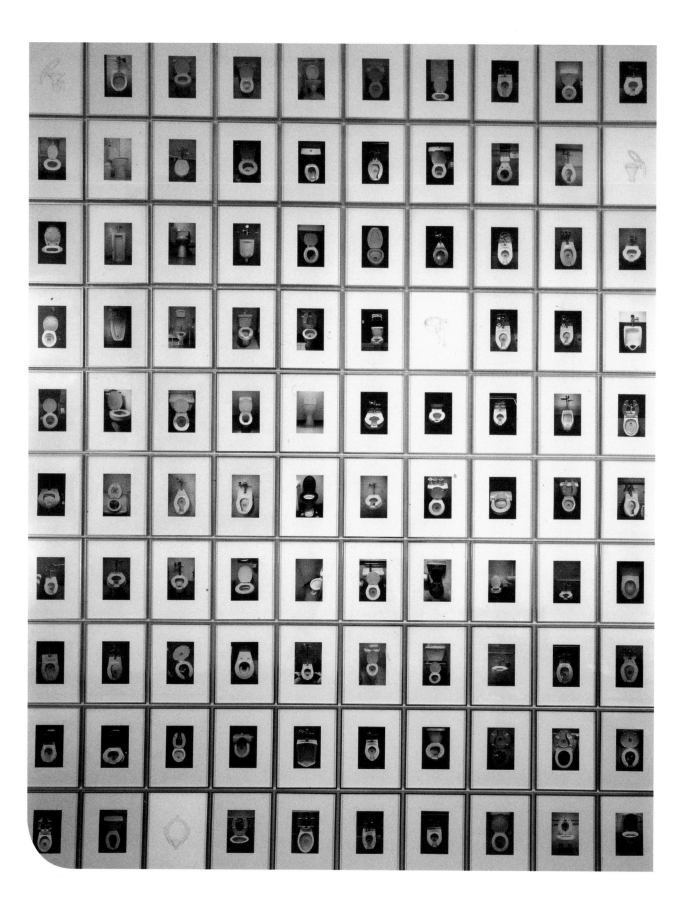

Hygiene is the religion of the twentieth century, and the toilet its ambiguous icon. This essay focuses on the "American Century" examining where the toilet appears within its symbolic order, tracing connections between European Modernism and its later American incarnations. The toilet's ambiguity as an icon revolves around two main axes: abjection and bodily anxiety, especially as manifested in gynophobia and castration anxiety; and in the conflicted position of the individual subject vis-à-vis public space. For the individual under modernity, there are two dominant ideological drives: on the one hand, toward individual integrity, finitude and agency; and, on the other, toward increasing entitlement of public space and mass culture. These drives are conflicting, and the conflict anxiety producing. This conflict appears in the interstitial spaces of modernity—in the twentieth century especially in public toilets, wherein one is most aware of being simultaneously private and public. Anxiety around the intimate non-spaces of modern public culture, especially the toilet, are manifested in the annals of modern art and architecture, in the reception of media events and, most persistently, in Hollywood film.

The toilet is the icon of the twentieth century. Octavio Paz observed that beauty was once bound to two realms, the sacred and the secular; that is, religious art and craft.[1] Under the forces of industrialization, art became independent of religious purpose and craftsmanship was supplanted by industrial design. Some vestige of religious beauty persisted in art and, indeed, Paz has argued that "the religion of art was born of the ruins of Christianity." Nor is industrial design as secular as the craft it replaces: an industrial object is at its most elegant, indeed its most beautiful, when its form most perfectly follows its function. As that which approaches an ideal, it lends itself to worship. As with modern art, a vestigial religiosity clings to its form: the toilet is such a beautiful thing and its iconography has been long in the making. When John Wesley declared that "Cleanliness is next to Godliness" he unwittingly initiated hygiene as a new religion. Thus, by the Victorian period, John Ruskin would declare that, "A good sewer was a far nobler and a far holier thing...than the most admired Madonna ever printed."[2] And in the early twentieth century, a urinal was once famously described as a "Madonna—or was it a Buddha—of the Bathroom."[3] But if the toilet is iconic, then the sacrament is reversed: in the Eucharist we imbibe the blood and body of the Christ figure. Here, in inversion, we present our blood and shit and piss before the shrines to hygiene and modernist aesthetics. That is, if god is said to enter our bodies in the pre-modern ritual, then it is we, as gods, who enter the body of the State and Metropolis in the modern ritual that is the adoration of the cubicle.

Let us examine more closely then, that supreme object of utility, shining, hygienic, gleaming in all its ostensible neutrality, that grand signifier of twentieth-century Modernism, that white porcelain of the toilet bowl. After all, "...a lot can be learned about a culture from looking at their bathrooms and their toilets."[4]

PORCELAIN[5]

> **Porcelain.** [a. F. porcelaine, a Venus shell, cowrie or similar univalve; hence the dense polished substance of these shells, and (from its resemblance to this) china-ware; ad. It. Porcellana (13th c. in Marco Polo)...the fine cockle or muscle shels which painters put their colors in...]
> 1. A fine kind of earthenware, having a translucent body and a transparent glaze...
> b. fig. With allusion to the fineness, beauty or fragility of this ware...1640, Brome,

1
Cited in Albrecht Wellmer, THE PERSISTENCE OF MODERNITY (Cambridge, MA: The MIT Press, 1993), pp. 95–97.

2
Cited in Peter Stallybrass and Allon White, THE POLITICS AND POETICS OF TRANSGRESSION (Ithaca, NY: Cornell University Press, 1986), p. 142.

3
See Beatrice Wood, I SHOCK MYSELF (San Francisco: Chronicle Books, revised ed. 1988, reprinted 1992), p. 30.

4
Claire Loos, fourth wife of Adolf Loos, paraphrasing Loos in Adolf Opel, ed., THE PRIVATE LIFE OF ADOLF LOOS, trans. Constance C. Pontasch (Vienna: Hermann Bohlaus Nachf., 1985), p. 79. Thanks to Catherine Lord and Carrie Paterson for bringing this volume to my attention.

5
See my "Porcelain" in A PLUMBER'S GUIDE (Los Angeles: Plumb Productions, 1999), pp. 31-35.

←
Margaret Morgan, CENTURY 1978-1998, 1998.
One hundred 8"x10" Inkjet digital photographs, each aluminum framed. All images are of public toilets, from Europe, the United States and Australia from my archive gathered over the past 20 years.

Sparagus Gard. v. viii. She is herself the purest piece of Purslane...1875, Tennyson, Q. Mary II i, That fine porcelain Courtenay, Save that he fears he be crack'd in using...should be in Devon too. [6]

Porcelain. The name of the ceramic used for toilets is the same name used to describe a tea cup, a baby doll, a woman's face, the pearl of womanhood, the exquisite corpse that is femininity in patriarchal culture. The associations between porcelain and the feminine are centuries old, so naturalized as to seem unremarkable. Venus rode the waves upon her porcelain shell, and painters used that self-same vessel to mix the colors by which to create her likeness. In the eighteenth century porcelain was a virtual currency, and the mania for its smooth, translucent form caused many an intrigue, excess and squandering of fortunes. Perhaps most famously, Augustus II, King of Poland, was known for his excessive tastes in porcelain and in women, fine and delicate commodities both.[7]

By the twentieth century, the porcelain figurine would transmogrify into a porcelain fixture, a feminine form still, albeit one with a signification relayed across an even more complex mesh of associations. At the level of the symbolic, the feminine is said to be on the side of the abject, the irrational, the unformed, the horizontal, the liquid, like bodies of water that take the form of their vessel; just as the masculine is said to be on the side of the subject, the rational, the normative, the distinct, the vertical, the categorical, the specific. By the nineteenth century, "woman," then long associated with open waters and floods,[8] came to be associated with the control of floods, the control that was modern plumbing.[9] In the history of American plumbing, this control was particularly precarious, always threatening failure, and the oscillation between reassurance and threat served only to heighten the charge that plumbing accrued. This very ambiguity puts plumbing on the side of the feminine so that "woman" and "plumbing" become mutually reinforcing tropes, juxtaposed in a tender and horrific embrace—from nineteenth-century sanitary engineers to histories of modern art to the films of Hitchcock to the boys in the suburbs of my youth—whose charming sobriquet for girls was *muck-holes.*

MUCK-HOLES

I'll trade you for your candy some gorgeous merchandise
My camera, it's a dandy, six by nine, just your size,
You want my porcelain figure,
A watch, a submarine,
Black lingerie from Wien,
I sell my goods behind the screen...[10]
— Marlene Dietrich, BLACK MARKET

Marlene Dietrich sings of a melancholy trade in the ravages of post-war Europe: she trades her goods, *her porcelain figure*, behind the screen, "no feeling, no stealing, a very smooth routine." She is the abject, impassive hooker, selling her sexual services as she does the other contraband in her possession. She understands the irony of the sales pitch—for surely her listener thinks the porcelain a little sullied from use—while simultaneously rehearsing the older coupling of woman and that pellucid "white gold." From our vantage point this porcelain recalls less a teacup or a figurine than it does a toilet bowl. Woman as prostitute has been synonymous with hidden disease for as long as the notion of disease has existed, ascribed a moral impurity

6
THE OXFORD ENGLISH DICTIONARY.

7
See Janet Gleeson, THE ARCANUM (New York: Warner Books, 1998).

8
See Klaus Theweleit, MALE FANTASIES, VOL. I: WOMEN, FLOODS, BODIES, HISTORY (Minneapolis: University of Minnesota Press, 1987).

9
See Suellen Hoy, CHASING DIRT (Oxford: Oxford University Press, 1995), (paperback ed. 1996), pp. 51; 73. In the Civil War, 'Whitewash and women were the best disinfectants,' and in the nineteenth-century women were enlisted to be the most activist sanitarians.

10
Marlene Dietrich, "Black Market" on her COMPLETE DECCA RECORDINGS, (Los Angeles: MCA Records, 1982) Side 2, Track I.

that, slippery metaphor that it is, segues easily into physical dirt, filth, mire. And woman has for centuries and misogynist millennia been associated with dirt: *Inter faeces et urinam nascimus.*[11] Here we see the poles between which this figure, woman, is consigned to vacillate. Under modernity, the chain of association from woman to filth to cleanliness—and back again—is sent underground, via plumbing.

In nineteenth-century Paris the equation of women and filth was manifested in the regulation of sex-work and sewage alike, via various ordinances, technologies and taxonomies:

> *If, without scandalizing anyone, I was able to enter the sewers, handle putrid matter, spend part of my time in the refuse pits, and live as it were in the midst of the most abject and disgusting products of human congregations, why should I blush to tackle a sewer of another kind (more unspeakably foul, I admit, than all the others) in the well-grounded hope of effecting some good by examining all the facets it may offer?* [12]

So argued the great nineteenth-century sanitary engineer, Alexandre Parent-Duchâtelet, in his study of Parisian prostitution. He developed his major designs in sanitary engineering at the same time as he conducted an intensive investigation of prostitution, moving with apparent ease from the sewer to that "sewer of another kind." It should be noted that Parent-Duchâtelet was an avid empiricist. Thus, in order to disprove a belief popular at the time that miasma caused disease, he—it seems with great gusto—used himself as a case study, by immersing himself in sewage and by smearing excrement on the walls of his rooms. He was quite comfortable living in such malodorous states, busily classifying effluvia into many different types. His study of prostitution was equally in depth, a detailed sociology that afforded rather sympathetic and unsensationalized glimpses into the ordinary circumstances of nineteenth century Parisian sex-workers. Yet in spite of his findings about her material lot, against the evidence of his very own empirical research, he still saw fit to judge the prostitute *more unspeakably foul*. To Parent-Duchâtelet, as Alain Corbin reads him, "the moral bases of such a conviction are evident: in the author's mind the virulence of the illness transmitted by female sewers, by the vaginal filth of fallen women is naturally linked to the mire and to excremental effluvia."[13] Of course Parent-Duchâtelet was not alone in his views. By the end of the nineteenth-century, civic-minded Americans, especially New Yorkers, went on a "social hygiene crusade" to rid their cities of moral as well as material dirt.[14] And in the First World War, government pamphlets and posters warned U.S. soldiers of potential sexually transmitted disease by arguing that *German Bullets* [are] *Cleaner than Whores.*[15]

The fantasy of the feminine is one of plenitudinous sexuality, be it damnable and detestable, or elsewhere, clean and pure:

> *What is it that gushes out of our water pipes then? If the desire for a flowing sexual yet clean woman has merged with the boundless oceans...Then what we wash ourselves with every day is that same ocean in its domesticated form, tamed within our water pipes. We use that substance, that 'pure mother,' to cleanse ourselves of the dirt of the world...the dirt that we are ourselves. In other words, tap water has become (among other things) the material incarnation of the anti-sexual abstraction 'White woman' ('pure mother'...).*[16]

11
"We are born between excrement and urine," St. Augustine, cited in Bernard Tschumi, "Architecture and Transgression," in ARCHITECTURE AND DISJUNCTION (Cambridge: The MIT Press, 1994), p. 73.

12
Alexandre Parent-Duchâtelet, cited in Charles Bernheimer, FIGURES OF ILL REPUTE (Cambridge, MA: Harvard University Press, 1989), p. 15.

13
Alain Corbin, 'Représentation', in Alexandre Parent-Duchâtelet, LA PROSTITUTION À PARIS AU XIXE SIÈCLE (Paris: Seuil, 1981), cited in C. Bernheimer, FIGURES OF ILL REPUTE, p. 16.

14
S. Hoy, CHASING DIRT, 1996, p. 80.

15
James F. Gardner, "Microbes and Morality: The Social Hygiene Crusade in New York City, 1892–1917," Ph.D. dissertation, Indiana University, 1974, p. 372, cited in S. Hoy, CHASING DIRT, 1996, p. 81.

16
K. Theweleit, MALE FANTASIES, p. 422.

Madonna and whore. Idealized and denigrated. Purity and filth. Modern plumbing, in its connection to woman, has acquired these associations, both revered and reviled. Plumbing is the uncanny embodiment of the sexualized and maternal figure of woman—erotic, comforting, horrific. Tap water is our pure mother, waste water our slut. We shall see this "woman" juxtaposed with toilets, plumbing, drains, in some of the key narratives of the twentieth century. Let us take a glimpse at that most famous of shower scenes, the shower scene in Hitchcock's PSYCHO (1960).

Elisabeth Bronfen, in her treatise on the hysterical body, takes the navel as the imperfect knot, the mark on the body, of the first and primary castration, a castration that both men and women experience, the castration that is the separation, at birth, from the maternal body.[17] Her brilliant reading of the shower scene in PSYCHO, identifies the gaze of Norman Bates, formally, filmically, linked to the body of his soon-to-be-victim, Marion Crane, whose torso we see mid-murder with the weapon pointing directly to her navel. Bronfen links this momentary flash—the view of the victim's navel—with the murderer's incommensurable desire to possess and return to his mother. The character, Marion Crane, for her part, is sexual, self possessed, fast-moving, a woman who takes charge of her destiny—she is the bad girl with whom we identify; the bad girl who, although with misgivings about her decisions, sets in motion a sequence of events that leads her to the Bates Motel and ultimately to her demise, her life blood literally draining down the waste pipe, her slumped body in close-up against an almost Edward Weston-like view of the toilet bowl, and then, the denouement of the first half of the film, her dead, open eye in close-up, famously dissolving into the drain itself, the gurgling admixture of water and blood draining into waste, the only sound we can hear.[18] In Bronfen's analysis the navel, or *omphalos*, is the non-site of the initial castration that is childbirth and separation from the mother, while it is also the knot that is at the centre of subjectivity.

I would take the *omphalos* a step further and apply it to the *mise-en-scène* itself, in this case, a drain-eye-navel configuration, to argue that that other non-site, or mark in the surface of the architecture, the drain, itself functions as an *omphalos*, an imperfect residue, a return of the repressed that cuts into the fantasy of seamless subjectivity and individual agency (of course here it is the woman's agency that must be cut). The drain returns to us its blank eye, half reminding us of that which we would rather forget. In the symbolic order of a patriarchal, body-phobic culture, woman and plumbing are the barely acknowledged holes in the symbolic through which seeps anxiety. Of course, I am speaking of a normative culture against which there are aberrations, deviations. Yet the dominant culture is no less compelling for being discontinuous; indeed it is its generality and exceptions that make it all the more cogent and invisible. In the normative culture, then, "woman" and "toilet," both cause anxiety about the porousness of embodied subjectivity that must deny or abhor that which undoes its finitude: to shit, piss, and bleed is to leave part of oneself behind, which is to have blurred one's margins, to have destabilized a phantasmagoric individuality. Similarly, to invoke a forgotten maternal body is also to deny one's identity as discreet and whole, and to acknowledge the profound interconnectivity of human subjecthood, the confusion of identities, the dissolution of self. Woman, toilet: these are the apparatus by which we are undone and which we abjure, in order to be who we are.[19]

THE SEWER IS THE CONSCIENCE OF THE CITY[20] Just as the self must be split from everything else in order to be, so the dialectic of the modern wants to split the private from the public, the individual from the mass, the domestic from the civic. Modernity necessarily presumed the split between, on the one hand, the expansion of individual sovereignty—the right to privacy if

17
See Elisabeth Bronfen, THE KNOTTED SUBJECT (Princeton: Princeton University Press, 1998).

18
This juxtaposition of (bad) woman and plumbing is reiterated even in her name, Crane, which is of course is a bird but is also the brand name of a popular porcelain fixtures manufacturer.

19
See Julia Kristeva, POWERS OF HORROR, trans. Leon Roudiez (New York: Columbia University Press, 1982).

20
Victor Hugo, LES MISÉRABLES, trans. Charles E. Wilbour (New York: Modern Library, 1992), p. 1090.

you like—and, on the other, the greater common ownership of public spaces and institutions. In its taxonomic drives, it relied on that split to keep "a place for everything and everything in its place,"[21] to appropriate Catharine Beecher's famous adage. Modernity sought to shore up intimacy in the hallowed sanctity of coupledom/domesticity while maintaining a monumental public-ness, erected without any of the inevitable dirtiness, out-of-place-ness, that personal touch might entail. Inevitably, however, the personal does touch the public and a psychic charge accrues to the places where these different registers of modern entitlement converge. Like sticky stuff to a wall, like shit in a public bathroom, this charge attaches to the intimate "non-spaces" of modern public life. Griselda Pollock identified those interstitial spaces for modernity in nineteenth century Paris: the brothel, the bar, the theatre.[22] In Pollock's analysis the figure of "woman"—specifically the sex-worker—becomes a cipher for the complex workings of modern anxiety not only around sexuality, disease, and embodiment, but also the incommensurability of the public/private split. The prostitute's "work places" afforded intimacy in public and semi-public space. Intimacy of the erotic kind that could include sex, conversation, and the badinage and flirtation that may precede sex, was thus open to public scrutiny and not sequestered into the drawing rooms and bedrooms of private space. Sex was part of a spectacular public culture in which commodities and pleasures circulated, and money—that most promiscuous of flows—was lube to them all.

> People have key self-constitutive relations with strangers and acquaintances; and they have eroticism, if not sex, outside of the couple form. These border intimacies give people tremendous pleasure. But when that pleasure is called sexuality, *the spillage of eroticism into everyday social life seems transgressive in a way that provokes normal aversion, a hygienic recoil, even as contemporary consumer and media cultures increasingly trope toiletward, splattering the matter of intimate life at the highest levels of national culture.*[23] [My emphasis]

Berlant's comments recall the Jerry Springers and Jenny Joneses of afternoon and late night talk shows and the spate, pre-September 11, of so-called Reality television shows, all of which indulge a voyeuristic *schadenfreude* in the spectacle of violence, sex, and emotional betrayal. It is interesting that even she describes these phenomena in metaphors of the toilet. The spillage, then, of privacy into public confounds the classification of the spaces of modernity, and the persons and behaviors ascribed to each. Consider for a moment the Salon of 1865 in which Manet's OLYMPIA first appeared. What was most provocative about the painting's appearance was the look of the model, Victorine Meurent, whose gaze was direct and unidealized. Her contemporary look squarely put the genteel, middle class heterosocial world of Salon viewing up against what would usually be reserved for a homosocial viewership. It was conventionally the blokes of the bourgeoisie who got to ogle, and on occasion more than ogle, women who might be sex-workers; slummingly crossing class boundaries while their wives and lady friends remained demurely cloistered in the domestic sphere, away from such lurid realities of masculine public life.

If, in the twentieth century, these once-contaminating and titillating marginal spaces of modernity are relatively normalized, consider the persistent discomfort around those other marginal spaces of modernity, the bathrooms and toilets of public and semi-public space. Plumbing, with every sanitary flush, with every gleaming knob and valve, every glint on the surface of the porcelain, is meant to allow you efficiently to forget about the fact of your personal

21
Catherine E. Beecher, LETTERS TO PERSONS WHO ARE ENGAGED IN DOMESTIC SERVICE (New York: Leavitt & Trow, 1842), p. 211.

22
Griselda Pollock, VISION AND DIFFERENCE (New York: Routledge, 1988, reprinted 1989), pp. 50–90.

23
Lauren Berlant and Michael Warner, "Sex in Public," CRITICAL INQUIRY, Vol. 24, No. 2 (Winter 1998), p. 560.

self. One quick flush and you're gone. The public bathroom is meant to be clean, devoid of matter-out-of-place—shit, piss, and homey decoration—devoid of signs of the very human presence for which it is intended. But with each raised and lowered seat, every splash of urine, every tear of toilet paper littering the floor, the bathroom and its plumbing point to the impossibility of keeping intimacy (the personal), out of the public, and of keeping the sovereign individual free of contamination. Thus, paradoxically, plumbing also connects you to every other denizen in the communal rush to separation. In this, the fact of a necessary cleanliness gives way to a symbolic cleanliness in which the shine and sparkle of smooth, white fixtures creates a flare, a flash, that covers over the irreconcilable conflict. But when you're sitting there in the stall of a public toilet, caught with your pants down, olfactories sensing someone in the adjacent stall, such

24
Kendall Thomas, "Shower/Closet" in Mark Wigley, ed., ASSEMBLAGE: CRITICAL JOURNAL OF ARCHITECTURE AND DESIGN CULTURE, No. 20 (April 1993), pp. 80–81.

25
The plunger was a phantasmatic object, a misnomer in the press subsequently taken up as a symbol of the obscenity of police brutality; the actual weapon was a broken broomstick. For a fuller account, see my Letter, "System Failure," ARTFORUM, XL, No. 3 (November 2001), p. 20.

26
See J.C. Stobart, THE GLORY THAT WAS GREECE (London: Sidgwick & Jackson, 1915).

27
Pierre Cabanne, DIALOGUES WITH MARCEL DUCHAMP, trans. Ron Padgett (New York: Viking Press, 1971), p. 58.

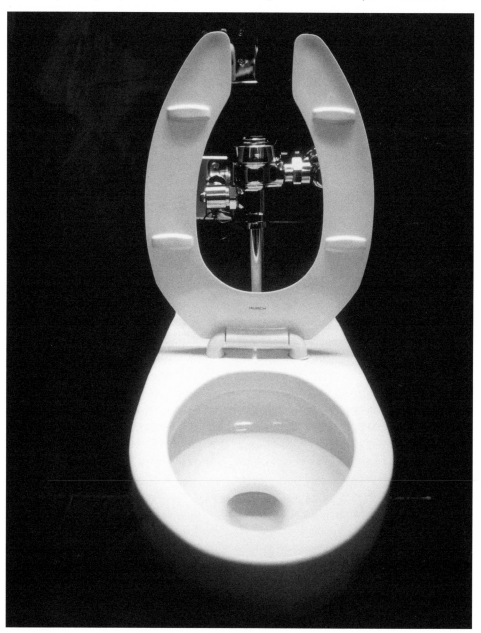

→
Margaret Morgan, UNTITLED BATHROOM NO. 993007, 1999 from the exhibition, "Porcelain," Galerie Inge Baecker, Cologne.

separation is undone. Small wonder these are the places used for the exchange of gossip and sex and cigarettes, contraband, violence, illicit encounters of all kinds. And it is the intersection of contamination and titillation that drives the charge of these interstitial, intimate semi-public places.

The toilet functions as omphalos, that non-place we refuse to acknowledge, lest we recall that which is "best left alone." It is the site of nervous laughter, loathing, fascination. A marker of the repressed, it recurs again and again in the narratives of the twentieth century: from the annals of art history to modernist architecture to the most quotidian aspects of contemporary mass culture. Recall, for example, the "don't ask, don't tell" fiasco about gays in the military under the first Clinton Administration: it was the *shower scene* that became the fulcrum of homophobic anxiety. How could straight men, comfortable with other straight men, still reliably *look the other way,* with men who were openly gay, in the same communal shower stall? The shower closet functions here as the scene of repression and desire, the butting up, so to speak, of the fantasy of a private, sexualized body with the public organ, the military.[24] Or think of the 1997 police brutality against one Abner Louima in NYC in a local precinct bathroom: it was the detail of the implement used to sodomize the Haitian immigrant—popularly reported to be an ordinary toilet plunger—that made the injustice all the more incendiary to the plunger-waving protesters.[25] Plumbing, so often aligned with bodily trauma, is a volatile signifier of that which cannot directly be acknowledged in the symbolic order—a toilet, a plunger, a shower stall to take the place of the unspeakable— and to make it all the more charged.

↑
Margaret Morgan, UNTITLED BATHROOM NO. 990531, 1999 from the exhibition, "Porcelain," Galerie Inge Baecker, Cologne.

A GOOD DRAIN IMPLIES AS MUCH AS A BEAUTIFUL STATUE[26] Let us now consider in greater detail a scenario in which a private fixture, in this case, a urinal, moves into bourgeois public view, into the heterosocial spaces of genteel art viewing: let us review again that most famous of art historical toilet narratives, the pseudonymous presentation by Marcel Duchamp, alias R. Mutt, of FOUNTAIN to the Society of Independent Artists. When Duchamp exhibited in New York in 1913 he functioned as an unofficial attaché of avant-garde culture. Direct from Paris, that center of all things modern, the work he exhibited was cubist painting. The local art scene was challenged by this difficult, ultra-modern work, the more skeptical critics haplessly searching Duchamp's NUDE DESCENDING A STAIRCASE for a nude or a staircase. Yet the nascent New York art scene was keen to be seen to be sophisticated—at least to itself—and eager to be abreast of all that was new from Paris. So by the time Duchamp himself arrived in 1915, his notoriety had already given way to a certain cache. As Duchamp observed: "I wasn't on the fringes in New York... When I was introduced I was always the man who had painted the NUDE DESCENDING A STAIRCASE and people knew who they were talking to."[27] Nearly a decade after Picasso's LES DEMOISELLES D'AVIGNON, New York arrived at the idea that avant garde art was cubist painting—and Duchamp its imported

28
Francis M. Naumann, NEW YORK
DADA 1915-23 (New York: Harry N.
Abrams, 1994), p. 36.

29
Slavoj Žižek, THE PLAGUE OF
FANTASIES (London: Verso, 1997,
reprinted 1999), p. 4.

30
Ibid., p. 4.

31
One might wonder: why are those
gaps there at all? Surely the stalls
could be constructed without those
narrow spaces through which
looks into and out of the stall can
be exchanged. It is almost as if
to heighten the tension between
public and private and to raise the
possibility of ostensibly prohibited
exchange.

32
Modernization in Japan has had
yet another effect on toilet design:
unable to deny the public-ness of the
public toilet, many Japanese women
took to the habit of flushing as they
peed or shat, to literally drown out
the noise of their ablutions, only
to flush again to remove the waste,
thereby doubling their consumption
of water. That is, of course, until in
late-modern Japan, customers were
given the option of pushing a button
which activated a recording of the
sound of water flushing.

incarnation. The press warmed to him; one critic remarking with a touch of surprise that Duchamp dressed quite correctly, was rather handsome and, indeed, looked "more like a well groomed Englishman than a Frenchman."[28]

Allow me a digression: Our American critic implies that to be English was to be neater, cleaner, and more presentable than the French. I am reminded of Žižek's distinctions between the German, French, and English as manifested in the design of their lavatories:

> In a traditional German lavatory, the hole in which shit disappears after we flush water is way in front, so that the shit is first laid out for us to sniff at and inspect for traces of some illness; in the typical French lavatory, on the contrary, the hole is in the back—that is, the shit is supposed to disappear as soon as possible; finally, the Anglo-Saxon (English or American) lavatory presents a kind of synthesis, a mediation between these two opposed poles—the basin is full of water so that the shit floats in it—visible but not to be inspected.[29]

In Žižek's triangulation, German, French, and English toilets reveal "German reflective thoroughness, French revolutionary hastiness, and English moderate, utilitarian pragmatism."[30] We shall see how these characteristics, the German, the French, and the Anglo-Saxon, apply in the ideology of plumbing's physical form and in the "symbolic toilets" of the narratives of Modernism.

But first, let us dwell awhile on the details of Žižek's observation. Consider the typical French public toilet of the twentieth century: dimly lit, two islands only upon which to set one's feet and then far behind, at a distance heightened by one's semi-upright stance, a barely discernable hole into which one must aim one's shot. Many fail this marvelous feat and the remains of their botched attempts spatter the surrounding tile—revulsion as much as revolution pressing the haste of one's retreat. The German stall, by contrast, is brilliantly lit, all the better to inspect the toilet itself and one's business on its middle ledge, the veritable heat of life still rising from the jettisoned abject. The German toilet is accompanied by papers and sanitary napkin bags, order and symmetry, a group of stalls conveniently arrayed, ready for thorough inspection. For the Anglo-Saxon synthesis, indeed the floaters shall float and, as for the rest, they will sink, as if into the unconscious, submerged and refracted at middle distance through the bowl of water. We can gauge the density of the turd by whether it floats or not; it is mass, not visuality, that's crucial here: a feeling, a partial glimpse, an image to be imperfectly recalled: a perfect scenario for active forgetfulness, repression bound to surface elsewhere. This then is part of the horror of the blocked toilet, the overflow of which threatens to engulf the mesmerized subject who, having just flushed the toilet, can only stand there dumbfounded, watching as the excrement against which he defines himself comes back to stick to his person, ankle deep in symbolic, as much as actual, shit. In the Anglo-Saxon toilet stall, usually only the toilet itself is spot-lit, the space around the fixture left ill defined in semi-darkness, lest one all too easily disrupt the fantasy of privacy that is the condition of being in a public toilet. We ignore the gaps in the partitions of the stall and refuse to see the person waiting without.[31] In the Anglo-Saxon experience, we maintain our ablutions in the illusion of privacy-in-public: we can look, but not too closely, pragmatic, sensible, not too shocking, and if we concentrate only on the well-lit toilet itself, we can deny the proximity of others and ignore the sounds of their ablutions.[32]

In short, the German shows all, the French nothing much, and the Anglo-Saxon just enough to leave a residue that percolates into the unconscious, only to appear again, half remembered, a return of the repressed.

To return to our narrative: within a year of his return, this nice fellow, Duchamp, challenging but not too confrontational, became a member—and Director of Installation[33]—of the newly formed Society of Independent Artists. By the time of the Independents' inaugural exhibition, Duchamp was firmly ensconced in the New York scene. He was a fixture, so to speak. That is, of course, until that other fixture came into the picture. Thousands thronged that first exhibit but were not to see the suppressed readymade, Duchamp's FOUNTAIN. As Beatrice Wood put it, "a small hurricane of controversy,"[34] ensued and, in the form of an absented artwork, the "dark hole" of Frenchness reappeared. Duchamp, in the guise of R. Mutt, was revealed to be not as English as the critics might have imagined, but actually very like a French toilet: unfathomable, a dark occlusion, an impulsive revolutionary, he who would be blasted for the dirtiness of his habits, for the immorality, the vulgarity of that "artwork"—his veritable self-portrait. Beatrice Wood recalls an altercation over FOUNTAIN between Walter Arensberg and George Bellows:

> 'We cannot exhibit it,' Bellows said hotly, taking out a handkerchief and wiping his forehead.
> 'We cannot refuse it, the entrance fee has been paid,' gently answered Walter.
> 'It is indecent!' roared Bellows.
> 'That depends upon the point of view,' added Walter, suppressing a grin.
> 'Someone must have sent it as a joke. It is signed R. Mutt; sounds fishy to me,' grumbled Bellows with disgust. Walter approached the object in question and touched its glossy surface. Then with the dignity of a don addressing men at Harvard, he expounded:
> 'A lovely form has been revealed, freed from its functional purpose, therefore a man clearly has made an aesthetic contribution.'
> The entry they were discussing was perched high on a wooden pedestal: a beautiful white enamel oval form gleaming triumphantly on a black stand.
> It was a man's urinal turned on its back.
> Bellows stepped away, then returned in rage as if he were going to pull it down.
> 'We can't show it, that is all there is to it.'
> Walter lightly touched his arm, 'This is what the whole exhibit is about; an opportunity to allow an artist to send in anything he chooses, for the artist to decide what is art, not someone else.'
> Bellows shook his arm away, protesting. 'You mean to say, if a man sent in horse manure glued to a canvas that we would have to accept it!'[35]
> 'I'm afraid we would,' said Walter, with a touch of undertaker's sadness. 'If this is an artist's expression of beauty, we can do nothing but accept his choice.' With diplomatic effort he pointed out, 'If you can look at this entry objectively, you will see that it has striking, sweeping lines. This Mr. Mutt has taken an ordinary object, placed it so that its useful significance disappears, and thus has created a new approach to the subject.'
> 'It is gross, offensive! There is such a thing as decency.'
> 'Only in the eye of the beholder. You forget our bylaws.'[36]

Echoing Arensberg's argument, Beatrice Wood, Pierre Roché, and Duchamp argued in an anonymous article in THE BLIND MAN that "[w]hether Mr. Mutt with his own hands made the fountain or not has no importance. He *chose* it. He took an ordinary article of life, placed it so that

33
At that time, the plumber in Europe was commonly known by the French appellation, *installateur*.

34
B. Wood, I SHOCK MYSELF, pp. 29-30.

35
I am reminded of the 1999 altercation between the then pre-9/11 Mayor of New York, Rudy Guiliani and the Brooklyn Museum of Art over the exhibition, "Sensation," and in particular Chris Ofili's paintings of Madonnas with elephant dung. Marx's words were never more true. History repeats itself, first as tragedy, then as farce.

36
Cited in William A. Camfield, "Marcel Duchamp's Fountain: Its History and Aesthetics in the Context of 1917," in DADA/SURREALISM, 1987, No. 16, pp. 69-70.

37
"The Blind Man No. 2," May 1917, reproduced in B. Wood, I SHOCK MYSELF, p. 30.

38, 39
Ibid.

40
See Mary Douglas, PURITY AND DANGER (New York: Routledge, 1966).

41
"The Blind Man No. 2," May 1917, reproduced in B. Wood, I SHOCK MYSELF, p. 30.

its useful significance disappeared under the new title and point of view, creating a new thought for that object."[37]

Yet Duchamp had been making ready-mades—"choosing ordinary objects and placing them so their usual significance disappeared"—since 1913 (think of BOTTLE RACK, BICYCLE WHEEL, IN ADVANCE OF THE BROKEN ARM), and he had been exhibiting them since 1916. None had caused a furor anything like that around FOUNTAIN. It is at the level of reception that this particular ready-made distinguished itself and set the tone for the reception of an entire artistic strategy. Its detractors argued that FOUNTAIN was a "plain piece of plumbing."[38] Of course such protestation begs the question: if a piece of plumbing is *just so plain*, why did it cause so much wiping of brows, raising of voices, contravention of bylaws and, to this day, writing of articles? Plumbing is no neutral, merely utilitarian object.

Duchamp's urinal was at one point renamed MADONNA OF THE BATHROOM[39] and was to its supporters a beautiful, flowing form; to its critics a desecration, an outrage to decency, the very antithesis of cleanliness and purity—feminized along that familiar axis, literally as Madonna and whore. But our slutty artwork goes further, by crossing the territories from masculine privacy-in-public, to being public in a wider sense. What is usually reserved for male viewership is presented for the gaze of all. A urinal, albeit an inverted one, suddenly shifts the private spaces of masculine modern public life into the centre of attention. Suddenly the public toilet, the men's public toilet, is revealed for all to see. Even the plumbing showroom, the other place to view a urinal, was not a place for bourgeois women to frequent; to this day, women in plumbing showrooms are often treated as oddities. In the proprietary spaces of bourgeois cultural exchange, the urinal is "matter out of place."[40] It is unclean, immoral, precisely because it reveals the personal, the intimate, the insinuated bodily workings, its abject wastes, all of this, all that is precarious and usually unspoken in modern masculinity, and by doing so, reveals the veil behind which the phallus normally hides. Duchamp inverts not only the urinal's physical form but its symbolic form as well. This in a gesture that puts the urinal on the side of the feminine, by destabilizing its signification, by making it oscillate between obscenity and beauty, between the private and the public, and between an all-too-close reminder of the abject as a profound expression of artistic autonomy. This object—or is it abject—neither lost nor found, a between thing, a dissolution, marked yet another boundary between modern privacy-in-public and public space: FOUNTAIN marked the shift from the relative privacy of the bourgeois Salon, to the infinitely more vast and open public spaces of mass culture, manufacture, engineering, spectacle—a harbinger of the late modernity that is our lot.

But, to return to the scene of the crime: George Bellows' outrage was underpinned by his sense that the Independents were being ridiculed, that the modernity of New York art was being affronted by a fishy joke, a watery inversion that could, would that it were actually plumbed, spray them in the face like a cheap, trick corsage. Bellows and the Directors of the Independents considered FOUNTAIN to be a mockery of their new modern institution, and, in a misguided bid to emulate their Parisian namesake, they suppressed the entry (albeit by a slim majority). Of course by abandoning its principles of "no jury, no prizes," the Society of Independents proved itself a rather empty vessel, justifying any mockery to which it was subject. What made R. Mutt's entry all the more pointed was the fact that, as Duchamp's supporters argued, "The only works of art America has given are her plumbing and her bridges."[41] Imagine how new modern cities, like Chicago and New York, would have appeared to a generation of European artists and intellectuals fleeing the ravages and displacements of World War I and the old modern cities of Europe. Certainly the New York Dadaists were aware of the contrast between French *dark*

holes and the efficiency of American plumbing; and, *me thinks*, the stridency of the Independents' reaction was directly proportional to the cogency of that argument. To acknowledge a plumbing fixture as art would be to make the Independents redundant, their efforts moot: in the pursuit of cultural supremacy, American sanitary technology had already beaten them at their own game.

PIPE DREAMS Europeans who visited the America in the late nineteenth and early twentieth centuries seemed to recognize this point all too well: in matters of sanitary technology and modern culture, European artists, architects and intellectuals readily acknowledged U.S. engineering and design as the *sine qua non* of modern form. This brings me to the Germanic corner of Zizek's triad. Let us consider the argument of that great evangelist of modern culture, the Austrian architect, Adolf Loos:

> *A home without a bathroom! An impossibility in America. The mere idea that at the end of the nineteenth century a country with a population of millions exists whose inhabitants cannot have a daily bath seems monstrous to Americans... Germany needs a bath. Let's consider the matter carefully: we don't really need art. We haven't even got a culture of our own yet... Instead of spending money on art, let's try producing a culture. Let's put up baths next to the academies and employ bath attendants along with the professors... The plumber is the pioneer of cleanliness. He's the State's top tradesman, the quartermaster of civilization, the civilization that counts today.*[42]

So wrote Loos, in his seminal (sic) manifesto, "Plumbers," nearly two decades before the FOUNTAIN affair. And by Loos' own account, it took him some years to come around to this, his most famous position on plumbing and modern life.

In 1893 Loos had visited Chicago and the World's Columbian Exposition. At the time, as he later admitted, he "was still totally convinced of the superiority of German crafts and handiwork... My years of residence [in the USA] have had the effect that I still today blush with embarrassment when I think of the disgraceful representation of the German crafts in Chicago."[43] The Americans, meanwhile, in misguided and unnecessary efforts to attain cultural ascendancy, were trying to emulate Europe, in this case, its Beaux Arts tradition. As one commentator in THE NATION put it, "It is not unreasonable to fear lest the Court of Honor [main pavilion at the Fair] mark the beginning of an outbreak of white classicality over the land, which will make the vagaries of Queen Anne and colonial style appear the height of good sense and taste."[44] Indeed, with its brilliant white, neoclassical facades reflecting all the brightness of the opening days, the exposition was dubbed the "White City." Yet surely this whiteness must also have been connected, in the symbolic register—at least in Loos' mind—to the white of the sanitation made available to the exposition's public. It was around the time Loos wrote of the shame he felt, retrospectively, at the paucity of the German contribution to the Exposition, that he, in the article quoted above, extolled the virtues of plumbing—English and American plumbing—as the great exemplars of contemporary modern culture. In the early 1890s Loos had been living first-hand with an American plumbing system that was the culmination of a decades-long effort by urban sanitary reformers, with their white clad street cleaners, their "White Wings," their white caps on the heads of newly converted children, their white tiles and white porcelain to symbolize hygiene and purity.[45] And surely Loos must have been deeply impressed, even if unwittingly at the time, by the 3,000 toilets installed, the filtered drinking water, the paved streets and the nightly street

42
Excerpts from Adolf Loos, "Plumbers," in NEUE FREIER PRESSE, July 17, 1898, this translation in Münz and Künstler, Adolf Loos, PIONEER OF MODERN ARCHITECTURE (New York: Frederick A. Praeger, 1966), pp. 220–221.

43
Adolf Loos, "The Leather Goods and Gold- and Silver-smith Trades," NEUE FREIER PRESSE, May 15, 1898, reprinted in SPOKEN INTO THE VOID, trans. Jane O. Newman and John H. Smith (Cambridge: The MIT Press, 1982, third printing, 1989), p. 7.

44
S. K., "The Columbian Exposition–IV," THE NATION, No. 1469 (August 24, 1893), p. 133.

45
See S. Hoy, CHASING DIRT, 1996.

MARGARET MORGAN

cleaning, of the Chicago World's Fair (as it is also known)—and all this in the shadow of Sullivan's Chicago, with its new sky-scrapers, its practicality, its technology. I cannot help but imagine the profound impression this other "white city" must have made on Loos.

> *Our [Austrian] bathroom fixtures are the weakest of the lot. Instead of using white tiles for the bath, we prefer colored ones, so that, as a manufacturer naively assured me (he didn't actually demonstrate) the dirt would show up less. Tin baths, instead of being enameled white, the only suitable color, often come in dark colors... Thus at M. Steiner's [designed by Loos] we may see excellent, smooth and hence elegant, American shower fittings, a new invention.*[46]

As different as are the strands of Modernism represented by Loos and Duchamp, each, in its own way, grapples with that fundament of modern culture, the plumbing of modern life. They, the Frenchman and the German, embody what Žižek describes as different attitudes toward excremental excess: ambiguous contemplative fascination, as Loos' diatribe would seem to suggest, and the hasty attempt to get rid of the unpleasant excess as fast as possible, witness the vanishing of FOUNTAIN. Here I might usefully apply David Trotter's notions of "waste theory," related to system and metaphor, and "mess theory," concerned with chance, contingency, and metonymy. Trotter argues that waste is a condition, and mess an event and that there are "two styles of commentary on modern life, one drawn consistently towards and into determinism, the other an acknowledgement of chance as matrix and occasion."[47] Adolf Loos, then, might be readily put on the side of waste theory and Duchamp, with the mess.

EVERY TAP AND PLUGHOLE IS A MARK OF PROGRESS[48] But what of Žižek's triangle: if Loos is to the Germanic toilet and "waste" as Duchamp is to the French and "mess," what of the "Anglo-Saxon" synthesis? Loos argued that "Our [Austrian] taps, sinks, water-closets, wash basins, etc. are far behind the English and American fittings... [It] seems most shocking to the Americans."[49] In the Anglo-Saxon (especially American) corner of Žižek's triangle, it is mass culture, per se, that is represented by the American toilet. As we have seen, these are overlapping formations, German, French, Anglo-American, and none can stand on its own without its relation to the others. Their interconnectedness multiplies Žižek's triad into a kind of pyramid. For the American part, mass culture, manufactured objects, plumbing and bridges, as the Dadaists knew back in 1917, have proved to be the ascendant cultural forms. For contemporary American mass culture, its McDonald's signs, its Disney Worlds, its Hollywood blockbusters, its television sitcoms, have become the heirs of modern mass culture: cheap, multiple, entertaining, spectacular. They are the icons of a very late modernity, themselves objects of laud and derision, across the country and around the globe. Interestingly, in the shift from late- to post-modern culture, both Disney and McDonald's are losing market share, their hegemony on the wane. What replaces them is yet to be seen. But let us return to those early motifs of the modern, that which literally embodied progress and domination.

> *It is hardly an exaggeration to summarize the history of four hundred years by saying that the leading idea of a conquering nation in relation to the conquered was in 1600 to change their religion; in 1700 to change their laws; in 1800 to change their trade; and in 1900 to change their drainage.*[50]

46
A. Loos, "Plumbers," pp. 221–222.

47
David Trotter, COOKING WITH MUD: THE IDEA OF MESS IN NINETEENTH CENTURY ART AND FICTION (Oxford: Oxford University Press, 2000), cited in Marjorie Garber, "Spitting, Sneezing, Smearing," LONDON REVIEW OF BOOKS, 10 August, 2000 (Vol. 22, Number 1516), p. 16.

48
A. Loos, "Plumbers," p. 221.

49
A. Loos, "Plumbers," pp. 221–222.

50
A. Lawrence Lowell, President of Harvard University, cited in Abel Wolman, "The Sanitary Engineer Looks Forward," WATER AND SEWERAGE WORKS, Nov. 1946 (Vol. 93, No. 11), p. 409.

So argued an American sanitary engineer, unwittingly confirming the Dadaists, 30 years before him. In the nineteenth and twentieth centuries, plumbing was intimately bound up with modern mass culture—in the conjoining of individual toilets, in discreet bathrooms, to separate water and sewer lines that then connect to the larger system of water supply and waste disposal. Plumbing literally, physically, linked the individual home with the larger state. Just as it linked the *man on the street* with the public sphere: you could stroll all day and still find somewhere to urinate without going home (and without necessarily just unfastening in the open). *Pisotiere* or *urinoir*, a barely private space in public, a simple structure with walls to cover only the mid-section of the man whose gaze could still return the look of the public, this humble structure *gave a man vent.* Or else that man could stare ahead, in the common knowledge that those other staring men, standing around a circular public toilet, would all be urinating *into the centre*, as if into a primordial campfire. In Europe this interconnectivity was more permanently a part of the development of modern plumbing. Symbolically it bespoke the integral connection between individualism and the public sphere, as if plumbing, connected to the larger waste and water systems, correlated to a more general understanding that the common good was also good for the individual. This is not to say that the Frenchman's experience of being private in a public, being simultaneously individual and mass was without psychic conflict; only that, for the American, for reasons we shall see, it became even more so. That is, as conflicted as the individual and the mass could be, they were, have been, held in uneasy suspension, albeit suspension none the less. American plumbing evolved rather differently from its European counterparts and in ways that suggest one basis for the on-going American obsession with hygiene/bodily anxiety. For the Americans, plumbing's etymology is at the level of the individual, its hooking up to a larger system coming only much later.

FILTHY BEAST According to travelers in the early nineteenth century, Americans were a "filthy, beastly lot" who bathed rarely and for whom dirt was simply a fact of life, or, if anything else, a sign of hard work, and nothing to be ashamed of.[51] The vast majority lived rather isolated lives in rural areas. Water was difficult to access, requiring that it be hauled long distances by hand and/or, in the colder months, chipped from blocks of ice.[52] Even as more Americans moved to more densely populated regions, water access remained a problem, and bathing was of lesser import than neatness and order.[53] John Wesley's adage that "cleanliness is next to godliness" was hardly observed, except perhaps in middle class homes, where bathing on a Saturday evening, before Sunday church, was a way to distinguish oneself from the lower and laboring classes, who did not have resources or servants enough to do the hard work of drawing a bath. In mid-century America, indoor plumbing was introduced to the homes of ordinary folk for the sake of convenience, the healthful aspects of plumbing to do, not with sanitation, but with labor-saving: household running water was considered good for the health only in as much as it reduced the amount of back-breaking work required to carry water long distances.[54] Plumbing was one of a long list of conveniences, from door bells to speaking tubes, furnaces to gas lighting, that were developed to improve the efficiency and comfort of the home; and the home was that individual sanctuary wherein the family could develop and prosper—a kind of "family that bathes together stays together" attitude.

The advent of hydropathy as a fashion in the 1840s also enhanced the American attitude to water. Sebastian Kniepp (1821–1897), was a German priest, healer, and hydro-therapist whose remedies included "various kinds of baths and ablutions, exposure to cold water, and prescribed water drinking, as well as healthful dietary habits and the medicinal use of herbs. The trend

51
See S. Hoy, CHASING DIRT, 1996, pp. 4–15.

52
Among the rural poor, plumbing remained pre-modern well into the twentieth century: witness the efforts of the Works Progress Administration, the Tennessee Valley Authority and the documentary photographs of Walker Evans.

53
See Catharine E. Beecher, A TREATISE ON DOMESTIC ECONOMY FOR THE USE OF YOUNG LADIES AT HOME AND AT SCHOOL (Boston: Thomas H. Webb & Co. 1842), revised edition.

54
See Maureen Ogle, ALL THE MODERN CONVENIENCES (Baltimore: The Johns Hopkins University Press, 1996).

↑
"A Waste Fitting for Water-Closets set in a Group at the Center of the Toilet Room" from R. M. Starbuck, STANDARD PRACTICAL PLUMBING (New York: The Norman W. Henry Pub. Co., 1910), p. 206.

55
A. Loos, "Plumbers", in NEUE FREIER PRESSE, pp. 44–49.

56
M. Ogle, ALL THE MODERN CONVENIENCES, pp. 12–13.

"Various Patented Forms of Traps" from R. M. Starbuck, STANDARD PRACTICAL PLUMBING (New York, NY: The Norman W. Henley Pub. Co., 1910), p. 68.
↓

continued and by 1890 his book MEINE WASSERCUR (My Water Cure) was widely read; cures, spas and other products bearing his name were sold internationally and were especially popular in the United States."[55] Again, the individual was key to the ideology of hydropathy: self-discipline and self-improvement were integral to its workings, as it was to the many other reform movements popular at the time, personal and civic progress an individual concern.[56]

Plumbing, too, was highly individuated, a matter of personal taste, choice, and affordability, among the myriad contraptions by then available on the market. It was very much a private affair—there were no state or municipal regulations or standards to which one must comply—and the limits of its technology went only so far as a dwelling's cistern and cesspool. Communities had reserves of water for civic purposes such as fire fighting and street cleaning, but individuals within those communities were responsible for their own separate water and waste supplies. This reliance on individual access to water and waste disposal created its own set of concerns and solutions. In the 1860s, for example, in order to maintain both water pressure and reserves, households were often equipped with large elevated cisterns, unseen but *felt*, in the attic. The elevated cistern became as much a source of expense and anxiety as convenience, the threat of flood, engulfment, and collapse, literally looming right over head. And here we begin to see a shift in the symbolic value of plumbing: before the development of proper traps and adequate venting, the unpleasant odors associated with cesspools and with early toilet designs for pan closets and long hoppers, were, though distasteful, inevitably tolerated in the name of the ideas of progress and convenience. It was only later, in the 1870s, that the inadequacy of plumbing design became an object of great fear.

Americans had for much of the nineteenth century embraced the theory that miasmata arising from stagnant waters were the source of disease. As a consequence, American sewers were open to air and sunlight so that waste waters could, in theory, quickly evaporate. Epidemics of typhoid, cholera, yellow fever, and other devastating diseases were, in the 1870s, finally linked to open sewers and to the "abominable filth" generated by individual households. Household waste turned into "liquid poison," seeping from cesspool to water supply and into "gaseous poison" escaping poorly engineered, inadequately vented soil pipes. Contaminated drinking water, overflowing cesspools, and sewer gas became the new enemies, made all the more fearful because of the invisibility of their threat and because they were *enemies from within*. George E. Waring, the great American sanitary reformer and "Apostle of

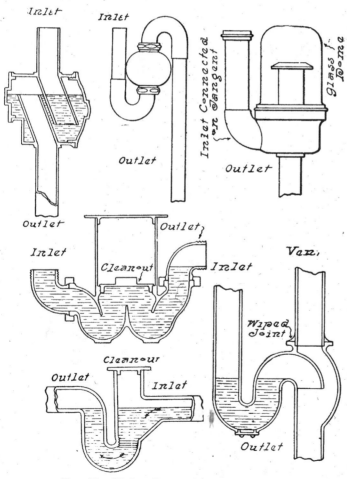

FIG. 30.—Various Patented Forms of Traps.

Cleanliness" crusaded against sewage and sewer gas with such zeal as to make New Englanders "fear it perhaps more than they did the Evil One."[57] Suddenly, in the new age of Sanitary Reform, plumbing was no longer a convenience in the home, but the very vehicle by which germs and disease were stealthily introduced into the hearth of the individual family, sewer gas seeping right into the parlor, "the odorless, mawkish exhalations first announc[ing] themselves by headache and debility."[58] Suddenly, this place of comfort, the home, was the site of disease and potential death, and its plumbing, model convenience, the carrier of it all.

> *'Be sure your sins will find you out', applies with particular force to the plumber; an ill-compacted joint will proclaim itself in a leak that will ruin a frescoed ceiling or a satin-covered suite in quick time.*[59]

Thus wrote Harriette Plunkett, in whose treatise, visions of the sullied finery of the middle class home, and elsewhere in the same volume, of the cellar's "dark, damp, spaces [that] were weird, forbidding, uncanny," operate within a symbolic register that, from our point of view, is, itself, quite uncanny: certain passages in her practical advocation of sanitary reform read like the story of a haunted house or something out of a horror film. The plumber, too, who knew as little about venting as anyone else, was more demonized than blamed for his apparent incompetence and ignorance, and sometimes for the blatant exorbitance of his fees. Again, if I am permitted to read influence in reverse chronology, I am reminded of Peter Weir's 1979 film, THE PLUMBER, in which a strangely persistent, obnoxious plumber wreaks havoc on the lives of two visiting professors at a local university. But more of that—later.

In short, in America toward the end of the nineteenth century, all things to do with plumbing were excoriated in the rather alarming realization of decades of ignorance and misconception. And here is where American plumbing gets interesting: the response to germ theory and the greater understanding of the causes of contagion was quite hysterical. All manner of ordinary objects that passed from hand to hand—including library books, street cars and, somewhat ironically, paper money—were suddenly fearsome threats to individual well-being.[60] To touch another, in passing on the street, was to become contaminated. Immigrants, "the Great Unwashed" (the new prostitute), were sources of disease to be avoided at all costs, save in the name of sanitary reform. Public space was a threat. Private space was a threat. There was nowhere to go to avoid contamination. And indoor plumbing? Many, in the first wave of reaction, had it removed completely, water closets replaced with earth closets, in a futile effort to reconcile the "safety" of pre-modern forms with the necessity of the modern. Saner, and in the end, lasting, responses included the realization that in order for plumbing to be hygienic it was necessary for it to be standardized, regulated, and hooked up to public water and waste systems. That is, at the symbolic level, the individual had to concede connection to the very organs that seemed to threaten it most. In America, where extreme individualism had for so long been the sustaining ideology, especially when it came to the regulating of personal ablution, individual integrity could now, paradoxically, only be maintained by embracing connection to a civic order. This suddenly discovered anxiety around contamination in the public and, at the self-same time, the compelling need to connect a private, individual plumbing system to a common and public one is what gives American culture both its obsession with hygiene and its ambiguous iconography of the toilet.

In the past 100 years, plumbing design and technology have stabilized; their principle venting and flushing mechanisms are basically the same as they were at the beginning of the last

57
Cited in S. Hoy, CHASING DIRT, 1996, p. 66.

58
George E. Waring, cited in S. Hoy, CHASING DIRT, 1996, p. 71.

59
Harriette Plunkett, WOMEN, PLUMBERS AND DOCTORS (New York: D. Appleton and Co., 1865), p. 95.

60
S. Hoy, CHASING DIRT, 1996, p. 99.

↑
"Seat operated water closet with long hopper without trap" from George B. Clow, PRACTICAL UP-TO-DATE PLUMBING, Chicago, IL: Frederick J. Drake and Co., 1906, p. 156 .

century. But lest one imagine that fear has abated in plumbing's symbolic register, let us look, to use Siegfried Kracauer's term, at the 'surface manifestations' of twentieth century culture. Here we will see that the idea of plumbing as a source of horror and threat is alive and well. We will see that plumbing still articulates the deepest fears of our anxious modern subject and that the watery, abject reflection in the toilet bowl still holds us transfixed. Where does this still occur with startling regularity?—in the bathroom scenes of cinema.

TOILET TRAINING As we sit in the darkened theater, our individual subjectivities collectively forgotten, we watch the toilet serve as the setting for murder, mayhem, and terrifying denouement. In popular film the bathroom, the basement, the sewer, the down-pipe swelling with unnatural unctions: these are the cinematic non-spaces wherein personhood is let go: the figure of the human is murdered, massacred, sucked into the plumbing's apparatus, its tenuous grip on the fantasy of stable subjectivity loosened, dispersed, annihilated, only to rise again, undead indeed, from the drains and sewers of cinema. And we watch the bathroom juxtaposed, in an endless loop, with a woman's gaping/screaming mouth, her dead eye, her bleeding body, from drain to misogynist drain, one hole substituting for another: ancient associations of woman with engulfment, woman with floods, and woman with the abject persist in these very modern plumbing tropes.

> The relationship between fantasy and the horror of the Real it conceals is much more ambiguous than it may seem: fantasy conceals this horror, yet at the same time it creates what it purports to conceal, its "repressed" point of reference.[61]

61
S. Žižek, THE PLAGUE OF FANTASIES, p. 7.

Fantasy travels without necessarily revealing its origins, no stamps in its passport, only a vague sense of compelling reason—a common sense—that begs scrutiny. It is as if one senses the fear that surrounds an object, and its own contagion, we catch that fear, that subliminal association, that persistent, nagging, vague feeling, like the 'flu about to come on. And that which we have caught catches onto other things, setting up a network of associations, chains of fear, none articulated, just floating, image mid-water in an American toilet, not quite acknowledged in our conscious minds. When this fantasy is located in the intertextuality of Hollywood film, the repetitions—as motifs, images, camera angles, certain shots, sound effects—perform a doubling, a tripling, a multiplying of the force of the fantasy that at once distances the viewer from the real and is therefore reassuring (the fun of horror movie watching), while at the same time disorienting (and producing an effect of extreme alienation). Yet it also produces an alias for the real that itself attains something approaching the real's horror.

Thus, for example, we re-experience the initial horror of Hitchcock's PSYCHO in its repetition in films as diverse as CARRIE (1976) or the remake of PSYCHO (1998) or even the not-very-good Michelle Pfeiffer flick, WHAT LIES BENEATH (2000). The shower scene from PSYCHO blurs the line between the filmic representation of psychic trauma and film as the very source of trauma. Its endless quotation in so many subsequent films produces the shower scene as a kind of "primal scene," itself as unapproachable as the real, as something which must be repressed and which then returns, at the level of mass culture, in those subsequent films. For if in my first viewing of the shower scene in PSYCHO, I was traumatized by the castration that it invoked; by the *omphalos* of the drain that articulates a sense of personal vulnerability within the architecture of the childhood home wherein I first viewed the scene (late at night, as a 10 year old, with my mother— we liked to watch the Hitchcock Hour on *telly*); and if the scene recalls that ancient split from

deep within one's individual prehistory, the split between mother and child that is child-birth, then the scene itself sinks, like the turds in the toilet, into that place of partial recall, forgotten, repressed, only to reappear in so many films thereafter. The fantasy functions as a real and our viewership as a kind of psychosis, a repetition of the incommensurable, beyond recollection but unforgettable, that never goes away. Does the viewing of PSYCHO recall a pre-existing trauma or is it its very cause?

Have you ever met someone with whom you've had a rapport, only to realize that all those things you have in common are in fact the movies you saw and were horrified by, the movies you loved, the movies you saw again and again? Memories of the movies, over time, can feel not so different from memories of actual things that happened to you. It's the inverse of the sensation when you realize you're recalling a photo of an event and, no longer, the event at all. If in Freud's terms, the source of trauma can be real or imagined, then, so too can the scene in the movie be the provocation of psychic effect, as real or imagined as anything else. What of this psychic effect if we think of all the bathrooms at the movies, their anxious subjects, their bodily anxiety, their gynophobia, their fear of the contradictions of being private in public? These scenes in the toilets at the movies are a toilet training indeed.[62]

For the child, toilet training is one of the landmarks by which is measured access to subjectivity and the symbolic order. The mirror stage, in Lacan's terms, is that period in her development when the child recognizes an ideal of herself—whole, finite, discreet—an image "in the mirror" (metaphorically if not actually), a version of bodily self-hood that corresponds with, but always supercedes, the "I." The child is learning verbal language by which to enunciate the "I" who wants, the "I" who is. The child is also learning social control over bodily functions which are necessary but intolerable to this notion of "I," of finite selfhood. In her individual pre-history—that plenitudinous time, in Kristeva'a terms, when the child knew neither "she" nor "me" but only the "everything" in a continuity of non-self/breast—toilet training was moot. As baby grows into child all this changes. "The incorporated/expelled objects—food, feces, urine, spit—designate the various zones of the body, later to become erotogenic zones—mouth, anus, eyes, ears, genitals. According to Lacan, sexual zones are structured as a rim, a space between two surfaces that can be seen as the boundaries between the body's inside and outside."[63] There is another toilet training we undergo, so often at the movies, itself a kind of *rim* between public and private space. These rims, these liminal places, on our bodies and in the built environment, are reiterated again and again, in the sewers, bathrooms and basements at the movies.

This feature of cinematic space appears in the latter half of the twentieth century, coincident with "the American century" finally coming into full force, as if after all that struggle for cultural ascendancy there is still a persistent residual anxiety, almost a habit of phobia, a deep uncertainty, about the integrity of American culture and the conflicted individuals who inhabit it. THE THIRD MAN (1949), a joint British-American production, sets the tone: set in just post-war Vienna, it is an allegory of European culture, high and low, and American mass culture; the threshold from war-torn Europe to its pragmatic, mass cultural successor, the United States. Its dialogic runs between the titular "third man," played by Orson Welles, with his savvy, charm and worldly cynicism, who undoes hygiene by conducting a trade in very diluted black market penicillin, against the naïve, but dogged, pulp fiction writer of the Holly Martins character played by Joseph Cotten. Welles, as he often does, finds his fate in the filth, in this case, also the very mechanism by which he kept his cover for so much of the film: he is shot and killed in the sewers of Vienna, his corruption echoed in the "sweet smelling" bile of the city itself. In TOUCH OF EVIL (1958), Welles' corruption, this time as a border town cop long gone bad, reaches its denouement

62
See my TOILET TRAINING, a
26-minute montage of Hollywood
bathroom scenes (Plumb Pro-
ductions, 2000).

63
Elizabeth Grosz, SEXUAL
SUBVERSIONS (Sydney, Australia:
Allen & Unwin, 1989), p. 72.

in the stinking refuse of a filthy river, a polluted flow indeed, as his bloated, corpulent form falls backward with a giant splash (again he has been shot), into the mire of the river's edge. The figure of the prostitute is there, in the guise of Marlene Dietrich, sporting a black wig, hooker with a heart of gold, as the only person who understood him, who rushes to the watery scene to witness his demise. Borders upon borders, marginalia multiplying, a *mise-en-abîme*, our old companions, moral and physical corruption, return yet again.

And what of the drains of horror film, the beasts and botched experiments that run amok in the sewers of cinema? Think of THE BLOB, and recall the girl in the 1988 version who struggles to save her little brother, her discredited boyfriend, her entire town as she dives and grimaces and chokes on the sewerage, the monster snapping, like a giant vagina (or is it an anus?), groping after her, its tangle of Medusa-like tentacles out to get her. And think of the basements of Hollywood, where pipes are never fixed, but always leaking, steaming, wreaking a permeability that is subjectivity. Across genres, from psychological thriller to schlock horror to drama, when trauma needs to be heightened, plumbing and bathrooms are the tropes to employ. And always, juxtaposed with the pipes, the feminine lurks in the associations, quoting ancient myths and recent phobias alike. And yet, to return to my other theme of this paper: have you ever noticed that the bathrooms, toilets, and basements of Hollywood horror are almost always from public and semi-pubic places? School showers, hotels bathrooms, city wide sewers, colleges, hospitals, libraries, motels, holiday places: these semi-public institutions are where the modern subject must confront both their bodily porousness and their conflicted relation to being, en masse, in public.

As I wrote my narrative, my PLUMBING OF MODERN LIFE, I had to stop myself from adding endless references, along the way, to scenes from Hollywood film, the overflowing tubs, the phantasmatic blood gurgling up from toilets, the axe murderers behind the shower curtains, the bodies sucked into drains, the gunnings-down in the toilet or the bathroom, the corpses rising from bathtubs, the Freddie Krugers in the tub, Carrie's menstrual trauma in the high school shower, and on it seems *ad infinitum*.[64] These are the images through which I dimly know the world and which stay with me, a toilet training indeed. And apparently, in "this immense toilet of a universe,"[65] I am not alone.

This essay first appeared in "The Toilet Issue," Sanjay Seth, ed., POSTCOLONIAL STUDIES, Routledge Journals, Vol. 5, No. 2, 2002.

64
See THE NANNY (1965), THE CONVERSATION (1974), FRIDAY THE 13TH (1980), THE BLOB (1988), PULP FICTION (1994), BLOOD SIMPLE (1985), THE SHINING (1980), NIGHTMARE ON ELM STREET (1984), and DePalma's homage to Hitchcock in CARRIE (1976), respectively.

65
Dominique Laporte, HISTORY OF SHIT, trans. Nadia Benabid and Rodolphe el-Koury (Cambridge: The MIT Press, 2000, first French ed. 1978), p. 131.

LIZZIE SCOTT

LOCK,
OUTLET, DRAIN

LIZZIE SCOTT

SIMON LEUNG

SITE
SPECIFICITY
EN ABYME...

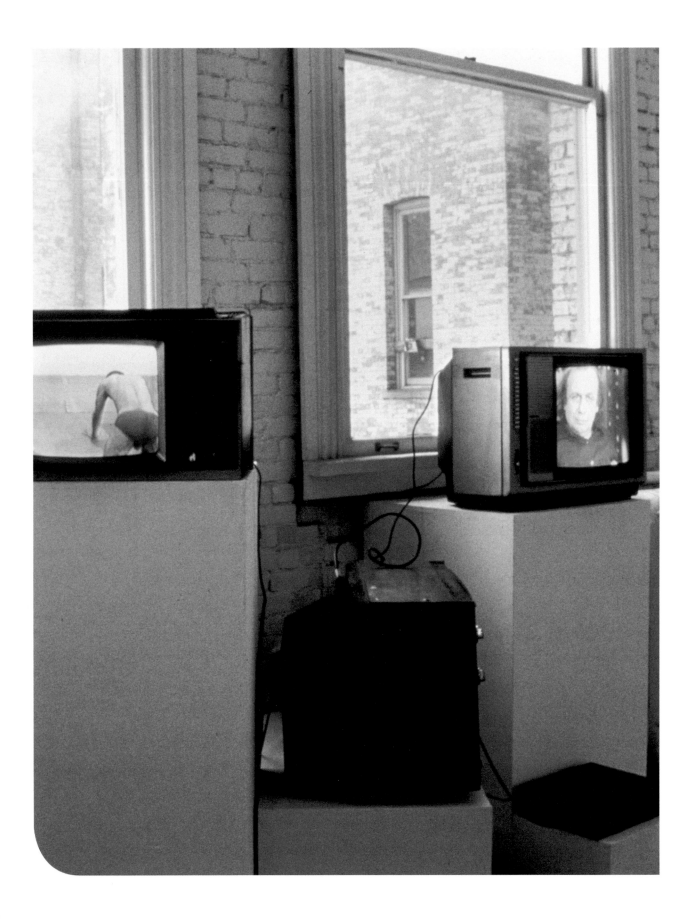

From the fall of 1992 to early 1993 I worked on a project at P.S.1 Museum called WARREN PIECE (IN THE '70S). In 1994 Renee Green invited me to give a talk on the project as part of "Negotiations in the Contact Zone," a conference she had organized at the Drawing Center in New York. In January 2002 I was invited by Cletus Dalglish-Schommer from the Graduate Art Department of UCLA to participate in "Radical Time 2002," a one-day conference held at the UCLA Graduate Art Studios. For the latter conference I chose to read the paper below, the one written for "Contact Zone" eight years earlier.

My decision to read this older work was motivated by a few factors. WARREN PIECE was a key project for me during my early years in New York, coinciding with a moment when "site-specificity" was actively being rethought in contemporary discourses. In the early 1990s, I took this discursive challenge quite seriously. At the same time, as an artist, I was also interested in producing new forms and models for thinking through questions related to "site" – ones that would simultaneously address the anxiety surrounding the fear of the loss of specific sites and interrogate the social and aesthetic demand for site's resurgence as both fetish and resistance. I felt that a complex interdependence existed between such anxiety and demand, and this was perhaps most succinctly seen in the rise of "community-based" projects that grew out of both the crest of the politics of the "culture wars," and shifts in the art market. In fact, it seemed to me that in the early 1990s, a form of aesthetic production once deemed to be radical for its time, namely historical Conceptualism, was exactly what was renegotiated in hyped-up contact zones —all words can shift, all practices can be re-framed.

Since my work from this time was about a return to the late 1960s/early 1970s, I took the temporal distance between 1994 and 2002 to be a productive parallel lag in thinking the contingency of "radical" practice. My thoughts now are less clear, perhaps, than they once were about what that moment meant, be it 1993, 1976, or 1968. Yet, if in 2002 I reread a text I had written almost 10 years ago, and have left it relatively untouched, I must not let it go without mention: if the original text already spoke of the problematic of "site-specific work as a genre at all," I returned to it as a re-implicated body. Perhaps this performative implication lies at the crux of what I have in numerous instances referred to as the "ethical dimension of aesthetic production"—how does "what is other" enter into the fragile aesthetic terrain from which we generate words like radical, resistance, or politics, or the aesthetic itself? In the early 1990s, WARREN PIECE was a site on which this was played out. In the end, as it was at its inception, WARREN PIECE had a great deal of trouble announcing itself in its own time—always too slow, too late; and all who spoke through it, on its behalf, or were hijacked by it, were implicated in speeches out of time. As I hope you will see, it was not in its own time, but in a time out of joint, where WARREN PIECE found its pace.

...OR NOTES ON WARREN PIECE (IN THE '70S)

For my presentation I will speak about some of my thoughts behind WARREN PIECE (IN THE '70S), a work I exhibited at P.S.1 last year as part of the 1993 STUDIO ARTISTS EXHIBITION. The following is a list of the seven parts which compose the project:

Collaborators: A photocopy of a letter I had written to Warren Niesluchowski, the assistant to the director of P.S.1, sent from Zurich in January 1993; a poster printed by P.S.1 publicizing the "Studio Artists Exhibition" (which functioned as the envelope in which the letter was enclosed); and a fax Warren sent me on the day of the opening of the exhibition.

Amnesty: Four pieces of paper which converged in a corner, two were carbon copies of the first two pages of an essay Warren co-authored with Krzysztof Wodiczko. The other two were copies of two pages from the September 17, 1974 issue of the NEW YORK TIMES, including the front page with the headline "Ford Offers Amnesty Program Requiring 2 Years Public Work; Defends His Pardon of Nixon."

nom de paix: A group of papers which traced the different names Warren was known by throughout the years. Some of the papers were photocopies of photographs of Warren, and objects belonging to Warren inscribed with his name. Also included were two versions of Warren's name, which he translated from English into Chinese.

Father/Son: Photocopies of photographs of Warren's father; photocopies of an identity card belonging to his father identifying him as an ex-prisoner of war, a photocopy of a photograph of Warren with his father, taken in a camp for "displaced persons" in Germany, where Warren was born.

Theory for War: Photocopies of the cover of the catalogue for the first exhibition at P.S.1, ROOMS; two pages in the catalogue including Vito Acconci's statement for ROOMS, and the same statement in which I had blanked out certain words.

Under History Lessons 1993: A video shown on a pedestal-based monitor showing an interview I conducted with Vito Acconci for this work.

Songs 1968-1975: A video shown on a pedestal-based monitor showing images of Warren working in his office and other images of P.S.1, overlaid with a soundtrack of a conversation I had recorded with Warren in which he recounted his life from 1968-1975. Inter-cutting the images were shots of Warren singing songs in various languages.

How Far is Far From Vietnam?: A video shown on a pedestal-based monitor showing Warren and myself doing Growtowski's physical exercises for the actor, overlaid with a soundtrack on which I asked repeatedly, "How far is far from Vietnam?"

The video monitors, VCR players and pedestals were provided by P.S.1. All of the photocopies were made with the photocopier in the office at P.S.1. Below is a statement I'd written for WARREN PIECE (IN THE '70S) on the morning of the opening. It was reproduced on acetate (also on the P.S.1 office photocopier), and adhered to one of the windowpanes in the room where the piece was shown.

> *A brief etiology is in order.*
>
> *When confronted with the proposition of presenting work at P.S.1 as part of the* STUDIO ARTISTS EXHIBITION, *I thought it apt to address this particular relationship (between artist and institution). However, uncompelled to perform a "critique" with the unavoidable moral overtones such a strategy would engender, I opted instead to "collaborate" with someone working at P.S.1. My reasons were simple: a studio artist and an employee share an equivalence, both functioning as "shifters" within a larger ideological body, brought together by such a body whose existence in turn continues beyond the tenure of such shifters. The intended project thus lent itself to an ethical essay, in the literal sense in which the Chinese define "sympathy" as "heart for*

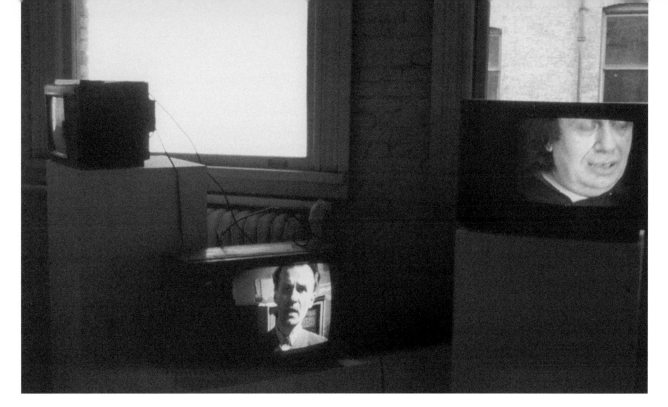

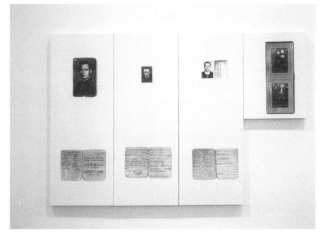

ones fellow traveler." Within such a framework I felt the genre of portraiture most appropriate.

I proposed this project to Warren at a party and he accepted. During that evening Warren also told me a bit about his history as an army deserter during the Vietnam War and his years of living in exile in France from 1968 to 1975. In addition, in his own work Warren has theorized about the consequential issues of war. This bracketed a perimeter in which I could think of a series of simultaneous moments, including what was made for this show.

Finally, a word on why Vito Acconci: a) his early influential work which was basically contemporaneous with Warren's years in exile and many of the years of the Vietnam War; b) I decided to read his artist statement from ROOMS, P.S.1's first and still most resonant show, as a theory about U.S. involvement in Vietnam and other wars; c) Vito and Warren went to the same school—Holy Cross College; d) Warren was once mistaken for Vito Acconci on the subway.

SPATIAL PREDICAMENTS It is my interest to use this statement, along with other texts, to re-read WARREN PIECE. But before continuing, I want to come clean regarding a repressed moment of resentment not recorded by my statement, an obscured origin not unrelated to the discussion of spatial predicaments. What I want to reveal is the source of my decision to collaborate with an employee at P.S.1. This came about when the curator confronted me less than one month after my residency began. I was told that unlike myself, my Australian, Asian, South American, and European counterparts had not only settled into their studios, but had begun to make work. This situation was made more obvious by the fact that since P.S.1 was due to be renovated, they had decided to accept only two Americans that year, of which I was one. I was also reminded that I had signed a contract and if I didn't use the studio soon it could be taken away from me. Apparently, I had embarrassingly under-performed my role as a contract player. This information would be unremarkable were it not for the fact that within the institution's desire and demand for this studio artist to perform, certain distinctions were overlooked—namely, economic. Among other reasons, such as having had just installed two large works elsewhere within twenty days of one another, I, as an American in the National Studio Program, could not be at my studio as often as I would have liked because I did not receive the stipend for housing, work, and living expenses which the international artists received from their governments. This didn't mean that I wasn't glad to have a studio, it merely meant that I needed to work two jobs so that I could be an artist and live in New York City. I decided to collaborate with an employee because that would be a way for me to both actively function within, and respond, to the effects of the institutional apparatus in which I'd contracted myself.

Yet, for me to set up my presentation this way is of course to further dilate the predicament of spacing a work of art in all of the contexts in which it is disseminated. Beyond positing the "intention of the artist," this is furthermore predicated by what we mean by spacing/a space: are we interested in the reception of a work of art in its experiential encounter or in its restitution? Do we site-specify a project based on the place in which it was made or the conditions under which its production and interpretation were made possible? Am I, in reconstructing a work made for another site, not also addressing this one as well as a site of production? The answers to these questions can only affirm the intelligibility of the questions themselves. These are old insights, one might call them Duchampian; but then to name the origin of insights—especially only in relation to the history of a named activity (in this case "art")—is to miss the point.

INDEXING ROOMS The first show at P.S.1, ROOMS, took place during less than three weeks in June 1976. Although relatively few people actually saw the exhibition, it was by most accounts considered both an artistic success and an innovative urban revitalization of ambitious scale. An excerpt from a ten page review in the October 1976 issue of ARTFORUM:

> *Art is shunning the audiences that so glamorized it in the 60s. The big fortunes have been made, so to speak, and the current scene reflects disillusionment with such stardom that it is often misinterpreted as disillusionment with art. P.S.1 helped set the record straight. The conservatism that pervades 70s life in general is reflected not in the art itself, which is as radical as ever, but in its new, more diffident posture. The art community is looking inward; its audience is redefining itself.*
>
> *It is, perhaps, typical of this retrenchment that 'Rooms' should have happened at an off-season time, in an out-of-the-way place, where relatively few people saw it; and it would be interesting to see what else emerges as the artists ensconce themselves in the studios there and begin to work...*[1]

Thus from its inception P.S.1 gained the status of a corrective within the imaginary of a larger body politic of the 1970s art world—what some referred to as "alternative." In addition, ROOMS was also a significant marker for critical writing at the time which had begun to theorize art practices increasingly called "Post-modern." If we remember the exhibition so well today it is perhaps because in the second part of her seminal essay "Notes on the Index," published in the journal OCTOBER in 1977, Rosalind Krauss used exclusively works from ROOMS as examples of the indexical logic in art practices during the 1970s.[2] Re-reading these essays, I found myself asking in what ways can the logic of the index be used to illuminate the historical relationship we now have with the middle 1970s, during a period of transition in the U.S. from "war" to "peace," from "Watergate" to "Bicentennial?" What are the art-historical relationships (my) contemporary practice has with these markers—NOTES ON THE INDEX; ROOMS; P.S.1...? In other words, to what extent is ROOMS productive as a genealogical index for Warren's life during his return from exile; and the lives of the institutions (Conceptual art, P.S.1...), that define the readability of a project such as WARREN PIECE? Worthy of note in the quoted passage above is the description of a schism between "the conservatism of the 1970s life in general" and the "art itself, which is as radical as ever." Although I did not come upon this account of ROOMS until after WARREN PIECE was completed, it was just such a gap between "art" and "life" that I was thinking of—the "ever" in "as radical as ever," belatedly grafting onto "the conservatism of 1970s life." WARREN PIECE (IN THE '70S) was conceived in this gap; and "the 70s" functioned not so much as a stable referent, but as a signifier, a catachresis.[3]

It would be useful to remind ourselves of some of the main points of interest. In "Notes on the Index," Rosalind Krauss sets the stage for locating the index as the primary terminology under which 1970s art can be thought. Using Vito Acconci's 1973 video AIRTIME as a point of departure in locating "the drama of the shifter," Krauss elaborates on the linguistic sign of the shifter by focusing on the part which follows a metonymic logic—that of the index. The index-shifter is a sign (to use Pierce's term), of "blind compulsion," a non-teleological, metonymic stamp which is empty of specific referents until called upon to signify. The example Krauss gives is that of the pronoun. In AIRTIME, Acconci alternately addresses a mirror image of himself with shifter-pronouns such as "I" and "you," thereby foregrounding the instability of the subject in language, showing what Lacan theorizes as the inevitable process of misrecognition

1
Nancy Foote, "The Apotheosis of the Crummy Space" in ARTFORUM, October, 1976.

2
Rosalind Krauss, "Notes on the Index," OCTOBER, The MIT Press, 1977. It should be noted that although I remembered the central role ROOMS played in these essays, not reading them while working on WARREN PIECE allowed for an enabling-forgetting.

3
My thinking of the catachresis is influenced by Gayatri Spivak's essay on reading Derrida with Foucault. See "More on Power/Knowledge," from Thomas E. Wartenberg, ed., RETHINKING POWER (1992), pp. 149-173.

necessary to coming into identity during the "mirror stage." Photography is the model medium of the indexical relationship in that not only is the photograph the result of a "physical imprint transferred by light-reflections onto a sensitive surface," but also unlike painting or sculpture, it reproduces something which seems to bypass the process of constructing "likeness" over to a direct manifestation of "the thing itself." But, insofar as the photographic representation has come to "stand in" for "the thing itself," it is at the same time like the shifter of the pronoun a highly unstable system, one which constantly requires text and context to anchor its meaning. Towards the end of "Notes...part 1" Krauss cites examples from art of the 1970s in which there was a pervasive use of photography "combined with the explicit terms of the index." Anticipating the second part of the essay, claims were made for the artists in ROOMS in the following sentence with which she concludes the first part: "Their procedures were to exacerbate an aspect of the building's presence, and thereby to embed within it a perishable trace of their own."

In "Notes...part 2" Krauss further employs the example of the trace as a feature of the indexical, a referent which "produces the need for a supplemental discourse." Supplementing ideas of photography as an explicitly context-bound sign system (via Walter Benjamin), already laid out in "Notes...part 1" is the Barthesian reading of photography as a "message without a code," based on the "quasi-tautological" circulation of signifier and signified within its system. The documentary status of photography derives from this tautology. Furthermore, the documentary/temporal-spacing nature of photography, according to Barthes, gives one "not a perception of the being-there of an object...but a perception of its having-been-there." Krauss uses this sense of "having-been-there" to look at artists from ROOMS who traced this past-present sense of the "there" in P.S.1 by using the narrative unfolding of moving through P.S.1's interior space to supplement or caption these traces. Among the artists discussed are Lucio Pozzi, Michele Stuart, and Gordon Matta-Clark. Of Matta-Clark's work DOORS, FLOORS, DOORS in which he removed rectangles from the first, second, and third floors in the shape of doors, Krauss writes, "The procedure of excavation succeeds therefore in bringing the building into the consciousness of the viewer in the form of a ghost."

My interest in citing "Notes on the Index" are quite specific: I find in the essay a description of an uncanniness which I believe must be productively rethought. Namely, the uncommon feeling one has of standing, at the same time, in both a building and its ghost. I want to use ideas from "Notes..." to read against the claims I made in my statement and my thinking at the time; and in so doing, extend the logic of the index beyond a theory of the operation of the artist, and towards a description of historical reception.

As you remember, the logic of the pronoun-shifter, which inaugurates "Notes on the Index" was already present in my statement. Warren and I, employee and artist, facilitator and "content provider," were both already contract-players from the start. We, in our equivalence as shifters, were inscribed in an institutional space in which we were already collaborators. WARREN PIECE (IN THE '70S) was a "collaboration" between "shifters," a cross-indexical essay. The project of "an artwork" we undertook in this sense was merely to put in front of the camera players already working for the studio. Like the reversal of "I" and "you" Krauss describes in AIRTIME, part of my intent was to blur the distinction between our shifter-positions, in that I would provide a service of facilitating Warren's narrative, while he related his story as the "content" of my work.

While working at/for the studio, what came to me, what indeed possessed me, was the metaphysics of the building, of which the presiding spirit dwelling in it was ROOMS. If artists in ROOMS brought forth the history of the physical building of P.S.1 "in the form of a ghost" in

1976, by the early 1990s, in the case of P.S.1, the situation was both, to borrow Krauss' term "exacerbated" and reversible. To look at its walls, to walk through its hallways, to be in its rooms, was for me to be a subject caught in the drama of the shifter endlessly circulating within a tautology between the time of my tenure and 1976. It was to be reminded that I was seeing the same walls, hallways, and rooms of P.S.1 that so compelled the artists in ROOMS. And like the unstable signified which hangs at the end of all signifiers, the physical building of P.S.1 itself became a signifier, a transfer, indeed a photograph of ROOMS. To encounter the building was similar to being the Barthesian subject who looks at an old photograph and fix upon the eyes of someone who saw another time, but who is nonetheless...looking at me. The texture of building touched me like a punctum.[4] Allow me to quote from the ROOMS catalogue:

> P.S.1 was conceived as an experimental work center for contemporary art. The project evolved as a response to the dynamics and changing needs of the late 70s art world. The work of the 70s has moved into the post-object era... Pieces are often created for a site, the very nature of the work being determined by its location.

and again:

> The raw, unfinished atmosphere of the building is compatible with much of the aesthetics of the 70s and allows for a greater degree of freedom in the presentation of work than that afforded artists in spaces presently available to them. This became apparent during the opening exhibition documented in this catalogue when 78 artists used the entire building including the roof, attic coal bin, bathrooms, boiler room, closets and hallways to install work.[5]

Foregoing a discussion of what "experimental," "post-object," "raw," or "freedom" might mean today, suffice it to say that by the early 1990s P.S.1 had itself become an index to the impulse towards the indexical in art production; in other words, a remainder of the "alternative space" embodied in the ethico-aesthetics of the 1970s. Looking back to how the catalogue framed ROOMS and how its artists (in some cases literally), attacked the space, it is not difficult to see what a problem this may pose for future artists working there. In a sense, P.S.1 contained within itself (contain in both the physical and metaphorical sense), the contradictory impulses inherent in thinking of site-specific work as a genre at all. If in 1976 all the rooms had been site-specifically framed, how can the space be framed again without recalling time itself as a frame? The catalogue for ROOMS, like a historical album of a more heroic time recalling the pathos of what must have already felt like a last gasp, was birth certificate, manual, family album and legend all at once—indexing the building page by page, room by room, yet all of which dated at the same time. WARREN PIECE, in invoking ROOMS, was an attempt to think that dynamic as a historical problematic in situ—to site-specify a site which had from its inception so specified itself.

COLLABORATORS/THEORIES FOR WAR

> (We would never) have thought of this kind of live stuff without the context of the time, without the context of demonstrations against American involvement in the Vietnam War. Demonstrations against the Vietnam War are the reasons why a lot of us could ever do single-person pieces then, because at that time it didn't seem like

4
See Roland Barthes, CAMERA LUCIDA, trans. Richard Howard (New York: Hill and Wang, 1981).

5
Linda Blumberg, ROOMS P.S.1, The Institute for Art and Urban Resources, Inc, 1977.

6
Quoted from interviews conducted
with Vito Acconci by Kathy O'Dell in
February 1989 and December 1996
for her Ph.D. dissertation, "Toward
a Theory of Performance Art: An
Investigation of its Sites," Graduate
Center, City University of New York,
1992, and her book, CONTRACT
WITH THE SKIN, MASOCHISM,
PERFORMANCE ART AND THE 1970S
(University of Minnesota Press,
1998).

*we were pointing out the grandiosity of the self. It was more about instrumentality
of "person," about the way in which a person could be effective.*[6]

—VITO ACCONCI

*Anything about which one knows that one soon will not have it around becomes
an image.* —WALTER BENJAMIN

But insofar as WARREN PIECE was embedded in ROOMS and that I felt obliged to index its
precedence, it was also important for me to address this temporal displacement outside of
the closed circuit of art. Regarding this, Warren the deserter became my guide. Since this
was a "portrait" built around Warren, to ask questions about the 1976 of ROOMS was also to
contemplate the year after the end of the longest war in American history. The Amnesty was
granted in 1974, the war ended in 1975, P.S.1 opened in 1976. This list ran through my head over
and over again. When working on WARREN PIECE, I was not interested in looking for cause and
effect relationships between war and art. Rather, I wished to preserve the complex integrity
of "simultaneous moments" evoked in my statement by thinking of them as parallels, as the
manifestations of presence—the evocation of a "having-been-there" when one has in fact
never been there. Like the logic of Smithson's gallery "non-site" which eventually, inevitably
corrodes the "real presence" of the "site," the delay-trauma generated from never having been
in Vietnam is "irrelevant" and yet exactly the point.

It is commonly known that during the late 1960s and early 1970s artists responded to the
war in Vietnam both thematically and through a radicalization of the aesthetic form. Examples
include the "actions" supported by the Art Workers' Coalition; Yvonne Rainer's TRIO A WITH
FLAGS and WAR; the May 1970 Art Strike in New York; the "My-Lai massacre poster"; Hans
Haacke's MOMA-POLL; and Terry Fox's performances, such as PISCES and DEFOLIATION, which
he has explicitly stated were allegories for his frail health and the melancholic paralysis he
felt in the face of the trauma of the Vietnam War—of knowing that the war is there and yet
you see it here, on television. In short, his solitary performances were viewed by him to be
displacements of the trauma of the televisual spectacle that exploded photography's "having
been there" with the "(not) being there" of "Vietnam." The index to the real, no longer the
provenance of the photograph alone, was by this moment in history increasingly understood to
be televisual. Television with its same-day broadcast, brought America "the living room war."
Like television, the temporally based media of process, site-specific, and performance works
were written with an eye cast on its spatial/temporal other, its outside—the city, the country,
the world, the war.

Thinking of the "dematerializing practices" of the late 1960s/ early 1970s which
corresponded to Warren's exile from 1968-1975, what these works provided for me was an
allegorical method of reading artistic strategies developed during a time of American history
which must be thought of in terms of Vietnam. It did not matter to me that some works from the
early 1970s addressed the Vietnam War directly, and other works from the same period didn't.
The displacement of trauma was one possible allegorical reading, many more were possible.
Take for instance the statement from the first show at the Paula Cooper Gallery in 1968, which
by all accounts was the first gallery show in Soho:

> *These 14 non-objective artists are against the War in Vietnam. They are supporting
> this commitment in the strongest manner open to them, by contributing major*

examples of their current work. The artists and the individual pieces were selected to represent a particular (a)esthetic attitude, in the conviction that a cohesive group of important works makes the most forceful statement for peace.

Among the artists in this group were Carl Andre, Robert Ryman, and Doug Ohlson, who also participated in ROOMS. What did the writer(s) of this statement mean by "aesthetic attitude," one in service of peace? What was the relationship between these artists' aesthetic attitude in 1968 and their aesthetic attitude in 1976, when they participated in ROOMS? [7]

How would one compare these artists' aesthetic attitude with the aesthetic attitude of say, Gordon Matta-Clark, whose work was built around the very destruction of the built environment, whose work dwelt in the ruins of the first world? How do we think of the gap between Matta-Clark's BLOW OUT, made the same year as his work for ROOMS, and Chris Burden's SHOOT, made during the height of the Vietnam War from five years before? The point of asking such questions with ROOMS in mind is not of course to set up false oppositions or congruence based on positivistic appearances of "seeming." Instead, it is to ask, if we follow Benjamin's observation that the allegorical "finds its most comprehensive expression in the ruin," [8] what is "the ruin" in 1976? What does it mean to give to artists, some of whom having had developed "aesthetic attitudes" of transferring an imminent abstraction's integrity into a moral protest regarding the Vietnam War a few years earlier, a space, which is by all appearance a category of urban ruin with all its connotations of abandonment, destruction, and withdrawal from conventional aesthetics, one year after the end of the war? By 1976 allegorical readings of war in art objects have already lost their currency, because 1976 was already closer to the 1980s than the 1960s, even though the residue of such allegorical readings still lingered, and the "aesthetic attitude" of such artists remained, one would assume, by the appearance of their work, relatively unchanged? It seems that P.S.1 in 1976 had, in the name of urban revitalization and the spirit of the time looked only forward. While I, with thoughts of the return of Warren from exile around the same time on my mind, looked at the catalogue from ROOMS seventeen years later and saw a string of puncta made anachronistic because they had arrived late. This was the second haunting of ROOMS that obliged me with remembrance. It erupted not from the imminent presence of P.S.1, but from the restitutions of ROOMS, the photographs taken in 1970s, so evocative of "the 70s," yet so uncannily already an index of its own time running out, of Modernism in ruins.

There is a page in that catalogue which lists three categories: "Text," "Index," and "Statements and Acknowledgments." Under the heading of "Text," a sentence reads, "Each artist was asked to contribute a short statement concerning another artist's work, his or her own work, or any aspect of the ROOMS show." This was Vito Acconci's statement:

> *Why did we all jump to be in this show? Afraid to be left out, just in case 'something was happening here?' Did we feel we'd better keep up a pretense of community? 'The community,' then, would allow each of us to 'keep our place': community as a base for habit, a ground where each of us needs only to play out our image—each of us becomes necessary to fill in the blanks of an art-world.*
>
> *Were we trying to find an 'alternative space,' or just trying to keep all the alternatives in the family? (Let's take over the alternatives before they go too far—a real alternative space, after all, would break down our defenses: with the solution— or dissolution—of distribution and marketing problems, we'd have no excuses, we'd have nothing else to do but reconsider the kind of work we were doing, we'd be*

7
THE ART WORKER'S COALITION, modeled on political groups of the time such as the Black Panthers, was founded in early 1969; Carl Andre was known to be an exceptionally active member.

8
Walter Benjamin, THE ORIGIN OF GERMAN TRAGIC DRAMA, trans. John Osborne (London: NLB, 1977), pp. 177-178.

forced to place reasons and consequences in terms of a whole world.)

Why am I saying all this now? (Will this get me off the hook?—"Look folks, at least I know I'm a government collaborator...")

For WARREN PIECE, I too decided to respond to the catalogue's request, although I was almost twenty years too late. The emptiness of the blank spaces was left to be filled by other sounds, like that of the word "war":

Why did we all jump to be in this _____? Afraid to be left out, just in case 'something was happening here?' Did we feel we'd better keep up a pretense of _____? 'The _____,' then, would allow each of us to 'keep our place': _____ as a base for habit, a ground where each of us needs only to play out our image—each of us becomes necessary to fill in the blanks of an _____.

Were we trying to find an '_____,' or just trying to keep all the _____ in the family? (Lets take over the _____ before they go too far—a real _____, after all, would break down our defenses: with the solution—or dissolution—of distribution and marketing problems, we'd have no excuses, we'd have nothing else to do but reconsider the kind of work we were doing, we'd be forced to place reasons and consequences in terms of a whole world.)

Why am I saying all this now? (Will this get me off the hook?—"Look folks, at least I know I'm a government collaborator...")

Or perhaps, nothing. With these lacunae, I returned this statement to its original author. I interviewed Vito Acconci for WARREN PIECE since he was, after all, another shifter, if not exactly a collaborator. If I had intended the "interview" to be the primary medium for this work, it was because the problematic one takes up as the inheritance of a discourse (be it portraiture, site-specificity, performance, or the Vietnam War), is not merely an author's animation of his relationship with his subject, but also a process of being "who" and "what" one is caught in the act of inserting oneself into a discourse; and in doing so to deconstruct both categories in an interpolating process which is formally exteriorized by the interview. Vito Acconci's statement for ROOMS and my puncturing of it when read together did not necessarily produce a temporal distinction of the two. Rather, they indexed one another, and we thought both at once. What I was interested in WARREN PIECE regarding reading the war with and against Vito Acconci was how Acconci's art-language at the time could also be thought of as being "sympathetic" to Warren's "life language" of desertion, exile, and return. To the best of my knowledge, Acconci's work at the time never directly addressed the Vietnam War. Sympathy—"heart for one's fellow traveler" is not predicated on reference to, knowledge of, or even "good wishes" for the other. It is the moment of the encounter when one realizes that one has been a fellow traveler all along.

NOM DE PAIX Warren—the proper name I have used thus far to denote the man for whom WARREN PIECE was named, did not always apply to the man. Warren—the name of the deserter—is a *nom de paix*, in the sense that Ho Chi Minh, for example, was a *nom de guerre*. The violence of the *nom/non de père* is also found in the *nom/non de paix*. This is a story of how "Warren" came to be. Let me explain: In 1968, a British actor by the name of Warren changed his name for the stage and thus the passport bearing his old identity became available. George Niesluchowski (our Warren), a deserter from the American Army who was stranded in England

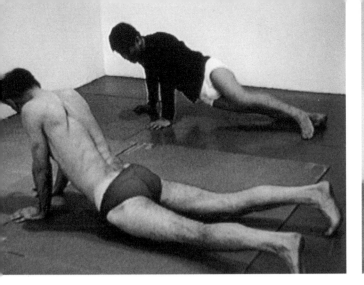
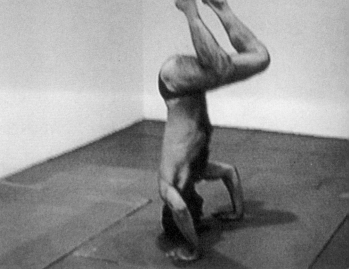

↑
Video stills from HOW FAR IS FAR
FROM VIETNAM?

9
See Susan Buck-Morss,
"Passports," DOCUMENTS MAGAZINE,
Vol. 3 (1993), pp. 66-77.

10
See Krzystof Wodiczko and Warren
Niesluchowski, "Beyond the Hybrid
State?" (on the first anniversary
of the Gulf War), published in THE
HYBRID STATE (Exit Art, New York,
1992).

without a passport , needed a new identity and passport to claim as his own. Thus George
became Warren. Ironically, "Warren," containing the sound and word "war," was the name that
enabled the deserter to escape from it; and the form in which this enabling was contained, that
of the passport, was originally invented as an instrument of conscription by the modern nation
state, in fact to prevent military desertion.[9] George Niesluchowski used the name Warren
during his seven years in exile, and retained it after his return. He had, in desertion...become
Warren. Central to my thinking of the *nom de paix* was how the deserter is inherently an identity
of resistance to the foundational violence of the nation state, a "work on the self," an askesis,
and thus by definition a process. Since 1975 Warren has used the amalgamation of "Warren
Niesluchowski" as his name, reconciling, however in conflict they may be, identities before and
after desertion and exile. This last manifestation of a string of potentialities in the violence of
the proper name is a double reflection of an earlier erasure produced by assimilation, in this
case once again an effect of war: George Niesluchowski, born in Germany in a camp for Polish
"displaced persons" after World War II, was Jerzy Niesluchowski (nes-woo-kof-ske) between
1946-1951, before immigration to the United States. From Jerzy to George to Warren, the *nom
de paix* meets the *nom de père*, inhabiting the same person—as deserter, as immigrant (both
veterans), living in the residual space of one war after another.[10]

HOW FAR IS FAR FROM VIETNAM? In closing, I will recall a film that taught me a great deal
about the ethics of representation, a film which in fact gave me the title for the last of the three
videos I completed for WARREN PIECE, HOW FAR IS FAR FROM VIETNAM? In LOIN DU VIETNAM, the
collective, dialectical anti-war film made in France in 1967 by Alain Resnais, William Klein,
Joris Ivens, Agnes Varda, Claude Lelouch, Jean-Luc Godard, and Chris Marker, the filmmakers
offered eleven registers of distance to watch the war everyone was already watching on
television. Among these different segments were scenes of the U.S. bombing of North Vietnam,
Hubert Humphrey's last European tour, the Loyalty Day Parades in New York inter-cut with
anti-war demonstrations on Wall Street, two North Vietnamese clowns satirizing Johnson and
MacNamara... The intention of the filmmakers—that they were making an unequivocal statement
of dissent, was viewed through the ironic position of the filmmakers inscribed in the title—FAR
FROM VIETNAM. This was explicitly stated at the conclusion of the film: The narrator tells the
audience that they (we) will leave the theater and remain "far from Vietnam," that they (we) live
in a society which hides its own violence. The distance between the theater of war and the seat of
judgment was in fact a site of the very production of violence.

In WARREN PIECE, this scenic apostrophe was, in my American context in 1993, reformulated as a question: How far is far from Vietnam? By the early 1990s, the summoning of the Vietnam War and the claims to represent it were no longer merely structured by moral debates about fighting the war, or along the divide between the Real of a Vietnam "there" and the traumatic nullity of a "here." Rather, distance from "Vietnam" was, by this historical moment, structured by the fault-lines of "betrayal" in its remembrance. "Vietnam" became the name of America's wound, and the collective memory of this wound, this lingering, was given a name—"the Vietnam Syndrome." But whose wound is it really? Or rather, who claims a right to this wound? I submit that this right was granted, first and foremost, to American masculinity, and it is in the name of His honor that we are asked again and again to negotiate how far is far from Vietnam.

During the Gulf War, George Bush tried to push Vietnam into the distant past when he declared that by bombing Iraq, America finally "kicked the Vietnam Syndrome." In Hollywood, the opposite impulse to collapse the distance made Vietnam always too close. Invariably a drama of Oedipal betrayal, Vietnam was the trauma that must be overcome because until it is, there's always the honor of masculinity at stake. And the price for not overcoming Vietnam was always masculinity's own collapse. To put Vietnam too close in order to overcome it, Hollywood's pathological masculine ressentiment has, whether with RAMBO or Oliver Stone, APOCALYPSE NOW, or YEAR OF THE DRAGON, repeatedly destroyed imaginary Vietnams, and its proxy—the Asian body (perhaps most of the Asian bodies employed in American films since 1975), in order to save the mythic (white), American masculine soul. If work was to be done in charting the inevitable violence of our distance from Vietnam, I reasoned that it was to be written as bodies—racialized, sexualized, Warren's, mine.

This is what I remember of CAMERA EYE, Jean-Luc Godard's section from LOIN DU VIETNAM. He is shown looking behind a large movie camera on a Parisian rooftop from a multitude of angles, the light of the camera flashes on and off. The inter-cut images that break up the scene are of ambiguous constructions of political solidarity—between the military striker and the filmmaker, between the Vietnamese peasants and the French intellectual Left. But what I remember most is his voice narrating his distance from Vietnam: if he had received permission to film in Vietnam, he would have shown the viewer peasants being strafed by American planes. But because he could not get the appropriate papers, because he, like the viewer, was far from Vietnam, he staged this mutual distance as a stand-off between intention and reality in the CAMERA EYE. As I made HOW FAR IS FAR FROM VIETNAM? I seemed to remember a portion of this narration in which Godard suggested that as an alternative to showing the real violence of war, he considered showing a nude body (no doubt in this case the nude body of a woman), while reciting what the technology of war—napalm or machine gun, I cannot recall—can do to the human body. Perhaps he actually showed this body, I don't know if I actually saw it or imagined seeing it in the CAMERA EYE. When it came time for me to videotape the last portion of WARREN PIECE, we did it very quickly. Warren and I went over what we agreed on—that he was going to teach me something he learned while a deserter in exile—Growtowski's exercises for the actor, a sort of somatic "thrownness." I doubt that I was doing any of it very well, it was a very cold day in the middle of winter, and we stripped down to our underwear to throw ourselves about on large pieces of corrugated cardboard I had collected for the occasion. I was thinking of LOIN DU VIETNAM, of a 1970s Vito Acconci biting into his flesh, and somehow I thought if we were to put all this on video, it would be just right.

DUNCAN McCORQUODALE

INTERVIEW
WITH PAUL
PANHUYSEN

CD TRACK II

Paul Panhuysen is a Dutch artist working since
the late 1950s. He works with sound-installation
and performance, architecture and urban plan-
ning, furniture and visual projects. Through the use
of systematic structures, often based on number
systems, such as Fibonacci series, and mathematical
proportion, his works explore the possibility of other
forms of visual, architectural and musical order.
Since 1982 he has presented worldwide his Long
String Installations, which are performed in concerts
and exhibitions. They utilize site-specific properties
of a given location in relation to musical performance
and tonality. He organized and directed the influential
Het Apollohuis, an experimental music and sound

venue in Eindhoven, from 1980–1997. This interview took place on May 13, 1992 at Het Apollohuis, Eindhoven, The Netherlands, and was originally published in the journal ARCH-TEXT 1. The manifesto preceeding the interview was translated from Dutch into English by Paul Panhuysen during the course of our conversation. Originally this manifesto appeared in ZORG VOOR DE OMGEVING, a book in which Panhuysen describes some of his ideas for a responsible approach to the built environment.

MANIFESTO Everybody has the right to shape their own environment and to express in it the way they think. Whoever likes to build must have the opportunity. (That is, of course, something which for a long, long period has always been the case.) The work of urban planners is to formulate the idea of the settlement, to give it shape in a plan—we call it a "beeld" plan, which means image-plan, a plan which is an image in itself—and to formulate the rules which can guarantee that this idea stays recognized during the process of building. Urban planning is an art. The work for architects is to design houses and workshops in direct commission of the people who will employ these, and to design buildings for common use in commission of the community.

It is the art of the architect to express the ideas of the commissioner in a personal way in private buildings and to express the common ideas of society in public buildings. It is the work of visual artists to express important ideas of society

in works of art. Works of art may be part of buildings or may be independent in the environment. If society is willing to take care of the quality of the environment the whole policy towards the environment has to be changed fundamentally. Since contractors deprive people of their right to express their own ideas in their environment, every influence of contractors has to be excluded. Everyone has to be able to build their own house. The government has to be responsible and has to take responsibility for the things people have in common. (The Dutch word for this concept is "algemeen belang.") It will be necessary to develop another financial policy for building that land speculation prohibits.

Since car traffic and social life in the same environment are excluding each other, it is necessary to reduce car traffic to its own area and to replace it by a well-functioning transport system. This requires other options of policy. Productive processes which hurt natural ecological cycles have to be stopped. This, too, implies another policy. If the policy stays the same it will turn out to be impossible to restore the quality of the environment and to develop new qualities in the environment.

DUNCAN McCORQUODALE: *Is it enough just to point out the need for change without proposing some kind of alternative?*

PAUL PANHUYSEN: Well, during the last century we had some of the most successful ideologists. And their ideas for change were quite radical. But those ideas resulted in disaster. They all involved the idea of leadership. They all involved the idea of leadership and the abuse of power. This can't be the solution.

DM: *So, it's got to be more broadly based, people taking their own responsibility for things?*

PP: I think it's wrong, the way we are using the media for profit and propaganda, where all those things that don't promise profit for the media are considered uninteresting. This represents a big change, which only took place in the last few years or so. The media, the structure of the media, the goals and the aims of the media have changed almost completely. And the same thing is happening in the world of art. Most artists who are now trained in art schools get this idea that they are training for a profession which should bring them an income. But that's not what art is. A problem with art is that if you really like to make art you probably think the expression of your feelings and your responsibility towards society is

WFPC (**A Long String Installation**),
Fort Point Channel, Boston USA,
May 10-11, 1986.
↓

more important than your income. That's what the choice is. And, of course, that's a problem. Artists should know this. It's something that shouldn't be seen in society as a weakness, which is becoming more and more the case. In general, people think it's unnecessary to say what you think, and unquestionable not to adapt to the rules of consumer society.

DM: *I can see clearly how this has happened recently in art. But it seems, as well, to have been happening for a considerably longer period.*

PP: This has always been the case. Art has always been dependent on people in power. But the difference lies in the quality of those people. For a long time these people were associated with religion. And religion, in a way, had a responsibility for morality. During the Enlightenment, people felt that art should be part of, and play an active role in, society. In Moscow and St. Petersburg there were collectors buying the work of artists from France, for example, the work of the Cubists. This contributed to the basis of Russian developments in the first part of the twentieth century. It's incredible when you see paintings, such as those of Van Gogh, Matisse, Picasso, Braque, in Russian collections. Most of the people who bought this work weren't in France. In France they were selling it. The strong involvement of those people in power in Russia until about 1900 was taken over by the new industrialists who invested in art other than the works (buildings and paintings), conforming to the orthodox tradition. Artists are not avant-garde, artists

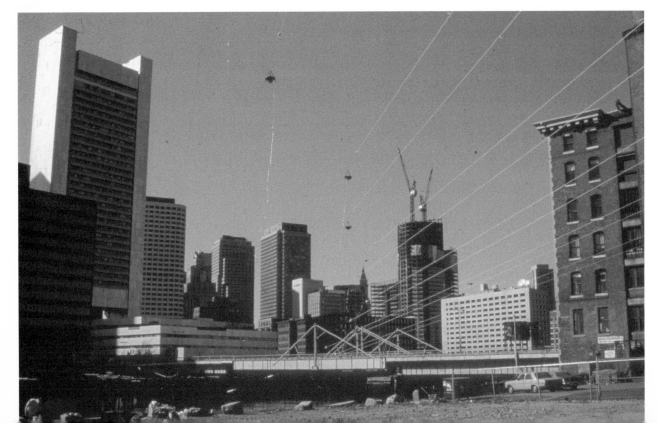

can't be avant-garde, they have to use the opportunities at hand. Art is not able to play such a heroic part. But nevertheless, art has always reflected the better ideas of people in power. Unfortunately, there are not so many of these ideas at present in our society. This is the real difference. At the same time there has always been a kind of idealism amongst rulers, as in Venice, Rotterdam, or Amsterdam. Those people didn't want to enter history as the criminals they were. They wanted to improve their image.

DM: *When you're talking about the lack of quality now, it's as though the impoverishment in society is reflected, in many ways, by the impoverishment that you see in the artistic practices and the lack of quality ideas informing those practices. Perhaps, in order to talk about it you have to determine some kind of criteria for quality. Is it human quality, or technical quality, or a combination of these?*

PP: Art is not giving many answers, it is not so much about truth. Mankind is not first involved in truth. That's not what our main concern is. Our main involvement, of course, has always been survival. That's normal. Every animal is trying to survive, to protect their territory and to try and manipulate the environment in such a way that their life becomes more bearable. What mankind did was to realize this through the development of tools, skills, and technology. I think the most amazing of our developments is electronic technology. But the development of such technology involved fewer and fewer people. It's very difficult to understand computers, for instance, to know what is going on in a computer. But to deal with one's environment requires reflection on the processes you see happening. To understand those requires all the skills man has. So, it's limiting to think, as many people still do in the art world, that visual art consists of painting and sculpture. For all sorts of technological media will be used in the near future by virtually everybody. But what is important is that we look at these not simply as tools, but as tools that may be useful. As we gain more influence on our environment we should also develop more of a responsibility for what we are doing. And there is no way to do this other than through education and providing people with the opportunity to act responsibly. If somebody builds a house for himself which is really ugly, I prefer the ugly house. An interesting city is not a beautiful city. The two are completely different. If all the houses are beautiful, if all the houses are old, that doesn't necessarily produce a city in which one can live. But if we destroy everything built 50 years ago, which could easily survive another 50 years, in

order to replace those with buildings built with the prospect of surviving 25 years, then, I think we have a problem on our hands. One of the things people should realize is that we are not the species best equipped for survival. Many animals are much more capable than we are of providing their community a good life. Certainly, we are the species that has changed the world more than any other species. However, so did horses and sheep. Maybe cockroaches will change the world. But the real problem is that as the structure of society gets more complicated, the organizations we are using get larger in scale, and more people get excluded from taking responsibilities.

DM: *How might this situation be opposed?*
PP: The only way is through the system opposing itself. There is not so much one can do anymore. In the late 1960s people thought they could change their culture, their responsibilities, their awareness. This frightened the authorities everywhere. So, in the 1970s and 1980s this potential was repressed in quite an intelligent way, by what Marcuse called "repressive tolerance." The authorities appeared to allow for change while all the time governing real change.

DM: *Yes, the illusion of possibilities where there weren't many.*
PP: This whole policy went quite far with the help of the media. The only thing which can and will work is that people who disagree with these developments come together or form networks. That's what I do with Apollohuis. It's a place for artists who are, as far as I see it, taking their work seriously. The artists are involved with their environment and society. Their statements are not so much statements of opinion, I don't believe in political art. For me art becomes weaker as it is more directly political. There is one thing art does, and that is provoke thinking. Everything you tell people as certainty is ineffective since it stops thinking. There is also the obvious point that even as things are true now, they can be false tomorrow. I think it's more important to work on a level of awareness, on the level of people themselves, than to provoke them in judging what is going on around them, to be critical all the time. Information is just information about facts. This is what I think the media should provide. But, the media selects the news. If you give information in such a way that you don't attract the interest of people, the information will not arrive. This also applies to art. There are works that are too complicated for people to be able to respond to, to actually do something with.

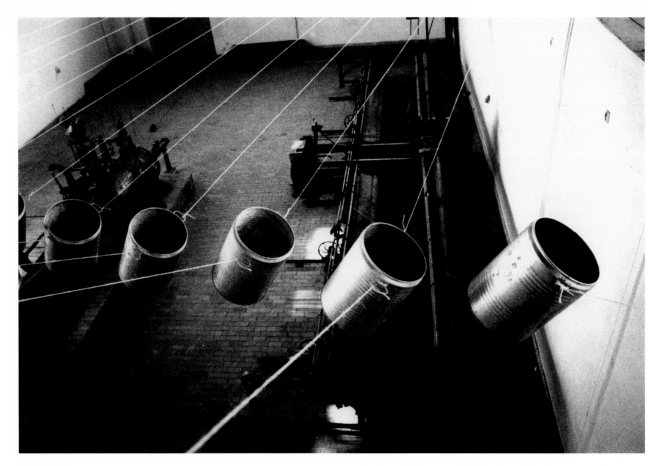

DM: *So that isn't very effective either.*
PP: No.

DM: *In speaking of this isn't there something of what you're doing in some of your musical work here? In some of your writing about your music you mention the idea of bringing to each performance something of that individual performance, because of the space, your responsiveness to the instrument in the space, and the people within the space. There's something of that in what we're talking about here, about a kind of a political or social responsibility. How might your music be seen to operate along these lines?*
PP: It does, at least, that's what I try to do. I think it most impor-

tant that people become critical in art, but in life too. It's all the same. I can't make a real distinction between the two. I was never able to split my life into different parts. I think it's terrible if you work and don't see the sense of the work you're doing.

DM: *So, there is a blurring of those boundaries?*
PP: Yes. One of the interesting aspects of working with architecture, with art, with music, is that you work in an area which is not so much architecture itself, or art itself, or music itself. There is this whole area which is in-between, which allows for something to be perceived as in-between. This is an area little known to most people. For many people art is supposed to be a creative force. But at the same time artists are supposed to stick to the rules of art. The majority of artists are looking to what other artists are doing and what was done before them. They don't really bring in their own point of view. They know what art is respected and what may be expected as art. That is what art is becoming more and more. What an artist should be involved in is other points of view, points of view which other people will recognize as another way of thinking,

or perceiving. But this is something you can never be sure of. Classical music is performed by people who try to become virtuosi. This has two effects. The first is that these musicians aspire to being better performers, but so much better that an audience could never think of doing something similar. The other effect is that it makes the performer stick to more and more rules. This results, not in open-mindedness, but in extreme narrow-mindedness. Both things are happening all the time in art.

When I perform, I perform in such a way that I show people the "problem" I have created. I make an installation which is made for a performance. And very often the performance is the first time I play on the instrument. So, I have created a "problem" and I'm dealing with the "problem" without being able to show any virtuosity at all. But still, I'm involved, in these performances, with doing things which may interest people. The problem must be an interesting one. It must, at least, bring attention to new or other experiences.

DM: *The way your Long String Installations work requires a considerable openness on the part of the audience. To bring such an audience to the sorts of sensitivities, to the different issues and the blurring of boundaries that you are concerned with at one level in your work seems problematic. It reminds me of Godard, of the danger of preaching to a converted audience. Might not your message be complicated to the exclusion of the way that people are accustomed to receiving information in a highly conditioned media society?*
PP: It depends on what the situation is. When I do a performance I don't try to show so much my opinions or my stand, but a physical phenomenon happening. That's what the Long String Installations do. It's very physical, more physical than musical. My interest is more in the physical aspects of sound production than the musical. And with the physical, as well as the musical, things like calculation and proportion come in. These are also means I use in painting. They provide ways for producing things you can't otherwise imagine. From proportions or series of numbers first imagined in your mind you can do things which are more complicated than those you could if you were to try to produce them empirically. And when you start to work in such a way you never know what the result will be. You don't work toward a known result, which suggests to me the idea that chaos is everything of which we don't understand the order.

DM: *So, in a sense, the systems and harmonies that you're using in the way you structure a piece are not strict at all, but something giving you a kind of freedom.*
PP: It's what I explore in a performance. I introduce the proportion and the harmonies into a work when I'm building it. I very rarely use the same system or the same structure more than once. But, of course, I take with me the experience of my former work. And these bring on other decisions. The work is developing, not in my studio, but in the places where I present it. There's no sense making a work and looking at it in terms of my personal style, to repeat a work if it was successful. This stops development. It makes things less interesting. I try to develop through the work. In a way, my whole attitude of working, of being, that's what I try to communicate to my audience. So, in this sense, a political or social stance is part of my work.

DM: *Yes, I think quite a big part. However, it's not polemical. Your work isn't proselytizing.*
PP: It opts for choices. There are many structures, especially systematic structures, which come from one center. I always hated that. Rather, I try to find structures where there is not one center, but where every place could be seen as a center.

DM: *You've mentioned the spaces in which the Long Strings are performed as being a kind of instrument. You inhabit that instrument, but the audience is also inhabiting that space with you.*
PP: They are in it, that's true. But I expect the audience to be quiet. In this way I share with Oscar Wilde his idea of the audience as something to be compared with the violin, on which the violinist is playing. In the 1960s I did many works that included audience participation. If an audience is made active that audience will probably end up destroying all that is there.

DM: *I don't quite follow. Why is that?*
PP: It's the same as when you give a one-year-old baby a toy that would be suitable for a child of five. The only creative thing the child can do with it is destroy it. The child doesn't understand how it works, what is going on. I think audience participation is something best done in a workshop. And the best workshops I have experienced are with children. You tell the children what they can do and then have them do it. This also has to go in an orderly way. But I never expect this. I quite often do workshops with the Long Strings where I have children playing on them. And if they are not all playing together at the same time, which is disappointing for everybody, but playing

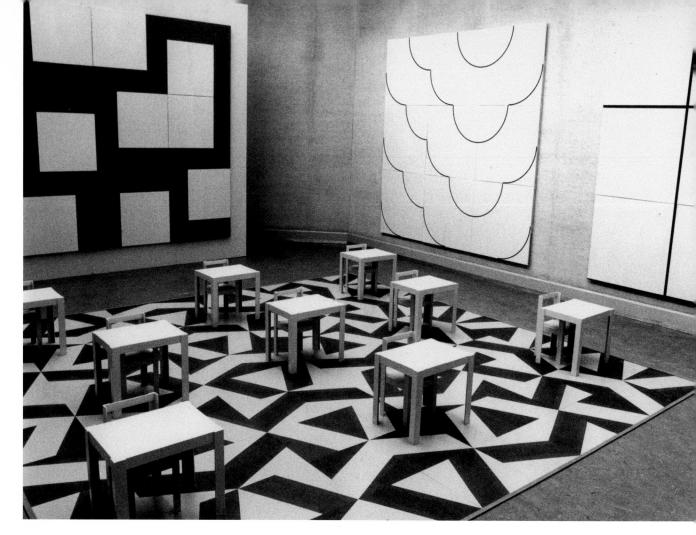

↑
SYSTEMATIC FLOOR PIECE, FURNITURE
AND WALL PAINTINGS, Van Abbemuseum
Eindhoven, The Netherlands, 1978.

one after the other, they really get into the instrument, become part of it, and forget each other. I think it's quite a good experience for them. But this is very difficult with a group of adults.

DM: *I guess they have many more inhibitions.*
PP: Yes. And, the people who are most assertive will be the first to do something, but they are usually not the most sensitive.

DM: *The kind of work that is being done in the Long String Installations and the work that the Macunias Ensemble [musical group started in 1968], does, are these very different?*
PP: Yes. In the Macunias Ensemble we first tried to get rid of all musical conventions. We didn't want it to be rock music, jazz, or classical music. We just wanted it to be a kind of conversation, sounds which came together, like when talking with someone. I think that's the closest comparison. Later on the Macunias Ensemble developed as a laboratory in which the musicians exchange, test, and discuss their ideas.

DM: *Is the music of the Long String Installations different in this sense?*
PP: That's not so much a conversation. It is related and it's different. The main difference is that the Long String Installations are presentations of a work which is initially conceived as a visual work, and is aurally examined during the course of the performance. Except, of course, in those situations where I do workshops. A concert, for me, is a work of art that is in between architecture, visual art, and music. What the performance adds to this sort of work is the idea of time and change. Of course, time is already part of these works, in that all of these installations have, so far, existed only for a

short period of time. I build them and then perform on them. But afterwards the work is gone. There is no way to replace the experience of the performance, by making photographs, or recording. One of the important aspects of the installations is that they are in a specific space. Within a given space the experience of one person may be completely different from that of another. Of course, this applies to all art. But it's much stronger, more remarkable, and I think people feel it more with the installations.

DM: *What about the relationship between architectural space and your installations, their musical aspect. You allude to architectural space and the idea of it being an instrument and there being some sort of co-habitation between these different things. This blurring of music and architecture, the way harmonics, Fibonacci series and human proportions are connected here is interesting.*

PP: I think that architecture and music are related more than are art and architecture or art and music. If an architectural space is interesting as a conscious statement it always concerns proportion. It's only very recently that architecture has forgotten about proportions. This started with Functionalism. But even there, through people like Le Corbusier, proportion has remained an important issue. As an artist I have, in the past, worked on commissions relating to architecture. In these my main point was always to relate the work of art to the architecture, to find the basic parameters of the work, the basic proportional decisions taken by the architect. I was very aware of the proportions. I always analyzed the proportional parameters of a work. Of course, there's a lot of architecture where there are no proportional parameters. When a room has bad acoustics, I think that has to do with the proportions of the room. There's a direct relationship. When people are blind they still have a feeling of space, of forms, of shapes and objects in space. The blind develop this sense to a very high degree. In a way, a sound sends us a space, and in this respect it is like sculpture. It renders what you hear through another sense. But we have not developed this sense because we get similar information more easily by seeing. But if you can't see it, then you develop this sense. The auditory aspects of architecture are important. However, people were more aware of this in the past than they are now. If we make a concert hall today, the architect will first destroy all of the reflections in a space. They make the space completely dead. And then, they add what is considered to be the optimum resonancy for producing and listening to classical

music, for instance. And for rock music similar additions are brought into a space in the form of technical equipment. I think this is very strange. The classical theaters of the Romans had antique vessels built under the stage, so that people who were standing on the stage had their voices amplified by the stage itself. People, in a way, used to know more about acoustics.

DM: *About proportion, how might this be seen to work in relation to architecture?*

PP: It's very easy—everything can be translated. The only problem with series, like that of Fibonacci, is that their numbers become bigger and bigger. But, if an architect were to use the Fibonacci numbers in public housing, for example, there could be five different modulated elements. This could provide a diversity of variation while still working in a very rational way. It's a question of effectiveness. Architects think about a structure as a whole, as a system of building, or in terms of a house which is repeated 500 times.

DM: *When we look at a work of art today do we appreciate it in the same way that we would have one hundred years ago? What about the use of new technologies and the resultant changed conception of time afforded by these. Hasn't this changed our perception?*

PP: Well, technology is, maybe, different, but this would mean that we should look to the development

→
Plan for the Wilgenroosstraat. Eindhoven, The Netherlands, 1977.

of new planes and not architecture. Of course, a lot of energy is invested in the design of new planes. However, this is not the case with housing projects. These are almost the same throughout the western world. Aah...even the differences between Russian and Polish housing projects and those realized here are not so great. Perhaps they look cleaner here, but this is rather unimportant. In general they're the same. It's the same everywhere. There is something lacking which allows people to identify themselves with the flat they're living in. If you have the same flat as your neighbor of course it looks the same. We even have architects who tell people what color curtains they should have as these "belong" to their building. This doesn't allow people to think "this is my place." People prefer to live in houses which were built 40 or 50 years ago, since they think of these houses as having some character.

FAIRY RING. Het Gebeuren. Veendam,
The Netherlands, July 1970.

PHOTOGRAPH BY PIETER BOERSMA
↓

DM: *They have more character than ones we are building now?*
PP: Yes. There were more details. A hundred years ago the sculptor could be like a craftsman working for the architect. But nowadays, in the Netherlands, there is a "percentage for the arts." I think it is one or one and a half percent of a building's budget that is spent on art. But if you look at the building of a rich entrepreneur from around 1900, this person has spent, possibly, 25 percent of the overall budget on art. So, you have to be very clever as an artist or architect to make the architecture itself more like sculpture. However, these ways are limited to a kind of interpretation which is closer to functionalism, to Minimalism, to looking at architecture as a composition of volumes, of blocks. Like Constructivism, it's not in the details.

DM: *In what capacity, as a planning advisor, were you trying to do that? And how did you attempt to introduce something of a sense of place into the communities with which you worked?*
PP: This has always been a very important point for me. One approach I developed was based on systematic series of

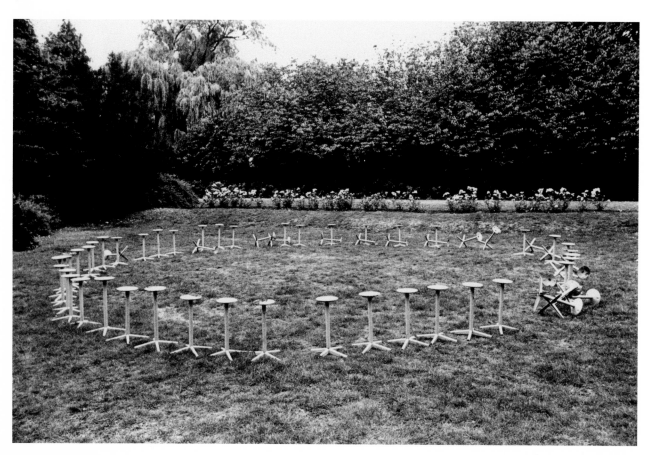

numbers and proportions. This was one of the things I tried to present the planners and architects. But during the period I was involved with those teams there was a tendency, in terms of building, to cut up the environment into bits and pieces and make of it a kind of organic organization. This cost quite a lot in terms of space, which I considered to be a waste. So, what I tried to do was have places where people could gather. I think it's quite important to have squares or parks or playgrounds in a neighborhood. It's also necessary to have places where people can start their own shops or kindergartens, that kind of thing. But this is very difficult. The contractors and the people who prepared the economic infrastructure were opposed to this. The only thing I could do was tell them it would be worthwhile if people were able start a shop in their garage or do something else with such places. In some cases this happened. But more importantly I was concerned with the social structure. For me one of the main points of urban planning is that of image, a kind of simple map which can be stored in your brain. This can be used as a way to identify where you are, the place, the town or the city in which you live. Such a "map" is based on organic ordering principles and on geographic points of orientation. For example, a river is always something you can relate to. So is the center of a city. These things have to be very simple. They have to be simple ideas that can be stored in one's mind and which are always there. You don't need a map, because it's already in your head. But this restricts the size of what a city or township can be. If a city becomes too big new centers should be developed. There can be no end to this knitting onto the structure of the original city.

DM: *How do these two things go together? The proportional aspects versus the sociological concerns on the other?*
PP: One thing is this image, the image of the city or the city plan. This means that the city has a center, different quarters and outskirts. I think that all these things can easily be under-stood. To know if you are in one quarter of a city or another is something which can be enhanced by architecture. A church tower or water tower serve as points of orientation from afar. If you take a circular town with four gates, like a medieval town, it becomes easy to know where you are and what you can expect there. It's also easy to remember what is in which quarter. Medieval towns went much further in this respect. They had quarters where people were dying fabrics, a place for people working copper, and so on. I think this is something that can be provided by places like shopping centers, which are very recognizable.

DM: *On the scale of a medieval city it's conceivable as to how that kind of planning intervention might work. But with large cities these things seem to break down.*
PP: Of course, but most cities grew gradually. To imagine a new city all at once is quite difficult. But I think there are many ways to avoid some of the problems of large cities. For example, having a simple traffic infrastructure is indispensable. This can be used to suspend other elements of the city and to develop them further. Everything doesn't have to be decided on. We can enlarge the period of time involved in developing towns and cities. Usually, there is a government, and the government says to the city that it can grow. So, in the next ten years, housing is built for 50,000 people. This is because, from a macro-economical point of view of planning, this would be good projected growth. But this produces many problems for a city's urban planners. But there are different ways of doing things.

DM: *What about the ways in which series can be seen to have an impact on planning? In some ways, series as generators of form have a lot to do with both your music and your urban planning proposals. When you conceive of something in planning terms it's quite different from what you realize in, say, a musical progression. What is the idea informing the relationship between plans and actual spaces?*
PP: What series do is allow gradual change. This is perhaps more easily understood in music. Music takes place in time, while the planning we have been speaking of takes place in space. The visual aspects of a neighborhood change in character from one place to another. The use of series wouldn't imply too much individual planning. Instead, it would provide for a kind of efficiency. Rather than having a different design for every situation the use of series would allow for gradual changes in a design.

DM: *Is there implicit in this a sense that uniformity might lend character to a town or city?*
PP: It would be in between. A certain uniformity is not a problem. But if everything is uniform, or different, there is a problem. That's not what makes an environment really interesting nor what creates familiar situations that can easily be recognized.

DM: *These are, for the most part, small-scale interventions, parts of a larger fabric. There is nothing in this that looks towards a master plan or anything like that. Are you concerned with large projects of this sort?*

↑
BLOCKING A STREET, Het Gebeuren.
Veendam, The Netherlands,
July 1970.

PP: Master plans are fine if one has to plan quickly, if there is not much time for an environment to evolve. It's better to make only very basic decisions. The planning of New York is a perfect example, Barcelona too, both are good examples of planned cities. They are simply grids. And what happens in time is that parts of the grid get their own character. I prefer this in cases when there is no time to wait for development. I don't think it's necessary to design new towns completely, or that everything should be in place when people first come to live there. It's better if there are chances left for them. But planners often try to decide on everything beforehand. People then come to a place where they are unable to do anything, to adapt to that place. It shouldn't be complete, it shouldn't be finished.

DM: *You've mentioned that you also worked as an environmental artist. What about this part of your work, making large-scale interventions, not from the point of view of an urban planner necessarily, but more from that of an environmental artist.*

PP: What I did, for instance, was try to introduce into urban planning a kind of axis, based on what already existed. In one project, I was involved in the planning of a new township at the mouth of the river Maas, near den Bosch Maaspoore. To begin with, there was an area that had to be protected, which was green and dyked, and which was very vulnerable. I proposed to have a passage through the area leading up to the dyke, so you could have a broad view of the river. This split up the new township into two parts. I then allowed for points of focus along the axis whereby buildings could relate to each other. I also provided a kind of public space in each of these areas. I tried to get rid of the wasteland which was neither private nor public. This I proposed as being for private use. There are all these small lawns which, actually, maybe there only for dogs. I tried to do this in a rational way. And so, my main plea for the idea of planning on rectangles is that there is not so much wasted space. One can be much more efficient with attributing space. It's also very easy for people to work with right angles. During this period there were many new towns built in The Netherlands. In some of them it's impossible to give simple directions when someone asks the way somewhere. It's not possible to say: "go straight ahead and take the third right and then the second right and you'll be where you want to be." The planning done in those years! Even after seven meters you wouldn't know what was straight and what wasn't.

DM: *In these projects you seem able to take freely from different disciplines. The axis reminds me of a rational or classical approach to planning, as do the processional moments marking this axis, providing a sense of place along it.*

PP: Yes. But I feel more sympathy for an architect like Aldo van Eyck than for people like Krier or Bofill, who lack social feeling and an understanding of the individual's needs. They are the architects of the bureaucrats, I can imagine they like this sort of work. But for the people who have to live in Bofill's buildings, where windows don't correspond to residential floor levels! They just have to fit into the structure as a whole.

DM: *But you're very much concerned with a sense of place in your urban planning proposals?*

PP: It's human life, social life, that is my main concern, that's where I started. One of the aspects of urban planning is that it conditions people's lives, both their social and private lives.

If you are lucky and you live in a green neighborhood, you will be able to learn, from early childhood onwards, about insects and animals, about nature. But when you are born in Brooklyn, you might be lucky if you see a bird by the time you are five years old. I think this deprivation of experience is of very basic importance. As a medium, street life is ten times more important than all of the media we have. For three or four years I organized, once a year, a festival on the street where I used to live. The first year I organized games and things for the children. In the second year there was added a meal which was shared together, with tables in the street. So, in this way, the adults were also involved. But the strange effect was that after those festivals, which took place in May, there was a social life on the street, until winter when you can't have an outdoor social life. Then, in the spring, everybody stayed in their houses, even when they no longer had to. Without the festival there seemed to be little social contact at all. I wouldn't say, though, that the festivals were only positive. There were some bad, as well as good, relationships resulting from them. But in general the relationships and the exchange of information grew, and this led to a feeling of self-consciousness, people were proud to live on that street. I was asked to make a plan, to renovate the street, so that it would be possible to maintain this social life throughout the year. But the municipality did not want such a plan. There were people who lived on the street who were dependent on the municipality. So, people on the municipal council told them to go against the plans. They told them that the plans would prevent residents from parking their cars in front of their houses. This just made a lot of trouble. On the last occasion I just organized a festival without planning any ideas for change, just to, in a way, restore the "normal" context of the street.

DM: *Are these festivals still going on?*
PP: No. These were in the early 1970s, from 1971 to 1974. But these were the main reasons I was invited to become an artist/advisor on urban planning teams, stemming from this experience. From that time onwards I worked in planning towns. One of the ideas I had in my first plan was to make traffic slower in residential areas. I used speed ramps to reduce the speed of cars in these areas. This was put into effect generally in residential areas. Many new neighborhoods now have those awful sleeping policemen I invented. Later on I changed that plan and, instead, proposed a row of trees for the middle of the street. This looks better, it doesn't look like something that regulates the traffic.

DM: *So cars would have to maneuver these trees, or are there any cars?*
PP: In this plan a car has to drive slowly between two narrow lanes of trees. But a tree is something you accept. These things made especially for drivers to slow down, psychologically provokes the opposite in some people. This made me change my initial idea.

DM *Where did this involvement in street life and urban planning come from?*
PP: In the 1960s I was involved in situations, happenings, events, kind of environmental things. And so, I started collaborating with other artists. But finally I invited my neighbors, people who were living nearby. I used everybody I could think of in my events. I invited them to become part of the event. These first happened in museums, theaters, and later on, in public spaces. This was a kind of natural development. Then one of my neighbors came to me and said: "You are asking me always to go with you to the museum and to the theater and to perform with you. But why you don't do this in the street? I would like you to do this in the street. Why you don't do that?" And I said: "Nobody asked me." And he said: "I will take care that everybody will ask you." And so, he started to organize this, which led to me [laughter] doing this thing in the street.

DM: *This was part of what was going on in those years?*
PP: Yes, that was the early 1970s. Before this I had been quite active in the artists 1969 Revolution. I was a member of the Board of Dutch Artists Association. At that time we were telling the government that they were failing, not only in art, but in housing policy and in all kinds of things. So there is this very natural development in my work. In the early 1970s the students started becoming politically involved. Things started to be organized in a very repulsive way. For me, at least, it was repulsive. Things became so politically dogmatic. I just drew back from this and concentrated on what was happening within my immediate environment.

DM: *How do you articulate the boundaries between what you're calling your environment and political dogmatism or otherwise? When you're doing a performance I can imagine the space you speak of as an instrument and, then, within that there are the relationships, where you "play" the instrument, and the musical aspect of the piece. And, in another way, there's the building in which the instrument is situated. And, then, the environment of which the building is a part. How do these relate to one another?*

PP: They interfere. They always reinforce or destroy each other. There are places where nothing can happen. At first, the 1960s were bursting with ideas having to do with the social awareness of the post-war generation. The artists followed. This ended up with the ideas of the hippies, with flower power, and so on. Art would and could become a new cultural force if it were to choose the side of the people. Of course, in the early 1970s it was already clear that most of the people involved in flower power, after finishing their studies, continued to do the same as their parents had done. So, it was clear that the dreamed-of development wouldn't continue and there wouldn't be large-scale cultural change in the Western world. To me, it was also clear that artists were not really willing to change either. It was clear, too, that the people artists were collaborating with were only willing to support them in such a way that there was a real question as to whether to continue as an artist or not. In the mid-seventies I decided to stop performing completely. I concentrated more on the development of my own ideas. The seventies, for me, was a period of research based on my experiences of the late 1960s and early 1970s. The last performance installation I did, until starting again in the early 1980s, was at the "1971 Paris Biennale." But during the period of performance in the art world I didn't do performances. Twenty people in a room, all artists, and everybody had their turn to do a performance. It was so meaningless to me. I didn't have any interest in this at all. So, what happened instead was that we made these street festivals, which gave me the idea that everybody could be an "artist". I'm still sure that people can be "artists". But society would have to provide a different structure that would emphasize contacts between people. So, that's what I tried to do in my work with the street, enhance the contacts between the people and create opportunities for them to express themselves. This is a difficult process, where one really has to start with children. But parents, like their children, want to express what they feel. In my work they started to express themselves, which, of course, produced problems. But I think quite healthy problems, problems that should be occurring all the time. However, we had no chance to develop this, for the authorities were opposed to this sort of social awareness. They are not ready for it. They would rather leave the problems as they are. Even knowing that there will eventually be terrible problems. But this kind of continuous social change is necessary. We are living in medieval cities, but with completely different sets of tools, of traffic, and so on. Gradually, I became aware of wide-scale change not being possible. In the early 1980s I started Apollohuis. That was the point when I decided that it would be most worthwhile for me to contribute to keeping a part of humanity critical and alive, to offer people a place where they can discuss and develop their ideas and work. I think it is necessary.

CHRISTOF MIGONE & ALEXANDRE ST-ONGE
PHOTOGRAPHS BY PAUL COUILLARD

DISCLOSURE

CD TRACK 9

IE. SITE: corridor, second floor. laying flat on our backs with a small speaker coming down from the ceiling into our open mouths, the voice of one is heard via the mouth cavity of the other. as they come up the stairs, the audience encounters the longitudinal line of our bodies, they have to step over one set of feet to enter the site. we have closed all the windows and doors, during a heatwave. it is stifling. a dimmer jerry-rigged with a small motor dims up and down continuously as our only source of light. the motor buzzes, it overheats at times interrupting the dimming temporarily. we have bare bulbs running down from the ceiling beside the speakers going into our mouths. the abandoned rooming house oozes

its past. paul, the curator, had found a syringe and a court
summons for a case of bodily harm in the kitchen as he cleaned
up the place for us. to occupy an empty apartment is to fill it
with its own emptiness, to saturate it with nothing. to disclose
is to open yourself up to closeness, a reduction of distance,
a proximate and narrow. how to read a corridor as a throat.
DURATION: 30 MINUTES.

CLOSE. SITE: bathroom and closet, third floor. two, cramped.
after LIE we move upstairs and to begin we take unhinged
doors and block ourselves in. one in bathroom, the other
in closet. two small black and white tv monitors are in the
room which includes closet and is adjacent to bathroom, they

have a live feed from the enclosures and show details of the performances. two guitar amplifiers are in a windowless room diffusing the sound we produce inside. we swallow our mouths. a reduction of distance, a proximate and narrow. how to read a closet as a mouth. how to speak here, in the next room and in the other's mouth. in the closet we found a note written on the wall above the threshold, only visible if one is standing inside the closet: *Whoever is reading this message, God bless you and congratulations 'cos you are one of the few in this world who has read this. This message was written by someone who is going to be very famous one day.* —[illegible signature] 1992. DURATION: 20 MINUTES (VARIABLE).

HOLD. **SITE**: room on third floor facing street. one holding the other for as long as possible. hand to forearm. both out-stretched. at the end of CLOSE, one ends before the other (we would alternate over the three days we performed). that person removes the door, and goes to the room, lifts one arm to stomach level, and leaves it outstretched. the other, once done, undoes the barricade and comes over to hold the awaiting arm. two bare speakers lie on the floor beside us, one sits on top of the other. one speaks, the other listens, they feedback and create a rhythmic tic. bare speaker, barely speaking. to enclose is both to hold and to be held by your own grip. we both shake and waver imperceptibly. "It began getting very boring. Nothing happened. I felt like I was in a trance. I looked again.

CHRISTOF MIGONE & ALEXANDRE ST-ONGE

They seemed to exist outside of time. Then I became acutely aware I had observed them earlier as specimens, but now felt their humanity." lucie sparham reviewing the performance for lola, fall 2001 issue. after each performance we would get the mattresses we had stored in the abandoned restaurant on the ground floor and reinstall ourselves in this room. the only one where we felt comfortable, barely. on the last day we noticed a bullet hole in one of the windows, it seemed to have originated from inside. DURATION: 15 MINUTES (VARIABLE).

DISCLOSURE *was performed four times over three days, June 28-30, 2001, at 228 ½ Parliament Street, Toronto, Canada.*

ATAU TANAKA

COMPOSING AS A FUNCTION OF INFRASTRUCTURE

CD TRACK 4

Music is an art form that traditionally has tended to inhabit space. As an acoustic form, it depends on physical space for its manifestation. Yet with the advent of recorded media and audio data storage, music's relationship with space has shifted. The arrival of recorded media, Walkmans, and peer-to-peer music sharing networks, have transposed music out of physical and public space towards personal and interpersonal space. This shift from acoustical space to network space is a transformation that has yet to be thoroughly considered from a musical perspective.

This text seeks to examine the potential impact on compositional practice proposed by such changes of infrastructure. An approach built on the understanding of the acoustical relationships of sound and space can be expanded to investigate the possibility of a social language for music occurring across networks. I describe the composition of a work for radio and the Internet to lend concrete examples to the concepts proposed. Ultimately I hope to chart out a possible methodology for addressing new spatial paradigms in music.

MOTIVATIONS PROMÉTHÉE NUMÉRIQUE is a radio art piece commissioned by German radio SWR2, for network installation, live performance, and radio broadcast in 2002. The work is structured around a website and relies on input from internet users. The challenge was to create a composition that made use of radio and internet, mixing the two media while maintaining their distinguishing dynamics and characteristics. In composing the work, I sought to recreate in musical microcosms the social dynamics observed in each respective medium. The result is a work that extends upon the dramatic and experimental traditions of *hoerspiel* (radio drama) to propose a critical investigation of the humanistic implications of network media.

When asked to create a piece for radio and internet, my response was to seek out a dynamic that would differentiate, not amalgamate, the two media. Although internet audio-streaming has had some impact in democratizing audio broadcasting, most net-radio projects have simply replicated models of traditional radio. Meanwhile, commercial broadcast radio has seized the opportunity to mirror programming on the Internet as a means to extend geographical reach.

I was interested in exploring this scenario of one medium duplicating, and then worse yet, being co-opted by, another. I sought to exploit each constituent medium for qualities particular to its infrastructure and using one as a foil against the other. I investigated and question the claims staked out in defense of each medium: Is the Internet truly democratic and open? Is radio really free and ubiquitous? My goal was to create a musical piece that would traverse these different infrastructures, a single work that would have a distinct identity and mode of listening in each.

WORK The online component of the piece is an open content database that comprises the materials of the piece. These materials are available on a dynamic website for viewing by the public before the performance. Visitors see a moving text/image/sound mass on-screen, a lifelike "creature" to which they are invited to add to its evolution. The website is not an informational resource about the piece, but rather is an integral component of the work itself. It is a manifestation of compositional structure outside traditional musical time/space dimensions. It lends a different light to the materials and "houses" the machine performer of the piece.

PROMÉTHÉE NUMÉRIQUE'S metaphorical basis is found in literary references, called upon to build a dramatic trajectory. The principal source texts were PROMETHEUS BOUND of Aeschylus, and FRANKENSTEIN by Mary Shelley. Also included were excerpts from PROMETHEUS of Goethe, L'HOMME MACHINE (Man a Machine) by La Mettrie and A CYBORG MANIFESTO by Donna Haraway. Each of these sources provides a historical view of the assimilation of technology by humans.

1
Neil Postman, TECHNOPOLY :
THE SURRENDER OF CULTURE OF
TECHNOLOGY (New York: Vintage
Books, 1993).

In the secondary source texts, La Mettrie describes human function in terms of clock-like mechanisms, concluding that Man is a machine. Haraway's text is a manifesto, a definition and declaration for cyborgs—the post technological human, the modern day Centaurs. If we fear the take over of humanity by technology,[1] La Mettrie and Haraway are historical and contemporary harbingers of this potential. All the source texts are used in four languages: English, French, German, Japanese. The different translations were stored on the online database of the piece, and were used to score the trans-continental performance.

While these literary sources provide the basis for the libretto of the work, fundamental network principles become the root of musical process. The work invites the public to enter the creative process whereby participatory internet activity drives the evolution of the materials of the piece. A network media server is built on algorithmic processes that take the form of an autonomous life-like entity. Visitor contributions nurture the growth of the media database, constituting a continuing evolving data-organism. The work addresses the myth that there might be life and identity in the machine. Through the agency of musical network interaction, the work explores human-human interaction in a machine-mediated world.

WEB The online creature is made up of sounds, images, and texts that comprise the core compositional materials. It is the entity that will be the machine performer alongside the human performers at the premier of the piece. If its form is constituted of elements from the media database, its actions and behaviors are programmed by the use of lifelike algorithms. It is a dynamic visual form that serves as graphical interface to the database server. By interacting with this entity via the website, we prepare it for a performance debut. The creature embodies the information-repository nature of the Internet. The graphical form reacts to visitor actions and evolves to reflect media contributions. It can acknowledge the arrival of a visitor, and expresses appreciation when it is fed. It lives on a life cycle of "behaviors," different modes of action and interactive tendencies varying across time. These behaviors affect on-screen appearance and movement, sound generation, reaction to user provocation, and its overall "mood," be it active, dormant, or out of control.

It is through the creature that we perceive the different elements of text, image, and sound of the piece. Text from the literary sources is used to construct a 3D-like polygon frame that constitutes the skeleton of the beast. Lines from the text are mapped to the skeletal frame structure of the creature's body on-screen and scrolls through the bones as the creature moves across the screen. The skin of the creature spans the space between the bones. Images from the database are called up and stretched across the non-rectangular surfaces delineated by the text skeleton. Media uploaded by visitors are integrated into the skin of the creature. The behavior state of the creature determines the uniformity of images mapped across the different surfaces, as well as the rate of change of the images, affecting the visual stability or erratic shape. Points of intersection of the bones are the joints where sounds emerge. The source sounds are also culled from contributions held in the media database. The mood of the beast determines the choice of sounds and their rate of change. The geometry and sound is determined by the elemental and behavioral state of the creature at any given moment in time.

These basic elements are distributed and interconnected on-screen to embody the creature and at the same time reflect their distributed network origins. One part of the interface proposes enigmatic statements, excerpts drawn from the texts of the piece. These provocations proposed by the creature instigate the visitor to contribute sounds or images. The user selects a media element on his own computer that answers to the proposition, and uploads it via the web

interface. The user may or may not see his element appear immediately. The creature reacts to acknowledge these injections of media by sending e-mail and SMS (short text to cell phone), messages to the contributing user. If the user has just contributed a media element, the creature is kind and thankful. If the user has not visited the site in some time, the creature begins to nag the user, behaving like a jilted lover. Through this treatment of the various precomposed and web contributed elements and a dynamic of reaction provoking reaction, I sought to give form to the notion that internet activity and content could be considered a living entity.

PERFORMANCE The performance took place on March 23, 2002, and connected three geographic locations via the network: Karlsruhe, Germany; Ogaki, Japan; and Montréal, Canada. Each performance site was equipped with multiple client/server systems for transmitting and receiving audio streams and live images with one another. The remote performance configuration is a critical investigation of the effects of the network on human communication. We are told that the modes of communication made possible by the Internet can collapse physical geographical distance. In attempting to carry out this promise, one quickly confronts the reality of time delays and quality loss. I did not wish to hide these realities but instead to consider them as qualities contributing to the compositional process. Network transmission latency became the "acoustic of the network"[2] to be respected and used as one does when composing for specific resonant spaces. If the web component explored spatial domains, the performance addressed temporal domains.

The time delay of data transmission in each direction was 30 seconds—far too long to even try to compensate by performative anticipation. Simultaneity took on a new meaning, expanding the notion of a musical instant to a swath of time. Connecting three points in this way added a multidimensional complexity that created a different combination of time-of-arrival of sound sources at each performance site. This precluded the possibility of imposing a single temporal displacement as a corrective measure. The result was a music exploiting time in a relative, and not absolute, manner.

This configuration had the result of creating one performance, one music, that was simultaneously perceived differently depending on locale. There were five distinct audiences— Karlsruhe, Ogaki, and Montréal live, along with radio and internet audience—each with a different sonic regard to this "single" piece of music. It was as if the piece had five simultaneous remixes. Some listeners were able to listen to both the live radio broadcast and the internet streams, thus able to layer two "remixes," or create a mix of their own.

The hub of the piece was a concert hall in Karlsruhe. The performance was the physical point and temporal moment of contact between network medium and broadcast medium. As composer, I orchestrated the remote performance modules, with the assistance of artists from Ogaki and Montréal. Their interventions came via network media streaming and were mixed and shaped for broadcast.

The performance also gives structure to the amorphous online elements, and ties the bond between radio space and internet space, between defined time and suspended time. At performance time, the creature cycled through its five behavioral phases, articulating sounds and images that had been uploaded by web visitors prior to the performance. These different layers—sound or image, sampled or synthesized, pre-structured or live, are sculpted following a compositional score.

RADIO The orchestration and participatory structure of the performance creates a situation

2
Atau Tanaka, "Netmusic—a Perspective," in the catalog, FESTIVAL DU WEB (Paris: Webart, 1999).

where the network's character comes to life, to be evoked in the dramatic trajectory of a one-hour radio broadcast. The radio is the final perceptive window, a rich audio vessel that reconciles the diverse elements of machine performer, human performers, pre-stored database materials and live performative materials into a non-hierarchical yet differentiated musical form. The spatial reach of the web manifestation and the temporal breadth of the performance are channeled to the radio, a medium with its own space-time dynamic.

Each medium has its own time-space specificities. Concert performance is specific both in time and space—it is an event that takes place at a precise time, in a precise location. Information on the Internet, on the other hand, is time-space generalized. Network data is ideally universally accessible. The temporal axis of the network is not event based, but demand based. Music on the Internet, then, is normally expected to be accessible anywhere anytime. Radio is very precise in the time axis but quite general in the space axis. Broadcast programming is pre-planned down to the second, while the reach of the signal can cover a wide geographical area. By presenting PROMÉTHÉE NUMÉRIQUE over radio, the time/space specificities of networks are hybridized with the corresponding qualities of performance. Radio is the destination medium where the disparate elements fuse.

COMPOSITION PROMÉTHÉE NUMÉRIQUE is a composition deployed over these infrastructures. It develops a core musical and dramatic theme, orchestrated over different media. The structure of the composition was represented in a notated score. The score did not make use of traditional musical notation. Instead, it was written in graphical form across a reference timeline. It served to coordinate the remote performers, and synchronize them globally with the progression of phases of the creature. Each performer had the full score and could see what the other performers were meant to be playing at any given time.

The score serves as the unifying element of the piece that reconciles the otherwise distributed geography and dispersed temporality of the performance. It traverses distance to create a cohesive sense of space. It gives a common time reference that resolves network latency. While it does not eliminate transmission delays, the score provides an anchor point from which the relative time offsets can be perceived.

The compositional structure takes the qualities of the various elements in the piece: participative nature, machine performer, time latencies, and makes them part of a musical form inspired by the conceptual and literary themes. The unpredictable nature of the network contributions and time delays can be seen as the Promethean fire we must tame. The life-like algorithm running on the web server is the monster we may or may not be able to control or co-exist with, thereby confronting the foundations of musical instinct.

The metaphors are the basis of a dramatic structure, a composition of broad strokes that could instigate tendencies within which unanticipated actions could be elicited from the participators and creature. This high level structure is defined as a series of five stages defining phases in the life of the creature. These phases exist on multiple time scales depending on the local destination medium. They are defined as:

1. *Dormant*
2. *Awakening*
3. *Excited*
4. *Out of Control*
5. *Tamed*

In the pre-performance web period, the creature lives phases 1-3 in the course of one month. Depending on the current phase of the creature, it can be more or less lively on-screen, more or less responsive to user action. The expanded time scale of the online period gives web visitors a chance to get to know the creature in a certain phase at the same time perceive an evolution.

At performance time, phases 1-3 are relived in accelerated time, and then extended into phases 4-5. Here the creature lives one entire cycle of its life in a 40-minute time frame. Rather than idling in the ambient sphere of the web, this time the creature is onstage alongside human performers. The behaviors take on new implication with respect to interaction with the public and participants.

After the performance, the creature returns to its web life, alternating between the intermediary phases. It is not a simple repetition of previous phases—here the creature is fully formed, with an ever growing media base, an entity that has lived life once and who lives on awaiting the next performance of activity.

MEDIA PERSPECTIVE The work extends the notion of idiomatic writing—that a music written for a certain instrument should respect, abide by, and extend, the qualities of that instrument. Here these principles are applied to media that form the building blocks of the piece. Networks, a participative dynamic, and interaction are considered to be materials of the piece. The view of idiomatic composition serves to exploit the inherent musical qualities of these materials.

By tracing the history of assimilation of technology in music, we gain insight into music's relationship with media. The advent of recording technology brought fundamental changes in our techniques for creating music. Recording once served as a way to capture and represent a live musical performance. It was a displacement of the moment of action. The development of multitrack recording, studio production techniques became more sophisticated and diverged from the practice of live performance. By directly manipulating tape and other elements in the studio, electro-acoustic music, a music unrelated to instrumental performance was born.

The continuing development of various recording formats drove the development of academic and popular compositional form. 45 RPM vinyl records limited recording time to several minutes, giving rise to the pop single of the 1950s—a song that makes its impact in three or four minutes. With the arrival of 33 RPM records in the 1960s, recording time increased to 20 minutes per side. This led to works of electronic music composed specifically for the vinyl medium. Meanwhile in popular music, the 33 RPM format combined with multi-track recording technology brought about the "concept album."

By the 1980s the sophistication of the recorded medium completed the inversion between performance and recording. The recorded medium was often thought of as a poor copy of a live human performance. The listener yearned to have the chance to see the musician in the flesh performing live. As studio sophistication increased, musicians found themselves on-stage unable to recreate the rich and complex layers and textures composed in the studio. An audience would attend a concert expecting to hear the artists perform exactly as they had on record. The recording usurped the position of the original performance as the absolute reference. In less than 100 years the recorded medium went from being an emulation of the human to becoming something larger-than-life that humans struggled to recreate.[3]

IN CLOSING By creating an open musical form, I wanted to explore the proposal of the Internet as a shared environment and participatory space. Public opinion generates broad statements about technology, both enthusiastic and critical. The integration of networks into daily life leads

3
Jacques Attali, NOISE: THE POLITICAL ECONOMY OF MUSIC, trans. Brian Massumi (Minneapolis: University of Minnesota Press, 1999).

us to consider these intangible data infrastructures as social spaces. We often hear claims that the Internet is:

an information space
a communications space
a democratic space
a "virtual" space
an Anglo-centric space
a non-temporal space
a self-perpetuating space

I take a musical stance to consider these statements, putting to task my role of composer. In doing so, I am interested in questioning the title of composer and how the resulting work takes on a form to reflect that process.[4]

Throughout the compositional process, I was treating network and visual media, never forgetting the fact that the project was ultimately a radio project. The use of text paid due respect to the medium of *hoerspiel*. At the same time, the multilingual and abstract settings build upon traditions of experimental radio art. Text readings were transformed through the process of network collaboration to create the soundscapes guiding the radio listener through the dramatic trajectory. Linguistic abstraction creates dramatic tension and release of meaning dependent on the local language of the listener.

This is not the first musical piece inspired by the myth of Prometheus. Composers through time have called upon the legend in symphonic, operatic, and popular works. The story carries a power that seems to speak to musicians. For me it was particularly appropriate in offering a foundational viewpoint from which to address issues of media technology and network societies. It provided the basis to consider the fascination with the possibility of life in the machine.

The pertinence of historical writings as commentary on technological society served as point of departure. The instrumental perspective became the process and means to explore the possibility of exploiting space/time continua as compositional material. The ultimate challenge was to see how these concepts would be apparent through the looking glass of radio.

If music has evolved to utilize qualities of new instruments, then it would seem that composers have a natural tendency to find an idiomatic language for each new medium.[5] At the time of this writing, musicians and listeners are still coming to terms with the possibilities afforded by network-based dissemination of music. I stopped short of putting into question the act of composition itself, instead seeking out its place in these infrastructures. The composition I describe here is an attempt to explicitly apply the notion of idiomatic composition to networks, to find a musical language that reflects inherent qualities of the medium.

Acknowledgements, credits for Prométhée-Numérique/Frankensteins Netz. *Composition and realization: Atau Tanaka; Artificial network character design: Antoine Schmitt; Media database server: Peter Hanappe; Visual design: Gregory Pignot; Project coordination ZKM: Goetz Dipper; Dramaturgue/Producer: Sabine Breitsameter; Executive Producer SWR2: Hans-Burkhard Schlichting; Performers: Atau Tanaka [in Karlsruhe]; Zack Settel [in Montréal, Canada]; Reiko A. and i.d. [in Ogaki-City, Japan]; Recorded recitation: Christiane Bachschmidt, Steve Karier; Commissioned by Südwestrundfunk SWR in co-production with: ZKM Karlsruhe, Institute for Music and Acoustic, Deutschlandradio Berlin, Radio-Canada Montréal Chaîne Culturelle Goethe-Institute Montreal, Goethe-Institute Tokyo, Intermedium2, in collaboration with McGill University Montréal and the Institute of Advanced Media Arts and Sciences IAMAS, Ogaki-City, Japan.*

4
Atau Tanaka, "Musical Implications of Network Infrastructures: Perturbations of Traditional Artistic Roles," in ACTES DE PROCEEDINGS H2PTM'01: HYPERTEXTES HYPER-MEDIAS, NOUVELLES ECRITURES, NOUVEAUX LANGAGES, Balpe, Leleu-Merveil, eds. (Paris: Hermes Science Publications, 2001).

5
Scot Gresham-Lancaster, "The Aesthetics and History of the Hub: The Effects of Changing Technology on Network Computer Music," in LEONARDO MUSIC JOURNAL, Vol. 8 (1998) pp. 39-44.

BRANDON LaBELLE

SPLIT SPACE. PRACTICES OF TRANSURBAN LIFE

"I will be an inhabitant of the world, in spite of the world."

—Gaston Bachelard, THE POETICS OF SPACE

To address: is to call out, as a directed effort, toward another.
　❋
Addressing public space is a traumatic process: How will I be received within the social sphere? How will this gesture affect my presentation as an individual?
To address public space thus marks a difference, for one moves from an inside to an outside, and in the process exposes oneself as a subject. Such exposure sets one apart, for to address public space is to ask for a different kind of conversation. This "apart" is not so much a separation as a movement of agency, whereby public space functions as a medium. Such agency announces itself with the intention of extending beyond the individualized performativity of everyday life—what could be called "the patterns of being"—and appropriating the larger context of such performativity as a medium itself: everyday life thus functions as a kind of "site" for the redirection or disruption of its patterns.

LINEAGE Such a practice of everyday life finds its articulation across modernity, from Baudelaire and the flâneur to Breton's surrealistic wanderings, in the juxtaposed and montaged rush of Parisian bohemianism; from Benjamin's "One Way Street" which, as an inventory of spatial constructs charts an unsettled psychic trajectory, to Situationist drifts aiming at disrupting the heart of the spectacle by diffusing the subject across the city in libidinal flows—to suffuse the patterns of daily life with those of desire. Such lineage, in demarcating a subterranean field of urban potential, in turn draws out such potential as a philosophical and political project: the medium of public space is made apparent as a site of negotiation.

Against such practices we can place a philosophical program as reflected in Henri Lefebvre's CRITIQUE OF EVERYDAY LIFE (1947) and Michel de Certeau's PRACTICE OF EVERYDAY LIFE (1973), both of which sought to examine the everyday as a sociological subject that necessarily exceeds classification. As Lefebvre states: "Everyday life is profoundly related to all activities, and encompasses them with all their differences and their conflicts; it is their meeting place, their bond, their common ground." Everyday life is "what is left over after all distinct, superior, specialized, structured activities have been singled out by analysis..."[1] Thus everyday life is both "what is left over" and what is related to "all activities": it is only as a "left over" that it becomes a totality. In this way, to track its course is also to succumb to its rules, for by its very definition it will always pose a challenge to one's discursive grasp. "This suggests that the everyday cannot be properly accommodated by rationalist thought and that the everyday is precisely what becomes remaindered after rationalist thought has tried to exhaust the world of meaning."[2] Yet it is here, at this problematic—where it diffuses rationalist thought—that the everyday may be useful in providing such thought with its own nemesis. Here, we can follow the everyday as it gets situated between avant-garde artistic practice (Breton), and what Ben Highmore calls an "avant-garde sociology" (Benjamin, Lefebvre). Such an intersection can be seen as the meeting point of discursive analysis and empirical practice, between thought as a reflective mode (representation), and action as performative event (the real). While maintaining a distinction, everyday life's theoretical and practical arguments may offer a productive antagonism: by colliding into each other theory and practice tease one another into an ongoing discussion.

Urban geographies and architectural theory can be seen to further articulate the lineage of everyday life practice, for such theories have at their core the probing of the "place" of the

1

Henri Lefebvre, CRITIQUE OF EVERY-DAY LIFE, trans. John Moore (London and New York: Verso, 1991), p. 97.

2

Ben Highmore, EVERYDAY LIFE AND CULTURAL THEORY (London and New York: Routledge, 2002), p. 19.

BRANDON LaBELLE

individual "body": both as geographic spaces and psychological centers, as intersections of political and social values. Thus, the psycho-geography of Situationist theory finds its parallel in Kevin Lynch's analysis of urban design: how the city itself bears down on the individual as an "image" which both supplies and undermines potential direction and the development of place. Here, the body and the city are wed in a conversational struggle or negotiation in which one both liberates and articulates the other through spatial conversation.

This lineage of parallel texts and practices, collisions and intersections, around the everyday can be seen to find its shared ground in the form of "space." Questions of space feature in theories and practices of everyday life, from Breton's urban drifts to Situationist critique of urban planning. Urban, eccentric, impoverished, crowded, the traversal of space is an urgent and fecund movement, and is seen as the framework in which daily life and its potential find form, are given a sense of locality and physical presence, and through which experience unfolds, as coordinates within an idiosyncratic map. Space is both medium and product of everyday life: it provides a vocabulary in the pursuit of the "left over" as well as a stage for the "left over" to take shape. Space can be seen to function as a key term because it is what the body inhabits: the everyday then could further be defined as the intersection of body and space. Such an intersection in turn brings into play social and political forces, for the body as individual and space, as that to which the individual is bound, as an external situation, sets into dialogue the negotiation between the private and public.

BODY The body is featured as both user and intruder, fulfilling and sabotaging spatial order. As Bernard Tschumi describes:

> First there is the violence that all individuals inflict on spaces by their very presence, by their intrusion into the controlled order of architecture. Entering a building may be a delicate act, but it violates the balance of a precisely ordered geometry... Bodies carve all sorts of new and unexpected spaces, through fluid or erratic motions. Architecture, then, is only an organism engaged in constant intercourse with users, whose bodies rush against the carefully established rules of architectural thought. No wonder the human body has always been suspect in architecture: it has always set limits to the most extreme architectural ambitions. [3]

Such disruption of the architectural order on the part of the individual body has built within it the power, as Jane Rendell describes, to "(un)do architecture. Such (un)doing in effect articulates 'spatial and temporal rhetorics of use' and ultimately function as 'strategies of resistance.'"[4] Through their persistent nagging of the architectural order, rhetorics of use—found in De Certeau as "ruses"—remind architecture of its own power to shape and define experience. Architecture, as an external force bound to the law through the legal framework of urban planning, building codes, city politics, etc. thus imposes, however gently, a force which the individual negotiates. To move from use to resistance in effect initiates the everyday as a site of difference, and marks the individual: one is effectively "traumatized" by the recognition of an outside, as force and as medium. Such trauma though sets in motion a conversation, however unstable or quiet, through which one becomes conscious of both architectural power and the power of one's own body: as a subject, I am made aware of a larger order to which I am both held and made responsible. This intersection in effect could be understood as the formation of the subject in general: for in this recognition one is separated from an exterior body (social)

3
Bernard Tschumi, ARCHITECTURE AND DISJUNCTION (Cambridge, MA and London: The MIT Press, 1996), p. 123.

4
Jane Rendell, "doing it, (un)doing it, (over)doing it: rhetorics of architectural abuse," in OCCUPYING ARCHITECTURE: BETWEEN THE ARCHITECT AND THE USER, Jonathan Hill, ed. (London: Routledge, 1998), p. 234.

and bound to it as symbolic system (representation). Against such trauma though, spatiality itself offers potential escape routes—it is where use becomes resistance and the order of the individual intersects with the order of law. Rather than overturn architectural order, such intersections remodel, on a micro level, the patterns of its articulation. For, following Rendell, one resists through an undoing that in turn creates other forms, and thus, other experiences.

FLOWS It is against this overall schema of everyday life that I would like to situate contemporary descriptions of the "transurban." Or rather, it is to the transurban that I would like to turn as a way to follow the course of the everyday into contemporary spatiality.

"Transurbanism" can be described as a shift from the material city to the immaterial flow of information, from traditional views of location to the greater "flows" of globalization. Such a shift finds its articulation in economic, social, and political transformations made manifest generally in a shift from a Cold War political structure, which locked one economic force and ideology against another, and in an overall splintering of such forces into micro-movements and the expansion of corporate capital. This economic view is inextricably tied to the technological advances in telecommunications, for the importance of information shared across global networks provides a sustainable infrastructure for exchange and the immediacy of decision-making necessary for global markets.

Against these larger movements of corporate capital and communications we can also witness a shift in individual movement and experience. For such transformations open up an entire network of "connectivity" through which individuals fashion their own idiosyncratic itineraries and goals. This manifests itself not only in the material opportunities of interactive technologies, such as the Internet, mobile communications, "smart houses," etc., but also filter, into a psychic imaginary: "connectivity" seeps into fantasies of relationships and identity. Transurbanism thus describes the globalization of economic exchange, while recognizing the increased agency of individuals to function independently, or to one side of, national borders, media centers, and economic brackets, within specific localities. Michael Peter Smith defines "transnational urbanism" as:

> ...a marker of the criss-crossing transnational circuits of communication and cross-cutting local, translocal, and transnational social practices that 'come together' in particular places at particular times and enter into the contested politics of place-making, the social construction of power differentials, and the making of individual, group, national, and transnational identities, and their corresponding fields of difference.[5]

In a recent publication, transurbanism is given further definition as "...a design strategy that allows cities to organize themselves as complex systems, where small local structures incorporate global flows."[6]

It seems a question arises: How does the undoing of architecture enacted by the body as a conscious effort of spatial resistance find ground in the transurban "collapse of dimension" in the acceleration of space and time, as a "cinematic" rush of images? Whereas such intersections of the local and the global seem to form a new situational vocabulary, and along with it new understandings of spatial narrative and practice, the inherent destabilizing of transurbanism gives way to a different formulation of practice, beyond a recuperation of grand narrative or an intensification of the individual as autonomous body. Here, the rhetorics of use, while

5
Michael Peter Smith, TRANSNATIONAL URBANISM: LOCATING GLOBALIZATION (Oxford and Malden, MA: Blackwell Publishers, 2001), p. 5.

6
TRANSURBANISM, Arjen Mulder, ed. (Rotterdam: V_2 Publishing/NAi Publishers, 2002).

maintaining its force against architectural space, as a private form of resistance, relocates itself on transurban terrain. For space itself is increasingly determined by the intervention of places outside and beyond singular models or definitions: the transurban both disrupts locality (as singularity), while making possible its amplification (as communicable network); in turn, I would propose, it disrupts the locality of the body in space, while amplifying such interaction as communicable vocabulary.

The intensification of place, from singular to transurban, can be seen in what Saskia Sassen names the "global city." According to Sassen, the global city is the product of transnational and global economic flows, exemplified by the multi-corporate accumulation and movement of capital, networked and telecommunications, and the general consciousness of displaced borders, dual nationality, and migrant workers. In turn, to follow Michael Peter Smith, such economic flow has at its base political processes that unfold inside specific localities, at particular moments. Such movements both reinstate capital across the discrepancies of local situations, while making these situations open to their redefinition. For, as Sassen proposes, such shifts in the "global city" produce openings or "fissures" in the traditional hierarchies of national power, destabilizing borders and what it means to be a citizen[7]—sovereignty slides across the transurban map of the "global soul."

Citizenship itself is made more complex as it becomes less tied to a single nation, or caught in the fluctuations of statehood, migrations, and the conflicts of the reorganization of capital, repositioning the way in which we connect with place, territory, home, etc. Such repositioning is symptomatic of transurban disruption, for it suggests a network of interaction and agency existing on top of the map of traditional borders, both of territory and of identity. Yet this other network, as a kind of spatial terrain, weaves in and out of formal recognition: in other words, there is as yet no direct map which defines these localities and their inhabitants. Rather it can be seen as an "informal" space, where both multi-national companies and single individuals collide, in the fissures Sassen recognizes as resulting from transurban restructuring. For it seems we make connections across an increasingly dispersed and random map, personalized according to individual trajectories that move across greater distances, and that nonetheless confront transnational movements. And yet, as Smith reminds us, such dispersal does not eclipse the persistent reality of the individual body situated within locality, identity, and history (here we can recall that such trajectories are often forced migrations). What this suggests is that as place itself becomes dispersed and repositioned on the transurban map, it in turn gains significance on a micro-level: the transurban as a global feature thus gives way to both large movements of capital, migration, and dispossession, and smaller movements of personal practice, informal connections, and illegal traffic.

PLACE Place itself is increasingly defined and redefined outside such formal terms as "nation" and "state," for in displacing locality the transurban makes possible a reorganizing of its very definition—inside the fissures, cracks and openings, and by extension, inside the "disjunctive" moment Tschumi names as the meeting point of the body and architecture. Such a disjunction becomes amplified in the reverberations of locality caused by transurbanism: how locality extends out, past itself, is carried along by the individual subject, across borders, and through transient meetings. In a sense, these redefinitions are made concrete in the informal connections made across disparate and seemingly disconnected points or locations, connections that in turn form their own network. From websites devoted to domestic abuse networks aiding victims, to botanists exploring rare bacterial diseases of the tulip, such highly refined needs and

7
From a lecture by Saskia Sassen, December 2002, at the London School of Economics.

necessities are given significance as they organize themselves around an extremely pragmatic concern and ambition, namely to address the conditions of "the real." The "real" here refers to what Scott Lash describes as part of the transurban: specifically as arising from a collapse of the symbolic (meaning) and the appearance instead of a "regime of operationality."[8] For Lash, the transurban is a condition in which it is no longer a question of apprehending meaning and participating in its organization (sameness/ singularity)—where all points refer to a set of recognizable terms, either on this side or that—but rather, where all such terms unfold as a set of negotiations and flows (difference/networks). The regime of operationality then is the turning of the real as it binds and unbinds us to different practices and to different localities, pushing us up against the stratification of power relations and beyond metaphysics. It would seem that this "real" consists of a different spatial organization, in which global flows reposition the strata of locality, diffusing the traditional hierarchy of town and country, center and margin, authentic and inauthentic, and with it, the very position of the body within architectural space. The transurban it could be said promises not so much the liberation of individual desire—as a pinnacle of Situationist ambition—but instigates a reorganizing of locality as a set of values.

PROJECT I: SPLITS Thinking of the "frame," of the framing that limits the field of vision, these photographs were taken with the intention of "splitting": to complicate the field of vision by introducing an "outside." This outside is revealed in the instant of holding a mirror up, in the very photographic process of taking and producing images—to allow interference to splinter the coherence of perspective. Here, the separation between body and space is displaced, opened up by the reflection of the one who takes the photo and the space that is captured in the photograph, as multiple locations.

8
From a lecture by Scott Lash, November 2002 as part of the "Transurbanism" conference, organized by V_2, Rotterdam, Holland.

The mirror, following Lacan, is both a constitution of the subject and a disruption of its completeness: one is made a subject and in the process such subjectivity is made complex, split in the field of desire and the imaginary image. "This moment [the mirror-stage]...inaugurates, by the identification with the *imago* of the counterpart and the drama of primordial jealousy... the dialectic that will henceforth link the I to socially elaborated situations."[9] To complicate the photographic frame—for photography and the mirror share the same ocular determinism—in this way is to resituate the center by "splitting the image," introducing the social into the field of vision and the space it captures. Here we not only see ourselves, but all that lurks in front and behind us—the storefronts, the streets, the passers-by, etc. These loom up, press in, and pressurize the uni-directional gaze on to oneself as object of fascination. What the photographic frame introduces, and the mirror echoes, is an architecture: the imposition of a structuring in which such gazing occurs. It is this relationship that presses forward at this "mirror stage"—that moment when the space around determines the subject: I stare at myself and what I see is that which surrounds my image and how such an image, on the surface of the mirror, comes to occupy the same visual field—in this way, I am reduced and enlarged by the environment surrounding me. Such expansion and contraction thus problematizes the body as self-contained object—I marvel at myself, not as a body in control, but one disrupted, at precisely that moment I am held, as a stable referent in the mirror, by all that threatens to overtake the image, and shatter the imaginary. Here, the real in effect looms because this mirror is a public mirror—I am no longer an infant in the confines of the home, against my mother's breast, but rather a singular figure. I am added and subtracted in the margins of public space, vulnerable to forces outside the frame and at the same time constituted by such forces. I am made a subject at this instant of vulnerability—this complicates and affirms my place as a subject; it throws the body and returns it, as a participant in the complex of public life.

SPLIT SPACE

> *What I have in mind is the following remarkable fact. As a rule the patient was free from pain when we started work. If, then, by a question or pressure upon her head I called up a memory, a sensation of pain would make its first appearance, and this was usually so sharp that the patient would give a start and put her hand to the painful spot. The pain that was thus aroused would persist so long as she was under the influence of the memory; it would reach its climax when she was in the act of telling me the essential and decisive part of what she had to communicate, and with the last word of this it would disappear.*
>
> —Sigmund Freud, STUDIES OF HYSTERIA

If we push the psychological rupture of the individual named as the split subject, with the understanding of the split not so much as a pathology but as a condition, a split that continues splitting beyond oneself to a point of always returning, that is, becoming actually recognizable; if we take this and map it, superimpose it, across architecture, we arrive at something like "split space." Split space could be described as a spatial dispersal that, rather than collapsing into ruin, returns to itself as a constituted and recognizable form. It is a kind of rupture and renewal of architectural form—an architecture, in a sense, wedded to the transurban features of contemporary culture and the conditions of "the real." For split space, in tracing the flows of transurban movement, proposes the same informal possibility of individual trajectories across

9
Jacques Lacan, "The Mirror Stage" in ÉCRITS, trans. Alan Sheridan (London: Routledge, 2001), p. 6.

the global map; the form of architecture's renewal as delivered up in this splitting of space is one of promiscuity: here, space flirts with everyone. And this flirtation brings architecture outside itself, extending its forms into a field of desire that in itself falls apart, flings itself in acts of excitation, anxiety, and jouissance, at moments when architecture becomes political property. The return, as found at the beginning and end of splitting, then is not so much a recuperation of something lost, but a division that remains susceptible, in gaps that remain open as part of both form and function. It is where architecture becomes public beyond singular locations, as a site of negotiation, caught in the "disconcerting concert of advanced technologies."[10]

10
Paul Virilio, LOST DIMENSION, trans. Daniel Moshenberg (New York: Semiotext(e), 1991), p. 22.

ENVIRONMENTS Split space thus redefines locality as ephemeral and immaterial, yet grounded and pertinent. As a condition of differentiation, it drives the unfolding of form in which linear perspective curls at the ends and frays or dissolves into split ends at the edge of the architectural crown. Split space digs in, just for a moment, then departs, in varying rhythms. In this way, it slides across the scale of perception, along the threads of certainty, as a communicable object. It is a kind of trace of form, or tracing, appearing in the instant of experience—there!—while remaining a kind of after-effect.

This after-effect though, through a slight shift in perceptual priority, could also become the first effect, the primary product. For instance, if we hear the sounds of a car driving by outside we immediately picture the car as a form or object—it comes to mind as the primary identifying image. This occurs without recognizing, as a perceptual moment, that in turn what we hear is the car as it is driving down a street with specific acoustic, social, and individualized conditions. In fact, the car is not strictly an object, but rather a medium moving through a spatial situation and bringing that situation into a kind of aural knowing. What I want to suggest is that if we shift our attention from the car itself to recognizing the street, the environment in which the car drives, and the spaces through which sound travels before arriving at the ear, in the cradle of perception, we are in a way recognizing "the real" as an operation beyond forms and their differences. In this way, sound is only an indication of form—it may highlight dimensionality while at the same instant producing other effects; drawing attention to a larger context, to ephemeral occurrences that have real presence.

Such an example sets the stage for a shift in both perception and cognition, for it proposes a larger field of recognition: here, subjects and objects operate not so much within a given narrative of cause and effect, but rather as events which interact, overlap, inform, and affect the other, as multiple conditions that produce and form a kind of "environmental organization."

The splitting of space thus can be understood as an "environmental" operation, rather than a language of meaning, as transient definitions. The environmental here should be seen not in relation to the "natural," but rather as a paradigm. It shifts the locus of attention to a broader spectrum whereby notions of progress and relation unfold as a lateral figuration—an ecology of forms and their functions. The environmental thus throws architecture into greater dispersal because it necessarily refers back to a spatiality in which it is immersed, captured, and shuffled in the mix. In this way, the built is perceived as existing within an expanded nexus, figuring inside collaborative and disrupted categories, as an infrastructure.

PROJECT 2: PIECE FOR A LISTENER In the winter of 2000 I mounted a series of signs in Hampstead Heath in London. The signs consisted of a text-score (written by the artist Achim Wollscheid), which addressed the random passer-by. The score reads as follows:

Please listen carefully to the different sounds of your environment
Adopt one of these sounds
Try to imagine this single sound expanded over one minute
Do not change it, just maintain it
Try not to hum it, just think it
Then quit

In effect, the text-score asks us to shift our attention and consider sound as an affective and influential physical phenomena in the world, as an ordering term. And more so, as an ecological layer in which we are implicated. Such an intervention has reference to Acoustic Ecology, or soundscape studies. Acoustic Ecology began in the early 1970s in North America and continues today.[11] As an active community of ecologists, musicians, scientists, and listeners, Acoustic Ecology can be seen to outline a sociology of sound, for what becomes apparent in soundscape studies is the overall structure of social institutions, their manifestation in governmental policies related to noise, and the ways in which a more general attitude towards sound as reflected in listening consciousness is manifest in social relations. Acoustic Ecology, as an agenda, puts forth a philosophical platform that promotes an "environmental" viewpoint: environmental being a paradigm opposed to the "frontal alphabetical gaze"(singular), a dispersed and multiple outlook, the interconnectedness of things, their interplay across the senses, and the implicatedness of the individual within a broader field of concern, all of which shifts epistemology laterally. Knowledge is always found to one side, as a web of points rather than a hard knot.

Aurality here throws us into such a web: the acoustical wave is deflected and reflected across the demarcations of buildings, over the lines which define one neighborhood from the next, traveling beyond and outside its intended recipient (while in a restaurant we learn how to block out the noise of the crowd in order to speak to our friends).

CURLS The aural forms the basis for an altogether different knowledge, one of immediacy, non-representational, and "tactile" knowing. Derrick de Kerckhove proposes that such tactile knowledge is intensified in the increased connectivity of contemporary society. He sees that even in the seemingly disembodied digital rush of communications—Virilio's "crisis in the conceptualization of dimension"[12]—the body as sensual being is made more present rather

11
For more on Acoustic Ecology please see R. Murray Schafer's influential TUNING OF THE WORLD.

12
Paul Virilio, LOST DIMENSION, trans. Daniel Moshenberg (New York: Semiotext(e), 1991), p. 25.

than vacated, for "with interactive systems we have been putting a new emphasis on tactility on the one hand and also on the physical interaction with the objects of our attention so that we're learning a lot more about the very thing that we didn't know much about before, which was the tactile sense."[13] In this way, the transurban, as determined by telecommunications, moves from an alphabetical paradigm (singularity), toward an "environmental" one (difference): it weaves varying threads of input and connectivity and immerses an individual in a field of communications, while reinforcing locality as physical and political site, as tactile knowledge within an expanded frame.

This can be seen in the insertion of mobile phones into the social body. Mobile phones in a sense displace the borders of private and public by transposing private speech onto public space: they inaugurate a new kind of orality and audition by "mobilizing" both. They also produce a new form of confrontation whereby a public must overhear an individual's private conversation. This goes beyond the known form of general conversation overheard at a restaurant or park, even through the walls, because it occurs as a monologue, or half-conversation, announced and hidden in the technologized instant of transmission whose process makes strange the human voice inside the public domain—individuals now seemingly speak to themselves, as kinds of zombies, displaced, and yet placed in the same instant. In addition, the mobile phone initiates a personalized form of empowerment: one can make calls without resorting to public and landline phones, as a civic and commercial infrastructure; conversations can occur inside spaces traditionally meant for other actions; and the circumference of the privacy integral to individualized and intimate relationships is extended to a beyond that unsettles traditional zones of speech and conversation. This process throws the voice into greater orality, and across the centering and de-centering of spatiality.

> —*Barbara?*
> —*Coffee to go*
> —*Just north of here*
> —*Yes, I'm listening*
> —*Make that three cups*
> —*Let me call you back*

Many bemoan the loss of public space, and by extension, the political, as more of the population gains access and inhabits electronic spaces of the Internet (a recent NY Times article stated that average Americans spend about 20 hours a month online)[14] and network technologies, which are assumed partly to take one out of the physical needs and expectations of democracy, and into a privatized isolationism.[15] These arguments raise pertinent questions regarding the establishment of communities in cyberspace, and their consequences on political and social processes. At the base of these inquiries the question is raised of how individuality can in fact participate in the social, for the social is conceived of as a "place" to which we can refer, and thus a stable referent in the lexicon of interaction. What mobile communications, and other interactive technologies, inadvertently initiate is a shift in such a lexicon, for the social as a site is on the move—increasingly affected by conversations that extend beyond its localized borders. Such dispersal though, in revising the social in general, highlights the complexities of the voice to define itself according to another language. The power of public space is dependent upon the power of the individual to use his or her own privacy—to remain hidden, out of view, on the edge of language (meaning), sliding off the scales of answerability, and thereby directing attention to other perspectival points and modes of participation.

13
From an interview with Derrik de Kerckhove by Tim Wilson, to be published in SOUNDSCAPE JOURNAL, Sabine Breitsameter & Brandon LaBelle, eds. (Vancouver: WFAE, 2003); also see Derrik de Kerckhove, ARCHITECTURE OF INTELLIGENCE (Basel: Birkhauser, 2001).

14
Amy Harmon, "Exploring of World Wide Web Tilts from Eclectic to Mundane," NEW YORK TIMES, August 26, 2001.

15
For an informative essay on this subject please see Michael Heim, "The Cyberspace Dialectic," in THE DIGITAL DIALECTIC: NEW ESSAYS ON NEW MEDIA, Peter Lunenfeld, ed. (Cambridge, MA: The MIT Press, 1999) & Howard Rheingold, THE VIRTUAL COMMUNITY: HOMESTEADING ON THE ELECTRONIC FRONTIER (Cambridge, MA: The MIT Press, 1993).

The mobile phone could be seen as a redefinition or amplification of free speech because it "augments" reality by superimposing a multiplicity of spaces onto each other—between the spaces from which one speaks and the spaces which one hears—thus announcing itself in broader terms without fear of being overheard and without the desire to seek consensus. In contrast to the notion that social space is a definable location, mobile communications exert spatiality at that moment of use—here, such communications creates a public arena in which to organize highly diverse and active conversations: mobile speech forms public space wherever it may be. In this way, the mobile phone brings together the spoken with the spatial in such a way as to suggest new perspectives on the forms of both. In the highly personalized trajectories taken in everyday life, one is always negotiating between the proximate and distant demands that bring one into the fold of language and architecture. Mobile speech throws the body into a network of orality that sustains relationships by always being available, ready to answer, across spatial coordinates.

To return to our initial thoughts on everyday life, as the intersection of body and space, we can propose that the transurban amplifies such intersections by throwing it beyond the self-contained city, out against national borders, as a projected virtuality through which real space gets magnified, real bodies mingle, voices speak. For, if what marks the transurban is the intensification of a global institutional framework (economics), as well as the increased agency of individuals to operate within such a framework (usage), we can update understandings of everyday life to take into consideration the global field, as a site of negotiation, of desire and as a political space. It is on this amplified field that "rhetorics of use" must learn to speak more than one language.

PROJECT 3: UNOFFICIAL GEOGRAPHY

> *And with these, the sense of the world's concreteness, irreducible, immediate, tangible, of something clear and closer to us: of the world, no longer as a journey having constantly to be remade, not as a race without end, a challenge having constantly to be met, not as the one pretext for a despairing acquisitiveness, not as the illusion of a conquest, but as the rediscovery of a meaning, the perceiving that the earth is a form of writing, a geography of which we had forgotten that we ourselves are the authors.*

> —Georges Perec, SPECIES OF SPACES

Perec reminds us that the world is authored by a very "personalized" writing—of body and space, of desire and its play in and against the world, of movement and its physical residue, in the "rhetorics of use," which is traumatic and overpowering. Such writing could be thought of as an "unofficial geography," a graffiti through which the city is authored by secretive marks and covert scribbles that press upon the greater lexicon of language and space. Graffiti positions language on the outside, across the city, appropriating the building as its page. Graffiti is a kind of architectural addition that, like the everyday, forms a residual totality: it is what is always left over, when space itself has been accounted for. Graffiti thus authors according to a writing that takes on public space, and in doing so, comes out of the closet. What we read in graffiti is both agency and its anxiety projected out across architecture, for it reveals and hides itself: it speaks to those who know, in a move toward legibility, while making those who don't know aware of their separation, and their inability to "arrest" meaning. Graffiti announces itself on a spatial level—by

marring public space, and by extension public authority—and on a writerly level—by turning language into secret forms. These lines of legibility are thus drawn across multiple borders, underscoring language and space as forces of knowledge.

For an exhibition at the School of the Art Institute of Chicago (entitled "Resynthesis" and curated by Philip von Zweck), I make reference to this notion of graffiti as an unofficial geography. The installation project, SOCIAL MUSIC, consisted of a series of benches placed in different locations around Chicago: within the exhibition space, at a hostel in the city, the central library, and on the grounds of the Institute. Mounted on each bench was a placard with the following statement:

> *Please answer the following question using the bench as a writing surface. Be as imaginative or descriptive as you like; use as much or as little space as needed: What is Music?*

In effect, the benches were meant to serve as both "listening stations" and "writing surfaces" for the inscription of idiosyncratic marks. Such a combination would cause an intersection of seemingly opposing operations, that of language as representational system and music as non-representational. The work thus invited people to define for themselves what constituted music, and in doing so, to realize that music and language necessarily form an unstable relationship. In this way, thinking through and arriving at definitions functioned as a personalized practice, wedded to the experience of being situated within particular localities, and at particular times. In such acts of inscription it was my feeling that a sensitivity to sound would be the basis for such definitions: people would pause, and in thinking begin to listen.

And further, in making a mark, such a process would lead to a graffiti that, while sanctioned by the exhibition, would write across public space in such a way as to define it as a space of writing, yet as a writing of many voices—of imagination, of humor and whimsy, of thought and its excess, in effect, a writing of noise. Such writing would be infused by a listening that would in turn redefine writing as unfixed, social, and idiosyncratic.

AMBIENT In essence, what I am describing is an approach toward the transurban as predicated on a kind of "perspectival absence" or splitting, and the operations of the real, as found within our own processes of knowing and of being known, as local bodies situated within increasingly dispersed fields of information and desire. The transurban absence forms a shift in space, and how one may practice not only everyday life, but its theorization. The dispersal of contemporary culture hints at not only an urban transformation but a shift of interior space, and the figuration of psychic architecture. Here, the trauma of addressing public space—of moving from use to resistance, theory to practice and to theory again, from the library to the shop to the home— must in itself partially define *what* space is in fact public, and to what public one's address is made. The splitting, which is both a global movement and an individual movement of desire, is in turn part of what Deleuze calls "societies of control," which, following "disciplinary societies," replaces spaces of "enclosure" with the implementation of "controls."[16] Controls, in effect, span the varying spaces, activities, and movements of the social body; whereas enclosures confine an individual to institutional frameworks, such as schools, prisons, and hospitals, the society of control administers a network of starts and stops through which one must pass and that will "continually change from one moment to the other."[17] Such controls, as imagined by Deleuze, necessarily find their implementation through advances in computer technology, and the transurban. Deleuze's declaration for the need for "new weapons" to combat such controls, registers against what I see as the softer claim I have been pursuing here—to recognize the potential for movements not so much against the spatial ordering of transurbanism, but through and within, as a micro-practice within the "fissures." Such fissures form an "ambient architecture"—a kind of environmental field connecting various points or locations, into a geographic network, in which desire and context interpenetrate, personal and political tensions cohere, and the transurban gives way to multiple and informal conversations. What this ultimately points to is a process of finding centers beyond symmetry, in the instances of private negotiation, as a lateral movement across the real.

 If we follow that it is no longer a question of participating in the organization of meaning but being present inside the dynamics of operations, that the loss of center is but an opening up of lateral articulations and ambient environments, knowledge gains currency on the terrain of interactions: as micro-exchanges across dispersed spaces. "I think, however, and speaking in general, that the manner in which humanity can experience and live its human dimension in this post-modern world is by developing the positive potential of a 'declining' experience of values, one that is more diffuse and less intense."[18] Such "declining" as Vattimo outlines here, proposes an alternate construction of the individual as housed, not so much in the metaphysical Platonic ideal, but in the realm of appearances, and the real; where the loss of idealism is not so much a giving up, but a shift in attention to something outside the frame, and an apprehension of alternative marks on the page, like a grocery list found in the margins of philosophy.

16
Gilles Deleuze, "Postscript on the Societies of Control," OCTOBER No. 59 (Winter 1992), pp. 3-7.

17
Ibid.

18
Gianni Vattimo, "Bottles, Nets, Revolution, and the Tasks of Philosophy," in CULTURAL STUDIES, Vol. 2, No. 2 (May 1988).

CAROL BROWN

PHOTOGRAPHS BY MATTIAS EK

SIGHT LINES/ FAULT LINES:
OVERWRITING PERSPECTIVES

My body is everywhere: the bomb which destroys my house also damages my body insofar as the house was already an indication of my body. —Jean-Paul Sartre, BEING AND NOTHINGNESS ❖ **CHAMBER** HISTORY If all work can be said to begin from a condition of homesickness, I have for many years improvised my way out of this longing and nostalgia, by a process of being domiciled in the act of performance. As a movement artist, making a home for myself in the apparatus of performance means creating a fragile shelter, a contingent space for the staging of corporeal presence. Performance becomes location but not destination; an arrival here, here and here; an assemblage of soft-core actions and de-familiarized behaviors; and a collection of arterial routes. The body becomes a place of passage and a conduit sequenced by the trajectories of the history of spaces. A dance becomes a series of grasped moments and the flows that occur in the intervals between bodies and spaces as bodily **stages.** To the touring artist the stage is a temporary

arena, a working environment, existing within the time of fit-ups and get-outs, like a shelter it is not presumed to be lasting or enduring, it is a contingent space. Each form of staging enables a different form of incorporation, for the corporeal subject is shaped according to the contours of the built environment and the practices of space it enables. The stage becomes a sheltered housing system, a site for the dehiscence of the stable subject and a platform for vaga bondage. I am constantly on the move. ❀ **CONTINGENT** SPACES How are we installed in the world? As a movement artist I build structures in which to site and install corporeal presence. Some of these structures contest traditional assumptions about what a stage is, others work within the boundaries of the convention to de-familiarize it. I use performative presence to explore the limits of the body within fabricated spaces. As a contemporary artist for whom touring is an essential means of survival, I am forced to negotiate my inventions within the space of the given, the "always already" conditions of perspectival thought and the traditions of theatrical staging. Against such conditions, I fall into ditches [Nerve]. I balance on shelving systems [Shelf Life]. I make a machine house [Machine for Living]. But I cannot exorcise the deep print of theatrical space from my skin, for deep binding is involved. ❀ The theater is an inside without an outside. It assumes the significance of a universalized model of space and encourages the forced perspective of the paranoid. While acknowledging the tempo of history within the staging of dance as representation I am seeking to develop work which foregrounds the simultaneity of perceptions accreted through shifts in temporality and spatial thought. In this sense the moving body becomes a repository of a plurality of spaces, a linkage between theatrical presence, presentation, and signification and a signpost pointing to a range of different kinds of spaces. It is as much a resistance as a negotiation.

black box space	*penetrate*
white cube space	*float*
monumental space	*disinter*
corner space	*hide*
hair space	*disrupt*
holy space	*hand*
factory space	*articulation*
virtual space	*intertwining*
street space	*cut*
transit space	*passage*
perspectival space	*deep map*
tower space	*dive*

opera house space	*placement*
park space	*interference*
desk space	*play*
screen space	*compose*
body space	*dissect*

Though I continue to feel the collective weight of the past in paradigms of perform-ance which reinscribe the tempo of history in perspectival space, I reach towards a counter-spatial project which cuts against the normalizing tendencies of modernist, universalist, and hygienic space. Thus the theater space is both a physical stage for the meeting of bodies, and an ideological site for the intersection of bodies of thought. ✸ **DISAPPEARANCES** Her appearance is not separated from her materiality, the theater becomes her: In this text I am going to speak between performances within theatrical and non-theatrical contexts as a way to expose the shifting territories and investments of their body/site relations and the axes of power these differing contexts of performance give rise to. These perenigrations will focus on the relationships between figure and ground to create an interplay between body, home, city, and stage. This work can be considered an attempt to make transparent the body boundary so as to stimulate greater fusion between personal and environmental events.

URBAN DANCE ONE—PERFORMANCE EDGE OR HOW THE CITY GRAZES THE BODY DANCED
In Opera Romana Iasi, Romania (20 March 2002) dancing flesh text [**Flesh.txt**]: Strangers assemble quietly beside me, in the wings, in the margins of this deep space, watching, they are also whispering. I can hear them more than I can hear myself. A woman called stage manager sits poised, expectant in a glass cubicle on the corner of the stage under a soft light. Her hands are empty, there is no script, no score, no set of instructions. The audience is distant. There is an ocean between us; a pit without an orchestra and no conductor to suture the spaces of this ancient model, this house for the body as representation, as sign; for this space is divided according to the order of the same, it is upstage and downstage, foreground and background, onstage and offstage, it is going black and lights up [little city]. ✸ I experience the city of Iasi through its theater: The Opera Romana, a late nineteenth-century neo-baroque building in the Viennese style. Small and perfectly formed according to classical proportions, its fan-shaped auditoria elaborately decorated in gold stucco provides a rich architectural platform for our bodily stages. This theater is a persistent monument within an otherwise volatile urban space. Elsewhere, there are communist-era concrete shells and external wooden scaffolding propping up

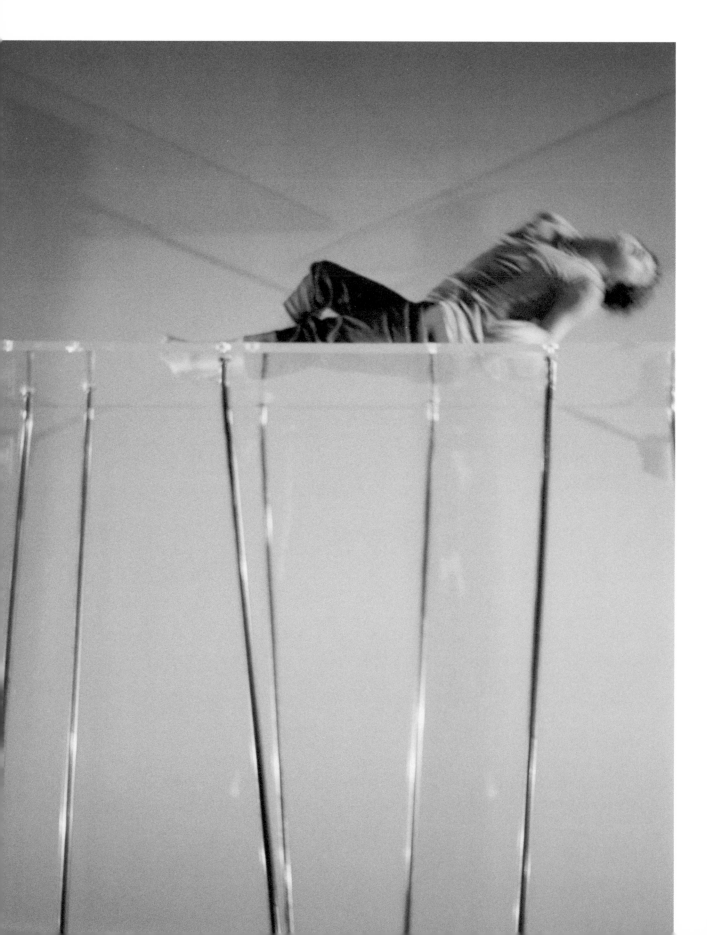

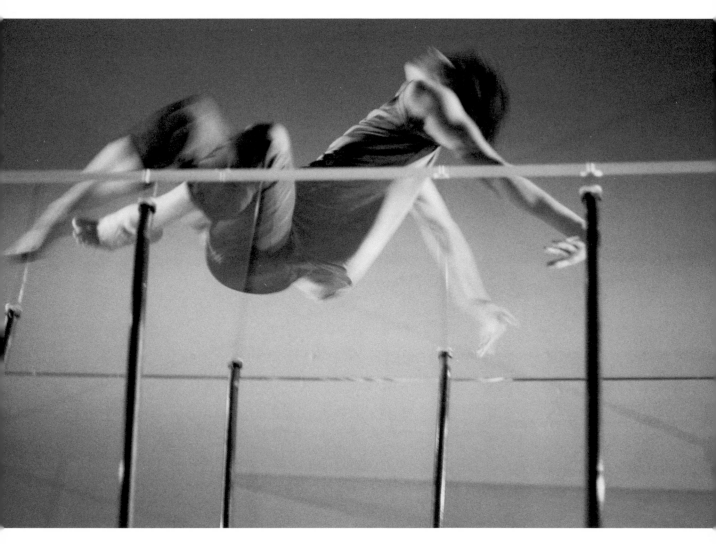

ancient Romanian Orthodox churches. This theater is like and unlike other theaters: It is in the center, the place of maximum visibility and the place of intersecting stories. But it is also on the cultural periphery, in a place stranded by history and the exhaustion of ideology. We experience the anomalies of being guest artists from London, here to represent some alternative stylizations of flesh to the centrality of the classical; to displace the center with some culture from the margins, but within a cultural economy described by local artists as, "periferic" and a province of global capitalism (Alexandru Polgar, The "Cultural Periphery" as province of global capitalism, in [periferic:5] THE PERIFERIC BIENNIAL 2001.) ✤ We engage in an exercise in cultural translation, trying to negate the trans-cultural tendencies of the theater with its universalism and 'always already,' by jamming the discourse of sex, dressing the stage with narratives of dogs, divas, and dancers. But in this overwriting of perspectives, we experience the rub of contrasting ideologies and

cultural economies. In this meeting of movements and places across history and culture, our small bodies amplified by the apparatus of performance take on an iconic status at odds with the counterspatiality to which we ascribe. Fault lines figure as prominently as sight lines. ❀ The problem remains of how to suture the interior lived spatiality, inscribed through our gesture-words, to this inside-without-an-outside of a theatrical ruin. I look outside to its edge and opening and shifting ground, and contemplate the slippage between place and site. ❀ The entry from the outside befits the grandeur inside. A sparse row of trees and some stone dead fathers of the city form an avenue. We bypass a group of artist-hustlers selling cut-price oil paintings to occasional strangers. The edges of the facade of the opera house are crumbling into a moat of sludge which encircles the theater as site. [In London, much later, I will clean my shoes of these traces]. ❀ There are some huts for migrant workers in the garden. From my dressing room I can watch homeless and sick dogs wander between these huts. From a distance the silhouette is baroque exuberance from up close it is a crumbling museum of a theatrical past. The theater as survivor, of post-Stalinist totalitarianism and the existential mutations of post-communism, becomes a meeting point for histories and bodies. The ground slips beneath my feet. In this performance without a conductor the body becomes a hinge, an articulation between inside and outside, here and over there, past and present, east and west. In this double gesture, you should be a bridge for me, as I should be one for you. But these bridges are not the same our relationship puts power into play. For though we denounce the tyrants of the past we deny the ideological tyranny which continues to circulate between us [Luce Irigaray, TO BE TWO.] ❀ *A man called Machinist wears a blue uniform and stands in the lighting booth at the back of the theater with a sequenced array of dials and dimmers. He lives off in one month what we are provided with in one day as per diems courtesy of the British Council. (Later that day I will be asked to supplement the workers wages.) A woman in a tracksuit, a former Olympic gymnast, will offer us back massages in the basement of the hotel's swimming pool. A girl in the workshop the following day will lie exhausted on her back, she tells me she has tuberculosis.*

URBAN DANCE TWO—SHIFTING GROUND Ocean Skin [the body swept by waves and multiple fluctuations becomes a theater of murmurs, pulses, jarrings, power surges and lunges] I am making my breath audible by breathing into a microphone concealed inside my jacket as I make circles by running around the perimeter of the stage. I am running fast, drawing energy into the center as if dragging these silent spectators with me or into me. I am also angling myself to the contours of the stage, glancing the sidelights so as to catch the edge of the visible. The space splinters, I

ride concentrated pockets of turbulent air to the point of exhaustion. The theater fragments. Into this poetics of exhaustion the fixity of the surrounding space, its persistence as a stable object loosens its hold. Head to the floor with legs balanced behind, one elbow as a prop and wrist holding all, I become a levered fulcrum, *a mechanic of fluids.* Flesh, that *"invisible-inked signature of the living"* becomes the developer [Rebecca Schneider, "Performance Remains" in PERFORMANCE RESEARCH 6(2)]. I no longer remember where up is, where down is, how to be up-right, how to be-have. Turning into the center of the stage I am holding a course and I am on the verge of losing control. I slip up. The floor is greasy with the accumulated traces of the past. Last night, Bizet's CARMEN was here, does she linger in the curious gazes of these silent bystanders, in the empty hands of the stage manager, and in the unexpectedness of this? �֎ A thin line stretches from wing to wing in front of me, a horizon line beyond to inscribe the lifeline within. *We tug the tension wire between these two invisible lines in performance towards the vanishing point.* The narcissistic subject is at home here in her dark chamber. But the underside of her constructions reveals her bruised and torn skin which stains the floor. In this moment she hovers between a narcissistic identification with the role of performer and a strangely powerful will to lose power experienced as the loss of her body. ✖ *"What remains to be given is a perspective to perspective itself."*—Luce Irigaray, TO BE TWO

[**LEAKAGE**] In the theater, through its walls and surfaces and frameworks for seeing, we enter a pictorial world governed by geometrical order and classical ideals. Into this space there is an irreversible asymmetry of flesh for frontal perspective assumes the impossibility of seeing things from the other side. Blind faith, we enter the dialogue of performance in a state of suspension—suspension of disbelief, suspension of time in being plunged into 'going black.' An aporia which leaves us blind to the ending. How will it end? ✖ The perspectival setting as a visual metaphor for transcendence does not hold sway. We are writing against the traditional unity of place. I am searching out spaces which cannot be seen, dancing beyond the ending, escaping the imaginary totalizing fixity of the eye/I, for the everyday has a strangeness to it. This strangeness surfaces only in split second moments of recognition and incisive disturbances it is an undercurrent outlined against the visible in fractiousness. History has ignored this seepage and continued blind to its accumulated residue. For the theater persists as a stable object while the world changes around it. ✖ **MORE HISTORY** I spend three years undoing the accretions of "Woman as sign" within the boundaries of theatrical space, I spend the next five attempting to push, prod, and disintegrate the intrinsic authority of perspectival vision within this body of work.

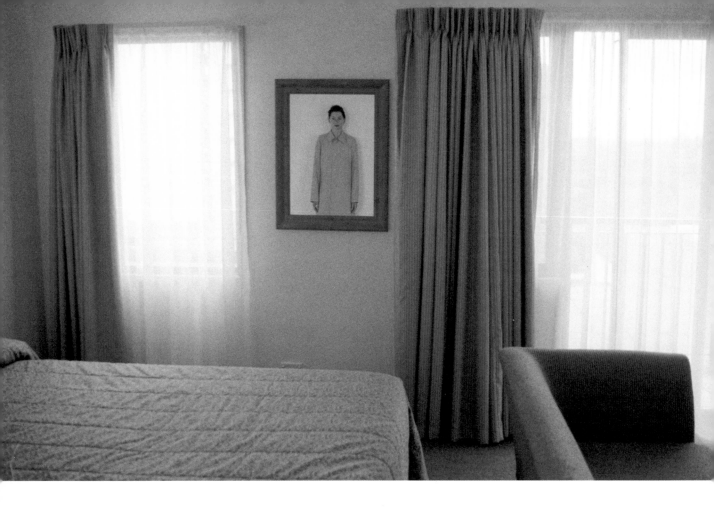

URBAN DANCE THREE—PRIVATE ROOM **Machine for Living** Greenwich Borough Hall, London, November 9, 2001. there are several partial rooms. they are porous. the performers move from room to room. they angle themselves around the edges, they press into and create small vibratory moments of tension enlivening dead steely surfaces. they are interpenetrated by light. animation creates shadows on the walls and floors extending their morphology into an ecology of perception. each other presses into and holds compressing skin and enfolding in fleshy exchanges. the space binds them together in their collective fantasies. there is no front, no back, no inside and outside. rooms which unfold and concertina. sight/ site lines mutate as we move in a constant dance of sensual unrest. here there is attraction and repulsion. ✿ I'm all yours say the performers all of my sidedness and surfaceness and I forfeit my authorial position to your grazing gazes. one body becomes a meeting place for another; a shelter for a whole community of others. outside the Law. ✿ being in close proximity the body becomes a hinge, a fold disrupting concepts of vision based upon transcendental perspective. I feel the brush of air against skin. in this close hushed space air compresses and is agitated between us. sweat flickers leaving a luminous flux.

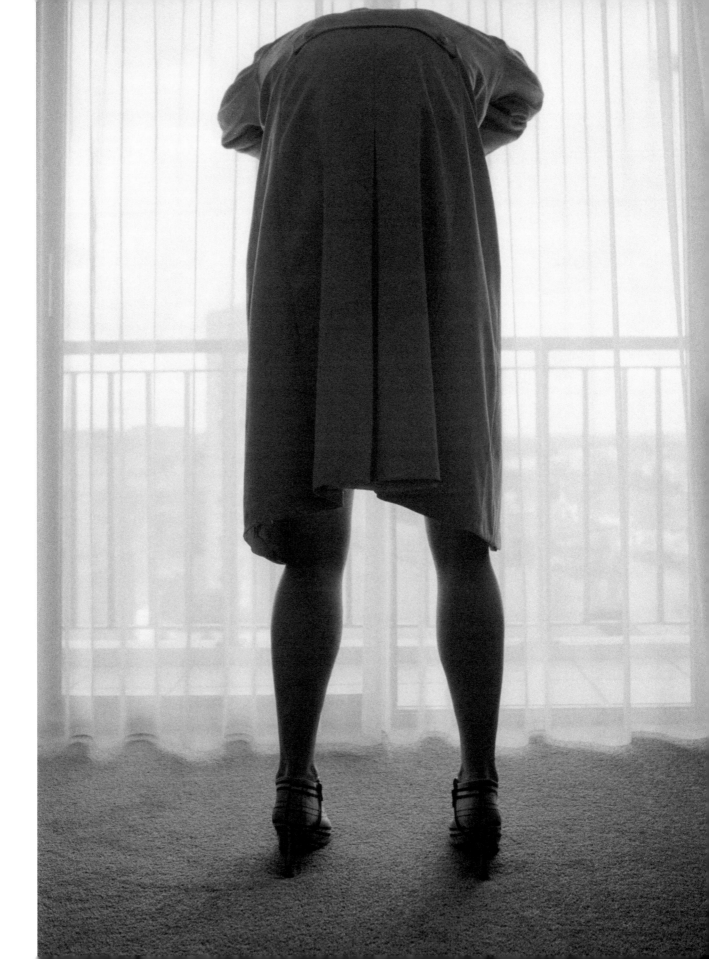

[ENFLESHING] In dancing we flesh out space with our gestures and gesture words. We alternate between movement and posture, our doubled vision simultaneously dissolving and constituting in an oscillation between memory and invention. Something supplementary to my body, a corner, a word, a sound is recomposed in flesh, and an interior becomes shaped by an exterior. The organic space of the body blends with the space in which we perform, hence our bodies are never reduced to a state of naturalism and we are dressed even when naked. The body provides the organic tissue though which the city is experienced in the theater.

URBAN DANCE FOUR—POROSITY Sleeping in Public ZKM, Zagreb, June 9, 2002. The history of dance is contingent upon the history of spacing. We alter the depth of the space and we change the performance. In Zagreb, I estimate the distance between you and me, mapping out the performance, measuring the fit between body and ground, its geometry in traveling from one end to another end. I sit in the empty auditorium and look at the blank stage. Outside, Croatian football supporters are jubilant at their World Cup victory against Italy and occupy the streets and squares with spontaneous parties. Inside, I test your capacity for vision from here, here and here. There is a power in this geometry, which Foucault notes as being mapped to oligarchic structures. The body-building anthropomorphism, as an originating point of central projection is placed in question by devices which extend, fragment and disembody. The performer hovers between narcissism and its opposite in her displacement of the powers of speech. ❀ How do I sound? I reassure myself that when you are here my voice will not sound so thin, it will deepen because your body will absorb it, thicken with it, we will be in sound. I imagine how your bodies will fill the thinness of my sounds as I attempt to speak. A shotgun mike is placed on the floor between us. It stands on the stage apart from my body but unseen. The house becomes flooded with the body of sound. But I am disembodied, for nothing attaches to my clothes, to my skin. "How can I touch you if you are not there?" (Luce Irigaray, TO BE TWO.) What is the relationship between the you who exists in space and the voice inside my thoughts? Our hands touch without taking hold (this is a performance after all), and I am becoming porous, subject to leakage between body and ground.

[INDIVISIBLE] In the staging of our performance the light upon us does not disclose us it caresses, different gradients, different degrees of dimensionality. This distance between us allows attraction without consummation (a flirtation of sorts). Were we to dissolve this boundary there would be touching but no sensing. For we do not yet know how to look at or listen to each other attached as we are to a

centered gaze, a fixed sight. As Irigaray reminds us, we still have everything to know, like how to leave space and air around and within the other. ✿ *I look at someone who, to a certain degree, remains invisible to me. I refuse the separation between the visible of this world and the invisible of the beyond. I look at you who are invisible against a background of invisibility: a background composed of our interiorities, our becomings.* —Luce Irigaray, TO BE TWO

DISMEMBERED The body as experienced in contemporary performance is radically different from that at the center of humanist tradition upon whose proportions and perceptions the European proscenium theater was founded. The body as experienced in this contemporary past is in pieces, fragmented, prosthetically extended, divided. Its limits, interior and exterior, are ambiguous. Its power lies, "no longer in the model of unity but in the intimation of the fragmentary, the morselated, the broken" [Anthony Vidler, THE ARCHITECTURAL UNCANNY.] The body in this sense is no longer centered and binding. The dismembering of the classical body is an ongoing project. In experiencing the theater as site and de-familiarizing its conventions, performance becomes a bodily staging towards the breakdown and reinscription of spaces. ✿ **DEEP SURFACE** The power of performance is contingent upon me taking up a position in space here and you taking up a position in space over there. It is a spatial matrix of histories and bodies, of feet and surfaces. For the movement artist, the body as home creates a condition of travel as a mobile stage. We are imminently tourable. We venture into unfamiliar territories with our performance texts and make them fit, tailoring them to the conditions of each venue, to their conventions of staging, we are continually rehousing ourselves. The theater across time becomes a living archive of the body and its traces. The dead are its masters. I can smell them in the musty wings just as I can hear the voices of dissent interpenetrating their walls.

Finally she speaks:

I was swimming and I saw you, you were underneath my skin,
I was swimming and I saw you half under,
Shed skin, shed kin, shed in.
Are you reading me? Are you reading me? Are you reading?
This is the story of a dead girl, this is her autopsy.
Is she listening to me? Is she listening?

(Spoken text from **Ocean Skin**)

CHANGING ORTHOGRAPHIES I leave some gaps in my spacing, not mapping the entire trajectory of my dance so that the feel of the space will direct its orientation rather

than its rational breakdown. � We escape our limits by listing them. I make a list of my neuroses—being lost, forgetting, breathing difficulties, aphasia—fears which form the terrain which borders each performance. I have no sense of direction, my internal compass gives off confused readings. My journey to the Opera Romana in Iasi is confused by my attempt to follow a map which lists different street names to the ones I encounter en route. I realize that the slavicised orthography introduced as a process of Russification of the Romanian language in the 1950s is being changed back to its original Latin form. I read one city through another. The journey from the Hotel Moldova to the Romana Opera House requires a process of backtracking and renaming in this process of changing orthographies. ✱ Inside the Opera Romana with its whispers and shadows in the wings, the spatiality of my perception is altered, my dance develops new fronts. My forehead transposes to other zones of my body. I am leaking sidewise. The same music is played again and again and again. Into this repetition is an absence—no choreography, no predetermined gesture or movement—there is a not-knowing and there is an improvising. Into this accidental space, this ruptured continuity, (how many times have I performed this gesture this sequential phrasing of movements), comes something new, something different because it resists my repetition of the same. In this moment I realize I will never perform this again. Invention requires an absence. In the shifting grounds of histories, places and bodies, performance as what does not remain, becomes a living archive a troubled disappearance, an encounter which reverberates as a spectral haunting of the present, a ghost in the bones.

BODY MOVIES

BODY MOVIES is a large-scale interactive interven-tion in public space. It is the sixth in the series of "relational architecture" installations I've designed for cities in Europe and America over the past 7 years. These pieces have been exploring the inter-section between media technologies and urban environments. Pieces in the series normally involve the transformation of emblematic buildings using projections, sound, 3D sensors, networks and robotics. ❂ Relational architecture can be defined "as the technological actualization of buildings and public spaces with alien memory." My work is not an attempt to reinforce or undermine essential power narratives of a site, but rather to create situations

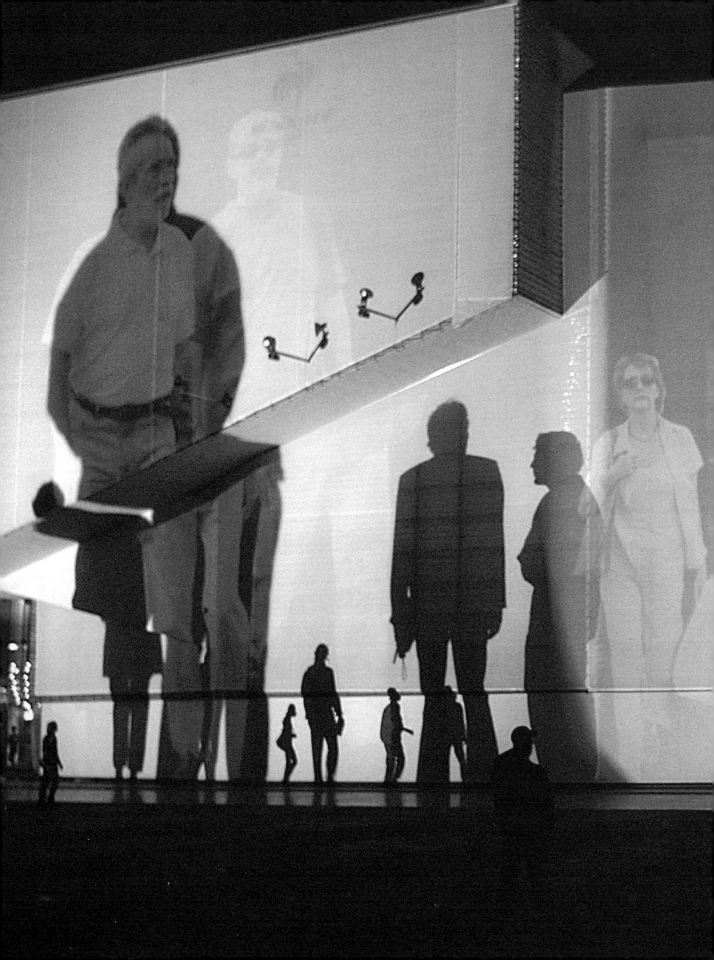

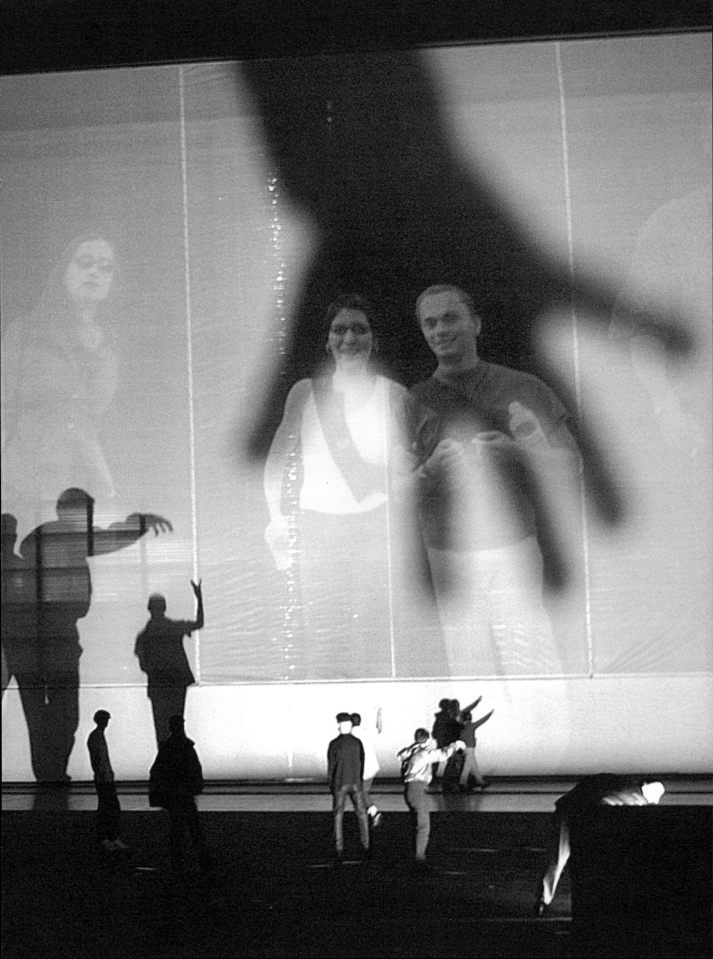

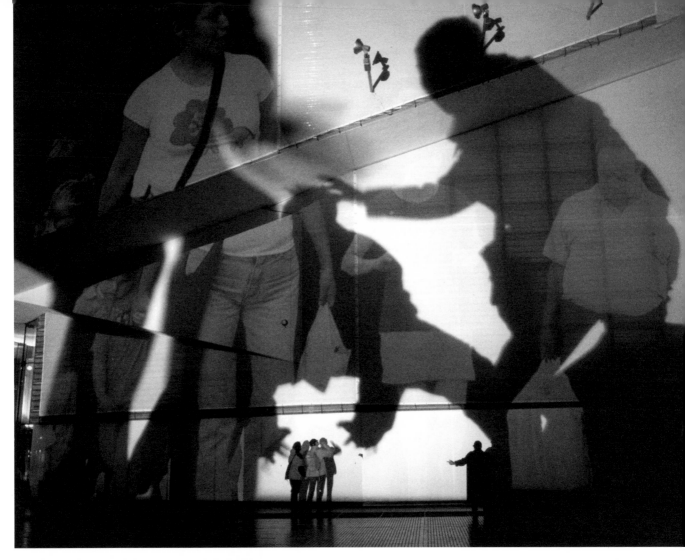

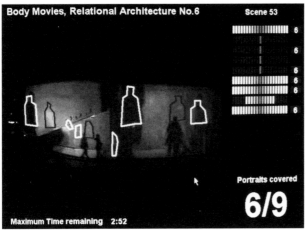

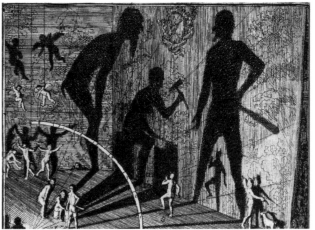

↑
Computer interface for
BODY MOVIES.

↑
"The Shadow Dance," engraving
by Samuel van Hoogstraaten,
1675.

where buildings may temporarily decline their roles in the daily urban performance of identification. I am interest-ed in connecting disparate planes of experience so that new "alien" relationships may emerge. This is why I call my work "relationship-specific" rather than "site-specific." I look for ad hoc, artificial readings of our surroundings. The pieces provide a starting point for eccentric readings without a pre- programmed outcome in terms of what people should or should not do. A relational architecture piece should be, by definition, out of the control of the author.

BODY MOVIES was commissioned by V2 for the Cultural Capital of Europe Festival in Rotterdam. From August 31 until September 23, 2001, the Schouwburgplein square in Rotterdam was transformed by the projection of huge interactive portraits on the façade of the Pathé Cinema building. Thousands of portraits taken on the streets of Rotterdam, Madrid, Mexico City, and Montreal were projected using robotically-controlled projectors located around the square. However, the portraits were only visible inside the projected shadows of local passers-by, whose silhouettes measured between 6 to 66 feet high, depending on how far people were from the powerful light sources placed on the floor of the square.

When the Schouwburgplein was empty the portraits could not be seen, since the light sources completely washed them out with strong white light. A camera-based tracking system monitored the location of the shadows in real time, and when

RAFAEL LOZANO-HEMMER

the shadows matched all the portraits in a given scene, the control computer issued an automatic command to change the scene to the next set of portraits. In this way the people on the square were invited to embody different representational narratives as well as create their own shadow play. Up to 60 people took part at any given time, controlling 11,000 sq. ft. of projections and creating a collective experience that nonetheless allowed discrete individual participation. BODY MOVIES acted as an ephemeral structure through which the participants self-organized. Rather than public space being defined strictly by architectural design or by corporate branding, BODY MOVIES situates such space and those who occupy it, in a conversational mode with the space itself.

The installation's use of shadows as an interface directly references Samuel van Hoogstraten's engraving "The Shadow Dance" which appears in his book INLEIDING TOT DE HOGESCHOOL DER SCHILDERKUNST. Produced in Rotterdam in 1675, this engraving depicts a minute source of light placed at ground level and the shadows of actors taking on demonic or angelic characteristics depending on their size. The optical devices deployed by Dutch masters of *trompe l'oeil* and anamorphosis are the starting point for a piece that investigates the crisis of urban self-representation. BODY MOVIES transformed the cinema building into a stage for reverse-puppetry, attempting to create an anti-monument of alien presence and embodied relationships.

JENNIFER GABRYS

PHOTO ASSEMBLAGES BY BRIAN ROETTINGER

MOTOR CHORUS: SPATIALIZING AN AUTOMOTIVE CITY

We are in an epoch of simultaneity: we are in the
epoch of juxtaposition, the epoch of the near and
far, of the side-by-side, of the dispersed.
 —Michel Foucault, OF OTHER SPACES

Space and art can be rescued from further
mystification only by being grasped as socially
produced categories in the first instance, as
arenas where social relations are reproduced, and
as themselves social relations.
 —Rosalyn Deutsche, UNEVEN DEVELOPMENT

1.

SPATIAL OPERATIONS: DISCOVERING MOVEMENT Space, as many theorists
have convincingly argued, is a medium that is constructed through practice.
Writing of "Walking in the City" in THE PRACTICE OF EVERYDAY LIFE, Michel De
Certeau indicates how the individual act of walking is an operation that constructs
and constitutes the city. A city like Los Angeles forces the translation from
pedestrian to automotive mobility. Driving reveals a peculiar course of spatiality, a discovery
of movement that is a likely dominant practice of urban space today. Los Angeles, a city where
mobility is executed almost exclusively through driving, can be elucidated through an automotive
reading of De Certeau. The motivations behind automotive operations, contained both in the
various architectures of longing (fragments, labyrinths, exits), and the micro-architectures
of control (the car itself), indicate how driving persists in making space. The implications of
such longing suggest counterpractices or counter-organizations that can bring attention to the
construction and potential transformations of space through driving.

De Certeau suggests that as ordinary practitioners walk in the city their bodies write an
urban text. This forms an understanding of the city that is based not on formal exposition, but
rather on practices and operations which refer to "'another spatiality,' and to an opaque and
blind mobility characteristic of the bustling city."[1] Space is constructed through movement that
is nearly occlusive in its embodied distraction. De Certeau's focus on pedestrian operations
could equally describe how automotive operations constitute a city. Perhaps a more prosaic but
accurate exegesis of individual mobility, driving exhibits the De Certeauian interface of individual
practice in an urban system.

By establishing walking as an act that makes up the city, De Certeau points to everyday
movement, or the act of passing by, as a gesture that is not localized, but rather spatializes.
Walking through the city is a way of being in the world that articulates points and places in a
spatial network. Drawing on a linguistic analogy, De Certeau goes so far as to state that "the
act of walking is to the urban system what the speech act is to language or the statements
uttered."[2] Walking is a "space of enunciation," which teases out, appropriates, and mouths urban
topographies. Two different viewpoints arise from the speech/pedestrian act: the "forms used
in a system and the way of using this system."[3] Arguably, De Certeau asserts that the formal
system is irrelevant unless the enunciative operation occurs.

The allure of body articulating space acquires a metallic prosthetic where such enunciation
is understood through the car. Appropriating urban topographies and spatially acting-out a
place occurs not with the discriminating footsteps of a flâneur, but rather with the weight of steel
and rubber on concrete. This more burly articulation is an articulation, nonetheless, that has

1
Michel De Certeau, "Walking in the
City," in THE PRACTICE OF EVERY-
DAY LIFE (Berkeley: University of
California Press, 1984), p. 93.

2
Ibid., p. 97.

3
Ibid., p. 98.

4
K.T. Berger, WHERE THE ROAD
AND THE SKY COLLIDE: AMERICA
THROUGH THE EYES OF ITS DRIVERS
(New York: H. Holt, 1993), p. 57.

5
Reyner Banham, LOS ANGELES:
THE ARCHITECTURE OF FOUR ECOLO-
GIES (New York: Harper & Row
Publishers, 1971), p. 23.

6
Mick McConnell, LAX: THE LOS
ANGELES EXPERIMENT (New York:
SITE/Lumen Books, 1994), p. 25.

7
K.T. Berger, WHERE THE ROAD AND
THE SKY COLLIDE, p. 17.

8
Douglas R. Suisman, LOS ANGELES
BOULEVARD: EIGHT X-RAYS OF THE
BODY PUBLIC (Los Angeles: Los
Angeles Forum for Architecture and
Urban Design, 1989), p. 48.

9
Ibid., p. 45.

the spatial consequence of structuring the city through use. Los Angeles, a city whose physical fabric is purported to be 2/3 concrete, demonstrates to what extent practice can define space.[4] L.A.'s definitively bounded ground plane gives way to boundless trajectories. From gas pump to parking meter and garage, or to desert and back, the automotive navigation of L.A. writes and speaks the operational urban text. Twenty minutes on the interstate, from supermarket to mall, is a negotiation of the organized possibilities of an automotive spatial order. Like De Certeau's walker, spatial possibilities can be realized, invented and avoided by the individual motorist. In movement and access the car can apparently afford more freedom than walking. It becomes the penultimate expression of individualism, where the micro-architecture of the automobile, the range, speed and destinations are determined (within the spatial order) by the individual driver. In cities like L.A., the structured freedom of the car even goes so far as to compromise the freedom offered by other forms of mobility.

L.A.'s *genius loci* is its *genius operandi*. Reyner Banham heralds the automotive force of the city, stating that "one can most properly begin by learning the local language; and the language of design, architecture and urbanism in Los Angeles is the language of movement. Mobility outweighs monumentality...and the city will never be fully understood by those who cannot move fluently through its diffuse urban texture, cannot go with the flow of its unprecedented life."[5] Banham learns to drive in order to understand L.A. In the process, he comes to understand that the car is the form of transportation, and by extension an icon of the way of life in L.A.

All of this suggests that the car is more than just a means of travel. Architect Laurie Hawkinson notes that the car can scarcely be separated from the city, as the body can scarcely be separated from the car. This "situation of prosthesis" generates conditions where "the car is also a very large purse, an extended living room, a mobile phone booth, a protective armor, a fishbowl, a lens to the city, an office, a speed machine, an alter ego, a mode of transportation."[6] A mobile urban site, the "car/body/space" constitutes an interface of speed, scale, and type. The car even becomes a second skin, as "in their psyches, most Americans are part-human, part-machine." William Gibson, commenting on this fusion of flesh and machine, suggests that the car ultimately affected his perception of reality more than the computer.[7]

While drivers may delight in the apparent freedom and mobility offered by mechanicaly navigating the city, this same condition structures and restricts spatial experience. The physical sensation of driving, when gone awry, can be responsible for "road Rambos," those drivers who reach the limits of frustration and burst their discrete automotive shells. To diffuse transit chaos, a traffic infrastructure attempts to map the way toward fluid, yielding space. Painted lanes on asphalt, traffic surveillance cameras, and traffic lights: an entire discipline of traffic engineering delights in the orderly channeling of the automobile. Freeways serve this purpose, facilitating flows of traffic in the "new and liquid language of the automobile." Douglas Suisman charts the shift from mass transit to automobile in L.A., noting that "the power of the combustion engine and the agility of rubber tires meant that steep grades, quick stops and starts, short turning radii, and all of the other limitations in rail transport were almost magically swept away, leaving in front of the engineer's dazzled eyes a vision not of great bridges but of great rivers, flowing swift and smooth and unchallenged across every conceivable terrain."[8]

Less conducive to free flows, the boulevard was denigrated as "too narrow, erratic, and discontinuous to satisfy the traffic flow requirements of a modern city."[9] In a duplicitous gesture, the freeway presents the greatest freedom of movement, yet also exhibits the greatest control of access. Boulevards, a "sieve-order" snaking through the city, limit speed of movement, but permit different degrees and types of access.

As much as driving configures space, it configures our perception of space, with new mechanical speeds shaping perception.[10] Consciousness can be gauged in miles-per-hour, as the framed view of the windshield captures and articulates the urban spatial order, and billboards become flickering landmarks. Conditions of "vigilant attentiveness and motor readiness," as Jonathan Crary notes "were especially developed through the rise of the automobile (and the prosthetic relations it entailed), and persist, intact, though more intensified, in contemporary digital culture."[11] Within this motor readiness, perception and attention is tied to the "body, its pulsings, its temporalities, and to the intersection of that body with a world of transitions, of events and of becoming."[12]

At the same time that mobility and attentiveness are subject to codes, in the logic of De Certeau they may also be gestures of transgression. Walking (and driving) to adapts and manipulates the urban spatial system. Elaborating on this point, De Certeau says that ways of appropriating places are both manipulations of constructed order and deviations from the literal meaning of the urban system. Ultimately, "walking affirms, suspects, tries out, transgresses, respects, etc., the trajectories it speaks. All the modalities sing a part in this chorus, changing from step to step, stepping through proportions, sequences, and intensities which vary according to the time, the path taken and the walker."[13]

The space between code and deviation becomes manifest in the act of walking—and driving. As driving constructs spaces and networks of relations, so too is it a process of legend making. The folkloric status of L.A.'s freeways is sustained, among other things, by incessant radio warnings reporting accidents, chases as well as spillages of glue, nacho cheese and goats.[14] Within the act of travel are exits that open space to something different, forming gaps in the technocrat's comprehensive city—a process that is essential to the spatial relationship. De Certeau notes that "to walk is to lack a place. It is the indefinite process of being absent and in search of a proper. The moving about that the city multiplies and concentrates makes the city itself an immense social experience of lacking a place."[15] The anticipation of the other, of absence, is the driving force behind spatial operations.[16] Banham also attempts to characterize this drive as an inherent trait of Angelenos, identifying room to maneuver—mobility as well as the sustained "frenzy of internal motion" in a landscape of ephemeral structures—as part of the equation in the movement toward absence.[17] The lust for mobility begins to explain the appeal and primacy of the car in constructing space through practice.

2. SPATIAL LONGINGS: PERSISTING MOVEMENT
Just as De Certeau sees the spatial longing "to be other and to move toward the other," as constituting the basic element of spatial practice that permeates private and public spaces and disrupts the rules of the city,[18] so too does Bernard Tschumi consider the longing to be other as an essential spatial operation. What he terms the "streetcar named desire" is exactly that momentum toward absence. Space is marked by the perpetual plunge, an operation of extension where the body's actions demarcate the paths of its practice.

Writing in ARCHITECTURE AND DISJUNCTION, Tschumi evokes the image of the labyrinth to capture a notion of space where "all sensations, all feelings are enhanced, but where no overview is present to provide a clue about how to get out."[19] The embodied, on-the-ground perspective of the motorist, who experiences space through everyday practice, constitutes the Labyrinth. This space is an assemblage of (architectural) fragments, "splits [that] have no existence other than being the passage from one fragment to another. They are relays rather than signs. They are traces. They are in-between." The movement between fragments is most

10

Jonathan Crary, SUSPENSIONS OF PERCEPTION: ATTENTION, SPECTACLE AND MODERN CULTURE (Cambridge: The MIT Press, 1999), p. 306.

11

Ibid., p. 309.

12

Ibid., p. 289.

13

Michel de Certeau, "Walking in the City," p. 99.

14

William Alexander McClung, LANDSCAPES OF DESIRE: ANGLO MYTHOLOGIES OF LOS ANGELES (Berkeley: University of California Press, 2000), p. 195.

15

Michel de Certeau, "Walking in the City," p. 103

16

Ibid., p. 110.

17

Ibid., p. 242-243.

18

Ibid., p. 110.

19

Bernard Tschumi, ARCHITECTURE AND DISJUNCTION (Cambridge: The MIT Press, 1994), p. 42.

fundamental, as this movement is "neither a part of language nor of structure...it is nothing but a constant and mobile relationship inside language itself."[20] Tschumi's use of a "streetcar named desire" demonstrates the essential oscillation that simulates "the movement toward something constantly missing, toward absence," where each fragment dissolves upon approach. Architecture is ultimately not a fulfillment of utilitarian function, but an instrument that "sets in motion the operations of seduction and the unconscious."[21] This architecture becomes less a condition of form and mass, and more a condition of operation: of provoking practice.

Spatial vehicles that move between fragments and tracings describe spaces that could be termed *heterotopic*: those sites that mirror, reflect, contest, and invert all other real sites and traditional time found in culture.[22] Foucault approached exactly this understanding of space through movement with the quintessential heterotopic space of the ship. He says,

> the boat is a floating piece of space, a place without a place, that exists by itself, that is closed in on itself and at the same time is given over to the infinity of the sea and that, from port to port, from tack to tack, from brothel to brothel, it goes as far as the colonies in search of the most precious treasures they conceal in their gardens, you will understand why the boat has not only been for our civilization, from the sixteenth century until the present, the great instrument of economic development...but has been simultaneously the greatest reserve of the imagination. The ship is the heterotopia par excellence. In civilizations without boats, dreams dry up, espionage takes the place of adventure, and the police take the place of the pirates.[23]

The implications for understanding the car as exactly that ship-like heterotopic space are manifold. The car is positioned today not only as a vehicle of economic development, but also as the generator of escapist narratives in the form of advertising, road movies and songs. Like Tschumi's "streetcar name desire," the car/ship/vehicle facilitates and embodies pursuits that constantly fabricate and construct space through this headlong careening.

At the same time that vehicles promise possession of the other, the fragments that compose

20
Ibid., p. 95.

21
Ibid., p. 96.

22
Ibid., p. 24.

23
Michel Foucault, "Of Other Spaces," in DIACRITICS 16:1, p. 27.

our understanding of the labyrinth compel mobility that is charged with the desire for exit. While we make sense of space through movement, we have a paradoxical desire for the cool remove that allows contemplation of complete, abstract space. A steady oscillation occurs between experience—the practice of everyday life—and the desire for exit, to view the labyrinth from the tower of reason. The car is a mobile unit that at once navigates the labyrinth, yet allows a certain exit through relatively constant mobility and a controlled interior environment. Positioned as a modified tower, the car practices space through a conflation of its own hermetic privacy with the public freeway. Collective experience is then formed through the shared desire for mobility and escape, and as one motorist would have it, this is a "mobile way of plugging into the world."[24]

In L.A., collective automotive space is both recorded and broadcast from highway patrol helicopters, which inform drivers of road conditions, hazards, and perils. Banham remarks that a "variety of commanding authorities—moral, governmental, commercial and mechanical...direct the freeway driver through a situation so closely controlled" that automatic control systems could just as well execute the practice of freeway driving.[25] Within this highly engineered system, scores of drivers cherish the illusion of roadway independence and freedom. It is exactly this illusion that binds the collective experience, and as Banham suggests, the freeway makes a "single comprehensible place, a coherent state of mind, a complete way of life, the fourth ecology of the Angeleno."[26] The freeway maintains its operation allure through its total and individual space.

Describing the longing for exit as a quintessentially automotive operation, Michael Dear summarizes this aspect of Los Angeles by stating that "the American way to overcome contradictions has generally been to drive away from them."[27] Both in the desire for exit and movement between fragments, a city such as L.A. is a polyglot "experience as a passage through space, with constraints established by speed and motion, rather than the static condition of solids or buildings that define the pedestrian experience of traditional cities."[28] Mobility is an apparent escape from the weight of stasis and solid, simultaneously giving license to individual vehicles of meaning. Cars entertain this fantasy of individual mobility, hinging on control of motion and control of fate.[29] To make this point, Marc Augé cites a Renault Espace ad that proffers, "One day, the need for space makes itself felt...It comes to us without warning. And never goes away. The irresistible wish for a space of our own. A mobile space which can take us anywhere. A space where everything is to hand [sic] and nothing is lacking." Augé's "non-places" are exactly those (typically transitory) sites where place is absent from itself, a roving state of often solitary passage.[30]

Although individual attempts at coherency may be assembled through movement and speed, these same factors contribute to the fragmentation and repetition of the urban fabric. Similar to De Certeau's walker, the movement between fragments is a way to generate "local authority" of spatial experience that "floods private and public spaces, undoes their readable surfaces, and creates within the planned city a 'metaphorical' or mobile city."[31] This "wandering of the semantic" is exactly that local meaning that, through movement, cannot be captured or circumscribed. In contrast to the watchtower of reasoned, abstract space, people make sense of the labyrinth and fragments of the city by "secreting" spatial paths. Describing the structure of L.A., Richard S. Weinstein suggests that the "primary image of the city is an extended repetitive fabric, bounded by the sea or mountain edge, overlaid with a discontinuous, contrapuntal net of freeways, with periodic concentrations of high-rise development that are conceptually mapped during high speed travel."[32] L.A. is at once fragmented and discontinuous, non-hierarchical and flexible, making its automotive-dictated urban form unlike more traditional (European)

24
K.T. Berger, WHERE THE ROAD AND THE SKY COLLIDE p. 27.

25
Reyner Banham, LOS ANGELES, p. 220.

26
Ibid., p. 213.

27
Michael Dear, "In the City, Time Becomes Visible: Intentionality and Urbanism in Los Angeles, 1781-1991," in THE CITY: LOS ANGELES AND URBAN THEORY AT THE END OF THE TWENTIETH CENTURY, Allen J. Scott and Edward W. Soja, eds. (Berkeley: University of California Press,1996), p. 34.

28
Ibid., p. 35.

29
K.T. Berger. WHERE THE ROAD AND THE SKY COLLIDE, p. 15.

30
Marc Augé, NON-PLACES: INTRO-DUCTION TO AN ANTHROPOLOGY OF SUPERMODERNITY, trans. John Howe (London: Verso, 1995), p. 85.

31
Michel De Certeau, "Walking in the City," p. 110.

32
Richard S. Weinstein, "The First American City," in THE CITY, Allen J. Scott and Edward W. Soja, eds., p. 84.

33
Ibid., p. 30.

34
Ibid., p. 35.

35
Henri Lefebvre, THE PRODUC-
TION OF SPACE (Oxford: Blackwell
Publishers, 1991), p. 13.

36
Quoted in Rosalyn Deutsche,
"Uneven Development: Public Art in
New York City," in EVICTIONS: ART
AND SPATIAL POLITICS (Cambridge:
The MIT Press, 1996), p. 78.

37
Bernard Tschumi, ARCHITECTURE
AND DISJUNCTION, p. 91.

38
Ibid., p. 92.

39
Simon Sadler, THE SITUATIONIST
OF THE CITY (Cambridge: The MIT
Press, 1998), p. 54.

40
Henri Lefebvre, THE PRODUCTION OF
SPACE, p. 177.

41
Ibid., p. 177.

42
Rosalyn Deutsche, "Uneven
Development: Public Art in New
York City," p. 106.

cities. Indeed, "the spatial porosity of the system, its void/positive character, together with the blockages represented by parking structures and the emptiness of parking lots, effectively preclude the hierarchical, linear, narrative ordering of traditional urban space."[33] The ordering of the city occurs through the automotive instrument. Decidedly, for any sense to be made of the urban fragment, automotive mobility is a near imperative.

These leftover spaces are one in the same as Tschumi's architectural fragments, which promote movement, and contribute to possibilities for meaning. The same physical expanse that makes the city unreadable and perhaps unbearable from the pedestrian scale promotes its flexibility at another. Material structures bear the mark of collective tracings and spatial paths. Forms and spaces are a response and result of automotive positioning. The flexibility of vacant lots, parking lots and freeway residues is a self-perpetuating structure, at once allowing for flux and impermanence, but reinforcing the repetitive and temporary pattern of L.A.[34]

Material urban space exists as the result of and the reinforcement/embodiment of driving practices. As the discussion of De Certeau has revealed, our practices reinforce and interpret this spatial material reality. A reading of Lefebvre might indicate that we produce and are produced by driving. Energy inscribes space, traveling in every direction, and space is a product of energy. In this way, "energy cannot therefore be compared to a content filling an empty container."[35] Attention to driving as a practice constituting space, motivated by longing, can ultimately suggest a spatial praxis, defined by Edward Soja, as "the active and informed attempt by spatially conscious social actors to reconstitute the embracing spatiality of social life."[36] The awareness and transformation of driving can occur from such a perspective, and lead one to consider how the automotive imperative can breed vicissitudes, counter-practices, and counter-organizations.

3. SPATIAL EVENTS: PERFORMING MOVEMENT In prompting driving, as architecture, to a condition of counterpractice, Tschumi would likely have suggested that the pleasure of such a condition arises from spatial conflict. Pleasure, excess, and desire, constituting the erotic order of Tschumi's architectural typology, lead him to suggest that "the ultimate pleasure of architecture lies in the most forbidden parts of the architectural act; where limits are perverted and prohibitions are transgressed."[37] His charge, in preserving architecture's erotic capacity, is to disrupt the form that most conservative societies expect: not through destruction, but through exceeding and frustrating the pragmatic.[38]

Similar to Tschumi and Lefebvre, the Situationists have held that for "a social transformation, to be truly revolutionary in character, [it] must manifest a creative capacity in its effects on daily life, on language and on space."[39] The transformation of space and spatial practices can be seen as occurring not through adopting yet another urban design model, but rather through an expenditure of excessive energy. Lefebvre asserts that "it is the nature of energy that it be expended—and expended productively, even when the 'production' involved is merely that of play or gratuitous violence."[40] In the release of energy, space is modified and new space is generated. Waste of energy as well as "play, struggle, art, festival—in short, Eros—are themselves a necessity."[41]

Within this philosophy of excess, a social/spatial agenda arises that is perhaps best articulated by Rosalyn Deutsche in her discussion of public art and the city. She argues that public art "appropriates the space of the city—reclaiming space for social needs against space organized for profit and control—and diverting it, in a manner similar to what the Situationists call détournement, from its prescribed functions."[42] Function, as beauty, relegates

the meaning and form of space to a univocal position, thereby creating manageable, orderly, and dominated space.

As Deutsche indicates, the Situationists articulated an agenda or theory of moments that embraces and creates urban situations. The Situationist agenda warned that "the primitive conception of current urbanism as the organization of buildings and spaces according to aesthetic and utilitarian principles will of necessity be superseded by a conception of the habitat as the decor for life as a whole, as a collective creation at the level of an authentic art, a complex art of extremely varied means."[43] In the Situationist conception of urbanism as art, all space becomes performance; and all people become performers, challenging the condition of the spectacle.[44]

Moving past functionalism to "an enthralling functional environment," the Situationists saw themselves as architects of the moment, promising that "their architecture would one day revolutionize everyday life and release the ordinary citizen into a world of experiment, anarchy, and play."[45] The Situationist opposition to a rationalist discourse on the city raises questions for a Situationist position on traffic: How would the auto and its potential for events be constructed to provide such a performative urban space? And in the course of these operations, does the apparent necessity and functional utility of the automobile dismantle itself, much like the clogged freeways annihilate their function of speed?

The Situationists do offer certain manifestoes on traffic in the city, yet their proposals remain largely encumbered by notions of the traditional city. Such proposals include schemes for "Dérive by the mile," where a large fleet of moderately priced taxis would replace private vehicles (thereby offering a cure for parking problems in Paris). They argue that "only taxis allow true freedom of movement. By traveling varying distances in a set time, they contribute to automatic disorientation. Since taxis are interchangeable, no connection is established with the 'traveler' and they can be left anywhere and taken at random. A trip with no destination, diverted arbitrarily en route, is only possible with a taxi's essentially random itinerary."[46]

Obviously uncomfortable with the excesses of the automobile, Guy Debord of the Situationists considered it a mistake for urbanites to rely on the private automobile as a means of transportation. An efficacious tool of capitalism and social destruction, the car was an item of abjection. Yet it remained in that realm of détournement—an ideal condition where people could control the city to such a degree that switches on street lights would allow one to turn lights on and off at night.[47]

At the same time that the Situationists critique the auto, they identify the extreme concentration of autos in the city as undermining their efficient transportation role, and propose that travel as pleasure usurp the concept of travel as work. Replacing the auto for practical movement in Debord's mind were certain models of U.S. Army, one-person helicopters, which would spread to the general public.[48] Ironically enough, Banham reports that exactly these types of legitimate proposals have been forwarded within the city of L.A.[49]

From taxis, helicopters, jitneys, and vans, the possibilities of the automotive

43
Libero Adreotti and Xavier Costa, eds., THEORY OF THE DÉRIVE AND OTHER SITUATIONIST WRITINGS ON THE CITY (Barcelona: MACBA / ACTAR, 1996), p. 90.

44
Simon Sadler, THE SITUATIONIST CITY, p. 105.

45
Ibid., p. 69.

46
Ibid., p. 47.

47
Ibid., p. 110.

48
Ibid., p. 81.

49
Reyner Banham, LOS ANGELES, p. 91.

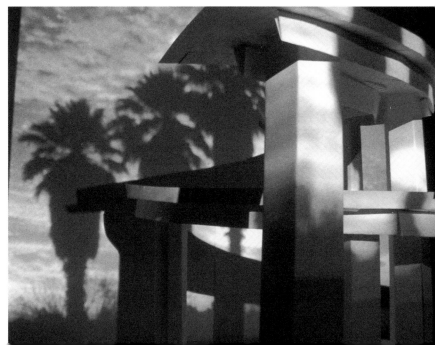

50
Michel De Certeau, "Walking in the City," p. 99.

51
Henri Lefebvre, THE PRODUCTION OF SPACE, p. 172.

52
Jonathan Crary, SUSPENSIONS OF PERCEPTION, p. 304.

53
Reyner Banham, LOS ANGELES, p. 215.

54
Henri Lefebvre, THE PRODUCTION OF SPACE, p. 191.

55
William Alexander McClung, LANDSCAPES OF DESIRE, p. 190.

56
Ibid., p. 190-91.

57
Henri Lefebvre, THE PRODUCTION OF SPACE, p. 54.

moment expand through transportation types. De Certeau's perspective of walking, however, is a reminder of the body and its modalities both in experiencing and transgressing spatial trajectories.[50] As Lefebvre suggests, the position of the body in the travel operation can be considered in its expression of the "material modalities of active occupation."[51] The energy deployed in creating form—essential to the reality of space in Lefebvre's mind—can be read in space.

Yet the bodily space of driving remains peculiarly restricted, where faster mechanical speeds are reciprocally related to new forms of bodily stasis.[52] Still, Banham remarks, the "actual experience of driving on the freeways prints itself deeply on the conscious mind and unthinking reflexes. As you acquire the special skills involved, the Los Angeles freeways become a special way of being alive...the extreme concentration required in Los Angeles seems to bring on a state of heightened awareness that some locals find mystical."[53] This automotive attention might ideally be tempered by an equal awareness of the gestures, movements and traces of the automotive spatial instrument, ultimately generating a code that asks for the reinvention and appropriation of the automotive body. Lefebvre asks, "is not social space always, and simultaneously, both a field of action and a basis of action? Is it not at once actual and potential?"[54] Both material and tool, the automotive space of L.A. raises questions about the supposed utility of driving, and in its excesses and regimentation indicates how driving can begin to deconstruct itself as "utilitarian" at the same time that it becomes, paradoxically, a more pleasurable form of travel.

At various times in L.A., a nascent understanding of the possibilities for pleasurable driving has surfaced. Norman McClung cites a 1927 article in the NEW REPUBLIC entitled, "Los Angeles: The City that is Bacchanalian—in a Nice Way," where the writer gushes: "I saw huge boulevards, sixty paces wide, unfurl in smooth ribbons through the welter of sandstone and steel. Parks rolled out like green rugs... At every street intersection one roadway dipped beneath the other. The city turned rapidly into paradise–retaining its motorcars."[55] Similarly, the 1929 Olmsted plan, which positioned parkways as the center of L.A.'s transportation system, proposed "universal neighborhood access to a kind of 'automobile park,' a linear city of movement through an endless ribbon of green." In these schemes, pleasure of movement is the objective, and vaguely envisioned destinations seem less important than "the trips themselves, which have the important effect of making the city of the imagination roughly co-terminous with the city of maps and boundaries."[56]

Such a perspective allows one to go beyond transportation alternatives such as "transit-oriented villages," new brands of transit technology or toll roads, to examine the existing spatial practice of driving, its motivations, and performative possibilities. Lefebvre suggests that "a social transformation, to be truly revolutionary in character, must manifest a creative capacity in its effects on daily life, on language and on space."[57] Unintended daily performances of excess already occur on freeways and streets in L.A., where the current clogging of traffic and the endless preoccupation with the car's micro-architecture (cell phones, CD players), undo the utility of the car. In the stopped arteries of freeways or sieve-orders of boulevards, the eruption of these events from their secure chrome shells to practices of everyday excess could change the configuration of driving. Marshall McLuhan suggests that we need to find new environments to adjust and better live with our inventions. Will we soon create off-ramps for pleasure? We will undoubtedly have our traffic-light remote controls in hand when they appear.

PASCALE JEANNÉE

WOCHENKLAUSUR: ART AND SOCIOPOLITICAL INTERVENTION

The artist group WochenKlausur has been conducting social interventions since 1993. The concept of intervention, which has become an increasingly visible trend in recent years, is often used to initiate any form of change. In contrast, WochenKlausur, at the invitation of art institutions, develops and realizes proposals—small-scale but very concrete—for improving sociopolitical deficits. In the context of many twentieth-century artists who understood how to actively take part in the shaping of society, WochenKlausur sees art as an opportunity for achieving long-term improvements in human coexistence. Artists' competence in finding creative solutions, traditionally utilized in shaping materials,

can just as well be applied in all areas of society: in ecology, education, and city planning. There are problems everywhere that cannot be solved using conventional approaches and are thus suitable subjects for artistic projects.

Theoretically, there is no difference between artists who do their best to paint pictures and those who do their best to solve social problems with clearly fixed boundaries. The individually selected task, like the painter's self-defined objective, must only be precisely articulated. Interventionist art can only be effective when the problem to be solved is clearly stated.

THE GROUP It all started in the winter of 1992. For an exhibition at the Vienna Secession, WochenKlausur was invited to work on solving a localized problem. Within the normal time span of an exhibition, the group was to work in closed session to develop and realize a small but concrete measure to improve conditions for homeless people. This first project succeeded in making medical care available to this group. Since then, a mobile clinic has treated more than 700 homeless people per month free of charge.

An invitation from the Zurich Shedhalle followed, where WochenKlausur—in a new line-up— developed a pension for drug-addicted women. A year later, the group established a social center with a bocce court for the older residents of the Italian community Civitella d'Agliano. In Graz, 7 immigrants were assisted in obtaining legal residency in Austria. Interventions in Salzburg, Berlin, Venice, and Fukuoka followed. A total of 12 interventions have been successfully conducted in recent years by alternating teams that have involved a total of over 40 artists.

WochenKlausur's office is housed in a former storefront at Gumpendorferstrasse 20 in Vienna. It is responsible for conceiving and organizing new interventions, recruiting local artists from the communities where projects are to be held. Furthermore, it also serves as an information center.

WORKING PRINCIPLES The prerequisite for every intervention is the invitation of an art institution, which provides Wochen-Klausur with an infrastructural framework and cultural capital. The exhibition space itself serves as a studio from which the intervention is conducted.

The name "Wochenklausur" could be translated as "weeks of closure." The German word *Klausur* is related to the English words *enclosure, seclusion,* and *cloister.* The group's projects are collective efforts that take place in the concentrated atmosphere of a closed-session working situation. A strictly limited timeframe—usually eight weeks—gives rise to an unusual concentration of the participants' energies, allowing the planned interventions to be realized very quickly.

The issue to be addressed is usually established before the project begins. Rarely have art institutions approached WochenKlausur with a specific request. It is up to the group to inform themselves about local political circumstances and propose corresponding interventions before the project's start. After extensive research, the group makes a final decision concerning what is in fact to be accomplished.

Through its work, WochenKlausur would like to show that certain human living conditions do not necessarily have to be the way they are. Many people have no lobby: of their own accord they can do little to make themselves heard or improve their situation. In industrial society, with its highly developed division of labor, it is practically unquestioned that the right specialists are assigned to solve every problem. Still, many problems cannot be so easily delegated and demand new and unorthodox approaches.

Realization of the projects thus often requires cunning, strategies, and trickery. In Ottensheim, a small town in Upper

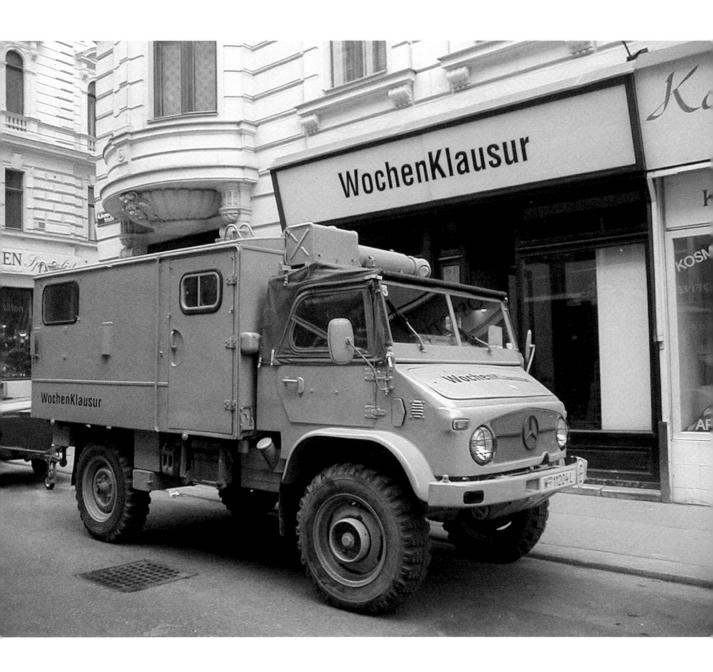

Austria, WochenKlausur developed a model for involving residents in communal political decisions. One part of the strategy for realizing this concept was the construction of a skater ramp for the local youth. The group thought that a youth sport facility would not have any opponents at all. That was true, but agreement among political parties with regard to the location of the skater ramp could not be reached. Without hesitation, WochenKlausur set up the wooden ramp in the town's historic center so as to bring about a decision. Three days later, the mayor announced its permanent location on the banks of the Danube.

Clever maneuvering was also called for in the first project, when it came to covering the running costs of paying a physician to staff the mobile clinic for the homeless. The intervention was already coming to an end, and the city councilor responsible for such expenditures had not yet approved the subsidy. The decisive turn of events came thanks to the support of a correspondent from the magazine DER SPIEGEL, who did not want to write a report but nonetheless agreed to approach the councilor as if he were researching. Believing that DER SPIEGEL would otherwise report unfavorably, the city councilor decided to cover the expenses for the doctor.

WochenKlausur works toward concrete goals. When a project has been completed, it is possible to observe how many of its objectives have been achieved. It is then the task of the critic to compare the intention with the result.

PROJECTS

INTERVENTION TO AID HOMELESS PEOPLE, VIENNA SECESSION, AUSTRIA, JUNE-AUGUST 1993

When WochenKlausur began its project at the Vienna Secession, Karlsplatz, the plaza outside its doors, was one of the places where homeless people congregated. At this time these people had practically no access to medical care. Without money or insurance vouchers, the homeless simply were not treated. Within the normal duration of an exhibition, the group succeeded in making such basic healthcare services available. To this end, a mobile clinic was designed, a healthcare "bus" that regularly stops at locations in Vienna where the homeless meet. If the patient cannot visit the doctor, then the doctor must come to the patient.

With the help of numerous sponsors, WochenKlausur obtained a bus and converted it into a traveling clinic. The relief organization, Caritas, agreed to take over operation of the medical bus as long as this created no additional personnel costs for the organization. Obtaining funding for the project proved to be difficult, particularly to cover the continuing salary costs of the physician to staff the bus. Following protracted negotiations, the responsible city councilor agreed to provide funding for a trial period of one year.

The bus quickly became an established fixture in the community, and soon there was no longer any consideration of discontinuing its operation. Since December 1993, the mobile clinic has treated more than 700 patients monthly free of charge. Foreigners who otherwise have no access to medical care are also treated—no questions asked. In 1998, after five years in service, the old bus was replaced by a new, larger vehicle. Following thorough renovation it began its second tour of duty as a mobile clinic in Sofia, Bulgaria.

INTERVENTION IN DRUG POLICY, SHEDHALLE ZÜRICH, SWITZERLAND, FEBRUARY, MARCH 1994 AND FEBRUARY 1995

In the Shedhalle Zurich, WochenKlausur turned its attention to the city's much-discussed drug situation. The team soon recognized that pseudo-ideological political positioning is responsible for much of the drug-related social trauma. The addicts' misery could be turned into a good source of political capital for the competing parties.

WochenKlausur first arranged small boat excursions on Lake Zurich. During the daily "boat colloquies," different groups of four experts on drug issues were given an opportunity to exchange information and clarify their positions. A total of 60 individuals responded to the invitation, including the chairmen of all of Switzerland's political parties, four Zurich city councilors, two senior prosecutors, the chief editors of the Swiss newspapers, experts from the fields of prevention, therapy and medically controlled narcotics distribution, and last but not least, drug users and workers from relief organizations.

A number of small advances were the result (distribution of narcotics to people who are seriously ill, the admission of social workers as legal representation in court, etc.). The contacts established through the boat colloquies helped to realize a second project: the creation of a pension where drug-addicted prostitutes could occasionally find shelter. These women are at the very bottom of the social hierarchy. They have practically no rights and are subjected to humiliation and violence by their dealers, clients, and the police. Because they work at night, they cannot make use of the city's normal shelters.

WochenKlausur rented a suitable building and organized the necessary remodeling work. Startup funding was provided by private foundations, but the opening of the pension was at first blocked by massive protests against the house by the neighborhood citizens' committee. A year later the group came together again; in four weeks the old concept was reworked and a new property was found. The city, canton and the federal governments agreed to bear 2/3 of the operational expenses, while the remaining third is covered by private donors. The new shelter, named "Zora," was opened, and since then WochenKlausur's Isabelle Schaetti has been its permanent director. The facility offers 20 women per night a place to sleep and is almost always filled to capacity.

INTERVENTION IN THE SOCIAL STATUS OF ELDERLY PEOPLE, PROGETTO CIVITELLA D'AGLIANO, ITALY, JULY-AUGUST 1994

Civitella d'Agliano is a small picturesque village 90 km from Rome. The PROGETTO CIVITELLA, created as part of an effort to revive this economically depressed region, is a summer symposium for artists from many countries. In 1994 WochenKlausur was nominated to participate in the PROGETTO. The group decided to make its contribution by improving the quality of life for Civitella's senior citizens. Because jobs can only be found in nearby Rome and Viterbo, most of the village's young people move away. Many only return to their hometown after they have retired, and thus the percentage of older residents is constantly increasing.

WochenKlausur worked to help the senior citizens' association open a new social center, something which had been promised by the community for years. Initially the group arranged for an article to appear in the local newspaper, thus informing the villagers of their plans. As a means of emphasizing the seriousness of their intentions, the team bought a bar equipped with a refrigeration unit and set it up in the abandoned construction site where the promised social center had been planned.

The traditional village festival, with pizza, beer, and dancing, presented an ideal opportunity for raising money to pay for the new equipment. A mural depicting the historic village center was painted and set up in the castle courtyard. During the festival, families, individuals, and associations could have themselves photographed in front of it; a farmer with his sheep, the priest with the alter boys, nephews, grandchildren, and sports fans. By buying these photos, the village residents were making a contribution to the opening of the center: the money WochenKlausur raised through this effort was enough to cover the costs of interior decoration and the refrigerator bar. Next to the social center was a bocce court that had gone to seed. At WochenKlausur's initiative this facility was also reactivated; a new sand surface was laid, floodlights were installed, and a water tap was provided. Before the group's departure, the village residents were already playing bocce on the new court. Since the opening of the social center, the association's membership has grown. The elderly have become active in volunteer work for the community, and in return the community has been generous in supporting the association's activities, lectures, and excursions.

INTERVENTION TO INTEGRATE REFUGEES, STEIRISCHER HERBST, GRAZ, AUSTRIA, AUGUST-OCTOBER 1995

Work and income are crucial foundations of each individual's integration into society. WochenKlausur's project in Graz concentrated on making legal employment opportunities accessible to those foreigners who can no longer return to their homeland due to political, ethnic ,or religious persecution. Foreigners need a work permit in order to obtain legal employment in Austria, and the Social Minister sets a yearly quota establishing the number of permits to be issued. At the time of the project, it was impossible to procure even a single additional work permit.

WochenKlausur made use of a special regulation for artists. According to Austrian immigration law, foreign artists are allowed to stay in the country as long as they can live from their artistic activity alone. The group simply increased the number of legally self-employed refugees to include seven foreign artists. At first, sponsors and patrons had to be found who would provide funds to commission these artists to produce artworks. Their contracts and honoraria would enable the foreign artists to prove their means of financial support and thus take advantage of the special provision for artists.

The works commissioned were conceived as SOCIAL PLASTICS: their realization involved the preparation of relief materials for each artist's homeland. For instance, the Bosnian artist, Rasema Santic, received a commission from the Graz Women's Council to produce the following SOCIAL PLASTIC: for one year she was to collect children's clothes for the refugee camp in Tuzla—the more the better. Other artists collected baby food or repaired old bicycles for the economically disadvantaged.

In order to give the SOCIAL PLASTICS more legitimacy as

art, all of the works were presented at a public exhibition. Thereafter, the items were transported to their destinations by relief organizations. The project ensured the refugees legal residency in Austria for one year.

INTERVENTION IN A SCHOOL, UNIVERSITY OF APPLIED ART, VIENNA, AUSTRIA, NOVEMBER 1995-MARCH 1996

Pupils have no lobby. They also have almost no influence on the design of the classrooms in which they spend many years of their lives. They sit on chairs that conform to official standards but are not ergonomic, and at desks that are built with frontal instruction in mind.

In close cooperation with the pupils of a Viennese secondary school, WochenKlausur redesigned two of the school's classrooms. The precisely elaborated standards contained in the booklet that normally provides guidelines for school interior designers were simply ignored. Instead the pupils were asked to make design proposals and voice their needs. Thus WochenKlausur discovered that the seating arrangement in the second-year class was inconvenient and discouraged group work. In response, the group built rounded desks in four concentric rows. The radial organization of the desks improves communication and provides a better view of the blackboard. Coat racks that had long been in the way were transferred to the corridor, and the space thus saved was turned into a cushioned sitting corner. The lighting system was also improved and adapted to the new situation.

The 17-year-olds in the seventh-year classroom had space problems as well. Eighteen almost full-grown pupils had only 23 square meters at their disposal. The use of space was optimized with a seating arrangement having two semi-circular, concentrically arranged rows. Difficulties arose around the issue of wall decoration. After a decision process lasting several weeks, everyone finally agreed on a comic book motif that was then painted on the wall.

Aside from circumventing official furnishing standards, obtaining funding for all of the alterations was the project's biggest challenge. Since the authorities are unable to make allowances for the design wishes of individual school classes—especially for those that do not fit into the narrow standards—the group was forced to rely on their own efforts and the support of sponsors.

INTERVENTION IN A DEPORTATION DETENTION FACILITY, SALZBURGER KUNSTVEREIN, AUSTRIA, AUGUST-SEPTEMBER 1996

Foreigners who have fled their native countries for political, religious or economic reasons, and have entered Austria without being granted asylum, can be held in detention for up to six months before they are deported. The Salzburg Police Detention Center is one of the largest such detention facilities in Austria. Although deportation detention—as lawmakers stress—is not penal incarceration, the conditions in these detention facilities are worse than in any prison.

Before the project's start, many inmates did not know the grounds upon which they were being detained and were inadequately informed of their rights. The food was deficient in quality and quantity. Inmates could only shower once a week and the simplest hygiene articles were unavailable. They had no possibility to wash their clothes. For up to six months, the inmates were closely confined without anything to do, without even radios or reading material. The fact that the Salzburg Police Detention Center had the highest suicide attempt rate of any detention facility in Austria spoke for itself.

In order to improve detention conditions, the group worked toward providing social services for the inmates. An external agency was created that would coordinate the work of all those involved in deportation detention. Of course the police were initially unresponsive to such an initiative. Thus WochenKlausur organized small discussion groups with recognized figures from politics, the media, the sciences, the church, the police, the Interior Ministry, and relief organizations. The meetings took place in a specially constructed cottage in Salzburg's historic center. In the course of these discussions, the detention facility's director agreed to allow that social services be provided to the detainees.

Funding for the coordinating agency was obtained from the Protestant Refugee Service. Every refugee is now assigned to a volunteer caseworker. A minimum of social, legal, and hygienic services can thus be assured. After the facility administration also agreed to the creation of dayrooms, WochenKlausur collected games, books, newspapers, fitness equipment, a table soccer unit, a television, and radios and gave them to the coordinating agency at the end of the project.

INTERVENTION IN COMMUNITY DEVELOPMENT,
FESTIVAL DER REGIONEN, OTTENSHEIM, AUSTRIA,
JULY-AUGUST 1997

Ottensheim is a town with 4,000 residents that is situated 8km north of the provincial capital Linz. In recent years an enormous increase in population has strongly altered the community. It has become a popular living place for people who are seeking to unite the peace and quiet of a small town with the advantages of a big city.

At the start of the project, WochenKlausur sent out a total of 1,500 questionnaires to all households in order to become familiar with the residents' concerns and learn about their wishes for community development. Numerous discussions took place in public houses, and WochenKlausur also recorded statements from town councilors on tape. Specific measures could later be called for on the basis of these tapes.

The group then worked out a model for resident involvement and started three interest groups: the first for revitalizing the town's historic center, a second for integrating the elderly residents, and a third representing the interests of youths between the ages of 10 and 14. The interest group for youth (IG Youth) built a skater ramp with WochenKlausur's assistance; the necessary materials were provided by local firms. Following its completion, attention was turned to the creation of a youth center for year-round activities. The IG Seniors, in cooperation with schoolchildren, collected stories from the older generation as a way of establishing regular contact. The IG Market-place made an effort to increase the town center's attractiveness, primarily by initiating a weekly market.

A total of 15 meetings were organized and moderated by WochenKlausur. This enabled suggestions, information and professional experience from the fields of architecture, spatial planning and social work to be brought into the discussion. In conclusion, WochenKlausur presented the town council with a catalog of measures that would serve as a basis for discussion of further communal political decisions. The interest groups still hold regular meetings to discuss and realize their ideas. The grassroots party "Pro-Ottensheim," which formed during the project, has become the third-largest party represented in the town council.

INTERVENTION IN LABOR MARKET POLICY,
KUNSTAMT KREUZBERG AND N.G.B.K., BERLIN, GERMANY,
MARCH-MAY 1998

Hardly any other question marks current political debate as much as that of possible ways out of the unemployment crisis. The discrepancy between the shortage of privately financed work and the increase in socially necessary activities formed the basis of WochenKlausur's work in Kreuzberg. This district has the highest unemployment figures in Berlin and the highest percentage of foreigners and welfare recipients as well. Despite numerous social and cultural initiatives, the media has labeled Kreuzberg a "social hotspot" that is turning into a slum.

In response, WochenKlausur created the "Workstation," an agency designed to oppose current developments on the labor market with an alternative in which work is seen as more than just a means of securing financial subsistence. In contrast to public counseling and placement offices, this agency would not use the existing market as a yardstick for evaluating possible occupations, but rather the ideas and potential of the individual.

The Workstation consists of two sections: an InfoTank for counseling and a ThinkTank for developing the necessary contacts and implementing new work projects. The InfoTank advises jobless people in Turkish and German and informs them about existing employment opportunities and social services. The ThinkTank supports jobless people in realizing projects that create a personalized employment plan. It checks the feasibility of each client's proposals and seeks partners for cooperation, who make their skills available to individual projects as a form of immaterial sponsoring.

The district agreed to provide office space in a highly frequented location. Furnishings and computers were made available by a service company, and an initiative named Springboard, which offers training in finding, financing, and realizing ideas, took over coordination of the Workstation. The Workstation is currently in operation thanks to donations of time, money, and equipment.

INTERVENTION FOR THE FUTURE OF WORK, EUROPEAN CULTURAL MONTH, LINZ, AUSTRIA, AUGUST-SEPTEMBER 1998

What for one person is waste, requiring proper disposal, can be the raw material of a new product for another. "Upcycling" is a term for creating new products from items that would otherwise be disposed of: bags made of truck tarpaulins, CD covers made out of old LP records, office supplies created using defective circuit boards, or Christmas tree ornaments from aluminum cans. These are only a few examples of the extensive pioneer work being done in this area. However, the production of prototypes is extremely complicated and unprofitable.

As a paradigmatic contribution to the future of work, WochenKlausur started a small enterprise that specializes in networking designers into business and creates new jobs in the upcycling branch. Numerous consultations with experts from the ecological, advertising, and technological fields indicated that Linz would be a favorable location for such an agency. In the first weeks, WochenKlausur took over the role of a startup team. On one hand, it was important to assemble a pool of designers who had experience in tilizing industrial leftovers; on the other hand, production facilities and potential customers had to be found.

A first concrete example for activity in this new economic sector was found during the group's stay in Linz. An Austrian brewery commissioned a floor made out of pressed aluminum cans for its taproom. In the spirit of WochenKlausur's concept, the client supplied the material: beer cans that were defective and could not be used for their intended purpose. The commission was implemented to everyone's satisfaction. The next order was for promotional gifts made out of discarded cellulose. At the end of WochenKlausur's project, an individual with experience in eco-business was found who was willing to take over the agency's operation.

INTERVENTION IN EDUCATIONAL OPPORTUNITIES FOR KOSOVO REFUGEES IN MACEDONIA, 48TH BIENNALE, VENICE, ITALY, JUNE-OCTOBER 1999

In view of the catastrophic effects of the war in the Balkans, WochenKlausur set itself the task of developing a network of language schools for refugees in Macedonia and Kosovo as its contribution to the "48th Venice Biennale." Although international relief organizations were satisfying the basic needs of people displaced by the war, providing this kind of educational opportunity, particularly for the youth, was an important step toward restoring normalcy and facilitating postwar reconstruction.

In cooperation with the Macedonian civil rights organization ADI (Association for Democratic Initiatives), eight suitable facilities were rented in the area surrounding Gostivar and Pristina. School furniture, electronic equipment, and teaching materials, which WochenKlausur had solicited from a wide variety of donors, were transported to Macedonia by two 18 square meter-long semi-trailers. Their load consisted of desks, chairs, storage cabinets, and blackboards as well as a copy machine, 20 computers and 2.4 tons of teaching material (dictionaries, grammar books, learning tapes and videos, CDs, etc.). The costs of transport were paid by the relief organization, Caritas. The network is managed by the Albanian coordinator Ardit Musliu, who is responsible for distributing teaching materials, administrating the budget, hiring teachers, and scheduling. In a minibus that was provided by the Austrian film production company, PPM, he regularly visits each of the learning centers, supplying them with teaching materials and facilitating cooperation. At present, instruction in English, German and Italian is being offered. The courses are taught by paid teachers who are currently unable to practice their profession due to expulsion. An English teacher from Cambridge, who learned about the project at the Biennale, has also volunteered to work in Macedonia. At the end of each course, the participants receive a completion certificate recognized by the Macedonian government. The project is able to serve approximately 1,000 refugees.

INTERVENTION IN JAPANESE SCHOOLS, MCP (MUSEUM CITY PROJECT), FUKUOKA, JAPAN, NOVEMBER 1999-JANUARY 2000

Conformism, hardening, diligence, and constant rote learning form the basis of the Japanese school system. The pupils are left hardly any time at all for the development of their individual gifts and interests. Throughout the country, the government curriculum is the same for all pupils up to the age of 18, and practically no provisions are made for field trips or other activities.

Together with three artists from Kyushu, WochenKlausur decided to found an agency to facilitate project teaching in Japanese schools. In place of regular instruction, it offers school classes an opportunity to get away from their usual textbooks and drills for a few days and learn actively through practical exercises. Precisely defined real-life tasks are accomplished by working in teams together with experts.

During WochenKlausur's stay in Japan, the first pilot projects were started in three different schools. One class cooperated in working out a page with interviews, reports, and scores for the sports section of NISHI NIPPON, the nation's largest daily newspaper. Another class supported the small shops of an economically ailing neighborhood by designing advertising strategies for them, and the third built houses out of cardboard together with an architect. Today the Agency continues to arrange projects in schools, and the MCP has taken over its patronage.

INTERVENTION TO FACILITATE CIVIC PARTICIPATION, DANUBE UNIVERSITY AND KUNSTHALLE KREMS, AUSTRIA, APRIL, MAY 2000

When the design of public space is at issue, many people are no longer in agreement with the decisions made by democratically elected officials. Criticism of spatial alterations, however, is only a symptom of the general questioning of representative democracy.

During the early part of the year 2000, a community initiative in Krems expressed the residents outrage over newly installed public benches, which the city had commissioned an artist to design. For the city's next public design project, WochenKlausur was thus commissioned to search for a solution together with the residents and thereby explore new models for democratic decision making. The next project to arise was the redesign of Krems' Pfarrplatz (parish church square). Whether an underground parking garage was to be built or a fountain erected, whether the church was to be wrapped in nylon or if nothing should be done—the populace was to decide for themselves.

In contrast to direct democracy and many traditional processes for civic participation, WochenKlausur wanted to include only those people in the planning who got involved, informed themselves, and invested their time and energy. Because all people cannot be informed about everything, they also should not be allowed to vote on everything. Interested people were given the opportunity to inform themselves at six lectures on the square's history and architectural foundations, at roundtable discussions and at expert hearings. They were to get involved by completing a questionnaire, taking part in a traffic and market study, and, most importantly, by participating in two working groups given the task of developing consensual proposals.

Following six weeks of discussion, the working groups' speakers presented their results to the community council.

Surprisingly, their suggested alterations were more of a functional than of a formal nature. They proposed, for example, that the square be used as an open-air market, the lighting improved, parking forbidden, and a passageway to the neighboring square created. The results produced by the 20 participants were not dictated from above or determined by a vote, in which majority interests ignore those of minorities. At a concluding festival in the square, the mayor promised to realize all the proposals.

INTERVENTION TO IMPROVE THE CONDUCT OF PUBLIC DEBATE, INSTITUT FUER MODERNE KUNST, LOG.IN NUREMBERG, GERMANY, AUGUST AND OCTOBER 2000

Over two months' time, WochenKlausur dealt with the topic of mediation in Greater Nuremberg, where the group decided to carry out a project relating to conflicts that would come to the public's attention. Skillfully arranged discussions were to provide help in situations where negotiations had broken down or disputes had become emotionally-charged and hardened.

Parties in conflict from a diversity of fields met in three small pavilions built out of Euro-pallets at central locations in the three cities of Nuremberg, Erlangen, and Fuerth. The duration of the meetings was limited to about two hours, and a total of 32 discussions took place. Many participants actually met personally for the first time. The meetings were always closed to the public, which nonetheless was made aware of their occurrence.

The owner of a Turkish travel agency, for example, discussed regional policies regarding foreigners and dubious statements made by Christian Social Union politicians with the chairman of the CSU youth organization. In Erlangen, members of an ultra-rightist student society spoke with young punks. Nuremberg's City Councilor for Legal Affairs met with the director of an organization that assists asylum seekers to discuss the issue of the discretionary decision margin in "deportation practice."

The series of continuing initiatives and the discussion participants thoroughly positive response led WochenKlausur to develop a framework for the continuation of the discussions on a yearly basis. Essential identifiable factors, such as the removal of the conflicting parties from their usual context, the form of the conflict space and media presence, are to be maintained. In autumn of 2001, the project was organized by the mediators who had participated in the initial discussions.

Fourteen interventions have been successfully conducted in recent years by alternating teams that have involved more than 40 artists: Anna Artaker, Monique Benz, Barbara Baier, Geraldine Blazeovsky, Carmen Brucic, Dagmar Buhr, Martina Chmelarz, Eva Dertschei, Licia Dragotto, Elisabeth Eitelberger, Sigrid Feldbacher, Rosa Gasteiger, Marion Holy, Peter Hörmanseder, Dominik Hruza, Pascale Jeannée, Christoph Kaltenbrunner, Matthias Klos, Friederike Klotz, Ulrike Kohnen-Zülzer, Andreas Leikauf, Katharina Lenz, Petra Mallek, Viken Mazakian, Manuela Mitterhuber, Felix Muhrhofer, Ulrike Müller, Susanna Niedermayr, Stefania Pitscheider, Alexander Popper, Christian Rupp, Isabelle Schaetti, Horst Scheiböck, Matthias Schellenberg, Oliver Schmid, Anne Schneider, Nina Schneider, Michaela Schweiger , Simon Selbherr, Karl Seyringer, Carola Stabauer, Paul Stefanowske, Erich Steurer, Stefan Szigetvary, Gudrun Wagner, Malte Willms, Bernhard Wolf, Andreas Zinggl, and Wolfgang Zinggl.

MICHAEL ASHER

LECTURE GRAZ 1997

*T*he following is a lecture I gave at SYMPOSIUM ON PHOTOGRAPHY VII, *"Agents and Agencies: Photography between Discourse and Document II." The symposium took place October 17-19, 1997 as part of the Steirischer Herbst. This series honored the writings and photography of Allan Sekula through presenting different methods of documentary practices.* ❋ The artwork I have been invited to present is a project I did originally for D&S AUSSTELLUNG, a group exhibition of 56 artists which took place at the Kunstverein in Hamburg from October 14 to November 26, 1989. The project consisted of eight postcards. Each postcard has a photograph of a truck printed on the front and descriptive information printed on the

Hersteller/Fabrikat: Daimler Benz
Fahrzeugtyp: 1633
Hersteller Aufbau: Langendorf
Art der Ladung: Strahlsand
von: Blohm & Voss HH
nach: Mülldeponie Schönberg/DDR
Datum: 15. 09. 1989
Ort: Zollgrenzübergang Schlutup/Lübeck

AUSSTELLUNG

© **Michael Asher** · Projekt für D & S Ausstellung

Foto: André Lützen · Hrsg. Kunst im öffentlichen Raum

back. The trucks photographed were at the same border crossing on their way from Hamburg to what was then East Germany. Each truck was hauling different types of waste products to be dumped into landfills and other disposal sites in the Eastern block. Many of these landfill sites had resulted from the extraction of natural resources which had then been exported to more powerful industrialized nations. For each load accepted, the East German government was paid an amount based on weight and toxicity.

The information block on the back of the postcards included the manufacturer of the truck, model, manufacturer of the container, contents, point of origin of the truck, its destination, and the date and the location of the photo. Some drivers felt they could not answer all of these questions and this was also recorded in the information block. It also became apparent from some drivers that documentation of the trucks might compromise them unless their license plates were cropped out of the photograph on the card. Once printed, the postcards were made available for purchase from a carousel at the front desk of the Kunstverein.

I first became aware of the D&S AUSSTELLUNG in March of 1989 when I received an invitation to participate along with a copy of the exhibition concept. The invitation was in English and read as follows:

Dear Michael Asher—
The reason for my letter is that I would like to introduce you to a project called D&S AUSSTELLUNG which is organized by the Kunstverein in Hamburg and planned for fall 1989. Its aim is to present current artistic contrasts by contemporary artists who cope with the theme of "real-art, reality's art" (Realkunst-Realitatskunst) in their works and to show art's everyday nature fictionalization and internationalization.

D&S AUSSTELLUNG works beside a central space with various places and different ways of representation. The exhibition will put in direct confrontation the European versus the American practice within this framework.

Initially I was puzzled by the passage in this letter which expressed the theme of "real-art, reality's art" (Realkunst-Realitatskunst), in juxtaposition to art's everyday fictionalization and internationalization. The exhibition concept attempted to clarify the theme in this way:

July 21, 1969 Neil Armstrong is the first man to step onto the surface of the moon. Fully conscious of the mass media, he nevertheless declaims in an apparently spontaneous way, "A small step for man and a large step for mankind." [1]
McLuhan's idea of an electronic network as the nervous system of a global village had become reality for the first

[1]
In 1989 while preparing my proposal for the Kunstverein in Hamburg, I didn't think Neil Armstrong's words were necessarily spontaneous, yet I didn't know when or how they came to be realized. While writing this paper, I found the following information regarding the lunar landing: "In 'The First Lunar Landing: 20th Anniversary' by NASA Public Affairs, a reporter asks Neil Armstrong when he began to think about what he would say as he stepped onto the moon's surface. Armstrong replied: 'Yes, I did think about it. It was not extemporaneous, neither was it planned. It evolved during the conduct of the flight and I decided what the words would be while we were on the lunar surface just prior to leaving the LM.'"
The sources I consulted indicated that Neil Armstrong's statement deviated from the quotes in the exhibition concept. According to APOLLO—A RETROSPECTIVE ANALYSIS by Roger D. Launius (published by NASA in MONOGRAPHS IN AEROSPACE HISTORY, Number 3, July 1994): "After checkout, Armstrong set foot on the surface, telling millions who saw and heard him on Earth that it was 'one small step for man—one giant leap for mankind.'"

Hersteller/Fabrikat: Daimler Benz
Fahrzeugtyp: 2429
Hersteller Aufbau: Ellermann
Art der Ladung: (Auskunft verweigert)
von: (Auskunft verweigert)
nach: Mülldeponie Schönberg/DDR
Datum: 15.09.1989
Ort: Zollgrenzübergang Schlutup/Lübeck

© Michael Asher · Projekt für D & S Ausstellung

D&S
AUSSTELLUNG

Foto: André Lützen · Hrsg. Kunst im öffentlichen Raum

time— a reality that was shown on millions of televisions and monitors through the means of an electronic beam. Yet immediately the subversive question arose: did the moon landing really take place, or was it a staged media event? Became reality a surrogate of itself?

We appear to experience reality only, via the television or movie screen. There, in the media, it acquiesces the kind of presence that it has lost in everyday life. The omnipresence of electronic images lets reality in its entirety appear as a picture; the media image pushes itself in front of reality and begins to substitute for it. This has repercussions on art, which always found itself in an imitative or representative relationship to reality, especially when it tried to undermine any such thing. The early avant-garde movements illustrate this...

Reality implies art. Art has become a repertoire of public consciousness. Its strategies make growing use of the quotation and the copy, as for example, reflections about the work of the New Fauves in the ongoing discussion about Postmodernism. All historical developments which art has run through are now available for their expressive potential. The medium is the message. The same goes for the reality separated from art, if such a thing can still be found.

In terms of "reality," was the exhibition concept implying that the media image wasn't reliable in delivering to a viewer the experience of the original event? On the other hand, how could the image be expected to stand in for an actual moment when the 2D space it will eventually occupy is necessarily illusionistic, therefore telling the viewer that the image has been abstracted from another context? Furthermore, the moon-landing paragraph as well as the following two seemed to suggest that the media image existed as a ground for infinite readings untouched by any external corroborating information and thereby furnishing such images with an unattainable meaning and an authority they might not otherwise have.

As for myself, I do not experience media-generated representations as having the "omnipresence" suggested in the exhibition concept, nor do I believe that the media is the primary clearinghouse of images. Moreover, the failure of the exhibition premise to distinguish among different types of media, which infers that they operate in similar ways, seemed to describe conditions which were not apparent in actual practice.

But for a moment let's agree that the television media has a major influence on how we understand images and that the

Hersteller/Fabrikat: MAN
Fahrzeugtyp: 26 291
Hersteller Aufbau: Ellermann
Art der Ladung: Hausmüll
von: MVA Borsigstraße HH
nach: Mülldeponie Schönberg/DDR
Datum: 15. 09. 1989
Ort: Zollgrenzübergang Schlutup/Lübeck

D&S AUSSTELLUNG

© Michael Asher · Projekt für D & S Ausstellung

Foto: André Lützen · Hrsg. Kunst im öffentlichen Raum

Hersteller/Fabrikat: Iveco-Magirus
Fahrzeugtyp: 19 033
Hersteller Aufbau: Langendorf
Art der Ladung: Schlacke
von: AVG (Hamburg)
nach: Mülldeponie Schönberg/DDR
Datum: 15. 09. 1989
Ort: Zollgrenzübergang Schlutup/Lübeck

D&S AUSSTELLUNG

© Michael Asher · Projekt für D & S Ausstellung

Foto: André Lützen · Hrsg. Kunst im öffentlichen Raum

Hersteller/Fabrikat: MAN
Fahrzeugtyp: 19 362
Hersteller Aufbau: Roland Tankbau
Art der Ladung: Hausmüll
von: (keine Angaben)
nach: Mülldeponie Schönberg/DDR
Datum: 15. 09. 1989
Ort: Zollgrenzübergang Schlutup/Lübeck

D&S AUSSTELLUNG

© Michael Asher · Projekt für D & S Ausstellung

Foto: André Lützen · Hrsg. Kunst im öffentlichen Raum

Hersteller/Fabrikat: Volvo
Fahrzeugtyp: F 12 Intercooler
Hersteller Aufbau: Roland Container Bau
Art der Ladung: (Auskunft verweigert)
von: (Auskunft verweigert)
nach: Mülldeponie Schönberg/DDR
Datum: 15. 09. 1989
Ort: Zollgrenzübergang Schlutup/Lübeck

D&S AUSSTELLUNG

© Michael Asher · Projekt für D & S Ausstellung

Foto: André Lützen · Hrsg. Kunst im öffentlichen Raum

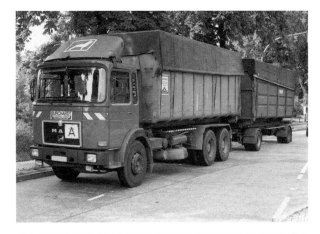

Hersteller/Fabrikat:	Iveco-Magirus
Fahrzeugtyp:	26 030 Turbo
Hersteller Aufbau:	Atlas-Weyhausen
Art der Ladung:	(Auskunft verweigert)
von:	(Auskunft verweigert)
nach:	Mülldeponie Schönberg/DDR
Datum:	15. 09. 1989
Ort:	Zollgrenzübergang Schlutup/Lübeck

D&S AUSSTELLUNG

© Michael Asher · Projekt für D & S Ausstellung

Foto: André Lützen · Hrsg. Kunst im öffentlichen Raum

Hersteller/Fabrikat:	MAN
Fahrzeugtyp:	26 281
Hersteller Aufbau:	Fahrzeugbau Tippe Krane
Art der Ladung:	Hausmüll
von:	MVA Borsigstraße HH
nach:	Mülldeponie Schönberg/DDR
Datum:	15. 09. 1989
Ort:	Zollgrenzübergang Schlutup/Lübeck

D&S AUSSTELLUNG

© Michael Asher · Projekt für D & S Ausstellung

Foto: André Lützen · Hrsg. Kunst im öffentlichen Raum

ideas and representations taken from television can be used in art production. Then I would like to know, from my perspective in the United States, why I don't see many artists who utilize this media by selecting as their source such programs as "Handy Hints," which in the early 1950s showed the viewer how to reuse tomato cans, paper towel cores, and used Kleenex boxes for pencil holders, candle molds, or hardware organizers. I find it odd that codes from this period governing fashion and design, from furniture to studio sets, are quoted regularly in contemporary art practice while 1950s models for avoiding waste are ignored.

While visiting Hamburg in the summer of 1989, I finally formulated the idea for the postcards of trucks used for the shipment of waste materials. My project was a response to the corollary I saw between the exhibition concept's reference to limitless meaning and the potential I saw for limitless waste, both being agents for the colonization of space, whether it be in the mind or in a debt-ridden country.

The postcards were also chosen as objects that could conceivably circulate as waste and perhaps even be hauled by one of the vehicles depicted on the front. Should this happen, it would suggest that different groups of objects, some highly-sought-after and others in great need of disposal, share some of the same conditions whereby the objects or materials accrue value spontaneously. Only in retrospect does it seem like the choice of a postcard, an object which is easily discarded, was perhaps an attempt to resist an expansion of value for art while noting the expansion of value for waste.

Regardless, I couldn't help but wonder if one outcome in creating a separation between the producer of waste and the recipient of waste wasn't a way of guaranteeing that a disparity in wealth would be maintained through this type of truck transport.

No one that I was communicating with at the time seemed to anticipate that on November 9, 1989, conditions would change radically: The Iron Curtain would fall, travel would no longer be restricted between East and West Germany, and unification would begin.

KEN EHRLICH

GAS STATION AS FORM, GAS STATION AS CONTENT

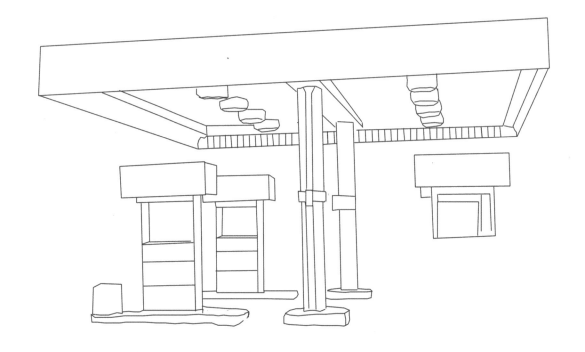

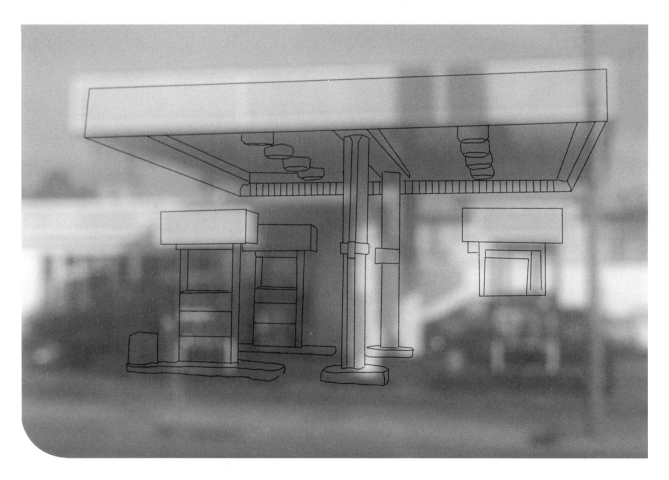

Trace: *noun*—I. archaic: a course or path one follows: road 2. a mark or line left by something that has passed; also footprint 3. a sign or evidence of some past thing; vestige 4. something traced or drawn as in the marking made by a recording instrument (as a seismograph or kymograph), or the ground plan of a military installation or position either on a map or on the ground 5. the intersection of a line or plane with a plane 6. a minute and often barely detectable amount or indication.

Trace: *verb*—I. delineate, sketch; to form (as letters or figures) carefully or painstakingly; to copy (as a drawing) by following the lines or letters as seen through a transparent superimposed sheet; to impress or imprint (as a design or pattern) with a tracer; to record a tracing in the form of a curved, wavy, or broken line; to adorn with linear ornamentation 2. archaic: to travel over; traverse 3. to follow the footprints, track, or trail of.

In the fall of 2001, I began taking snapshots of gas stations in the neighborhoods surrounding my home in Los Angeles. Initially, I thought of the process as an extension of earlier work that investigated the material forms of infrastructure. I was particularly interested in linking the architecture of information to the architecture of infrastructure. As a way to investigate cultural investments in technology, I attempted to link aspects of material culture with epistemological and philosophical questions through video and sculptural installations. I also had an almost perverse interest in the possibilities of an experience of the sublime through a poetic engagement with material forms and structures. The most seemingly banal, familiar objects seemed to carry the potential to define artistic limits and in doing so, might re-arrange those very limits. The gas station, I felt, could function as a material and rhetorical site to literally engage the politics of form.

Over time, I developed a system to create images based on these snapshots that follows the systematic, procedural nature of design that I imagined gave birth to these fuel distibution structures. After processing the film and printing the snapshots through inexpensive commercial means, I scanned all of the negatives and began tracing the outline of the gas station structure in an image manipulation software program on the computer. In this way, I made simple line drawings that consisted of a digital trace of the material site. I then printed these line drawings on clear plastic, following the dimensions of a typical architectural blueprint. Returning to the original site of each snapshot with the corresponding digital tracing, I then re-photographed the site trying to match the traced image with the originally photographed structure. By forcing this series of mediated digital images back towards a physical location, I had little hope of returning to the real. Rather, it was a way to enact a performative process of moving towards a site, towards a physical location. In this movement I sensed, to varying degrees, hope, doubt, anxiety, power, and catastrophe. There was never a sense of arrival; only the ongoing attempt to move closer and closer to the object of desire.

What is hidden in the most familiar locations? What is left behind after a fleeting glance? What remains after a barely perceptible gaze? This visual trace, or what might be thought of as a kind of fantastic psychic remainder, is the intersection of site and memory, the collision of projection and materiality. This leftover is the contested space of the possible...

Within the rarefied realm of art production and history, the notion of "site" appears as a highly charged and contested topic of debate. Canonized as a practice that originated as a way to investigate the specific contexts of art production and exhibition and one that signaled movement outside of the gallery walls, site-specificity has become a kind of catchphrase for

art production that takes into account the location of its creation and reception. Beyond the loose application of the term "site-specific," for artists working with issues of architectural or public space important questions remain about the rhetorical limits of phrases like "public and private" or "the boundaries of transgression and complacency." This sort of language has become embedded in the discourses surrounding site-specificity. The very language used in describing art practices that take cues from given contexts becomes caught up in the stategies of these modes of production. Indeed, the very definition of "site" is suspiciously flexible, subject to variable meanings. Miwon Kwon, for example, traces a movement within recent art historical discourse that works through evolving models of site-specificity. Though careful to avoid presenting the process as a linear evolution that moves towards more and more ephemeral notions of site-specificity, Kwon demonstrates the way in which "site" within artistic practice has been "transformed from a physical location—grounded, fixed, actual—to a discursive vector—ungrounded, fluid, virtual."[1] Drawing on numerous examples from recent art history and citing technological transformation on a massive scale, this quasi-historical trajectory witnesses the conception of a "site" that has evolved into entities as diverse as a "...repressed ethnic history, a political cause, a disenfranchised social group."[2] It is with this interest in discursive sites in mind that I want to bring attention to the unique forms of gas station architecture; and by extension back to materiality, to structures and to objects. Although Kwon and others have gone to great lengths to avoid dialectically opposing discursive and material sites, ultimately many discussions around "site" often ignore material questions and conditions—the very things that much so-called site-specific work seeks to address. Speaking very specifically about politics, Žižek unearths a parallel problematic tendency within Postmodernism:

> Postmodern politics definitely has the great merit that it "repoliticizes" a series of domains previously considered "apolitical" or "private;" the fact remains, however, that it does *not* in fact repoliticize capitalism, because *the very notion and form of the "political" within which it operates is grounded in the "depoliticization" of the economy.* [3]

How can I force together questions about form, the limits of an artistic mode (site-specificity), as political practice , and a consideration of a domain often considered antithetical to artistic production—namely, the economy? What might be gained from such an unlikely set of associations? I must confess an admittedly ambitious desire that in part motivates this investigation; that is, to evaluate the role of the artist as a social agent. If the notion of the artist-as-form-builder is one of the oldest, most persistent images associated with artistic production, the manner in which the contemporary artist calls attention to the context of art production and reception must be evaluated as a constantly changing movement. This intention to examine shifting modes of artistic-reflection is made more complicated as the perceptual dimensions of form building have shuttled from the territory of the hand-made into zones of mechanical and digital reproduction. To consider the site in site-specificity is, among other things, to suggest that form not be considered out of context. In re-examining the material aspects of a discursive site as artistic practice—in this case, the formal structures that store and pump gasoline—I am looking to put the materiality back into site and seeking ways to tease out the (not so) hidden political dynamics in a re-politicized economy.

Consider the contemporary urban gas station in Los Angeles. From one point of view, it could be thought of as an utterly banal structure in an already generic landscape; an uninspired

1
Miwon Kwon, "One Place after Another: Notes on Site Specificity," in SPACE, SITE, INTERVENTION: SITUATING INSTALLATION ART, Erika Suderburg, ed. (Minneapolis: University of Minnesota Press, 2000), p. 46.

2
Ibid., p. 47.

3
Slavoj Žižek, "Class Struggle or Post-Modernism? Yes, Please!," in CONTINGENCY, HEGEMONY, UNIVERSALITY, Judith Butler, Ernesto Laclau, and Slajov Žižek, eds. (London: Verso, 2000), p. 98.

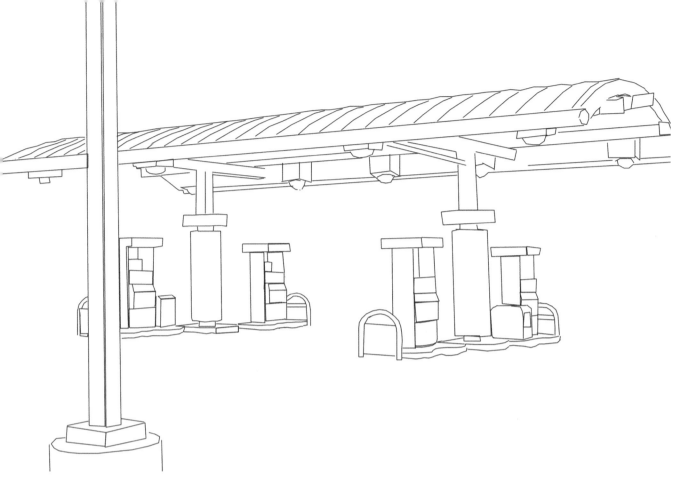

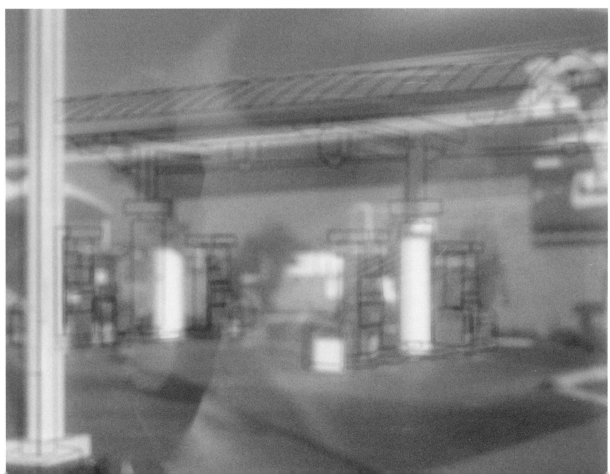

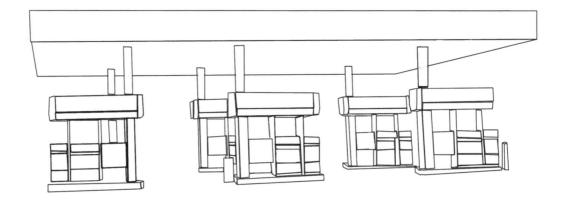

construction designed with flimsy materials in the name of efficiency. Usually built from masonry or prefabricated from plastic and metal parts delivered to a site on flatbed trucks, these structures are assembled by skilled laborers with an acute, economic precision. Invariably a symmetrical series of rectangular cubes and generally positioned on the corner of two streets, the gas station might be considered so mundane in appearance that it could easily be overlooked as a noteworthy formal structure. Indeed, the striking visual consistency among the architecture of gas stations often makes it almost impossible to distinguish one from another. And yet, these very structures might lend valuable clues to an associative investigation seeking links between political notions of place in an era of globalization and artistic notions of space in a time of hyper-commodification. As the material site where the global politics of oil reaches its ultimate consumer destination, the gas station iconically stands as a sign of corporate capital *and* freedom. If the sustaining mythic logic of capitalism finds it articulation in notions of flexibility, creativity, and movement, perhaps the automobile, the emblematic sign of *individual* movement, and its structural counterpoint, the gas station, can perform as metonymic conduits to interrogate points of convergence between the economic dimensions of artistic production and the psycho-social elements of material (political) space.

Questions of place and space are already questions of relations and context. By teasing out the generalities common among the structures that house reservoirs of fuel for an automobile dependent population, inevitably notions of universality and particularity come into conflict and the very complexity of an interlocking system of economies becomes immediately apparent. It's only by refusing the impossible dialectic of either abstraction or tangibility that any discussion of the meanings of gas station architecture might move us to look through the familiar confines of the structures that surround us. In this imaginary looking, our yearning for political agency, our desire to understand the seemingly incomprehensible dynamics of a globalized economy, and our inclination to define relationships between the act of looking and the activities taken up in public spaces become in themselves productive spaces of uncertainty. In this reflective space beyond either/or lies a potential encounter with materials, structures, and objects.

The architectural components of a gas station put forth an identity of functionality; we tend not to associate these everyday structures with great architectural significance. The basis for judging the success of such a structure may very well be the presumed functionality of the

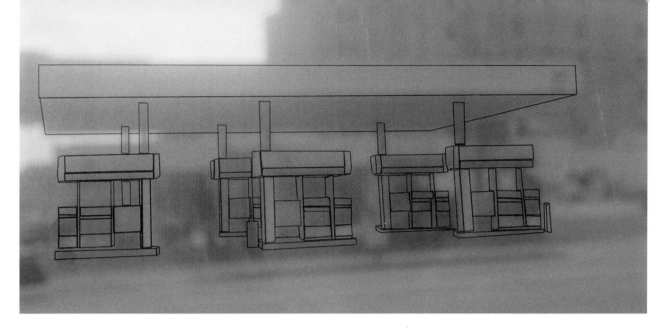

forms. If it works well, that is, efficiently, it is deemed an architectural success. Or rather, it is functionally a success by way of its continued presence in the urban landscape. But like so many structures that are ostensibly designed in the name of functionality, over time the form of the gas station has taken on aesthetic, if not iconic, qualities. Carl Petersen, who, notably, was not trained as an architect, is largely responsible for the design of America's roadside service stations. Working for Gulf Oil and Pure Oil from 1914 to the mid-1950s, he created the vernacular of efficiency associated with gas stations, and his model was widely imitated.[4] If we can trace elements of the forms of gas stations, back to this individual, we can also insist that, even historically, form never quite equaled function. In the use of objects, or buildings, types of functionalism associated with form draw on a loaded repertoire of symbols, a language that is inevitably tied to assumptions about perception. The designer who asks, "How can functionality be maximized?" is engaging in a rhetorical exercise related to efficiency. Carl Petersen, a self-styled interventionist, put forth an "architecture for the people" that, perhaps unwittingly, negotiates between models of efficiency, questions of form, and a brand of rugged individualism associated with the open roads of the American west.

Although there is a remarkable consistency among gas station forms, it is worth briefly noting the historical evolution and design variables of these structures. Although perhaps not the very first of its kind, Standard Oil of California opened a station in Seattle in 1907. By 1914, Standard Oil initiated the construction of 34 identically made stations that consisted of a small building with an attached canopy. Customers drove into the building itself to purchase fuel. By 1920, there were almost 15,000 gas stations in America.[5] The rush to construct gas stations paralleled the massive investment in the automobile as the preferred method of transportation. Oil companies rushed to build stations to meet the demand of an increasingly automobile obsessed population.

The curbside pump replaced a handful of manual filling techniques and was soon accompanied by a small shed where large storage tanks could be housed. The shed was quickly transformed into a structure that appeared much more like a home, as gas stations migrated into wealthy residential neighborhoods. The canopy, a common feature still visible on most gas stations, was developed to protect the customer from the glaring sun or inclement weather. Around 1925 gas stations began offering repair and maintenance services and the architecture responded accordingly. Most stations soon included bays to accommodate mechanical services

4
Stewart Brand, HOW BUILDINGS LEARN: WHAT HAPPENS AFTER THEY'RE BUILT (New York: Viking, 1994), p. 141.

5
John Jakle and Keith Sculle, THE GAS STATION IN AMERICA (Baltimore: The Johns Hopkins University Press, 1994), p. 132.

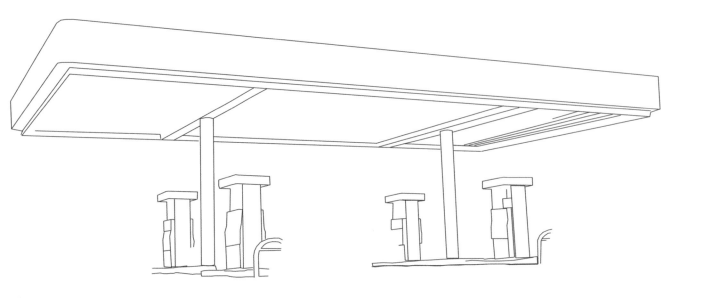

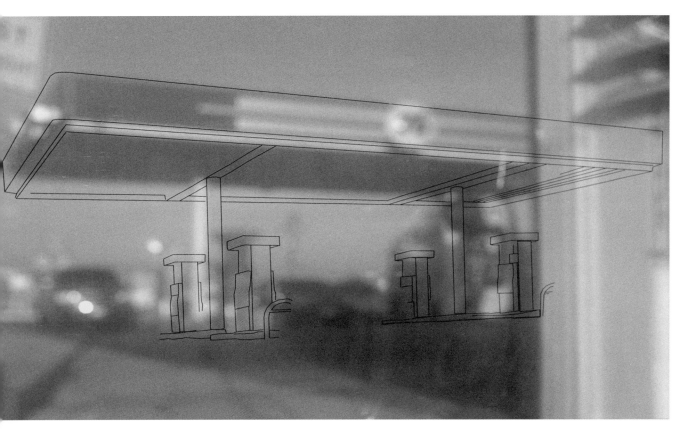

performed on vehicles.[6]

In the 1930s both the depression and modern architecture in Europe brought the introduction of an oblong box to the construction of gas stations.[7] Rather than imitating a residence, the modern looking boxes with glass facades became beacons of efficiency and modernity. The efficiency of building this simplified form was a means to decrease construction costs. The large expanse of glass covering the front of the building became an advertisement in light inviting business even late into the night.

Within the popular imagination, a consideration of the gas station in America no doubt brings forth the tropes of post war American idealism and an almost naïve faith in a brand of progress that relied on technological innovation. The American obsession with the automobile and the manner in which the car came to be understood as an extension of the driver's body and a receptacle for the housing of individual identity is bound to an imaginary moment in recent American history. Freedom, that enduring American fantasy, is, for so many, literally bound to one's ability to get in and drive away. The image of a brightly uniformed young man running out to greet an eternally happy couple smiling in the front seat of a convertible seems permanently etched into this cinematically informed collective memory. Likewise, the cliché of a lonely individual, alienated by the harsh and impersonal brutality of soulless society bent on the next best thing is typified in the dark romance of a film noir hero driving towards or away from trouble. And yet, within these diverse aspects of a larger collective memory a very particular version of history is remembered. In this rhetorical space of icons and images, the global politics of oil seems glaringly absent.

There is a certain familiarity to this potentially alarmist sort of insistence on "the other side of the story." Marxist critics and historians continue to spin their wheels decrying corporate greed, imperialist economic injustice, and a general state of amnesia when it comes to historical memory. The climactic resolution that this sort of analysis (often unconsciously), presumes will occur when "the masses" understand the depth of the conspiracy lurking just behind the social façade, is itself a cartoonish image that belongs to the realm of the imaginary. Nevertheless, there is some relationship, however difficult to identify, between our consumption of gasoline at the pump and a larger military and economic, that is to say, political reality. To trace the connections between individual movement and the larger social body does not imply an immediate and fundamental transformation of socio-economic relations. Instead, we turn to questions of form and a performative reading of political "realities" to highlight the role of the processes of perception and imagination in sites such as the realm of economics. In the way that discursive and material sites are mutually constructed, individual bodies project notions that are formed and informed by infrastructural economies.

The most familiar location for the imaginary in the space of the gas station is in the collapse between the architecture of the building and placement of advertising as architecture. Jackle and Sculle refer to this phenomenon as Place-Product-Packaging in the context of gas stations. Many gas stations lose money selling gas but function as brand markers for global oil companies and thrive as convenience stores pedaling alcohol, cigarettes, and packaged food. This standardization of consumer marketing relies on the customer's familiarity with specific signs. However accelerated this phenomenon has become in recent years, it is anything but new. Describing aspects of the iconic imagery embedded in the urban landscape of Las Vegas in 1972, Venturi, Brown, and Izenour state, "The gasoline stations parade their universality. The aim is to demonstrate their similarity to the one at home—your friendly gasoline station."[8]

We return to this question of the universal. The contemporary gas station experience is

6
Ibid., p. 142.

7
Ibid., p. 144.

8
Venturi, Brown, and Izenour, LEARNING FROM LAS VEGAS: THE FORGOTTEN SYMBOLISM OF ARCHITECTURAL FORM (Cambridge: The MIT Press, 1977), p. 35.

a complex intersection of a global marketing phenomenon and a literal conduit for individual movement. Confronted by print advertising, audio soundtracks, flashing information screens, and a digital interface that propels one into the realm of international economic markets with the slide of a credit card, the customer inevitably plugs into a network of patterns and flows both material and fantastic. We watch each other preparing ourselves for movement through the city. We imagine the visibility or invisibility of our own movements. In this looking, we reckon with the exhilarating and distressing collapse of the real and the imagined. The everyday performances that occur in a specific gas station in Los Angeles are a thread in an unfolding network of global dynamics at once similar and entirely different. "Universality is never empty; it is always colored by some particular content."

"If you take the signs away, there is no place." [9]

9
Ibid., p. 18.

Staring at familiar geometric forms and imagining the place without the signs, it is not so much that the place disappears. Rather, we come to know a place through continued reading of signs and whatever suspicions we harbor that beneath the signs, beyond the forms, there is something tangible or knowable are tempered by the rush of traffic, the maze of streets, the shadows of the surroundings...the residue of the city. The forms of gas station architecture leave behind an imprint; a reference to a past and future place. A place that exists as an image and is visible only through densely loaded layers of signs.

The meanings of gas stations are transitory. Meaning is constructed through use; by the nomadic parade of the customer's movements through the spaces of a sheltered exterior that constitutes an arena for performances of the everyday. Herein lies a catalog of past and possible recitals:

I. Appropriating the Ready-Made The performer creates a sign with the following text:

> *For a brief moment, consider the gas stations in Los Angeles as art, as found sculpture, as a collection of ready-made objects, recontextualized for your pleasure in and through the reading of this passage.*

The performer displays this sign at a familiar gas station for the duration of the performance.

2. Distance The performer memorizes the following text:

> *The City:*
> *alienation-highway sign bolted to over-pass*
> *banality-movie crew miming in blazing light*
> *melancholia-palm tree silhouette*
> *loneliness-your phone call*
> *distraction-helicopter sounds*
> *reverie-pale shoppers uttering slow-motion sounds*
> *isolation-curved sidewalk, pebble*
> *anxiety-radio dial*
> *confinement-out of focus glimpse of pure desire*
> *communion-wallet bulge in pocket*

Performer repeats this text aloud over and over in a pensive tone for the duration of the performance, at an unfamiliar gas station in the city where the performer lives.

3. Utopian Station In the spirit of an earnest sociologist, the performer conducts a scientific study recording the correlation between given customer's grade of gasoline purchased and year, make, and model of said customers vehicle. This performance must take place at diverse locations across the city and subscribe to characteristics of the scientific method. The performer writes up the results of this survey and attempts to publish them in any scholarly journal.

Possible hypotheses include:

a) The Gas Station as an emblem of a society where all individuals exist with equal footing

b) The gas station as a utopian reserve—serving the rich and the poor alike

c) 87—the poor, 89—the middle class, 91—the rich

4. Structural Operations Performer contacts architecture, engineering, and construction offices and performs audio interviews regarding the specifics of gas station construction. Investigates building materials, assembly, design schemes, use patterns, customer flows, gas pump technology, etc. Performer records all interviews and edits the audio into a suitable format for a public presentation.

5. Fantasy is a Technology The performer researches oil flows and attempts to locate routes the oil has taken in its production and distribution before reaching a particular station. This information is transposed to a color-coded flow chart, which is then put on display in the space dedicated to print advertising on the gas pump. This flow chart may also include maps and information regarding economic exchange.

6. Unity In an effort to identify with those who cling to holistic notions of subjectivity, the performer creates a bumper sticker that reads: *Banality does not stand in the way of self-realization!* This bumper sticker may be distributed through sales or by random application to vehicles stopped temporarily in gas stations.

7. War The performer researches trade restrictions and tax benefits available to American oil companies who trade internationally. See, in particular, NATIONAL PETROLEUM NEWS, the petroleum industry's leading trade journal. When well-versed in the rhetoric of the international oil trade, the performer writes an editorial for a newspaper incorporating the term "unfettered global markets" into the text.

8. Protest Either using a bullhorn or screaming at the top of his or her lungs, the performer repeats the following quote over and over until hoarse:

> *'Protest art' is not artistically radical (it is oblivious to the philosophical self-reflective historical relationship between the artist and the concept of art in this society) but is more likely an ad hoc expressionistic ad media appeal to liberalism.*
>
> — Joseph Kosuth[10]

9. A Roof of One's Own The performer creates a series of stencils and, using spray paint, applies the following text to the ceiling of the canopy that covers the gas pumps at a local gas station:

> *A solid roof over one's head is one of the prime requirements of a civilized existence, but permanent roofs are heavy and the problem of supporting them is really as*

10
Joseph Kosuth, ART AFTER PHILOSOPHY AND AFTER: COLLECTED WRITINGS, 1966-1990 (Cambridge: The MIT Press, 1991), p. 122.

old as civilization itself. When one looks at a famous and beautiful building—or indeed at any building—it is illuminating to bear in mind that the way in which the architect has chosen to solve his roofing problem has affected not only the appearance of the roof itself, but also the design of the walls and windows and indeed the whole character of the building.[11]

[11]
J.E. Gordon, STRUCTURES OR WHY THINGS DON'T FALL DOWN (New York: Da Capo Press, 1978), p. 211.

10. History's Site Using Ed Ruscha's TWENTY SIX GASOLINE STATIONS as a template, the performer investigates the site of each photograph included in that publication. Attempting to find the vantage point from which the original photograph was taken, the performer re-photographs the location, as it exists at the time of the performance.

11. Confessions The performer acquires a video camera and hires a cinematographer. The performer then conducts interviews with randomly selected people at an unfamiliar gas station and asks what associations come to mind from the following phrase: *The political economy of oil consumption as a discursive site.* If the opportunity arises to interview people sitting in their cars, the performer takes advantage of that opportunity. The video is edited in a straightforward documentary style.

12. Between Limits and Possibilities The performer makes an audio recording of the following text:

> *The gas station is a daily reminder of the ongoing existence of war; the pitched battle for the maintenance of our nation's global economic position vis-à-vis the politics of oil and the often desperate interiorized battle waged in response to the ongoing failure to live up to one's self-image.*

The recording is done in keeping with standard radio format presentation. The performer then locates a gas station in the city that pipes in music for the customer to listen to while pumping gas. The performer attempts to insert the audio recording into the filling station's regular soundtrack repertoire either through legitimate channels or by guerilla tactics.

13. Coda The performer improvises at will for the duration of the performance at a gas station either familiar or unfamiliar.

I would like to thank Brandon Lattu for his help in making the photographs seen and described here.

JANE RENDELL

AN ATLAS OF THE WELSH DRESSER

We all like to talk about ourselves and in the right setting we tell stories about our past. In deciding to write about a Welsh dresser inherited by my mother, I found myself remembering events from my childhood. What fascinated me was the way in which certain details altered each time I remembered them, while others somehow became fixed. Mieke Bal has pointed out that the story a person remembers is not identical to the one that happened, but that it is the "discrepancy" itself that becomes the dramatic act. *"Memory" is an act of "vision" of the past, but as an act it is situated in the memory's present. It is often a narrative act: loose elements come together and cohere into a story so that they can be remembered and eventually told.*[1] ❁ And for bell hooks, it is the lack of distinction between "fact and interpretation of fact" in our remembering of the past that has influenced her own thinking about autobiography: *Experimental memoirs have become the cultural sites for more imaginative accountings of an*

individual's life. [...] Audre Lourde—introduced to readers the concept of biomyth-ography to encourage a move away from the notion of autobiography as an exact accounting of life. Encouraging readers to see dreams and fantasies as part of the material we use to invent the self.[2] � Having read this piece, I misremembered Lourde's term "biomythography" as "biomorphology," or in my mind, "the shape a life takes," reflecting my interest in autobiography as a kind of spatial writing or even travelogue. Travel stories and autobiographies describe where we have come from, where we are going and what it is like along the way. � I am interested in a new way of working with the layout of the text on the page and my place within it. The way a writer positions herself in her writing is architectural and has implications for the way in which the writer meets the reader. Certain forms of writing make walls, others create meeting points; some stories close down possibilities for discussion, while others invite participation. Italo Calvino has explicitly explored the relationship the writer has to his/her writing in terms of position—where a writer stands—inside and/or outside a text. *Maybe the critical analysis I am looking for is one that does not aim directly at the "out-of-doors" but, by exploring the "indoors" of the text and going deeper and deeper in its centripetal movement, succeeds in opening up some unexpected glimpses of that "out-of-doors"—a result that depends less on the method itself than on the way one uses the method.*[3] � In another essay, Calvino discusses the places writers occupy in relation to their writing in terms of their different identities as subjects or "I"s: *And in these operations the person "I," whether explicit or implicit, splits into a number of different figures: into an "I" who is writing and an "I" who is written, into an empirical "I" who looks over the shoulder of the "I" who is writing and into a mythical "I" who serves as a model for the "I" who is written. The "I" of the author is dissolved in the writing. The so-called personality of the writer exists within the very act of writing: it is the product and the instrument of the writing process.*[4] � Each of the stories I tell are only possible because of the spaces they take place in. Certain forms of architecture offer possibilities for certain kinds of encounter to occur. Writing about what has occurred is not only the tracing of a story, but the creation

1
Mieke Bal, LOOKING IN: THE ART OF VIEWING (Amsterdam; G and B Arts International, 2001), pp. 47-48.

2
bell hooks, WOUNDS OF PASSION: A WRITING LIFE (London: The Women's Press, 1998), p. xix.

3
Italo Calvino, THE LITERATURE MACHINE (London: Vintage, 1997), p. 58.

4
Italo Calvino, "Cybernetics and Ghosts" in THE LITERATURE MACHINE (London: Vintage, 1997), p. 15.

of a new place in its own right. *Writing has nothing to do with signifying. It has to do with surveying, mapping, even realms that are yet to come.*[5] ❀ I am interested in writing that is architectural in form as well as in content, for example, writing as a bridge rather than writing about a bridge. In a collection of critical essays, A.S. Byatt examines her fascination with "topological fictions," fictions where the term topological means "both mathematical game-playing, and narratives constructed with spatial rather with temporal images."[6] Byatt names certain works by Primo Levi, Italo Calvino, and Georges Perec as the most interesting examples of this kind of writing.[7] For me, these authors have different ways of making topological fictions, or, spatial writing. While Calvino often uses combination and permutation as strategies for constructing the shape of stories, Levi might draw on an existing empirical structure as the meta-narrative and Perec's observations and descriptions of spaces produce a fictional place. ❀ I have always considered autobiographical writing to be confessional, part of a process of revelation, one that uncovers the truth beneath. Uncovering often involves being brave and prepared to lose or at least question authorial control. But once a story is repeated the fear seems to dissipate and over time the personal voice reclaims an authorial position. The use of "I" places me in a position of authority, even when I am discussing emotions I am not necessarily comfortable revealing. This concerns me. ❀ While writing this piece I started to read the work of Homi Bhabha and was drawn to his notion of performative time. Bhabha argues that the subject is only graspable in the time between telling and being told. This emphasizes the temporal element to "telling;" but there is also a spatial aspect, the time between telling and being told is also the place between here and somewhere else.[8] Importance shifts from the one who is telling, or "articulating," to where this articulation is taking place, the "topos of enunciation."[9] That the listener will tell again, somewhere else, helps to dissipate the omnipotence of the writer or speaker. The power to create meaning is reallocated, not only to the "Barthesian" reader or the listener, but to the teller, emphasizing both that there are multiple points of telling and that a listener can also be a teller. *As narrator she is narrated*

5
Gilles Deleuze and Felix Guattari, A THOUSAND PATEAUS: CAPITALISM AND SCHIZOPHRENIA (London: Athlone Press, 1988), p. 5.

6
A. S. Byatt, ON HISTORIES AND STORIES (London: Vintage, 2001), pp. 139-141.

7
See Primo Levi, THE PERIODIC TABLE (London: Penguin Books, 2000); Italo Calvino, IF ON A WINTER'S NIGHT A TRAVELLER (London: Vintage Classics, 1998) and Georges Perec, LIFE: A USER'S MANUAL (London: Collins Harvell, 1992).

8
Homi K Bhabha, THE LOCATION OF CULTURE (London: Routledge, 1994), p. 150.

9
Ibid., p. 162.

as well. And in a way she is already told, and what she herself is telling will not undo that somewhere else is she is told.[10] ❈ This essay is an encounter with a series of objects contained in a Welsh dresser. I sat with each object for a while and wrote down my thoughts. The thoughts I have start with the objects, with their nature as things, as material facts, as historical evidence, but spiral out creating a wider theoretical and spatial constellation. Walter Benjamin considered the photograph, as document rather than work of art, to invoke a mode of analysis rather than contemplation. But are these objects like photographs? Are my encounters with them moments of analysis or ones of contemplation? Is this where the thinking starts or where it stops? Certainly the view close-up reduces the frame, but this gives me time and space to reflect. An encounter with a detail is also a map of the imagination: an atlas of the Welsh dresser.

THE WELSH DRESSER

A dresser is a sideboard or table in a kitchen on which food can be prepared: or a table in a dining room or hall from which dishes are served. It is a kind of sideboard that is surmounted by shelves for storing and displaying dishes, plates, kitchen utensils, etc.

The Welsh dresser was constructed in the 1830s and has been in the family at least five generations. It has four legs, three drawers and three shelves full of jugs. The Welsh dresser lived in the dining room. I remember the room. It was in Aunty Ray's house in Cwmgors, a small mining village near the Black Mountains in South Wales. The dining room was one of two rooms that faced the street. Both were immaculate, seldom used, always cold. The Welsh dresser stood facing the window, obscured from the street by a layer of net curtain. It was a difficult thing, hung with gorgeous antique jugs that I never saw used. Every time a coal lorry passed by on the road outside they rattled.

10
Interestingly this quote comes not from Bhabha himself, but from Bhabha quoting Lyotard and Thebaud, in J.K. Lyotard and J.L. Theobald, JUST GAMING, trans. W. Godzich (Manchester: Manchester University Press, 1985), p. 41. See Homi K. Bhabha, THE LOCATION OF CULTURE, p. 150 and p. 267, footnote 31.

LUSTRE JUGS

Lustre: the quality or condition of shining by reflected light: a sheen or gloss; an iridescent metallic decorative surface on ceramics; the glaze used to produce this. A thin dress-fabric with a fine cotton (formerly also silk or mohair), warp and worsted weft, and a glossy surface, any fabric with a sheen or gloss. To make attractive be or become lustrous.

The Welsh dresser stood there gleaming through my childhood, through Christmas dinners and Sunday lunches, through rice puddings, cherry corona, beetroot chutney, faggots, and chips. As things fade into the distance, they seem to gain a glossy sheen. The fairy lights on the Christmas tree are always twinkling. My mother's hair is always shining. Nostalgia polishes the past so that we can see ourselves in the surface.

NEWSPAPER ARTICLES

wedding: the action of marriage
the married state, matrimony
a marriage ceremony
the performance of the ceremony itself

death: the act or fact of dying; the end of life; the final and irreversible cessation of the vital functions of an animal or plant.

Tucked in between the lustre-ware were smaller pots and tins that held many useful things: needles, threads, but also newspaper cuttings. Reading them helps me place emphasis. It allows me to think of my motherland, not my country of birth, but that of my mother and her family. It brings to mind small events and the big occasions, births, deaths and marriages, the coming together of the family at special times of year. Sitting on a blue velvet cushion. Slipping on the gloss of the wooden chair. Eating together around the dining table.

RED DICE

dice: a small cube whose six faces are marked with from one to six spots, used in games of chance by being thrown from a box, the hand, etc. the score being decided from the uppermost face.
a cube with different markings.
a solid with a different number of faces used in the same way.
an engraved stamp for impressing a design on some softer material as in coining,

striking a medal, embossing paper.
any of various devices for shaping bulk material.
of animate or sentient things.
of a person or animal.
loose life, cease to live, suffer, death, expire.

The drawers smelt of their practical contents–a wooden ruler, pencils with rubber tops, dry, thick-bound notebooks, tailor's chalk, and, strangely, a red wooden dice. Aunty Ray taught needlework and cookery; not a day passed without being asked to go to the Welsh dresser to get something useful. These trips were fraught with anxiety. The Welsh dresser was unsteady on its feet, the drawers stuck a little as you pulled them out, causing the jugs to knock against each other and clink.

RANDOM BUTTONS IN A BAG WITH NEEDLE AND THREAD
button: a small, knob, stud or disc attached to any object; one sewn to a garment to fasten it by passing through an opening or for ornament or attached as a badge. a button as a type of anything of little value. provide or adorn with a button or buttons. fasten or secure with buttons.

Buttons are odd things. Alone they are of little interest, yet as a collection they fascinate. Small and seemingly insignificant; they hold things together. Looking at one, then another, is meditative. Story-telling describes the world through connections making a coherent whole from a set of often random observations. Narrative understanding is a way of "seeing things together". In sequence or in juxtaposition, what happens to things when they are next to one another? As my grandfather, the butcher, lay in his dark coffin, tea and tongue sandwiches were served from the Welsh dresser in the room next door.

HOOK WITHOUT EYE
hook and eye: make hook-like or hooked; bend, crook, catch, secure, captivate, ensnare. attach oneself or be attached with a hook, fasten with a hook, attach or secure with a hook, connect or fasten together with a hook, or hooks and eyes.

As I stand in front of the Welsh dresser now, each object I take out and hold tells me something different, something about my family, my mother, her history, my Welshness. To attach one event to another and to explain their connection is the job of the historian. Writing history through an engagement with a series of objects provides an interesting material and spatial structure to the usually temporal

chronology. An object can remain mute or it can resonate. What is the nature of the resonance? What does this hook and eye tell me? How shall I describe it to you? Do you care what it feels like, looks like, smells like? I cannot "tell you how it is" I can only tell you what it means to me. My spinster aunt, who loved cooking and sewing also loved detective stories. When she died she left behind her a mystery surrounding an unworn engagement ring.

TWO KEYS

keys: an instrument fitting into a lock for locking or unlocking it, usually made of
metal and with more or less elaborate incisions etc. to fit the wards of the lock.
a key as representing the power of custody, control, admission.
a key as a symbol of office.
a thing that opens up the way to something; especially a sure means to or
a desired objective.
a place from which the strategic advantages of its position gives control
over a territory.
a solution or explanation of what is unknown, mysterious or obscure.
an alphabetical or other system for the interpretation of a cipher,
an allegorical statement.
a text explaining the abbreviations or symbols used in a book.
the figures in a photograph or picture.
a book containing solutions of mathematical or other problems.
translations of exercises in a foreign language.

96 Heol-y-Gors, Cwmgors, Dyfed, South Wales, a place where it always rained in the holidays, a place that as I kid I resented, but now, as it is being taken from me, I already begin to miss. How is my mother feeling today as she cuts off the last of our roots with that place she calls home? The archive originates with those who held the keys to the place that housed the documents of the past. These objects hold the key to my past. What do I see when they unlock the door?

TAILOR'S CHALK

tailor's chalk: hard chalk or soapstone used in tailoring etc. for marking fabric as a guide to fitting.

Tailor's chalk makes marks for action. Like chalk on the blackboard, these are marks that will be rubbed out. They have a short life span. Unlike blackboard chalk, they are marks for another making, for a line of cutting, folding, sewing. The new mark will in the act of its own making erase the tailor's chalk accidentally even before it is intentionally scrubbed out. Our words and gestures make room, prepare the way, for those that follow and necessarily get erased.

The furniture was far too big and covered in linen. The air was thick and still, silent. With the curtains drawn, it was very dark, but the linen glowed white, chalk white.

MY JUNIOR JET CLUB BADGE

badge: a distinctive device, emblem or mark worn as a sign of office or licensed employment or of membership of a society.
a distinguishing sign, token or emblem.
a characteristic feature revealing a quality or condition.
an ornamental window surround, or a representation of a window, at the stern of a small sailing vessel.

It's my junior jet club badge, a sign that I have travelled far and have been rewarded for it. My mum sometimes regrets how far she travelled from home. How she left Cwmgors for Aberystwyth, Wales for London. When she married my father, she went to live in the Middle East. She still remembers arriving alone on a desert airstrip on a hot night, pregnant with me. She is still saddened by the thought that she never saw enough of her own mother.

DIARY

DIARY: *journal, diary, daily allowance.*
a daily record of events, transactions, thoughts, etc., esp. ones involving the writer.
a book in which to keep such a record, usu. having dates printed in it.
a book or calendar with daily memoranda, esp. for people with a particular interest.
a person's list of forthcoming engagements.
a fever or illness lasting only for a day.

DAILY: *lasting for one day, short-lived.*

1965

Beth and Alan Married	June 7
Op Cyst in Neck	June 15
Carol O Level	Aug 23
Muriel Attack	Sept 4
Beth Home	
Alan Dubai	

1967

Jane Born	March 22
Jane Christened	

For a marxist historian, history has redeemable qualities only when it writes against the grain. Story-telling is dangerously close to the "once upon a time" mode of history. Autobiography is the story of an individual. For a feminist historian, the question of autobiography is vexed. Personal reflection has an important role to play in feminist practice, but the time and space taken up by men's anecdotes has been tiresome. We must tell our stories differently, stay aware of ourselves and our readers, stay critical.

As I went towards the mantelpiece to take a look at myself in the mirror, I saw for the first time in the reflection that the room was full of plants; so alive I could smell moisture still on their leaves.

WILL
will: the action of willing or deciding to do something.
intention, intent, determination, purpose.
a psychological drive, a deliberate or fixed desire or intention.
purport or substance of a legal document.
a person's formal declaration as to the disposal of his or her property after death having or intended to have legal force and usually made in writing, to be signed and witnessed, the document in which this declaration of intention is expressed.

This Welsh dresser tells the story of my mother's family. It has moved from a farm, down the road to a Victorian stone village house, and today to my mother's house in Cambridge. My mother doesn't own it yet. Its rightful owner lies in hospital in

South Wales with her heart failing, drifting between life and death. Her property has already been handed on. The Welsh dresser is a traveler, it has had many homes. From mother to eldest daughter, the Welsh dresser travels between women. My aunt never married, so the Welsh dresser went to her eldest niece. One day tradition has it that the Welsh dresser will be mine.

WHITE LINEN

I dreamt of the house last night. My mothers house in Cwmgors, South Wales, a place where it always rained in the holidays, that as a kid I resented, but now, as it is being taken from me, I already begin to miss. I was in the dining room; the rest of the house was empty except this one room. The furniture was far too big and covered in linen. The air was thick and still, silent. With the curtains drawn, it was very dark, but the linen glowed white. I went towards the mantelpiece to take a look at myself in the mirror, and I saw for the first time in the reflection, that the room was full of plants; so alive I could smell moisture still on their leaves.

JEREMIAH DAY

CONCRETE STEPS
IN MEMORIAM

"Concrete Steps" are the words five improvisa-tional dancers in Los Angeles chose to name themselves and describe the activity of dancing in public places that they began in January 2000. For the next two years, sometimes every week, sometimes every few weeks, Roger Burns, Dana Hirsch, Donna Leonard, Sarah Swenson, and Tom Young would meet in a location of the city and dance. Spanning the varying traditions of Butoh, Contact Improvisation, Modern, and Kinesthetic Awareness, Concrete Steps gathered in parks, subway stations, or street corners and just began. With no costumes, no invited audience, no announced time of stopping or starting, a group of people would start to stretch

and breathe, focus, warm-up, and then dance. They never founded a non-profit corporation around themselves, and they didn't rigorously document their efforts. Concrete Steps was more a commitment to an activity than anything else, and without other structures to sustain it, it should not be too surprising that they eventually stopped. The reasons these activities ceased are perhaps almost as important as the activities themselves.

The word "dance" likely brings forth an image of a ballerina, or the passionate release of the modern dancer, or perhaps even the rhythmic repetitions of a rock video, but Concrete Steps did not look like that, and to explain, a little bit of history is necessary. The proliferation of improvisational dance in the United States is largely due to the Judson Church Dance Theater. At the school several of Robert Dunn's students performed experimental dances that sought to move away from the orthodoxies of modern dance typified by the work of Martha Graham. It's important to recall that this time and place, the mid-1960s in lower New York City, was marked by sculptors, musicians, film-makers, poets, dancers, painters, all living and working in close proximity, and forming new social structures. Mail Art, Minimalism, Conceptualism, Concrete Poetry, Experimental Film, Fluxus, Earthworks, Happennings, the Living Theater, and, of course, Judson Church are some of the art historical names and categories for the more easily-labeled cross-pollinations of the period. While these terms can illuminate specific works of art and facilitate a general understanding, they obscure the specificity of the cultural context from which they emerged, a time and place of continual experimentation in which a commercially successful painter like Robert Rauschenberg might begin to choreograph dances, or Yvonne Rainer, a dancer, might begin to make films. In both the visual arts and dance, there were strong figures to rebel against—Clement Greenberg and Martha Graham, respectively—and reading interviews and writings of the period, one is struck by the almost arrogant assumption that the existing institutions for presenting culture publicly—the white cube art display and the proscenium stage—had been so clearly outmoded by cultural production that they would soon wither away, allowing other structures to take their place.

From this hubristic boldness, forms emerged that were embedded with both a new aesthetic and an enlarged conception of the possible role for culture in the public realm. From the Judson Church Dance Theater, Trisha Brown crafted a dance that shifted from roof to roof across lower Manhattan; Yvonne Rainer dissolved the difference between rehearsal and performance (and ultimately removed her authorial presence from her own company in order to democratize it); and most enduringly, Steve Paxton's investigations into the possibilities for movement drawn from common actions like standing or walking evolved into the popular form Contact Improvisation. In Paxton's work and the work of others, improvisation assumed an increasingly important role because it both allowed one to teach others to make their own dances, not just repeat the teacher's, and it gave the audience a type of participation: after all, neither the audience nor the performers knew what would happen next. Paxton's evolution can be compared with the shift during the same period from minimalist sculpture to Earthworks as a form of reclaiming landscapes devastated by industry. The new conceptions of process, materialism and phenomenology embodied in Robert Morris or Robert Smithson's sculptures and writings ultimately developed into a complete new model for the social and civic role of sculpture as land-reclamation. Similarly, the egalitarian instincts behind leaving the stage, abolishing the hierarchy of the choreographer, and challenging the distinction between the dancer and non-dancer culminated in Contact Improvisation, a social form, based on weight sharing between bodies that can be practiced at any level of skill and experience. More importantly, Contact Improvisation is today performed in "jams" (taken from the musical term), all over the world and forms a global community made of individual jams, each forming it's own community around the joy of "doing" Contact Improvisation.

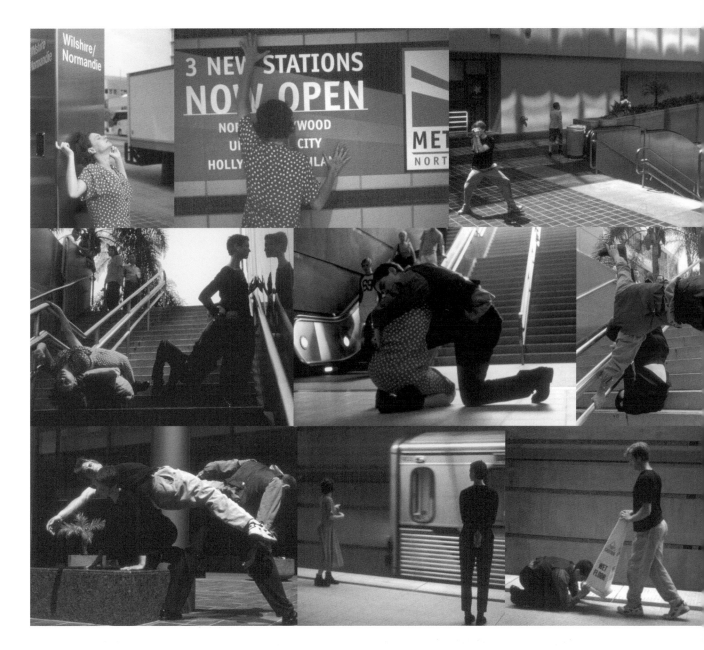

Concrete Steps, then, working from different techniques but emerging from the broader Contact Improvisation community, carried much of the Contact ethos out into the world with them. The literalism of this approach (working in real-time, willing to be "boring," performing as oneself, exploring the body as material), underscored the group's shared principle that dance is ultimately a form of activated attention—to one's own body, to one's context, to one's partners. Concrete Steps' improvisation did not establish any fictional realm, but rather a shared pluralistic focus that continually dialogued with their surroundings and each other. Butoh, a Japanese form marked by trance-like meditative focus and almost impossibly slow and ghostly movement, was juxtaposed with Contact, in which bodies are experienced as weight and movement expands from people shifting that weight against each other into rolling, flipping, colliding, and lifting. In turn, the more explicit dancerly articulate movements of modern, or the open attentive awareness of the body's shifting structure from Kinesthetic Awareness might lead to a composition in space that would come together, and then

separate again. Sometimes several different explorations would occur all far away from each other: one couple down by the trains, one more riding up and down in the elevator, and another person rolling along the floor slowly. Connotations emerged from the dance, then receded into abstract forms or the performance of a literal activity, as fragmented narratives or relationships cohered and dissipated.

Because this engagement with site was not a gesture but an ongoing practice, and because of each of the dancer's were accomplished in their craft, Concrete Steps' performances developed a precision that made the open-ended quality of improvisation even more vivid and dramatic. Like jazz improvisation, which, at its best, seems to involve the listener equally in the movements and forms a player crafts, Concrete Steps could be captivating, and passersby might stop for as long as an hour to witness this strange event. Strange because, absent of costumes or the baroque other-worldliness of a Happening, Concrete Steps seemed mostly like normal people making beauty out of themselves, and that literalness asserted the possibilities within the viewer's body as well. It was as if a ripple of attentiveness expanded from their bodies, implicating the spaces and the people around them in a focus that paralyzed some of the hustle and bustle of the city, and raised that which continued as normal equally into consideration by contrast. Absent of any frames, the dancing seemed to extend its own, as if illuminating its surroundings. This illumination made a space for others to be present in witnessing, a space in which one was not swept up into any vector of errands or functionalization of time and place. Concrete Steps offered those who were interested a possibility of briefly setting aside one's scripted afternoon to vicariously engage the reality that one stood upon: the kind of setting aside that traditionally has marked the boundary between the private and the public, between one's personal affairs and the broader world's. Curiously, this happened in places that were already in fact public, but absent of any public life.

This phenomenon, the absence of public life, is a Southern California cliché, and Concrete Steps were just as much a response to Southern California as anything else. "Car culture," tract-homes and malls are the symbols of the Southern Californian substitution of real-estate development for urban planning, a substitution that has now spread worldwide. Underlying this shift is in fact a deeper one, the shift from a built environment centered around res-publica—the public thing—to one flowing exclusively from an economic process. Gentrification is equally a consequence of this phenomenon

as real estate development, as old neighborhoods just as farmlands or open spaces are replaced seemingly overnight by condominiums, tract-homes, and malls. In this replacement of the market, agora, park, or common for an economic process, the built environment becomes an accumulation of pre-packaged social and economic products, designed and ultimately evaluated only in terms of customer satisfaction, effectively privatizing public space. Everything in between these privatized spaces becomes a kind of nowhere (like the empty sidewalk), and even these new forms like the mall or the ubiquitous chain coffee shops are not public but rather a place for many to conduct private business. This new landscape seems to reduce the physical environment to a function, like a prop in an over-arching process of consumption and production, with pre-determined routes to travel between. But, to lean a body on these props, to crawl between them and drag one's body around them, as Concrete Steps did, returns these psuedo-spaces to the terms of object-hood, and establishes a physically human frame of reference in what had been reduced to a mathematical equation. Though they often sought out sites that were exceptions to this status quo (dancing in the subway to try and link themselves to its counter-model of urbanity), Concrete Steps practice amounted to a counter-process against the grain of the Southern California landscape.

By reclaiming space for art-making, Concrete Steps had oddly re-asserted the traditional role of public space as a stage. It's only in recent decades that this tradition—seen in the market as a stage for social interaction, the agora a stage for dialogue, Burnham's urban planning or Olmstead's parks a stage for breaking down the class barriers—has shifted so dramatically. With public theater or civic sculpture as a perhaps unconscious reference point, Concrete Steps simultaneously were dramatizing and memorializing a tradition that had little place in their surroundings. Paradoxically, in establishing a new structure for themselves to dance within, they had reached back and, in effect, temporarily restored public space to its traditional role. Even more curiously, though there was no explicit political content in the work, its political nature was in its access to the root of politics, the space of the polis.

If Concrete Steps was out of place in Southern California, they were very much of their time, and if they were unconsciously accessing the traditions of civic art, they were quite conscious of their relationship to the other important form of public assembly—protest. They were self-consciously active within the re-birth of the protest movement (with the anti-

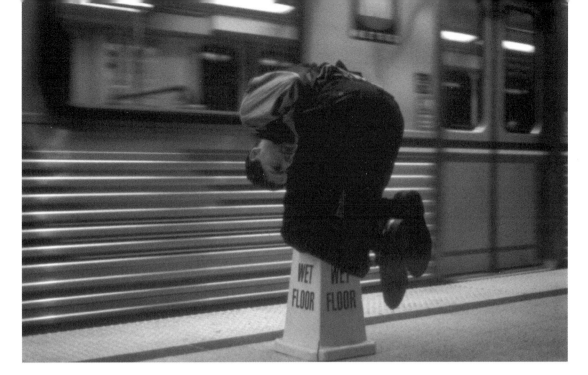

globalization movements' call "Whose streets? Our streets!") and (less consciously) active within the ongoing crisis of Los Angeles politics that had culminated in the 1992 riots and in the 1999 revelations of the Rampart police scandal. Besides the legalized brutality of the LAPD, revealed in the acquittals of the officers who beat Rodney King, the Rampart scandal (named after an LAPD station near the Echo Park area), disclosed that the so-called conspiracy theories had a basis in fact. Because of a chance arrest of one police officer, and his unprecedented willingness to testify on others, an entire system of corruption, drug dealing, and murder within the LAPD had come to light. Most striking was the ability of the Police to "frame" anyone they wanted, to fabricate facts to justify false arrests.

The stakes of that question—"whose streets?"—and, more importantly, the stakes of Concrete Steps' underlying assertion that the streets were public, took on a whole new meaning in the context of Los Angeles because to make such claims against this backdrop is no empty gesture. For instance, after the LAPD crushed a political demonstration downtown in 1999, the protestors were crowded onto the sidewalks to return to their cars as the police videotaped them from slowly passing vans. A few protestors comedically chanted "Whose sidewalks? Our sidewalks!," aware of the pathetic irony. Their bodies strewn across the architecture, rising to a moment of balance and then falling again, Concrete Steps dancing could be seen as equally a dramatization of the city as protest against it. Unannounced dance performances in the interstitial spaces of the city, desperately claiming the right to be, were perhaps the

most poignant artistic response to a privatized city, surveyed and controlled by brutal and corrupt police. That such efforts could only be transitory and fleeting grimly foreshadowed the impasse Los Angeles offered to the anti-globalization movement's attempts to protest the Democratic National Convention (with the sudden and brutal police crackdown during a performance of Rage Against The Machine). No banners were necessary to mark Concrete Steps' dancing as an act of protest, it was implicit in the act itself.

That a discussion of a dance group would lead one to thinking about real estate development or the consequences of police corruption is proof of a level of success in Concrete Step's attempt to engage their art into public life. After all, the words "concrete steps" are a pun, an allusion to the urban locale of the group's street performance, but also to the group itself as an attempt to break the logjam of dance's (or the arts, in general) seeming nullity in the face of political concerns and, equally important, "everyday life." So, why did they break up? Before answering, we must recall that, while Concrete Steps had broken out of the in-crowd and even fostered a certain model of audience, this audience could offer little of the financial or moral support and protection that institutions provide dance-as-entertainment or dance-as-high culture. Their success was, by most conventional measures, non-existent. Already burdened by the brutal balancing act of making art and making a living, with no carrots to be chased on their path or any buttressing beneath them, it should not be so surprising that the group eventually dissipated.

What Concrete Steps ultimately encountered was a crisis of audience. Gradually, going back over and over again into familiar neighborhoods became dissatisfying, and their instinct for experimentation drove them off their personal maps into the broader city around them. There they encountered (what they might have known intellectually, but could not possibly have fully reckoned with), that besides making a home for the entertainment industry and a thriving art community, Los Angeles is, as a recent study pointed out, the most racially segregated area in California. Moreover, it truly is a tale of two cities, as L.A. is simultaneously the richest and the poorest city in the United States. In other words, there are more millionaires both in quantity and percentage of the population than anywhere else, but there are also more people living at or below the poverty line. So, five white dancers, mostly immigrants to L.A., eventually found themselves breaking through the regimented isolation of the city, and, unlike most contemporary site practice, Concrete Steps wanted their work to dialogue with the people in those parks, or on those sidewalks. One can imagine the difficulty of the scene: earnest dancers of avant-garde traditions violating the public space of non-white immigrants who pass by exhausted from 10 hours of work. To demonstrate the width and breadth of human experience as a protest in that context could easily seem an invasive imposition, if not simultaneously pretentious and banal. Perhaps an uncomprehending or irritated stare from a movie executive could be tolerated, or even celebrated as proof of their violation of the city's power structure. The same look from a family of Guatemalan immigrants carried a different meaning, a charge of failure to truly engage the public, or even more painful, a charge that they were in fact part of the white minority's on-going violation of the Latino majority. It was in this period that the group lost drive and dissipated, and over the next year four of the five members left Los Angeles.

Because Concrete Steps was not simply the materialization of an intellectual exercise, nor the justification of a pre-conceived theoretical idea, a simple factual importance of human life played a crucial role in the impasse that they never overcame: namely, that no one in the group spoke Spanish. If someone had been able to speak to that Guatemalan family, or

rather been able to listen, they might have found that having fled the genocidal eradication of tribal culture (hundreds of thousands killed) to the land that had funded, trained, and illegally supported the catastrophe was in many ways deeply relevant to the broader social, cultural, and political crisis Concrete Steps was a response to. Such a new exchange might force a radical shift in the work, might change it entirely, but it would not have the same deadening force of wondering if one is complicit in racism. When one leaves the world of rhetorical politics and engages actual people, facts matter more and more, and it is proof of the group's engagement with the actual world that an unforeseeable, and seemingly slight factor could prove so crucial.

In sites around Los Angeles, Concrete Steps came together and danced perhaps 60 or 70 times over two years. They had left the dance studio and the stage for a tentative sense of art's possibility to engage their broader concerns about the world around them. Interestingly, their activities, as well as their motivations, link them with the broader tradition of site-specificity, and Robert Morris' hope for land-reclamation sculptures to be "especially relevant to and open for the public... That they defend an aggressive, non-elitist, an even anti-museum stance, while at the same time counting as advanced art" could equally describe Concrete Steps. Moreover, the stakes of their question—where is culture to be located, and for whom?—fixes them within an even broader tradition, marked by the moment artists, as Hannah Arendt described, "smelled the danger of being expelled from reality into a sphere of refined talk where what they did would lose all meaning." Is culture the domain of high society—where new painters are discussed in the same breath as new vacation destinations— or might culture emanate from a peer community of experimentation and collaboration, with a broader audience consisting of some part of the public-at-large? Such considerations are part of Concrete Steps wake—as is the lesson they provide in what is to be gained in establishing one's own stage—and both extend from the sense of possibility they offered in fleeting moments on street corners for those who just glimpsed them, and for those who lingered to witness.

Photographs by Jeremiah Day.

COPENHAGENOFFICE

ARCHITECTURE AS
DIALOGUE

Since 1999 CopenhagenOffice has aimed at form-ulating an architectural practice that engages dynamic and open collaborations by questioning the very limits of each project. In this regard, dialogue operates as initial design strategy, often engaging political and social agendas in conjunction with conceptual investigation. Such process leads to the development of modes of production influenced by global networking, project-based research and collaboration, and the investigation of the specific social conditions of projects. With a culturally critical attitude, CopenhagenOffice works range from small-scale constructions to inhabitable environments,

from architectural/social installations and housing projects to urban spatial strategies and writings.

PROJECT I: SUPERBLOCK

INTENTION The aim of this project is to generate a building volume through a collective design process. SUPERBLOCK places design in the hands of the dwellers—the users of the space. In today's building industry the architect, entrepreneur and investor have the primary responsibility for the final design of a building. SUPERBLOCK creates the possibility for anyone to become his or her own entrepreneur.

The dweller, whose involvement is generally limited to the selection of floor tiles or appliances, now has the possibility to alter structural and rudimentary spatial configurations. A designer as such not of isolated problems but of new colla-borative spatial possibility. Such developments occur by concentrating on the design of a "local volume" as opposed to an overall space plan. Economically, this approach is feasible because each dweller is designing smaller parts of a greater whole. SUPERBLOCK has no one ideal user, but supports a gamut of dwellers. Believing this contributes to a dynamic living unit, SUPERBLOCK generates the overlapping of individual spaces by instigating social interaction.

PARAMETERS As a diagrammatic point of departure for individual sub-projects, SUPERBLOCK functions as a flex-ible "blueprint" for the nurturing of spatial design as a conversational event. To facilitate such design, SUPERBLOCK operates according to parameters tailored to the specific requirements of projects. SUPERBLOCK thus becomes a set of tools, determined by parameters, which facilitates building while remaining open, allowing for individual customization.
• The first design parameter of SUPERBLOCK is discussion.
• The medium for SUPERBLOCK is a specific Volume sub-divided into smaller spaces referred to as Lumps. Each dweller acquires a number of Lumps, and starts to freely position these within the Volume through a continual process of discussion. No single individual can build in the Volume before all dwellers have been selected.

I. Density The density of the overall building Volume will be predefined. The number of dwellers depends on the density this Volume can obtain. The correct ratio of density to dwellers guarantees interaction and the orchestration of dialogue. For instance, the density ratio for a specific Volume could be as follows:
20% is specified for Air.
60% is specified for Built Volumes.
20% is specified for Shared Space.

2. Colors A maximum of three external colors include superblack, superwhite and superorange. These colors can be used in any combination and any relation to each other. A maximum of three internal colors are specific to each individual and of the individual's own choice.

3. Factor X is the variable that ensures both the possibility for hybrid, shared spaces and an active participation amongst the dwellers. For example, a multitude of diverse interests could create a hybrid spatial production. The intention of this factor is to inject a certain degree of complexity so as to promote the genesis of thought on a social level.

PROJECTS Two specific projects have been executed: The virtual flat SUPERBLOCK 01 and HOMEBASE, a new strategy for student housing. Future projects to be undertaken will include new homes for elderly people. The home in its variation is the selected building type for the first test projects, however SUPERBLOCK is not restricted to residential use.

SUPERBLOCK 01 is currently being tested in an Active Worlds virtual environment. This project provides the flexibility of working globally yet remaining site-specific. SUPERBLOCK 01 cannot be developed entirely on an individual level, but requires a collaborative dialogue and the interaction of a group. An individual dweller's wants and needs must include shared spaces developed in agreement with neighboring dwellers. In this manner the Volume is developed as one complete collaborative building. SUPERBLOCK 01 encourages interaction where spaces collide and overlap by fostering the hybridization of space. It is these points of intersection and overlap, where hybrid spaces occur, that suggest unconventional use. The dwellers affected by the overlap must negotiate the exact possibility of the space.

I. Most people have aspirations and dreams for a future and better home.

2. Through dialogue and interaction, the collection of individual aspirations becomes fused into an idea with one common goal. Individual desires are not compromised at the expense of the community.

3. The introduction of three parameters ensure the correct proportions, density and content. The parameters are meant to be refined according to the nature of the specific project. Individual ideas transform into three dimensional volumes, and common goals develop as (overlapping)shared spaces.

4. A structure is introduced into the project. Dialogue within the structure facilitates the building process.

5. The individual building projects are assimilated within the structure transforming into one communal project with a series of hybrid shared spaces.

compilation of ideas

HOMEBASE is an attempt to generate a new prototype for student housing that focuses on social interaction utilizing the principles of SUPERBLOCK. HOMEBASE has been developed in collaboration with Louise Griffin, UCLA architecture student.

Initially, analysis of the feedback from a questionnaire distributed to a group of students signalled the importance of social interaction both on an academic and personal level. Social interaction becomes the glue that binds the student to his dwelling and the dwelling to its surrounding. The first time away from home can be a challenging experience filled with enormous change and anxiety. The student must begin his or her higher education while establishing new friends, new rituals, and a new lifestyle. HOMEBASE attempts to ease this transition.

HOMEBASE is a large unobstructed common area with individual cells attached to this open space. The common area creates the opportunity for the dwellers to interact and can be modified to suit the needs of the group.

HOMEBASE is not a house, but rather a construction under a shell intended to serve several functions. A typical HOMEBASE-unit begins with private cells strategically located between two levels. The interstitial space becomes the public zone. A wrapper beginning at the ground and stretching over the cells to eventually encase the entire house covers the cells and the shared space. The principle of the HOMEBASE-unit's public/private spaces repeats itself over the site where outdoor public areas become invitations for meetings and neighbor interaction.

HOMEBASE is designed to be altered. A certain level of flexibility is essential for student housing where the dwellers are short-term occupants. A unit begins as a home for 3-5 students, however alterations are dependant on the students. The unit can be subdivided to accommodate a wide range of new living possibilities. Various cells and public spaces can be separated, creating shops, individual apartments, and/or sports facilities. The dwellers of the unit take charge and dictate the changes to the unit, thereby creating a dynamic living space.

PROJECT 2: SOCIAL DESIGN– OBJECTS FOR KUNSTART

The art group Kunstart, a collective fostering spatial awareness through organizing events, invited CopenhagenOffice to participate in a collaborative one-day event in H. C. Øÿrstedsparken in Copenhagen in the summer of 2001. The event took place on the Gay Pride Day, but was not specifically related. Rather, the aim of the event was to incorporate a larger part of the park through sound, art, and objects produced specifically for the park, thus creating an extended social event. The CopenhagenOffice project addresses the possibility of producing an artwork for the public with a 7-day turn-around and a very low budget.

H.C. Øÿrstedsparken is situated in the center of the city and was established at the end of the 18th century on the old fortification ring surrounding Copenhagen. The KUNSTART event was situated on a sloping area of the park, with an outdoor café at one end and the lake at the other. Beginning with the café, the area transitions from semi-commercial to public park to private recreational use. The altering of use goes unnoticed and allows for the co-habitation of café, topless sunbathing, recreational games and coincidental meetings all within roughly 50 yards.

The aim of the project was to produce a piece of furniture designed specifically for the park. The object was designed to be handled and moved around the park, providing optional sitting/ lying/ standing/ bending possibilities. With little functional expression, the furniture unit encouraged investigation of these different positions. The nomadic unit could be adapted to the individual's needs, and by filtering through the park, took on the role of a social object.

RAFI SEGAL AND EYAL WEIZMAN

WITH COMMENTARY BY ESTHER ZANDBERG

A CIVILIAN
OCCUPATION

THE POLITICS
OF ISRAELI ARCHITECTURE

Curatorial statement for the cancelled exhibition "Politics of Israeli Architecture"
which was to represent Israel at the 2002 World Congress of Architecture

National conflicts are characterized not only by the rapid processes of eruptive transformations, but also by the slower duration of building and the lengthy bureaucratic mechanics of planning. These form the scale at which territorial conflicts are played out. ❀ Throughout the last century, a different kind of warfare has been radically transforming the landscapes of Israel/Palestine. In it, the mundane elements of planning and architecture have been conscripted as tactical tools in the Israeli state-strategy, which sought in the organization of space and in the redistribution of its population, national and geo-political objectives.

→
Derech Haavot (the Way of the Pariahs), near Elazar, Bethlehem Region, 2002. An outpost settlement in the region of Hebron located on the historical Roman Road to Jerusalem. This outpost is one of about 100 similar ones that the Israeli Government has now agreed to dismantle in the context of the Road Map to Peace.

PHOTO BY MILUTIN LABUDOVIC

Shaked, Jenin Region, 2002. A Community Settlement located not very far out from the 1967 borders. Its positioning attempted to extend Israel's future borders. The concentric arrangement of the settlement is an attempt to maximize visual control of its periphery.

PHOTO BY MILUTIN LABUDOVIC

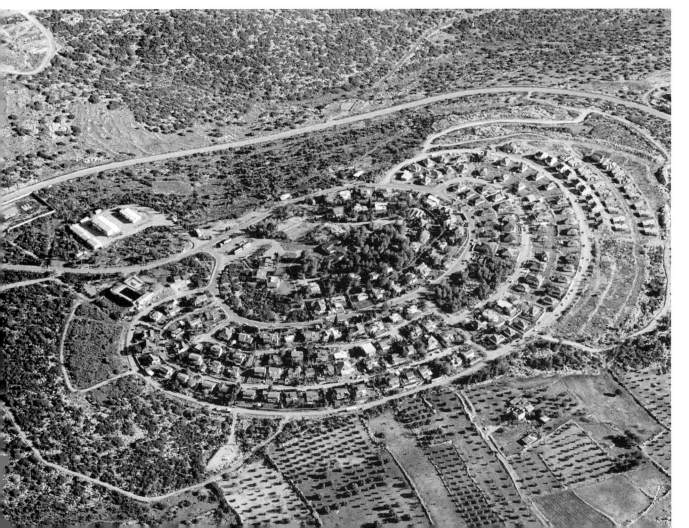

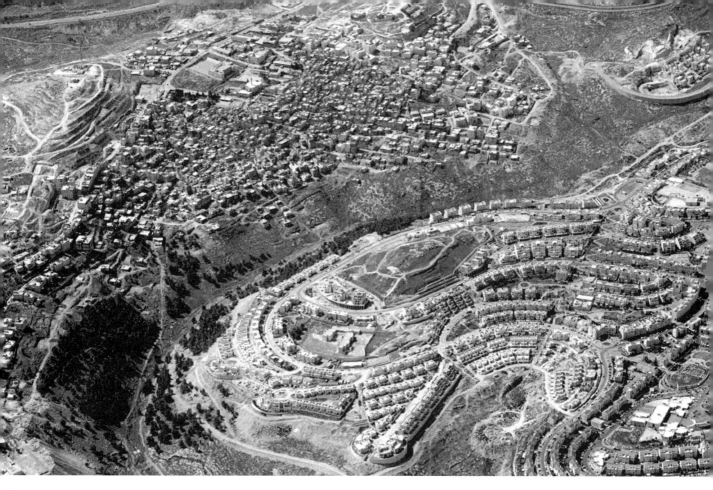

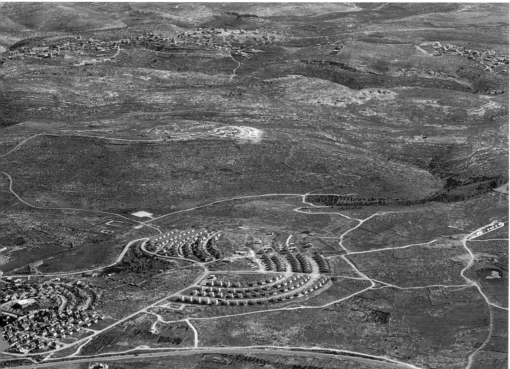

↑
Offra, and the Palestinian
Village of A Taybe, Ramallah
region, 2002. Here the geometry
of vision has generated a
settlement to function as an
optical device designed to
supervise its surroundings.

PHOTO BY MILUTIN LABUDOVIC

←
Pisgat Ze'ev and Anata
refugee camp, Jerusalem,
2002. PISGAT ZE'EV is a part
of a ring of Israeli neigh-
borhoods and settlements
around the occupied part of
Jerusalem. The neighborhood
of Pisgat Ze'ev bisects the
continuity of Palestinian built
fabric and controls the main
roads serving them.

PHOTO BY MILUTIN LABUDOVIC

RAFI SEGAL AND EYAL WEIZMAN

The landscape becomes the battlefield in which issues of power and state control, as well as resistance and subversion are put into play.

The relationship between the landscape and the Israeli/Palestinian conflict is symbiotic. The terrain dictates the nature, intensity, and the focal points of confrontation, while the conflict itself is manifested most clearly in the processes of transformation, adaptation, construction and obliteration of the landscape and the built environment. More than anything else the conflict is defined by where and how one builds.

In an environment where architecture and planning are systematically instrumentalized as the executive arms of the Israeli State, planning decisions do not often follow criteria of economic sustainability, ecology or efficiency of services, but are rather employed to serve strategic and political agendas. Space becomes the material embodiment of a matrix of forces, manifested across the landscape in the construction of roads, hilltop settlements, development towns and garden-suburbs. The images published here make these claims visible.

HAARTZ JOURNAL (Sunday, July 14, 2002, Israel Time: 11:08, GMT+3) "The Uninvolved" by Esther Zandberg:

The exhibition entitled THE POLITICS OF ISRAELI ARCHITECTURE, *which was supposed to represent the community of architects in Israel at this year's World Congress of Architecture, being held in Berlin, has been cancelled. Representatives of architects' organizations from dozens of countries are taking part in the meeting, which opens tomorrow and is considered the major event in the activity of the professional international community.*

The decision to cancel the exhibition was made last week by the Israel Association of United Architects (IAUA), which is the body that represents the Israeli architects in the Union Internationale des Architectes, which is organizing the Berlin conference. The association set up a steering committee, which chose the subject of the exhibition and the curators (architects Rafi Segal and Eyal Weizman). However, at the last moment, when the association's executive saw the catalogue of the exhibition, it ordered the cancellation. The verbal and visual content of the catalogue shows starkly the political significance of territorial planning and it is fraught with implicit trenchant criticism of elements of it, and of the role of the community of architects, in the national conflict. The way the leaders of the IAUA chose to deal with the facts was to silence the messenger.*

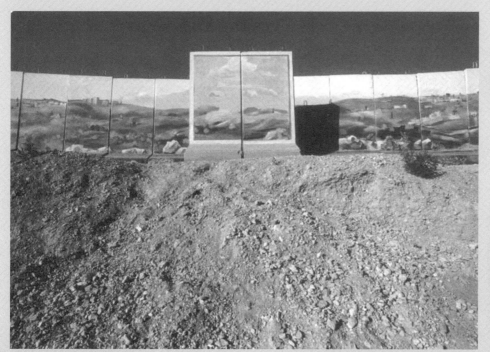

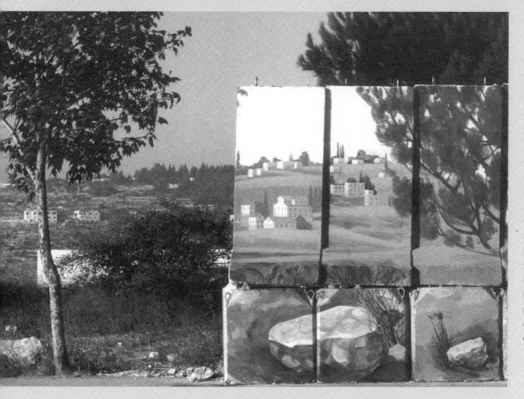

←↑
These photographs are of
the wall built around the
Jewish Neighborhood of Gilo,
East Jerusalem, 2002. The
photographs form a part of
a project commissioned by
EMULTI EXPOSUREI—THE BRITISH
ISRAELI PALESTINIAN AWARDS
SCHEME. The wall surrounding
the Jerusalem neighborhood of
Gilo was built at the start of the
al-Aqza Intifadah in 2000 after
several shooting attacks from
the neighboring town of Beit-
Jala. It was the same pastoral
landscape the settlers arrived
to enjoy that was now shooting
back at them. When the
landscape was replaced by a
painting the Palestinians were
cleansed out of the panorama.
PHOTO BY MIKI KRATZMAN

By this act of self-silencing, the IAUA is not fleeing from political involvement, as its leaders claimed, but from its responsibility to shape the physical image of Israel.

The community of architects very piously follows a total separation between "pure" professionalism and "dirty" politics. The chairman of the association, Uri Zerubavel, wrote to the curators that the IAUA "represents its members in regard to their profession and not in regard to the political aspect." However, the essence of their profession is to create political facts in the territorial space—irreversible facts are plainly visible.

In an article they published in the exhibition catalogue and which also appears in the June issue of the artistic monthly STUDIO, the curators observe that "planning decisions do not generally stem from economic or ecological considerations, but are meant to serve strategic national goals. The clearest expression of the conflict is the processes of change, adaptation, construction and erasure of the open landscape and the built-up surroundings. The singular topographic conditions [in the West Bank] dictate the points of friction, and the terrain becomes a field of battle on which themes of power, control, and resistance are played out."

This is illustrated in the catalogue by means of articles that survey the history of Jewish settlement in the country from the "tower and stockade" period to "the settlements on the hill," by disquieting photographs showing developments in the territories, and by an analysis of master plans of dozens of West Bank settlements. "The 'community settlement,' a new type of settlement that was developed in the early 1980s for the West Bank, is effectively a closed club," the curators point out. These principles are given clear physical expression on the ground in all aspects of the settlements, from their location on isolated hilltops that were suitable "for the development of this new utopia," to their master plans: "an enveloping ring of streets with no exit, sealed to their surroundings and encouraging communalism within a common formal identity. This is the built-up version of claustrophobia."

DISPUTE RESOLUTION SERVICES

Dispute Resolution Services (DRS) is a collective of artists intervening heterogeneously within "public space" since 1993. Within the images exhibited herein, it has been, and continues to be, our desire to interrupt the normative syntax and smooth functionality of urban sign systems in order to liberate virtual potentialities for communicating site-specific non-narrative moments and meanings in the lifecycle of everyday strife. By unhinging viewers' expectations as to the proper sequence of being, we seek to make space for an unexpected response and the imagination of the passer-by to emerge.

↑
One dozen cans of spray paint offered free of charge to young artists obliged to attend Hollywood High School. Specific gang-color red chosen for use value. The entire dozen was appropriated within minutes. (1997)

←
400 lbs. of smooth, gray, Mexican beach stones bagged up and hauled over the border by associates of Home Depot, to be bought by us and deposited at the corner of 7th St. Metro Center on 7th and Flower, just to remember what lies beneath. Only the unseen glass-encrusted downtown inner core, aggressive looking BMW and culturally diverse individuals are part of the image. (1997)

→
37 Black Holes lined up in front of Mann's Chinese Theater like soldiers. "William Shatner" and 36 unidentified stars, covered over with just enough pork lard to comfortably clench the felt circles. (2001)

↑
Four potted sycamore trees temporally conserved
from a future of wilderness landscaping at the
side of Temescal Canyon State Park's male and
female toilets, placed at the entrance, so as to
introduce car culture to the nature of pedestrian
traffic, while showcasing the factory in the heart
of the tree. (2000)

LUNAR RAMBLES

CD TRACK 3

My show at The Kitchen was in 1976 and it was titled LUNAR RAMBLES. In this show I reconstructed a sound object that I had in my studio in San Francisco consisting of 11 pairs of piano wires of different lengths and thickness. They were stretched across the floor, which made the floor into the resonator for the wires. The concept of the installation of the strings was based on the 11 rings composing the Labyrinth of Chartres. The longest strings represented the outside ring of steps of the labyrinth and the shorter pair of strings represented the innermost ring of stones. The wires were connected with turnbuckles fastened over wooden bridges. ❁ In this show I also showed a large metal

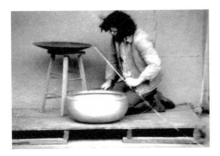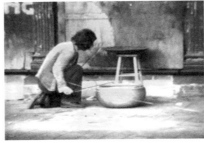

bowl and a parabolic steel plow disc. I could carry these two metal sound objects on each arm and I played them by bowing each one with a rosined violin bow simultaneously. Playing these two bowls was done by myself unannounced in five locations in New York. They were the Brooklyn Bridge, the Fulton Fish Market, the Underground Pedestrian Tunnel on 42nd Street, Canal Street, and a Lower Westside street (probably Greenwich Street). These performances were done each day over a five-day period and videotaped by (I think) Michael Shamberg. The day after each outdoor performance, the videotape was shown at The Kitchen during open hours in a separate room of the exhibition space with the above

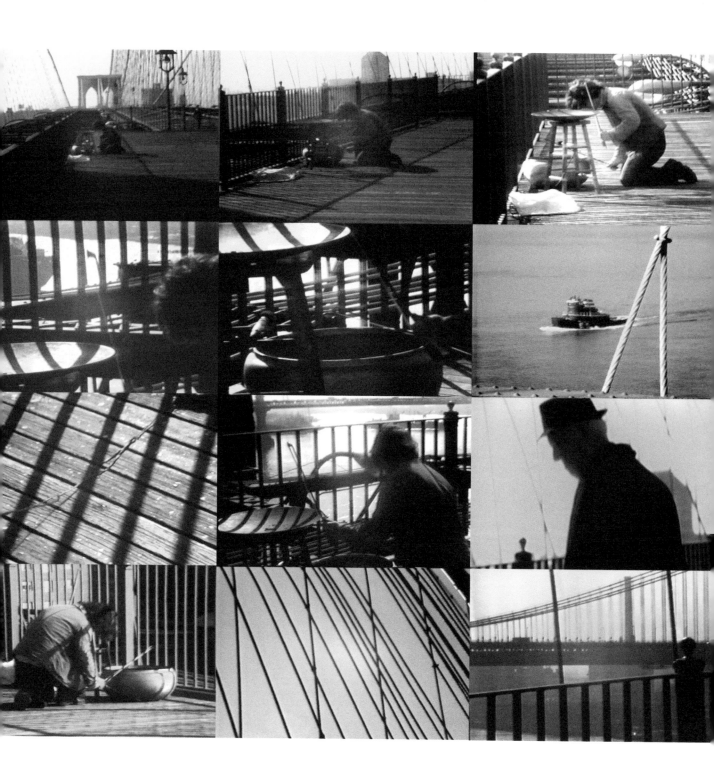

TERRY FOX

described sound installation. So, the spectators could see every day a new tape. I didn't have an audience at any of these performance-tapings except for passers-by. After my show at The Kitchen I brought the wires back to San Francisco, reconstructed them on my studio floor and did a 4½ hour performance on them that followed the 552 steps and 11 turns of the Labyrinth of Chartres.

BIOGRAPHIES

KIM ABELES Since 1985, Kim Abeles has created artworks exploring environmental and social issues, balancing form with content, metaphor with fact. "Kim Abeles: Encyclopedia Persona" was initiated and sponsored by the Fellows of Contemporary Art in 1993 as a mid-career survey curated by Karen Moss and organized by the Santa Monica Museum of Art. In recent years, Abeles has focused on community-based projects, including many significant public artworks such as Illuminated Fig Leaves for the City of Pasadena, California. Abeles has exhibited extensively throughout North America and Europe, as well in Mexico and Thailand.

MICHAEL ASHER is an artist whose installations have been exhibited in numerous museums and galleries both in the United States and abroad, including the Kunstverein Hamburg, The Renaissance Society in Chicago, Centre Georges Pompidou, Musee National d'Art Moderne and ARC in Paris, The Museum of Modern Art in New York, Van Abbemuseum Eindhoven in Holland, The Art Institute of Chicago, The Banff Centre in Canada, the Krefeld Kunstmuseum in Germany, the Venice Biennale in Italy, Documenta 5 and 7 in Kassel Germany, Los Angeles County Museum of Art, Museum of Contemporary Art, Los Angeles, Westfälisches Landesmuseum, XXlV Bienal de Sao Paulo, Brazil, Whitney Museum of American Art, and Kunsthalle Bern. His WRITINGS, 1973-1983, ON WORKS 1969-1979 has been published by The Press of the Nova Scotia College of Art and Design. He has been the recipient of a Guggenheim Fellowship, a National Endowment for the Arts Fellowship, and the Kunstpreis Aachen.

KATHY BATTISTA is a post-doctoral Research Fellow at the London Consortium where she is completing her thesis, WOMEN'S WORK: FEMINIST ART IN 1970S LONDON. She holds a BA in Art History from Fordham University, New York, and an MA from the Courtauld Institute. She is the co-author of ART NEW YORK (ellipsis, 2000) and RECENT ARCHITECTURE IN THE NETHERLANDS (ellipsis, 1998), and has contributed articles to MAKE, THIRD TEXT, WORLD ARCHITECTURE, and MARS: JOURNAL OF THE MUSEUM OF MODERN ART SLOVENIA. She is currently on the editorial board of CONTEMPORARY magazine and is Head of Interaction at Artangel, an agency commissioning art in unusual public spaces in London.

CAROL BROWN is a movement artist working in the fields of theater, dance and installation performance. Her London-based company, Carol Brown Dances, was formed in 1996 and tours internationally. The company is committed to the development of contemporary performance that communicates with audiences through a directness of physicality, content, and the construction of dance as an event-space. Carol is currently an AHRB Research Fellow in the Creative and Performing Arts at the University of Surrey Roehampton where she is developing a series of projects informed by contemporary architecture.

JULI CARSON is Adjunct Assistant Professor in the Department of Art at UCLA, where she teaches critical theory and contemporary art. Recent publications include: ON CRITICS, SUBLIMATION AND THE DRIVE: THE PHOTOGRAPHIC PARADOXES OF THE SUBJECT (The Other Press, 2002); ON DISCOURSE AS MONUMENT: THE NEW MUSEUM AND FEMINIST PROBLEMATICS (Minesotta Press, 2002); and (RE)VIEWING POST-PARTUM DOCUMENT (Generali Foundation, 1998). She is also founding editor of Vel Press.

OCTÁVIO CAMARGO is a composer and theater director, and has been teaching Aesthetics and Harmony at the University of Arts in Parana (EMBAP), Brazil, since 1992. His work explores a diversity of fields, from music composition, theatrical presentations, and impromptu actions, such as "Pé com Cabeça" (performance, 1995), "Ao redor da mesa" (theater play-1999), "Oraculo do momento" (installation, 2000), "Os Lusíadas" (performance, 2000). Since December 2000 he has directed

performances of dramatic enunciation of the Epic poetry of Homer in the translation of Manuel Odorico Mendes-Odyssei books I,II,III,VI and Iliad books I,III,XVI, and XXII.

SETH CLUETT is an installation artist and educator living and working in Troy, NY. His work has dealt with the relationship between the body and sound and with architecture as an extension of the body. His research deals with the effect of sound and light wave propagation on space perception and cognition. His work has been shown/performed at the ICMC in Habana, Cuba; the Acoustical Society of America; the ICA, Mobius Artist Space, MassArt/nonpod in Boston; Diapason and Engine 27 galleries; The Knitting Factory and ABCnoRio in New York; and at Betty Rymer, Heaven, and Artemisia galleries and Deadtech in Chicago.

COPENHAGENOFFICE Since 1999 CopenhagenOffice (Denmark) has established an architectural practice that encourages dynamic and open collaborations with artists, programmers, and scientists. Indicative of the Office's approach is the development of new forms of communication between clients and the social environment of projects. Such dialogues are integral to design strategy and conceptual investigations. Directed by Tanja Jordan, who studied at University of East London and Cooper Union School of Art and Architecture, projects range from inhabitable environments, architectural/social installations, housing projects, and urban spatial strategies and writings. In 2000 Jordan won 1st prize for a small-scale rooftop penthouse building competition, "Dwelling on Top of the City" with architects Malene Krüger and Ulrik Jagd. Since 1998 Jordan has been teaching at The Royal Danish Academy, School of Architecture in Copenhagen.

JEREMIAH DAY is an artist who works across media. His work has been presented at the California Institute of Technology, the Woods Hole Public Library, and Beyond Baroque Literary/Art Center, Los Angeles, where he was artist-in-residence from 2000-2002. Along with Fred Dewey, he founded the Beyond Baroque Working Group, a collaborative group of artists, architects, performers, and curators. He received a BA in Art from UCLA and is currently a participant at the Rijksakademie Von Beeldende Kunsten in Amsterdam.

STUART DEMPSTER is a sound gatherer, trombonist, didjeriduist, Guggenheim Fellow, and Professor Emeritus at the University of Washington. He has recorded for numerous record labels including Columbia, Nonesuch, and New Albion. His New Albion recording IN THE GREAT ABBEY OF CLEMENT VI AT AVIGNON has become, in the words of one reviewer, "a cult classic." Also on New Albion is UNDERGROUND OVERLAYS FROM THE CISTERN CHAPEL consisting of music sources for the 1995 Merce Cunningham Dance Company commission. Besides playing in Deep Listening Band, and Cathedral Band, he works with ROOM, a Seattle-based movement, sound and visual arts collective.

DISPUTE RESOLUTION SERVICE (DRS) is a collective of artists intervening heterogeneously within "public space" since 1993. DRS aims to interrupt the normative syntax and smooth functionality of urban sign systems in order to liberate virtual potentialities for communicating site-specific, non-narrative moments and meanings in the lifecycle of everyday strife. By unhinging viewers' expectations as to the proper sequence of being, DRS seeks to make space for the imagination of the passerby to emerge.

MELISSA DYNE is a visual artist who fabricates mechanical, musical, and optical instruments. The CAMERA OBSCURA is the first incarnation of her long-term project titled HYSTERESIS, a series of installations exploring the initial impulses of the mechanical and industrial eras. Through the use of simple mechanics and early (often obsolete), technologies reconstructed through a contemporary artistic process, her experiments involve the creation of useful and useless inventions. Her work has been exhibited in numerous spaces in Mexico and the United States. Originally from Lincoln, Nebraska, she currently lives in Los Angeles.

KEN EHRLICH is an artist and writer based in Los Angeles. He has recently mounted installations at California Institute of Technology, Beyond Baroque Literary/Art Center, and Side Streets Projects. He received an MFA in writing and Integrated Media from CalArts, where he co-founded and edited the journal TREPAN. Current collaborations include work with the Beyond Baroque Working Group and LAH*UB. He teaches writing and art in a variety of settings, most recently at U.C. Irvine and U.C. Riverside.

TERRY FOX was born in 1943 and was a central participant in the West Coast performance art, video, and Conceptual Art movements of the late 1960s and early 1970s. Working in the San Francisco Bay Area, his political, site-specific

performance actions explored ritual and symbolic content in the objects, places, and natural phenomena of everyday life.

His performances and works have been exhibited throughout the United States and Europe, including at the Everson Museum of Art, Syracuse, Documenta 5 and 6, and the Whitney Museum of American Art, New York.

JENNIFER GABRYS is currently a Ph.D. candidate in Communication Studies at McGill University. Previously, she practiced landscape architecture and art in Los Angeles. In L.A. she was involved with the Center for Land Use Interpretation in developing an online landscape museum, and with LAH*UB in devising a competition for open space in downtown L.A. She has completed several "landscape" installations, including a parking lot project, funded by the Weisman Art Museum; the insertion of altered bus schedules into the public transit circuit; and a (wet) audio installation in the Mojave Desert. She has previously taught landscape studio and seminar courses at Otis College of Art and Design in Los Angeles.

JEN HOFER is a poet and translator from the San Francisco Bay Area, currently living in Los Angeles. She has edited and translated an anthology of contemporary poetry by Mexican women entitled NO VISIBLE DOORS/SIN PUERTAS VISIBLES, co-published by University of Pittsburgh Press and Ediciones Sin Nombre in 2003. Her books and chapbooks include SLIDE RULE (subpress, 2002), LAWS (with drawings by Melissa Dyne, A.BACUS, Potes & Poets Press, 2001), THE 3:15 EXPERIMENT (with Lee Ann Brown, Danika Dinsmore, and Bernadette Mayer, The Owl Press, 2001), AS FAR AS (a+bend Press,1999), and CERTAIN PROPERTIES (with Dan Machlin, A Press,1998).

PASCALE JEANNÉE was born in 1976 and died in 2002. She graduated in 1999 with a degree in Graphic Arts from the Vienna University of Applied Art, and concentrated her final research on the subject of Art as an Instrument of Political Activism. She was a member of WochenKlausur (an arts activist group in Vienna) from 1995–2002.

ALISON KNOWLES travels in January 2003 to Bremen, Germany, for a solo exhibition focusing on the sound of paper. In the 1960s she composed the book NOTATIONS with John Cage and a color silkscreen print Coeurs Volants with Marcel Duchamp. She has traveled and performed with the Fluxus group for 40 years.

BRANDON LaBELLE is an artist and writer working in the field of sound and performance art. His work has been featured in the exhibitions: "Bitstreams" (Whitney Museum), "Amplitude of Chance" (Kawasaki City Museum, Japan), "9th International Symposium of Electronic Arts in Liverpool and Manchester," and "Sound as Media" (ICC, Tokyo). He is the co-editor of SITE OF SOUND: OF ARCHITECTURE and THE EAR and WRITING ALOUD: THE SONICS OF LANGUAGE, both published by Errant Bodies, and curator of the "Social Music" radio series, Kunstradio, Austria. He studied art and writing at CalArts and is currently a Ph.D. candidate at the London Consortium.

SIMON LEUNG e-mails this text from a room in the middle of his long railroad apartment in Brooklyn. From his desk he can see, out the window to his left, the Empire State Building, which seems to have turned permanently red, white and blue at night. If the tree on Devoe Street had not grown so tall, he would also be able to see the Chrysler building. The bedroom and kitchen are on the opposite sides of this apartment. From the kitchen he used to see a couple of large, identical oil tanks, but they were imploded by the city in the summer of 2001. From his bed on the other side of the apartment he used to look at downtown Manhattan. He is in the same place, but everything looks different to him these days.

LUCY R. LIPPARD is a writer, activist, and curator, and the author of 17 books including EVA HESSE; OVERLAY: CONTEMPORARY ART & THE ART OF PREHISTORY; MIXED BLESSINGS: NEW ART IN A MULTICULTURAL AMERICA; THE PINK GLASS SWAN, and THE LURE OF THE LOCAL: SENSES OF PLACE IN A MULTICENTERED SOCIETY.

RAFAEL LOZANO-HEMMER was born in Mexico City in 1967. In 1989 he received a B.Sc. in Physical Chemistry from Concordia University in Montréal, Canada. He currently lives in Madrid, Spain. His work is an intersection of architecture, technological interfaces, and performance art. He has exhibited in many countries, including the Istanbul Biennial (Turkey), the Liverpool Biennial (UK), Festival Printemps de Septembre (France), the ARCO art fair (Spain), Bienal de la Habana (Cuba), Architecture and Media Biennale (Austria), the Zócalo Square (Mexico), the Musée des Beaux Arts (Canada), European Media Art Festival (Germany), Ars Electronica Festival (Austria), and SIGGRAPH '93 (USA).

FRANCES-MARIE UITTI composer/performer, pioneered a revolutionary dimension to the cello by transforming it for the first time ever into a polyphonic instrument capable of sustained chordal (two, three, and four-part) and intricate multivoiced writing. Using two bows in one hand, this invention permits contemporaneous cross accents, multiple timbres, contrasting 4-voiced dynamics, simultaneous legato/articulated playing, that her previous work with a curved bow couldn't attain. Frances-Marie Uitti collaborates with pianist Rolf Hind, classical pianist Alwin Bar, filmmakers Frank Scheffer and Frans Zwaartjes, avant-garde guitarist Elliott Sharp, accordionist Pauline Oliveros, DJ Scanner, DJ Low, and Stephen Vitiello.

GORDON MATTA-CLARK was born in New York in 1943 and died in 1978. He studied French literature at the Sorbonne and Architecture at Cornell University. From the early 1970s, as a founding member of the artist-run Food Restaurant in New York's Soho neighborhood, Matta-Clark participated in numerous group exhibitions and projects. His work was presented in "Documenta V," and at exhibitions in Sao Paolo, Berlin, Zurich, and in the "9th Biennale de Paris." Major projects were staged in Aachen, Paris, and Antwerp. Following his death, retrospective exhibitions have been organized by the Museum of Contemporary Art, Chicago; Badischer Kunstverein, Karlsruhe, Germany; and IVAM Centro Julio Gonzalez, Valencia, Spain.

COLETTE MEACHER studied Social Anthropology and the Anthropology of Art at University College, London, and worked as a lecturer in Cultural Studies at the University of the Andes in Bogotá, Colombia. She has worked as a freelance photographer, Artist in Residence, and photography instructor, orchestrated and filmed pieces of improvised theater, and has curated two exhibitions of mixed-media work for the Brighton Library and No.12 galleries. An interview with the painter Jock McFadyen is due to appear in EYEING LONDON (London Consortium journal, 2003). She is a Ph.D. candidate at the London Consortium where she is researching "the mythic city."

CHRISTOF MIGONE is a multidisciplinary artist. He is the co-editor of WRITING ALOUD: THE SONICS OF LANGUAGE (Errant Bodies Press, 2001). He has collaborated with Alexandre St-Onge, Michel F. Côté, Gregory Whitehead, Lynda Gaudreau, Fly Pan Am, and Set Fire To Flames. He has released five solo audio CDs and has appeared on numerous compilations. He is a founding member of Avatar in Québec City. Migone currently lives in Montréal.

MARGARET MORGAN is an artist living in Los Angeles. Her practice includes drawing, photography, video, installation and writing. Recent writings have been published in WOMEN AND DADA (The MIT Press) and PLUMBING: SOUNDING MODERN ARCHITECTURE (Princeton Architectural Press). Her recent exhibitions of "shit drawings" were held at Susanne Vielmetter LA Projects and Galerie Patrik Schedler, Zurich.

LAURIE PALMER'S interdisciplinary art practice includes sculpture, writing, public art, and collaborative projects. She is a founding member of the artists' collective Haha, with whom she has worked for 13 years. She has exhibited both individual and collaborative work in the U.S. and abroad, and published her writing in FRIEZE, ARTFORUM, WHITEWALLS and other journals. She is currently Associate Professor in Sculpture at the School of the Art Institute of Chicago. In 2001 she received artist fellowship awards from the ArtCouncil, San Francisco, and the Louis Comfort Tiffany Foundation.

LIZE MOGEL is an interdisciplinary artist and independent curator working with issues of public space and cultural geography. Mogel recently curated two exhibitions of conceptual mappings of Southern California: "Genius Loci" at SCI-Arc, and "Alternate Routes" at the California Museum of Photography. For the past 3 years, she has also been an active member of the Center for Land Use Interpretation in Los Angeles.

ANTHONY MOORE is a composer and sound artist. Since 1969 he has composed soundtracks for experimental films. In 1970 he moved to Hamburg, where Polygram released several albums of his work, and he formed the band Slapp Happy in 1972. From 1973 he worked in different cities across Europe as a freelance composer, writing songs, film scores, and experimenting with sound. In 1996 he was appointed Professor and Chair for Research in Sound and Music in the context of New Media at the Academy of Media Arts in Cologne. Besides teaching, he continues making music and installations. In September 2000 he was elected director of the Academy of Media Arts, Cologne.

BRUCE NAUMAN Born in 1941 in Fort Wayne, Indiana, Bruce Nauman has been recognized since the early 1970s as one of the most innovative and provocative of America's contemporary artists. He graduated from University of Wisconsin, Madison in 1964 with a BFA and University of California, Davis in 1966 with a MFA. Nauman has lived in New Mexico since the early 1970s. Working with the diverse mediums of sculpture, film, video, printmaking, performance, and installation, Nauman concentrates on the way in which a process or activity can transform an action and become a work of art.

ERIK NAUMAN is a composer working with processed and unprocessed recorded sounds and live instruments. He has composed and performed pieces for tape, computer, and live instruments at such new music festivals and venues as the Brooklyn College International Electro-Acoustic Music Festival, the American Festival of Microtonal Music in New York, and the Pauline Oliveros Deep Listening Space. He also presented an interactive sound installation in the exhibit, "New York, New Sounds, New Spaces" at the Musee d'Art Contemporain in Lyon, France using his CD-ROM program "Concurrence of electrical transformers in several locations."

YOKO ONO is an internationally reknowned artist. Born in Tokyo in 1933, educated at Gakushuin University, Tokyo and Sarah Lawrence College, New York, Ono was a member of Fluxus, participating in events throughout the 60s in Japan, New York, and London. After her marriage to John Lennon, she collaborated with him on a number of projects in music, creating a bridge between avant-garde art and rock in UNFINISHED MUSIC FOR TWO VIRGINS (1968), WEDDING ALBUM (1969) and DOUBLE FANTASY (1980). Her work over the last 10 years has been widely represented in numerous venues across Europe, America, Japan, and Australia.

PAUL PANHUYSEN studied painting and monumental design in the 1950s. In 1965 he founded the artist group "De Bende van de Blauwe Hand," presenting exhibitions, environments, and happenings in streets, squares, museums and galleries. In 1968 he started the Maciunas Quartet, an experimental music group still active today. Since 1982 he has presented worldwide his Long String Installations, which utilize site-specific and architectural properties of indoor and outdoor locations. From 1980-1997, Panhuysen founded and directed Het Apollohuis, an international center where artists from divergent disciplines staged performances and exhibitions related to sound, music, and installation work.

MICHAEL RAKOWITZ is an artist and designer living in New York City and teaching at the Maryland Institute College of Art. He is the recipient of the 2002 Design 21 Grand Prix Award sponsored by UNESCO and Felissimo Design House. His work will be featured in the 2003 National Design Triennial at the Cooper Hewitt National Design Museum.

JANE RENDELL BA (Hons), Dip. Arch., MSc., Ph.D., is lecturer in architecture at the Bartlett School of Architecture, London. An architectural designer, historian, and theorist, she is author of THE PURSUIT OF PLEASURE (Athlone Press, 2001), editor of "A Place Between," PUBLIC ART JOURNAL, October 1999 and co-editor of STRANGELY FAMILIAR (Routledge, 1995), GENDER SPACE ARCHITECTURE (Routledge, 1999), INTERSECTIONS (Routledge, 2000) and THE UNKNOWN CITY (The MIT Press, 2000). She is currently completing A PLACE BETWEEN: ART, ARCHITECTURE AND CRITICAL THEORY for Reaktion press.

LIZZIE SCOTT received her MFA from CalArts, and studied at the Whitney Museum Independent Study Program. Her work has been exhibited internationally, and recently featured at PS 122 Gallery in New York City.

RAFI SEGAL completed his architectural degree at the Technion–Israel Institute of Technology, Haifa, in 1993; in 1992-2000 he worked with architect Zvi Hecker on the design of the Palmach History Museum built in Tel Aviv. In 1997 he was invited to teach at the faculty of Architecture and Town planning in the Technion in which he also submitted his M.Sc in Architectural Design titled THE ARTIFICIAL HORIZON. In 2000 he established his own practice in Tel Aviv and formed a partnership with architect Eyal Weizman. Segal has received the Ministry of Culture's Young Artist award (1996), and the Architects Association Young Architect award (2001).

ALEXANDRE ST-ONGE is a composer, sound-performance artist, and acoustic bass player. His works document and isolate certain actions that are connected by the dislocation and disintegration of various representational objects into sound excrement. The audio objects that survive the autopsy are no more than hard-drive dust or parasitic noise. St-Onge has detailed this phenomenon in KASI NAIGO (Squint Fucker Press), UNE MÂCHOIRE ET DEUX TROUS (Namskéio Records), and IMAGE/

NÉGATION (Alien 8 Recordings). He is also a member of Undo (with Christof Migone, Shalabi Effect, and Klaxon Gueule).

ATAU TANAKA was born in Tokyo and raised in the U.S. He was in residency in Paris in 1993 at IRCAM. In 1995 he became Artistic Ambassador for Apple France for his work in interactive music. He moved to Tokyo in 1997 for a project at NTT-ICC and subsequently taught at Keio, Wakayama, and Chukyo Universities. He creates digital music in real time through bodily gestures of the performer and time perturbations of the network. He has received prizes and support from the GMD, the Fraunhofer Society, and the Daniel Langlois Foundation. He currently resides in Paris and conducts research at Sony Computer Science Laboratories.

STEPHEN VITIELLO is an electronic musician and media artist. His work includes audio CDs (LIGHT OF FALLING CARS, SCRATCHY MARIMBA, UITTI/VITIELLO, BRIGHT AND DUSTY THINGS), site-specific sound installations (P.S. 1 Contemporary Art Center, The Project, the "2002 Whitney Biennial"), Internet commissions (Dia Center for the Arts, SF MOMA/Walker Art Center/ZKM) and over 75 soundtracks for independent film,

video and dance. He has collaborated with Nam June Paik, Pauline Oliveros, Tony Oursler, Scanner, Frances-Marie Uitti, John Jasperse, and performs internationally.

EYAL WEIZMAN is an architect based in Tel Aviv and London. Weizman is currently reconstructing the Ashdod Museum of Art (with Rafi Segal and Manuel Herz), and a set for the Itim Theater Company (with Rafi Segal). He has also conducted research for the human rights organization B'tselem on the planning aspects of the Israeli occupation of the West Bank (published as a human rights report titled LAND-GRAB). Weizman was the co-curator of the Israeli Pavilion at the UIA congress in Berlin and a participant in the Israeli pavilion at the "Venice Biennale." He is currently developing his POLITICS OF VERTICALITY project into a Ph.D. thesis, book, and film.

ESTHER ZANDBERG was born in Israel in 1946 and educated at the architectural-technical high school Tachnicum. She studied comparative literature at Tel Aviv University, and worked as architectural reporter and columnist for the Tel Aviv Ha'ir from 1982-1996. Currently, she writes for Ha'arezt daily, also based in Tel-Aviv.

INDEX

INTRODUCTION TO CD

To discuss cultural practice as a relational process is to skirt across a performative divide—for such processes can be understood as inherently conversational, unfolding through a multitude of negotiations, contexts and conduits made manifest through live actions. To highlight the performative and processional, the inclusion of an audio CD seems appropriate, in that the audibility of sound brings to the fore the processes that constitute performance. That is to say, a CD plays tricks with time, for its repeatability reenacts the original moment, and the durational unfolding of its content positions the listener as original witness.

The SURFACE TENSION audio compilation highlights performative strategies through documentation of live events, and actions that attempt to expand space through sound by probing the place of the body in performance, the resonance of found environments, and the interactivity of musical processes. Throughout the included works there is an intimate relationship with the selected sites, which are touched, activated, and listened to. In some cases, the interface is the body, as in Yoko Ono's throat, Bruce Nauman's feet, or undo's physical and durational actions. For other works, it is the instrument— the handmade paper shaker played by Alison Knowles, the strings of Frances-Marie Uitti's cello, the long strings of Paul Panhuysen's installation, or the trombone of Stuart Dempster resounding in a cistern. There are also works in which the microphone functions as an extension of the body, as in Erik Nauman's spatial and social mixing, and Anthony Moore's room performance. In each case, there is a dialogue, between artist and instrument, between instrument and space or context, through which an individual is connected to a larger environment, or the environment is produced through the performative moment. Such dialogues bridge the solitary figure with the spatial and proximate, as in Terry Fox's urban journey, and in turn remind the proximate of its new-found reach, made apparent in Atau Tanaka's global music-network.

CD TRACKS

1. YOKO ONO COUGH PIECE, 1961 (excerpt; 1963 recording).

2. ERIK NAUMAN CONCURRENCE OF ELECTRICAL TRANSFORMERS IN SEVERAL LOCATIONS, 2001.

3. TERRY FOX LUNAR RAMBLES, 1976 (excerpt; from videotape, courtesy of The Kitchen Archives).

4. ATAU TANAKA PROMÉTHÉE NUMÉRIQUE / FRANKENSTEIN'S NETZ: EXCERPT PHASE II: AWAKENING, 2002.
Recorded live during the festival Intermedium2 at the ZKM, Karlsruhe, Germany on March 24, 2002. Remote performance recordings from Ogaki, Japan, and Montréal, Canada.
Mixed at SWR2, Baden Baden, Germany by Atau Tanaka with Max Federhofer.

5. STUART DEMPSTER CONCH CALLING, 1995 (Track 1 of UNDERGROUND OVERLAYS FROM THE CISTERN CHAPEL, New Albion Records (NA 076), Deep Listening Publications.)
CONCH CALLING is a solo performance honoring the ageless world-wide tradition of the conch (pronounced "conk"), as a fanfare and signaling instrument.

6. ALISON KNOWLES SILK THREAD SONG (Song #2 of THREE SONGS), 1971 (live recording, December 2nd, 2001, Renee Weiler Concert Hall).
THREE SONGS was conceived when I had access to a blueprint machine at CalArts. The machine would accept real objects and print them directly on a sheet of paper, randomizing the elements and pressing them under the roller. The paper could be of any length. The patterns were suggestive of music and I rolled notations of 12 feet using onion skins, shoe laces and knotted silk threads in an edition of ten each. This was the early 1970s and ideas of sound and music production without notes was in the air. Some found objects that I used in printmaking I adapted to music making, namely the onion skins from making soup, two shoe laces from abandoned sneakers, and the silk threads from silk screen production in the photo lab.
 SILK THREAD SONG (Song #2 of THREE SONGS) The notation is carefully unrolled horizontally to start the performance. Two people hold the notation by the dowels at either end of the 12-foot length and face it toward the audience. The performers begin at either end of the scroll and sound the weaving, turning lines

of the threads that appears in sepia ink on vellum and run from one end of the paper to the other. The performer or performers move along the length of the print improvising what he/she sees into sound. Any instrument, object or the voice may be used. The notation may be read from the rear as well as using a flashlight. The performers wait until each has finished. The scroll is rolled up carefully and all exit together.

7. ANTHONY MOORE DAGMAR'S ROOM (excerpt, recorded 1971).
One of a series of recordings made in different rooms of various friends. The process involved close and more distant mics so that the room acoustics played a part. My instruments were miscellaneous sounding objects set up on a tabletop, including a chromatic octave set of tuning forks.

8. FRANCES-MARIE UITTI SHIFTING, 2001 (monotones for voiceless instrument, morin choor choir, and lost cello).

9. UNDO (CHRISTOF MIGONE/ALEXANDRE ST-ONGE) DISCLOSURE, 2001/2002.

10. BRUCE NAUMAN RHYTHMIC STAMPING/FOUR RHYTHMS IN PREPARATION FOR VIDEO TAPE PROBLEMS, 1969 (excerpt from Record, Tanglewood Press).

11. PAUL PANHUYSEN GATES OF PYTHAGORAS, Long String Installation, Spring 2002 (Aomori Contemporary Art Centre (ACAC) Aomori, Japan).

12. SETH CLUETT THE HIDDEN AUTONOMY OF WATER, 2002.
States of matter: solid, plasma, liquid, gas. Architecture often concerns itself with solids. Objects in a path determine motion and interaction. Each state consists of particles of varying degrees of stability; too often we believe that we have absolute control over matter. Consider air and water, we have little control here. They are the most flexibly structured, we often try to harness them, but we cannot control them with the same ease with which we can manipulate solids. They seep through cracks, deteriorate, resist resistance. In this piece the three states interact: The solidity of my hand moves water which in turn moves particles of air as sound. Maybe we try to control them because they are too similar to us. Maybe because they have a freedom that we may never know.